Sacred Mathematics

SACRED

PRINCETON UNIVERSITY PRESS
PRINCETON AND OXFORD

Fukagawa Hidetoshi

Tony Rothman

Mathematics

Japanese Temple Geometry

Copyright © 2008 by Princeton University Press

Published by Princeton University Press, 41 William Street,

Princeton, New Jersey 08540

In the United Kingdom: Princeton University Press,

3 Market Place, Woodstock,

Oxfordshire OX20 1SY

ISBN 978-0-691-12745-3

British Library Cataloging-in-Publication Data is available

Library of Congress Cataloging-in-Publication Data

Fukagawa, Hidetoshi, 1943–
Sacred mathematics : Japanese temple geometry / Fukagawa
Hidetoshi, Tony Rothman.
p. cm.
Includes bibliographical references.
ISBN 978-0-691-12745-3 (alk. paper)
1. Mathematics, Japanese—History. 2. Mathematics—Japan—
History—Tokugawa period, 1600–1868. 3. Mathematics—Problems,
exercises, etc. 4. Yamaguchi, Kazu, d. 1850. I. Rothman, Tony. II. Title.
QA27.J3F849 2008
510.952—dc22 2007061031

This book has been composed in New Baskerville

Printed on acid-free paper. ∞
press.princeton.edu

Printed in the United States of America

7 9 10 8 6

Frontispiece: People enjoying mathematics. From the 1826 *Sanpō Binran*,
or *Handbook of Mathematics*. (Courtesy Naoi Isao.)

To the Memory of **Dan Pedoe**

Who first introduced **sangaku** to the world

Fukagawa Hidetoshi

To **Freeman Dyson**

For long friendship

Tony Rothman

Contents

Foreword by Freeman Dyson

This is a book about a special kind of geometry that was invented and widely practiced in Japan during the centuries when Japan was isolated from Western influences. Japanese geometry is a mixture of art and mathematics. The experts communicated with one another by means of *sangaku*, which are wooden tablets painted with geometrical figures and displayed in Shinto shrines and Buddhist temples. Each tablet states a theorem or a problem. It is a challenge to other experts to prove the theorem or to solve the problem. It is a work of art as well as a mathematical statement. *Sangaku* are perishable, and the majority of them have decayed and disappeared during the last two centuries, but enough of them have survived to fill a book with examples of this unique Japanese blend of exact science and exquisite artistry.

Each chapter of the book is full of interesting details, but for me the most novel and illuminating chapters are 1 and 7. Chapter 1 describes the historical development of *sangaku*, with emphasis on Japan's "peculiar institution," the samurai class who had originally been independent warriors but who settled down in the seventeenth century to become a local aristocracy of well-educated officials and administrators. It was the samurai class that supplied mathematicians to create the *sangaku* and work out the problems. It is remarkable that *sangaku* are found in all parts of Japan, including remote places far away from cities. The reason for this is that samurai were spread out all over the country and maintained good communications even with remote regions. Samurai ran schools in which their children became literate and learned mathematics. Samurai combined the roles which in medieval Europe were played separately by monks and feudal lords. They were scholars and teachers as well as administrators.

Chapter 7 is my favorite chapter, the crown jewel of the book. It contains extracts from the travel diary of Yamaguchi Kanzan, a mathematician who made six long journeys through Japan between 1817 and 1828, recording details of the *sangaku* and their creators that he found on his travels. The

diary has never been published, but the manuscript is preserved in the ar-
chives of the city of Agano. The manuscript runs to seven hundred pages,
so that the brief extracts published here give us only a taste of it. It is
unique as a first-hand eye-witness description of the *sangaku* world, written
while that world was still at the height of its flowering, long before the sud-
den irruption of Western culture and modernization that brought it to an
end. I hope that the diary will one day be translated and published in full.
Meanwhile, this book, and chapter 7 in particular, gives us a glimpse of
Yamaguchi Kanzan as a mathematician and as a human being. Having
been present at the creation, he brings the dead bones of *sangaku* to life.

I am lucky to have known two scholars who have devoted their lives to
cultivating and teaching geometry. They are Daniel Pedoe in England and
the United States, and Fukagawa Hidetoshi in Japan. Each of them had to
swim against the tide of fashion. For the last fifty years, both in art and
mathematics, the fashionable style has been abstract: famous artists such as
Jackson Pollock produce abstract patterns of paint on canvas; famous math-
ematicians such as Kurt Gödel construct abstract patterns of ideas detached
from anything we can feel or touch. Geometry is like representational
painting, concerned with concrete objects that have unique properties and
exist in the real world. Fashionable artists despise representational paint-
ing, and fashionable mathematicians despise geometry. Representational
painting and geometry are left for amateurs and eccentric enthusiasts to
pursue. Pedoe and Fukagawa are two of the eccentric enthusiasts. Both of
them fell in love with *sangaku.*

Fukagawa Hidetoshi has been a high-school teacher in Aichi, Japan, for
most of his life. During school holidays he has spent his time visiting tem-
ples all over Japan, photographing *sangaku* as works of art and understand-
ing their meaning as mathematical problems. He knows more about *sangaku*
than anyone else in the world. Unfortunately, in the hierarchical academic
system of Japan, a high-school teacher has a low rank and is not highly re-
spected. He was not able to interest high-ranking professors in his proposal
to publish a book about his findings; without support from the academic
establishment, his work remained unpublished and unknown. After many
years he finally found a publisher outside Japan, with the help of Daniel
Pedoe.

Daniel Pedoe was my teacher when I was studying mathematics as a boy in
an English high-school long ago. He gave me my first taste of mathematical
research, asking me to work out a mapping of the circles in a Euclidean plane
onto the points of a three-dimensional Euclidean space. I found the mapping,

and my eyes were opened to the power and beauty of geometry. Many of the properties of circles became intuitively obvious when I looked at the map. Later, I renewed my friendship with Pedoe after we both moved to America. Forty years later, Pedoe discovered *sangaku*. He was then a professor of mathematics in Minnesota, and there he received a letter from Fukagawa. Fukagawa had written to six mathematicians known to be interested in geometry, informing them of the existence of *sangaku* and inviting them to collaborate in making *sangaku* known to the world outside Japan. Pedoe was the only one of the six who answered. He agreed to collaborate with Fukagawa in producing the book *Japanese Temple Geometry Problems*, which was published in English in 1989 by the Babbage Institute in Winnipeg, Canada. Pedoe paid for Fukagawa and his wife to come to Minnesota to work on the book, and he also visited Fukagawa in Japan. He remained a close friend of Fukagawa's and a promoter of *sangaku* until his death in 1998.

In 1993 I was invited to Japan to give lectures at Japanese universities, and I finally had a chance to meet Fukagawa in person. Dan Pedoe made the arrangements for our meeting. My academic hosts expressed surprise that I should wish to speak with a "lowly" high-school teacher, and tried to cut my visit with him short. They allowed me only a few hours to spend with him, visiting a temple where some outstanding *sangaku* are preserved and an abacus museum where we could see other artifacts of indigenous Japanese mathematics. I would happily have stayed longer, but my hosts were inflexible. Since then I have stayed in touch with Fukagawa as he continued to make new discoveries and deepen his understanding of the historical context out of which the *sangaku* emerged.

This book contains far more than the book that was published in Winnipeg in 1989, which presented the *sangaku* as a gallery of isolated works of art, without any information about their historical context. Little or nothing was said about the artists who created them or the connoisseurs for whom they were made. This book supplies the missing background information. One third of the book (chapters 1, 2, 3, and 7) is a narrative history of Japanese mathematics, with a full account of the leading individual mathematicians and the society to which they belonged. The middle section (chapters 4, 5, and 6) is an up-to-date display of *sangaku* problems arranged in increasing order of difficulty. The final section (chapters 8, 9, and 10) is a technical discussion of Japanese mathematical methods, with a comparison of Japanese and Western ways of solving geometrical problems.

In conclusion, I wish to thank my friend Tony Rothman for his big share in the writing of this book. I am responsible for introducing him to temple

geometry, and grateful to him for the long months of hard work that he put into the project. Although Fukagawa was the prime mover, it was Rothman who brought the task to a successful conclusion. Rothman translated and paraphrased Fukagawa's notes into readable English, and contributed many explanatory passages to make the mathematical problems and solutions understandable for English-speaking readers. Those familiar with Rothman's writing will recognize his work throughout. Without Rothman's massive and unselfish help, the book could never have been published.

Institute for Advanced Study,
Princeton, New Jersey

Preface by Fukagawa Hidetoshi

When I became a high school mathematics teacher forty years ago, I studied the history of Western mathematics and would present some of this historical material to my students. In those days, it was said that traditional Japanese mathematics had no material of any value for high school students. In 1969, a teacher of traditional Japanese literature showed me a traditional Japanese mathematics book printed in 1815 from wooden blocks. He asked me to decipher the book since it was written in difficult old Japanese. When I finished deciphering it, I found that traditional Japanese mathematics of the seventeenth, eighteenth, and nineteenth centuries had much good material for high school students. In those centuries Japan closed its doors to the outer world and many native cultures developed, one of which was traditional Japanese mathematics. In Japan in that era, there was no official academia, so mathematics was developed not only by scholars but also by ordinary people. Lovers of mathematics dedicated to shrines and temples the wooden tablets on which mathematics problems were written. We call this mathematical world "Japanese temple geometry." The mathematics lovers who formed this world enjoyed solving geometry problems. The present authors hope that readers of this book will also find enjoyment in trying to solve some of those same problems.

Preface by Tony Rothman

I vividly remember the day if not the year: It was 1989 or 1990; I had stopped by Freeman Dyson's office for lunch at the Institute for Advanced Study in Princeton, New Jersey. No sooner had Freeman raised his hand in his customary salute than he said, "Take a look at this," and placed into my own hand a small paperback book he'd received that very morning. The simple blue cover bore the title *Japanese Temple Geometry Problems, San Gaku,* and nothing more. The words meant nothing to me, and the blank expression on my face surely conveyed as much to Freeman. Paging through the book, I saw that it was a collection of geometry problems, assembled by Hidetoshi Fukagawa and Freeman's old math teacher from England, Dan Pedoe, who had sent it to him. Over the next few minutes, Freeman began to chuckle and then guffaw as he watched my expression change from bafflement to disbelief to open astonishment. For good reason. The first thing that struck me about the problems was how different they were from the those I'd studied in high school geometry. Nothing like this was ever produced in the West. The problems *looked* Japanese. The second thing that struck me was how beautiful they were, no less than miniature Japanese works of art. The third thing that dawned on me in those confused moments was how difficult they were. Without having attempted a single one of them, I understood quickly enough, standing there with dropped jaw, that I hadn't the faintest idea of how to tackle the majority—and I am supposed to be a mathematically inclined physicist.

Through Freeman I had stumbled on the strange and wonderful tradition of Japanese temple geometry. As readers will learn in the coming pages, for over two hundred years Japan was isolated by imperial decree from the West and had little, if any, access to Western developments in mathematics. Yet during that time Japanese mathematicians from all walks of life created and solved astonishingly difficult problems, painted the solutions on beautiful wooden tablets called *sangaku,* and hung the tablets in Buddhist temples and Shinto shrines.

Struck by this unique custom, I eventually wrote to Hidetoshi Fukagawa, the Japanese author of the problem book, and asked whether there was enough known about *sangaku* to warrant an article for *Scientific American*. Fukagawa, a high school teacher in Aichi prefecture with a doctorate in mathematics, replied that probably enough was known about the custom's origin for an article, and he generously supplied time and material. As it turned out, Hidetoshi was one of the world's experts on Japanese temple geometry, or more generally traditional Japanese mathematics. He himself had stumbled on a mention of *sangaku* in an old book decades earlier, decided they were an excellent teaching tool, and had been studying them ever since. Hoping to interest Westerners in the tradition, he'd written randomly to a number of European and American mathematicians. Dan Pedoe, a noted educator, alone responded and the result was the book that Freeman had received. And so, with substantial help from Hidetoshi, I wrote a piece for *Scientific American*, which after languishing in editorial limbo for three or four years, eventually appeared in the May 1998 issue.

The present book is partially an outgrowth of the *Scientific American* article and Hidetoshi's earlier work. However, we did not want to publish merely another problem book. Rather, we decided to try to place the problems in the context of traditional Japanese mathematics and, more generally, of the culture of the times. To set the stage, we have given a short introduction to Japanese mathematics, especially in the seventeenth century, when the tradition of temple geometry began, and we have also included a chapter on traditional Chinese mathematics, which so profoundly influenced Japanese developments. Throughout, we have attempted to maintain an historical flavor, including discussions of the important Japanese mathematicians and, along with the problems, vignettes about the creation and discovery of the tablets on which they are found.

Since the appearance of the *Scientific American* article, moreover, Hidetoshi and his colleagues have learned a great deal about the origins of traditional Japanese mathematics, and we are able to present significantly more material about the origin and purpose of *sangaku*. In particular, we are pleased to bring to a Western audience for the first time a substantial excerpt from the travel diary of Yamaguchi Kanzan, an early nineteenth century mathematician who took several extended walking tours around Japan specifically to collect *sangaku* problems. Yamaguchi's diary provides a "smoking gun" showing that Japanese mathematicians often hung the tablets

as acts of worship, thanks to the gods for being able to solve a difficult problem. In this sense, temple geometry is indeed sacred mathematics.

Finally, in the years since the article appeared, Hidetoshi has succeeded in organizing a large exhibit of over 100 *sangaku* at the Nagoya Science Museum, which took place in 2005 under sponsorship of the daily newspaper *Asahi Shinbun*. We are fortunate to be able to publish here some of the original photographs from the exhibit catalog. Readers cannot but be struck by the beauty of the tablets and we are certain it will add to the artistic aspect of the book. To that end, we have attempted to include contemporary drawings and illustrations that will put the mathematical art in the context of the prevailing art of the times. We have also included some of the original drawings of temple geometry problems from rare seventeenth-nineteenth century rice-paper books. We hope that they help make *Sacred Mathematics* as much an artistic creation as an historical and mathematical one.

The authors' collaboration for this project has been unusual. To this day Hidetoshi and I have never met and the work has taken place entirely by email. Hidetoshi has been the primary author. His collection of rare books on traditional Japanese mathematics, consisting of several hundred volumes, dwarfs anything available in Western libraries, and by now he has been studying the subject for forty years. My role has been to a large degree editorial. Hidetoshi's native language is far from English, and I speak no Japanese. Fortunately, mathematics is universal. I have taken Hidetoshi's drafts and attempted to render them in reasonably fluent English. I have also added substantial material, redrawn the diagrams, and gone through all the proofs, attempting to simplify them slightly. Hidetoshi's solutions are those of a professional mathematician, and I have frequently felt a few more steps and diagrams were needed to make them accessible to American students (or at least their teachers!), who we certainly hope will try the problems. In the more difficult exercises I have added more explanation, in the easier ones less, sometimes none at all; one or two of the solutions are my own.

My only guide in this procedure has been my experience of having taught many university students, often freshmen, from whom I have learned that if I have difficulty with a problem, they sometimes will. In *Sacred Mathematics* we often present traditional solutions. However, these are frequently translations from Kanbun to Japanese to English with modern mathematical notation, whereas traditional solutions did not use trigonometric functions, lacked indications of angles, and so forth. The "traditional" proofs in this

book therefore should not be regarded in any sense as literal transcriptions. When we have been able to closely follow the original, I have put my comments in brackets []; otherwise, I have edited the traditional proofs as I have all the others. Whether I have found a reasonable balance in all this, the audience will judge. I am certain only that professional mathematicians will be annoyed, but I hope they will indulge the lack of formality.

An ideal second author for this book would have been a mathematician fluent in Japanese as well as in Japanese history. The present circumstance is not perfect, especially in the case of Yamaguchi's diary, because I have no way of knowing how accurate my translation has been, except insofar as it has met with Hidetoshi's approval. But, as they say, I wanted to get the job done, and will welcome a better translation in the future by a professional.

Among the hurdles in learning Oriental mathematics is the bewildering profusion of transliterations and translations for Chinese names and book titles, some almost unrecognizable as referring to the same person or work. For the Chinese I have usually gone with the transliterations from the St. Andrews University MacTutor website, merely on the assumption that most readers will follow up there on any statements made here. Japanese names present their own problem. In Japan, it is customary to refer to people by surname first. Not only that, but Japanese mathematicians often have two names, one used by Westerners and one used by Japanese. In this book we follow the convention of surname first, and also use the names most common among Japanese. Thus the most famous Japanese mathematician, known as Kowa Seki in the West, becomes Seki Takakazu and Hidetoshi Fukagawa becomes Fukagawa Hidetoshi. After considerable discussion we have decided to use the Hepburn romanization system for the transliteration of Japanese words, which is not popular among the Japanese but is the most familiar to Western readers. We might also mention that we have, as consistently as possible, spoken of Buddhist temples but Shinto shrines.

Finally, despite all vigilance, errors must inevitably creep into a book such as this. Readers should report any such discoveries to the publisher or authors.

Acknowledgments

Fukagawa Hidetoshi would like to thank many friends and colleagues who supplied illustrations, books, access to *sangaku* and assistance while preparing *Sacred Mathematics*. They include Abe Haruki, Endo Shinosuke, Hori Yoji, Ito Akira, John Rigby, Matsuzaki Toshio, Naoi Isao, Nishiyama Hiroyuki, Nomura Tatsumi, Oyama Shigeo, Peter Wong, Fujii Sadao, Sasaki Eiji, and Taniguchi Takeshi. Most of all he thanks his wife Fukagawa Miyoko for her patience with his lifelong hobby.

The authors are also grateful to the Asahi Shinbun company for sponsoring the 2005 *sangaku* exhibit in Nagoya and making available images from the exhibit catalog for this book. We thank as well the numerous institutions who supplied material and illustrations. They are Agano City Board of Education, the Aichi University of Education Library, the Hiroshige Art Museum of Nakasendou, the Imizu city Shinminato Museum, the Japan Academy, the Maeda Ikutokukai Institute, the Nagasaki Museum of History and Culture, Nagoya Broadcast Network Co., Ltd., the Sekigahara Museum of History and Culture, the Tsurumai Central Library City of Nagoya, and Tamura City Board of Education.

This book would not have been possible without the cooperation of the many shrines and temples that permitted access to their *sangaku*, allowed them to be photographed, and to be placed on display. The authors are grateful to the Abe no Monjuin temple in Fukushima prefecture, the Atsuta shrine in Aichi prefecture, the Dewasanzan shrine in Yamagata prefecture, the Isobe shrine in Fukui prefecture, the Katayamahiko shrine in Okayama prefecture, the Kitamuki Kannon temple in Nagano prefecture, the Meiseirinji temple in Gifu prefecture, the Mizuho shrine in Nagano prefecture, the Shimizu shrine in Nagano prefecture, the Souzume shrine in Okayama prefecture, the Sugawara shrine in Mie prefecture, the Todaiji temple, and the Ubara shrine.

Tony Rothman would like to thank John Delaney of the Historic Maps Collection at Princeton University for supplying rare maps of Japan, the staff at Princeton University Press for their willingness to take on a complex project, Yasuko Makino for help with the transliterations, and Marvin Suomi for generous support.

What Do I Need to Know to Read This Book?

We hope this book can be read in three ways: as an art book that delights simply by the perusal of it, as a history book that provides a little insight into an aspect of Japanese culture rarely mentioned in standard surveys, and finally as a problem book that provides challenging exercises at both the high school and college levels.

Readers who intend to tackle the problems may wish to know at the outset the prerequisites. One requirement looms above all: patience. On first encounter with a *sangaku* problem there is a considerable "choke" factor. At first glance, Western students will find many of the problems strange, unlike those they have seen before, and one's first reaction tends to be, "I can't do that!"

Do not despair! Half the problems in *Sacred Mathematics* require no more than the most elementary methods, taught in any high school geometry course. The individual steps are no larger than in typical textbook problems. What *is* different is that *sangaku* problems are frequently far more intricate than the usual exercises American students encounter. Instead of running four or five lines, proofs may run four or five pages—if not ten. What is more, it is necessary to bring to bear *everything* you've learned from your geometry course. Sooner or later you will require virtually every theorem about circles, quadrilaterals, triangles, and tangents that you have proved. Some of the more difficult exercises require a good deal more than that. You should not be surprised if you spend hours—or days—working the advanced problems.

Following patience, a number of specific tools are required to solve *sangaku* problems. Because *Sacred Mathematics* is not intended to be a textbook, however, for the most part we do not teach basic methods. If you do try the problems it is a good idea to have a standard geometry text handy as a reference. A few suggestions, ranging from the elementary to the advanced are offered in "For Further Reading" on page 337; nevertheless, by way of helpful hints we can be a bit more specific here about what you will need.

A good drawing is indispensable. Many of the problems are fairly subtle, and it is not enough to make a rough sketch, which will deceive you; you need to make an accurate drawing that reflects the true conditions of the problem. Often the route to a solution becomes obvious when you've drawn in the appropriate auxiliary lines.

The single most important mathematical tool will be the Pythagorean theorem. This basic theorem, which was known to the Japanese through China, is used constantly throughout, and a large percentage of the problems can be solved with nothing more. If you are uncomfortable with the Pythagorean theorem, the problems in this book will be extremely difficult.

Hand in hand with the Pythagorean theorem, many, if not most, of the problems require solving quadratic equations. Not only will you frequently need the quadratic formula, which was also known to the Japanese, but it will often prove more convenient to solve the equation by "completing the square." Nearly as often you will encounter quadratics in the square root of a quantity, usually the radius of a circle, \sqrt{r}, and so you will need to know the basic methods for handling square roots, such as rationalizing denominators.

After the Pythagorean theorem and quadratics, the most frequently needed tool is probably properties of similar triangles, those theorems that go by names like AAA and SAS. You need all of them. Likewise, you will require virtually all the trigonometric identities involving sine, cosine, and tangent, that is, not only the basic Pythagorean identity, $\sin^2\theta + \cos^2\theta = 1$ but every variation on it, as well as all the half-angle and double-angle formulas.

The law of cosines also crops up often. This is the generalization of the Pythagorean theorem for nonright triangles that gives the third side of a triangle c in terms of the other two sides: $c^2 = a^2 + b^2 - 2ab\cos\theta$, where θ is the included angle between sides a and b. The law of sines also figures occasionally: $a/\sin A = b/\sin B = c/\sin C$, for triangles with vertex angles A, B, C and opposite sides a, b, c. Although traditional Japanese mathematicians did not explicitly use trigonometric functions, they did employ the equivalents and all these relationships were understood by them. Solutions to problems in chapters 4 and 5 will give a better idea of how those mathematicians operated.

Frequently, problems are solved by considering the area of triangles, rather than the lengths of the sides. In both this context and when employing the Pythagorean theorem, one basic fact crops up repeatedly: that two

tangent segments to a circle drawn from an external point P are equal in length. This is sometimes referred to as the "tangent segments theorem." If you have not seen this proven in an elementary course, you may wish to prove it now; it is very easy. The "intersecting chords theorem" is also frequently encountered: if two chords intersect in a circle, the product of the lengths of the segments of one chord equal the product of the lengths of the segments of the other chord (figure 0.1). Other theorems we introduce as needed.

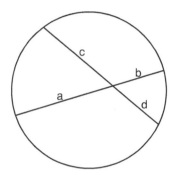

Figure 0.1. The intersecting chords theorem: $a \times b = c \times d$

For solving some of the more advanced problems, a "modern" technique that proves extremely useful is that of "inversion." However, because inversion is not generally taught in schools anymore, we include a chapter (10) to explain this powerful method.

A handful of problems requires calculus, but except for a very small number, this does not go beyond basic differentiation and integration.

Notation

\mathbf{W}e have tried to keep the notation used throughout this book standard and simple, but, at the risk of annoying professionals, have also tried to obviate some terms that nonmathematicians may not regularly encounter, such as "circumcircle" and "perpendicular foot." (Clearly, feudal Japanese farmers would not have used such terminology.) When avoidance of specialized terms has proven futile, if we do not define them explicitly, we trust they are defined in context. For the record, "circumcircle" is merely the circle circumscribed around a given polygon, while "incircle" is the circle inscribed within a given polygon. "Circumcenter" and "incenter" refer to the centers of these circles. When many figures are contained in, for example, a circle and touch one another, we sometimes speak of the collection as being "inscribed," although this may technically be a misuse of the term.

In dealing with triangles, upper-case letters refer to vertices, while lower-case letters refer to sides. The side opposite vertex A is usually labeled a. Sometimes we use the symbol for the vertex to refer to the angle itself, such as $\angle A$. All this is standard.

Although most American texts use radial lines or arrows to denote radii of circles, Japanese problems typically involve multitudes of circles, and drawing so many radial lines becomes confusing. Thus, we often denote the radius of a circle simply by a dot in the center with the indicated radius r nearby. This takes a little getting used to, but proves very convenient. Just as important to note is that we frequently speak of a circle by its radius, that is, "circle r" refers to the circle of radius r.

Sacred Mathematics

Plate 1.1. This rare map of Japan "Iaponi nova description" (Amsterdam, 1647–1656) was drawn by the Dutch cartographer Jan Jansson (1588–1664). The original print is 33 cm × 43 cm from copperplate. A modern map can be found on page 6. (Historic Maps Collection, Princeton University Library.)

One

Japan and Temple Geometry

Temple bells die out.
The fragrant blossoms remain.
A perfect evening!
—Bashō

Temples

No visitor to a foreign country has failed to experience the fascination and unease that accompanies an encounter with unknown traditions and customs. Some visitors attempt to overcome their fears, while the majority quickly retreats to familiar shores, and in this lies a distinction: Those who embrace culture shock are travelers; those who do not are tourists.

The most profound culture shock comes about when one is confronted by a different way of thinking. Most of us can hardly imagine walking into a Western church or cathedral to encounter stained glass windows covered by equations and geometrical figures. Even if we can conceive of it, the thought strikes us as alien, out of place, perhaps sacrilegious. Yet for well over two centuries, Japanese mathematicians—professionals, amateurs, women, children—created what was essentially mathematical stained glass, wooden tablets adorned with beautiful geometric problems that were simultaneously works of art, religious offerings, and a record of what we might call "folk mathematics." The creators of these *sangaku*—a word that literally means "mathematical tablet"—hung them by the thousands in Buddhist temples and Shinto shrines throughout Japan, and for that reason the entire collection of *sangaku* problems has come to be known as "temple geometry," sacred mathematics.

In this book you will be invited not only to encounter temple geometry but to appreciate it. There is a bit of culture shock to be overcome. A single

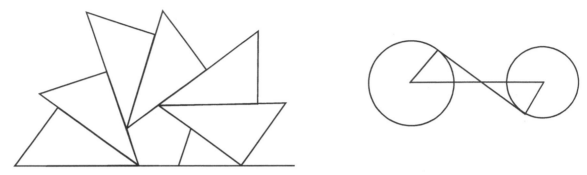

Figure 1.1. Which diagram would you guess came from an American geometry text?

glance at a *sangaku* is enough for one to realize that they were created by a profoundly different esthetic than the Greek-inspired designs found in Western geometry books. On a deeper level, one learns that the methods Japanese geometers employed to solve such problems differed, sometimes significantly, from those of their Western counterparts. Ask any professional mathematician whether the laws of mathematics would be the same in another universe and he or she will reply, of course. Real mathematicians are Pythagoreans—they cannot doubt that mathematics exists independently of the human mind. At the same time, during their off hours, mathematicians frequently speculate about how different mathematics could look from the way it is taught in Western schools.

Temple geometry provides a partial answer to both questions. Yes, the rules of mathematics are the same in East and West, but yes again, the traditional Japanese geometers who created *sangaku* saw their mathematical world through different eyes and sometimes solved problems in distinctly non-Western ways. To learn traditional Japanese mathematics is to learn another way of thinking.

Traditional Japanese mathematics, and with it temple geometry, arose in the seventeenth century under a nearly unique set of circumstances. In 1603, three years after defeating his rival *daimyo*— warlords—at the battle of Sekigahara, Tokugawa Ieyasu became shogun of Japan, establishing the Tokugawa shogunate. (A contemporary depiction of the battle of Sekigahara can be seen in the color plate 1.) The Tokugawa family ruled Japan for the better part of three hundred years, until 1868, when a decade after

Plate 1.2. An anonymous and undated woodblock print (probably mid-nineteenth century) shows Nagasaki harbor with the small fan-shaped island of Deshima in the foreground. Another view of Deshima can be seen in color plate 2.
(© Nagasaki Museum of History and Culture.)

Commodore Matthew C. Perry forcefully opened Japan to the West, the shogunate collapsed.

One of Ieyasu's first moves after Sekigahara was to establish his head-quarters at a small fortress town in central Japan, a town that became known as Edo (pronounced "Yedo")—today's Tokyo. For that reason the rule of the Tokugawa is also known as the Edo period. During the first years of the Tokugawa shogunate, Ieyasu (who, although living until 1616, officially remained shogun only until 1605) consolidated power by confis-cating the lands of other warlords, but nevertheless continued many of the foreign policies of his predecessor, the great *daimyo* Toyotomi Hideyoshi (1537–1598). At the turn of the seventeenth century, Japan carried on

substantial trade with foreign countries, both Eastern and Western. Nagasaki on the island of Kyūshū had become the base for the "southern barbarians" to import their goods, as well as to print translations of Western literature, much of it religious.

Foreign missionaries had by then been in Japan for over fifty years. In autumn of 1543, three Portuguese were shipwrecked off Kyūshū. The misfortune proved decisive in terms of Japan's relations with outsiders, for the men were carrying arquebuses, which were rapidly adopted by the Japanese warlords. Of equal or greater importance was that, within a few years of the fateful shipwreck, Portuguese merchants and Jesuit missionaries began to arrive, seeking both trade and converts. The Jesuits were particularly successful, converting as many as two hundred thousand Japanese over the next forty years and becoming de facto rulers of the Nagasaki region.

All of this alarmed the proponents of Buddhism and raised the distrust of Hideyoshi himself; he in 1587 took direct control of Nagasaki and issued two edicts designed to curb the spread of Christianity. But the Spanish soon arrived, with Spanish merchants vying with Portuguese for trade and Franciscans vying with Jesuits for converts. In 1596, after a Spaniard supposedly boasted that the missionaries were merely the vanguard of an Iberian conquest, Hideyoshi ordered the execution of twenty-six priests and converts. The warlord, though, had other affairs on his mind, in particular the conquest of China, and he failed to pursue a resolution of the growing tensions between the Japanese and Westerners.

The tensions were resolved, in a particularly decisive and brutal fashion, at the very end of Tokugawa Ieyasu's life and in the two decades that followed. In 1614 Ieyasu reissued an earlier edict with which he summarily ordered that all Christian missionaries leave the country, that places of worship be torn down, and that the practice of Christianity be outlawed. But other internal affairs intervened and Ieyasu died in 1616 without having taken much action. After his death, though, persecution of Christian converts began in earnest and by 1637, according to some estimates, three hundred thousand converts had apostasized or been killed. Throughout the 1630s Ieyasu's grandson, Togukawa Iemitsu, issued a series of decrees that offered rewards for the identification of *kirishitan*, forbade the sending of Japanese ships overseas, and forbade any Japanese from traveling abroad, on pain of death.

By 1641 the last of the Portuguese merchants had been expelled, leaving only the Dutch. The Dutch had arrived comparatively late to Japan, in 1609, and had shown more interest in trade than mission. For that

reason they were allowed to remain after the expulsion of the Iberians. The Japanese, however, by now utterly suspicious of Westerners, put severe strictures on the Dutch presence: The representatives of the Dutch East India Company were forced to move onto a small, man-made island called Deshima in Nagasaki harbor (see color plate 2 and plate 1.2). The fan-shaped island, originally created for the Portuguese, measured only 200 by 70 meters. A wall surrounded Deshima, posted with signs warning the Japanese to keep away, and it was entirely cut off from the mainland except for a bamboo water pipe and a single, guarded bridge. On this oasis, twenty or so members of the East India Company lived among the few warehouses, sheep, pigs, and chickens, and awaited the summer arrival of the Dutch ships. Upon making port, captains locked all Bibles and Christian literature into barrels, while Japanese laborers unloaded cargo.

That, for the next two hundred years, constituted Japan's trade with the West, and so began the policy of what would eventually become known as *sakoku*, "closed country." It is impossible to claim that *sakoku* was one hundred percent effective; certainly trade with Korea and China continued. Two Japanese did escape to Holland around 1650 in order to study mathematics. We know the scholars only by their adopted names, Petrius Hartsingius and Franciscus Carron, the former at least having achieved some distinction. Whether they ever returned to Japan we do not know. One doctor, Nakashima Chōzaburō, traveled abroad with a Dutch trader and risked beheading to come home. According to tradition, the local *daimyo* spared Nakashima's life because he healed one of the warlord's injured pigeons.

Such scraps of information do lead one to believe that by any ordinary standards the isolation from the West was nearly complete. In terms of mathematics, it is extremely unlikely that anyone in Japan learned about the creation of modern calculus by Newton and Leibnitz later in the seventeenth century, and there is certainly no evidence from *sangaku* problems and traditional Japanese mathematics texts that its practitioners understood the fundamental theorem of calculus.

One should not conclude from this state of affairs that *sakoku* had entirely negative consequences. To the contrary, the policy was so successful

RUSSIA

CHINA

HOKKAIDO

12

N

200 km

0 200 Miles

International Boundary
Prefecture Boundary
• City

Tsugaru-kaikyo

3

2

16

45 24

Sea of Japan

Sado

Yamagata

HONSHU

Fukushima

29

8

39

43 Nagano 10

15 26 14

6 9

Tsu Shima

42 22 Sekigahara Gifu 47 41 Tokyo (Edo)

37 31 13 Kyoto 36 Nagoya 19 4

11 Okayama 33 Nara 38 1

Hiroshima Osaka 23

46 17 28 44

5 20 40

Nagasaki/
Deshima

34 7

27 30

21

SHIKOKU

25

18 KYUSHU

Kamakura-
city

North Pacific Ocean

Prefectures		
1 Aichi	17 Kagawa	33 Osaka
2 Akita	18 Kagoshima	34 Saga
3 Aomori	19 Kanagawa	35 Saitama
4 Chiba	20 Kochi	36 Shiga
5 Ehime	21 Kumamoto	37 Shimane
6 Fukui	22 Kyoto	38 Shizouka
7 Fukuoka	23 Mie	39 Tochigi
8 Fukushima	24 Miyagi	40 Tokushima
9 Gifu	25 Miyazaki	41 Tokyo
10 Gumma	26 Nagano	42 Tottori
11 Hiroshima	27 Nagasaki	43 Toyama
12 Hokkaido	28 Nara	44 Wakayama
13 Hyogo	29 Niigata	45 Yamagata
14 Ibaraki	30 Oita	46 Yamaguchi
15 Ishikawa	31 Okayama	47 Yamanashi
16 Iwate	32 Okinawa	

Plate 1.3. The map shows Japan's 47 administrative divisions, known as prefectures, which are roughly akin to states or provinces, at least insofar as that each has a popularly elected government and single-chamber parliament. Prefectures are further divided into cities (*shi*) and towns (*machi*). Because prefectures are usually named after the largest city within their borders, one often sees "Nagano city" to distinguish it from "Nagano prefecture." The map also indicates some of the more important cities mentioned in the text.

at eliminating foreign conflicts that the 250 years of the Edo period became known as the "Great Peace." Moreover, with the stability provided by the Tokugawa shogunate, Japanese culture experienced a brilliant flowering, so much so that the years of the late seventeenth century are referred to as *Genroku*, Renaissance. At the time a gentleman was expected to cultivate skills in "medicine, poetry, the tea ceremony, music, the hand drum, the noh dance, etiquette, the appreciation of craft work, arithmetic and calculation . . . not to mention literary composition, reading and writing. There are other things as well . . ."[1]

We do not have space here to delve into the riches of Genroku culture, but one should recognize that during this era many of the arts for which Japan is renowned attained their highest achievements: Noh dance flourished; the great dramatist Chikamatsu Monzaemon (1653–1725) produced plays for both the Kabuki and puppet theatres; tea ceremonies, flower arranging, and garden architecture were on the ascendant, as well as painting in several schools, including the ubiquitous *ukiyo-e,* or "floating world" prints that illuminated the demimonde of courtesans and erotic love and fairly defined the entire epoch. *Ukiyo-e* prints were made using wood blocks, not because the Japanese lacked movable type, which had been imported from Korea during Hideyoshi's day, but because printers preferred the calligraphic and artistic possibilities afforded by block printing. Poetry was not to be eclipsed, especially haiku, which achieved some of its greatest expression in the works of Matsuo Bashō (1644–1694), who long ago achieved worldwide renown.

What is strikingly absent in the standard reviews of Japanese cultural achievements of the period is any mention of science or mathematics. And yet the isolation that produced such a distinctive esthetic in the arts certainly had no less an impact on these fields. The stylistic form of the impact on geometry will gradually become apparent to readers who delve into the mathematical aspects of this book, but it isn't coincidental that many *sangaku* problems resemble origami designs, nor that the practice of hanging the tablets began precisely during the Genroku, for, as we will see shortly, it was in the mid-to-late seventeenth century that traditional Japanese mathematics began to flourish.

[1] See Conrad Totman, *Early Modern Japan* p. 186 ("For Further Reading, Chapter 1," p. 338).

Plate 1.4. This ukiyo-e, or "floating world," print is from the series "Thirty-Six views of Mt. Fuji" by Katsushika Hokusai (1760–1849), one of the most famous artists of the Edo period. The print shows a distant view of Mt. Fuji from the Rakan-ji temple in Honjo. The original is in color. (© Nagoya TV-Japan.)

Regardless of the formal developments in mathematics at the time, Western readers invariably want to know how the strange custom of hanging tablets in shrines and temples arose. In the context of Japan, it was fairly natural. Shintoism, Japan's native religion, is populated by "eight hundred myriads of gods," the *kami*, whose spirits infuse everything from the sun and moon to rivers, mountains, and trees. For centuries before *sangaku* came into existence, worshippers would bring gifts to local shrines. The *kami*, it was said, love horses, but horses were expensive, and a worshipper who couldn't afford to offer a living one might present a likeness drawn on a piece wood instead. In fact, many tablets from the fifteenth century and earlier depict horses.

And so it would not have seemed extremely strange to the Japanese to hang a mathematical tablet in a temple. We cannot say exactly in what year, or even decade, the tradition began, but the oldest surviving *sangaku* has been found in Tochigi prefecture and dates from 1683, while the nineteenth-century mathematician Yamaguchi Kanzan, whose travel diary we excerpt in chapter 7, mentions an even older tablet dating from 1668; that one is now lost. Over the next two centuries the tablets appeared all over Japan, about two-thirds in Shinto shrines, one-third in Buddhist temples. We do not know how many were originally produced. From *sangaku* mentioned in contemporary mathematics texts, we are certain that at least 1,738 have been lost; moreover, only two percent of the tablets recorded in Yamaguchi's diary survive. So it is reasonable to guess that there were originally thousands more than the 900 tablets extant today. The practice of hanging *sangaku* gradually died out after the fall of the Tokugawa shogunate, but some devotees continued to post them as late as 1980, and *sangaku* continue to be discovered even now. In 2005, five tablets were found in the Toyama prefecture alone. The "newest" one was discovered by Mr. Hori Yoji at the Ubara shrine and dates from 1870. Two problems in chapter 4 are taken from the tablet and we present a photo of it in the color section, color plate 13.

Most *sangaku* contain only the final answer to a problem, rarely a detailed solution. (In *Sacred Mathematics* we usually give both answers and solutions, many drawn from traditional Japanese texts.) Apart from considerations of space, there seems to have been a certain bravado involved: Try this one if you dare! Nevertheless, as you will discover yourself from reading the inscriptions, the presenters of *sangaku* also took the spiritual, and even religious, aspect of the practice seriously, seeing nothing odd in offering a tablet to God in return for progress in mathematics. But just who were the creators of sacred mathematics? *Sangaku* are inscribed in a language called Kanbun, which used Chinese characters and essentially Chinese grammar, but included diacritical marks to indicate Japanese meaning. Kanbun played a role similar to Latin in the West and its use on *sangaku* would indicate that whoever set down the problems was highly educated. The majority of the presenters, in fact, seem to have been members of the samurai class. During the Edo period most samurai were not charging around the countryside, sword in hand, but worked as government functionaries; many became mathematicians, some famous ones. Nevertheless, the inscriptions on the tablets make clear that

whole classes of students, children, and occasionally women dedicated *sangaku*. So the best answer to the question "Who created them?" seems to be "everybody."

While contemplating this lesson, let us paint a fuller picture of the context in which *sangaku* were created by backing up as far as possible and briefly exploring the development of Japanese mathematics.

The Age of Arithmetic

The early history of Japan is inextricably bound up with that of China, from which it imported much of its culture, the Buddhist religion, as well as its system of government. This is true of Japanese mathematics as well; however, our knowledge about the state of mathematics in Japan prior to the eighth century is almost nonexistent. Perhaps the only definite piece of information from the earliest times is that the Japanese had some system of exponential notation that could be used for writing high powers of ten, similar to what Archimedes employed in the *Sand Reckoner*. Traditionally, the system was in place before the legendary Jimmu founded Japan in the seventh century B.C., but the date and the exact nature of the system are open to dispute.

More concrete information dates only from the onset of the Nara period (710–794), when a government was established at the city of Heijo, today's Nara, near Osaka. By then the unification of Japan had been in progress for four hundred years. Buddhism arrived from China in the mid-sixth century and by the eighth century had becomes extremely powerful, as evidenced by the "Great Eastern Temple" Todaiji that was built at Nara in 752. At the opening of the eighth century, the Nara rulers established a university and prescribed nine Chinese mathematical texts, six of them from what became known as the *Ten Classics*. The most important of these would have been the *Jiu zhang Suanshu*, or *Nine Chapters on the Mathematical Art*. The "mathematical art" of the *Nine Chapters* and the other books is for the most part arithmetic and elementary algebra; in Japan they were introduced principally to aid in land surveying and tax collection. Although their full impact would not be evident for nearly one thousand years, the Chinese texts provided the foundation for all Japanese mathematics and their importance cannot be overstated. They also offer an illuminating window onto Chinese society of the time, and the reader

Plate 1.5. The Great Eastern temple of Todaiji was built in A.D. 752 in Nara, near Osaka. Today it is one of the most popular tourist destinations in Japan. (© Todaiji.)

can get a taste of them by sampling the problems from the most influential classics in Chapter 2.

One impact of the Chinese texts was felt as early as 718. In that year the government passed the law *yoryō ritsuryō*, literally "law of the yoryō age,"[2] by which it created the office of *San Hakase*, meaning approximately "Arithmetic Intelligence." The Department of Arithmetic Intelligence consisted of about 70 midlevel functionaries whose job was apparently to measure the size of fields and levy taxes. According to the law, the members of Arithmetic Intelligence were to learn only enough math from the Chinese books to calculate taxes, and so, although the Japanese became proficient in arithmetic operations, higher mathematics did not develop at that time.

Calculations of the period were performed by a precursor to the abacus that consisted of a set of small bamboo sticks known as *saunzi* in Chinese, *sangi* in Japanese. Certain configurations of the sticks represented numbers, not dissimilar to the simple strokes that represent roman numerals in

[2] *Yoryō* is a proper name that literally means "cherish aged people."

the West. A member of the Department of Arithmetic Intelligence, intending to calculate some taxes, would place the *sangi* on a ruled piece of paper that resembed a chessboard, and with a series of prescribed operations he could carry out addition, subtraction, multiplication, division and extraction of roots, very much in the spirit that Western students performed long division before the advent of the calculator. (See color plate 3 for a photo of a *sangi* set.)

At the time, Japan's two religions, the native Shintoism and the recently imported Buddhism, coexisted in relative peace. Buddhist temples in particular—as monasteries did during those centuries in the West—became repositories of learning. In chapter 7 you will have the opportunity to visit the major Shinto shrines Ise Jingū and Izumo Taisya with mathematician Yamaguchi Kanzan as he tours Japan collecting *sangaku* problems. Although they are not mentioned in the part of the diary we excerpt, he also visited the two great Buddhist complexes of Hōryūji and Todaiji; at the latter Japan's largest statue of the Buddha was constructed with the temple in 752. Next to the temple is a wooden storehouse where a number of historical documents pertaining to tax collection in the Nara period reside.

These documents, which include maps drawn and signed by the members of the Department of Arithmetic Intelligence, reveal some sophisticated bookkeeping, for instance a rather involved expense account for an inspection of Suruga province[3] in 738. The *San Hakase* staff consisted of two directors, nine subdirectors, six officers, ten clerks, and forty assistants. A first group, made up of one director, one officer, one clerk, and six helpers, inspects one village in twelve days. A second group, made up of a director, three subdirectors, three clerks, and twenty helpers, inspects seven villages and stays four days in each village. There are seven such groups, all of differing composition, and the total number of people involved is 1,330. Directors, subdirectors, and officers all get the same daily allocation of rice, salt, and sake, but clerks and helpers get less. It is a substantial arithmetic calculation to determine the total expenditure of rice, salt, and sake, but the Department of Arithmetic Intelligence got it exactly right.

In order to quiet the various power struggles that plagued Japan during the Nara period, in 794 the seat of government was moved to Heian-kyō, "the city of peace and tranquility"— present-day Kyoto. Heian-kyō remained

[3]Now Shizuoka prefecture.

the capital until 1192, and for that reason the period is known as the Heian era. During this relatively stable epoch, Japan began to develop a culture independent of China, and a writing system independent of Chinese. The most significant developments of the time were in literature: *The Tales of the Genji* by Lady Murasaki Shikibu is considered the world's first novel, and Sei Shonagon's diary of court life *The Pillow Book* has also achieved renown. Only a handful of names even tangentially connected with mathematics have come down to us, from the Nara period through to the seventeenth century, and there are almost no advances to report for nine hundred years. The Chinese texts written at the time may well have been imported into Japan but, as in the West, clergy were little interested in science and mathematics, and as far as mathematics goes it was very much a dark age.

From the Kamakura period (1192–1333), when the Minamoto shogunate established its government in Kamakura, far from Kyoto, there do survive a few literary references to *sangi*, which indicate that they were still used for arithmetic calculation. For instance, in Kamo no Chōmei book *Hosshinsyu* (*Stories about Buddhism*), which was written around 1241 and consisted of one hundred stories, there are two mentions of *sangi*. One is to count the number of repetitions of a Buddhist chant; in another story the author describes houses destroyed by a flood as "like *sangi*," because *sangi* are scattered on paper. In the anonymous *Uji Syui* (*Stories Edited by the Uji Minister*) from the beginning of the thirteenth century, one of the 197 humorous stories concerns a man who wants to learn how to use the *sangi*.

Such meager scraps lead us to conclude that *sangi* continued to be used for arithmetic calculation, but there as yet appear to have been no developments in higher mathematics. This state of affairs continued through the Muromachi period, from 1338 to 1573, which takes its name from the Muromachi area of Kyoto, where the Ashikaga family reestablished the government. During this era, the story goes, one could hardly find in all Japan a person versed in the art of division. Nevertheless, not only was this an age when Japan carried out extensive trade with Southeast Asia and rich merchants appeared, but it was also an age of burgeoning culture. At this time, contemporaneous to the Italian Renaissance, Kanami Kiyotsugu (1333–1384) invented Noh drama, while his son Zeami Motokiyo (1363–1443) brought it to the peak of its development. A few hundred years later, Sen no Rikyū perfected the tea ceremony, which concerns far more than the drinking of tea; even today, millions of Japanese study the ritual as a path toward perfecting Zen principles.

As in the West, the final decades of the sixteenth century in Japan were far from peaceful. The Ashikaga shogunate came to an end in 1573 when warlord Oda Nobunaga (1534–1582) drove the last Ashikaga shogun from Kyoto. The following decades saw Nobunaga's successor, Toyotomi Hideyoshi, with the help of Tokugawa Ieyasu, conquer one province after another, until by 1590 Japan was finally unified. As it happened, both Nobunaga and Hideyoshi were great patrons of the arts and helped set the stage for the cultural blossoming that was shortly to come. Toward the end of his life, however, Hideyoshi appears to have begun behaving in an erratic and dangerous fashion, in 1591 forcing his friend and tea master Sen no Rikyū to commit ritual suicide. Not satisfied with the unification of Japan, the following year he launched a massive invasion of Korea, which ultimately failed. It did, however, have profound consequences for Japanese mathematics.

One of Hideyoshi's soldiers at the port of Hakata, which the warlord had established as his staging ground for the invasion, had in his possession an abacus, *soroban* in Japanese, which evidently came from China. The soldier's *soroban* is in fact the oldest surviving abacus in Japan (see plate 1.6 on page 15).

Whether or not the soldier's was actually the first abacus to reach Japanese shores, Japan's thriving trade at that time with other Asian countries made the importation of the Chinese *suan phan*, literally "calculating plate," inevitable. We discuss the development of the *suan phan* in slightly more detail in the next chapter, but its appearance as the *soroban* around 1592 revolutionized Japanese mathematics; traditional Japanese mathematics can be said to have begun with introduction of the calculating plate, aided by the peace of the Tokugawa shogunate.

The Ascendence of Traditional Japanese Mathematics

The *soroban*'s advent in Japan also heralded the first record of an identifiable Japanese mathematician, Mōri Shigeyoshi,[4] who flourished around 1600. Little more is known about him, except that he lived in Osaka until the city was taken in 1615 by Tokugawa Ieyasu and thereafter lived in

[4]In the West usually referred to as Kambei Mōri.

Plate 1.6. Here is the oldest known abacus, or *soroban*, in Japan. It dates from about A.D. 1592 and was in the possession of one of Hideyoshi's soldiers at the port of Hakata. (© Maeda Ikutokukai.)

Kyoto. There are stories, almost certainly untrue, that Mōri himself brought the *soroban* from China, but in any case he was an expert at its use and did more than anyone at the time to popularize numerical calculations. In 1622 Mori published a small primer *Warizansyo*, or *Division Using the Soroban*.[5]

Mōri himself was in possession of a Chinese book on the *soroban*, Cheng Da-Wei's famous *Suanfa Tong Zong*, or *Systematic Treatise on Arithmetic*, which was published in China in 1593 and made its way to Japan shortly afterward, in other words, at the same time as the *soroban* itself. Cheng's book (see Chapter 2) had a great influence on the course of Japanese mathematics independently of Mōri's work. Not only was a Japanese edition published in 1676 by Yuasa Ichirōzaemon (?–?), but already, in the 1620s, Yoshida Mitsuyoshi (1598–1672) studied the *Suanfa Tong Zong* closely, changing problems to suit Japan and adding many illustrations. Thus was born his

[5]The actual title of the booklet is uncertain because the title page is lost.

Jinkō-ki, or *Large and Small Numbers*, which appeared in 1627, becoming the first complete mathematics book published in Japan.

The title *Jinkō-ki* originated from an old religious book of the twelfth century, *Ryōjin Hishō*, or *Poems of Those Days*. Yoshida's *Jinkō-ki* mostly concerned computational algorithms for which we use a calculator today, such as the extraction of square and cube roots. The book achieved immediate and enduring popularity, running through about three hundred different versions over the next three centuries. There was the *New Jinkō-ki*, the *Treasure of Jinkō-ki*, the *The Concise Jinkō-ki*, the *The Riches of Jinkō-ki*. . . . Of course, most were ghost written, literally, but Yoshida did publish at least seven editions himself. In the 1641 version, he presented some open problems for readers to solve. When readers provided the answers, he published the next edition adding more open problems, and so on. In this way many Japanese mathematics books were published, the readers contributing their solutions.

One of the problems treated in the *Jinkō-ki* concerned the calculation of π. In response, mathematician Muramatsu Shigekiyo (1608–1695) published *Sanso*, or *Stack of Mathematics*, in which he uses a 2^{15}- or 32,768-sided polygon to obtain $\pi = 3.14195264877$. Nineteen hundred years earlier, Archimedes had arrived at his value of π by inscribing an n-sided polygon within a circle and approximating the circumference of the circle by the perimeter of the polygon. The more sides, the more accurate the approximation, and the better the value of π.[6] Muramatsu used essentially the same technique, as did his contemporary Isomura Yoshinori (1640?–1710), who employed a $2^{17} = 131,072$–sided polygon inscribed in a circle of radius 1 and obtained 3.141592664 for the perimeter. For some reason he wrote only $\pi = 3.1416$.

The most famous mathematician of the age, Seki Takakazu[7] (1640?–1708) also took up the challenge to calculate π. Using his own method, which was published posthumously by his disciples in the 1712 *Katsuyō Sanpō*, or *Collection of Important Mathematical Results*, he obtained $\pi = 3.14159265359$, which is correct to the eleven digits calculated. Seki's disciple Takebe Katahiro (1664–1739) succeeded in obtaining a value of π correct to 41 digits.

[6]More precisely, Archimedes bounded π by placing the circle between two polygons, knowing that the circumference of the circle was greater than the perimeter of the inscribed polygon and less than the perimeter of the circumscribed polygon. Employing 96-sided polygons, he achieved a numerical value of $3\ 10/71 < \pi < 3\ 1/7$.

[7]Usually known in the West as Kowa Seki.

Plate 1.7. From a 1715 edition of the *Jinkō-ki*, this woodblock print illustrates the advantages of using an abacus in business transactions. (Collection of Fukagawa Hidetoshi.)

Plate 1.8. A *soroban* exercise from a later edition of the *Jinkō-ki*, c. 1818–1829.
(Collection of Fukagawa Hidetoshi.)

Because of their importance, we devote much of chapter 3 to the *Jinkō-ki*, Seki, and the various calculations of π.

The start of traditional Japanese Mathematics is usually dated from the publication of the *Jinkō-ki* in 1627. The *Nine Chapters*, Cheng's *Treatise*, and the other Chinese classics continued to exert their influence on Japanese mathematics, either directly or through translations, but with the onset of *sakoku* the development of Japanese mathematics rapidly became independent of China. Strangely, though, the *Jinkō-ki* did not herald the immediate death of the *sangi*. The *soroban* did quickly replace *sangi* in everyday business calculations, but it was not so well suited for complex algebraic operations, in particular the solution of high-degree equations, of which Japanese mathematicians became very fond. As a result the *sangi* persisted side by side with the *soroban* well into the nineteenth century.

The samurai posed a major problem for the peace of the Edo era. Centuries of warfare had turned them into barely literate brutes who needed to be pacified and civilized. The Tokugawa expended much effort in this direction, with the result that within several generations the samurai were transformed into a highly educated class, literate and versed in the finer things of life, as a European noble of the time would be. Most of the warriors, having lost their jobs so to speak, became ordinary civil servants. For three or four days a week a samurai might go to the provincial castle to work, but the salary was so terrible that he often had to take on a side job.[8] During the Edo period there were no universities in Japan. Consequently, many samurai moonlighted as teachers in small private schools called *juku*, which were devoted to the three R's: reading, 'riting, and 'rithmetic, the last "r" standing for *soroban*. Whereas in previous ages samurai visited villages to levy soldiers, now their visits were less frequent, and farmers found they had to calculate the area of their fields by themselves. As a result, they also began to attend the *juku*, which was made possible by a low attendance fee. With people from every caste—from the rich to the poor, from samurai to farmers—going to school, *juku* began to flourish. The roster at one school, the Yōken *juku*, shows that 2,144 students, including many adults, attended it over the course of fifty years.

[8]The Tokugawa shogunate limited local warlords to one castle per domain and, with little fighting during the entire Edo period, previous military strongholds, "castle towns," became administrative centers. Mathematician Yamaguchi Kanzan speaks of them frequently in his diary, chapter 7.

Plate 1.9. The Yōken *juku*, where mathematician Sakuma Yōken (1819–1896) taught 2,144 students over a half-century. (Tamura city.)

Their teacher was mathematician Sakuma Yōken (1819–1896), and the small wooden school room still stands. A recent study[9] indicates that, by the nineteenth century, late in the Edo period, about 80,000 *juku* existed throughout Japan. Although, as in the West, children were considered laborers, not students, the home-grown schooling provided by the *juku* resulted in a literacy level that was high compared to other countries at the time.

Many mathematicians, usually samurai who had received "Master of Mathematics" licenses, visited these rural schools to teach mathematics—

[9]Ohishi Manabu, http:/library.u-gakugei.ac.jp (in Japanese).

and evidently more than simple 'rithmetic. For it was from this milieu, isolated from the Western world and increasingly divergent from China, that *wasan*, literally "Japanese mathematics," arose. Ordinary people at the *juku*, who could not afford to publish their own books, took up the ancient custom of bringing votive tablets to temples and began to hang *sangaku*, in this way both making a religious offering and advertising their results. Incidently, they created wonderful art.

Sangaku were not the only medium for disseminating geometry. The Koreans had been printing books with movable type 100 years prior to Gutenberg,[10] and both Korean and European presses had found their way to Japan before the opening of the seventeenth century. As mentioned, however, printing by wooden blocks on rice paper became the favored method of producing books in Japan, and, by the end of the seventeenth century, a plethora of mathematics texts had begun to appear, many of which contained problems from or identical to those found on *sangaku*. Sometimes these texts provide solutions not written on the tablets, and we often quote from them in the solution sections of our own book. Many of the illustrations found throughout *Sacred Mathematics* also come directly from rice-paper books, originally printed in the seventeenth through nineteenth centuries.

Thus, by the end of the seventeenth century, *wasan*, traditional Japanese mathematics, was firmly established. It would be over the next two hundred years, however, that traditional methods produced their most striking and original results.

The Flowering and Decline of Traditional Japanese Mathematics

It was the eighteenth and nineteenth centuries, as Japan's isolation deepened, that saw the greatest number of traditional Japanese mathematics texts published, the most interesting theorems proved, and most of the *sangaku* problems created.

The majority of results obtained by traditional Japanese mathematicians were not path breaking by Western standards, partly because Japan

[10]If, indeed, Gutenberg used movable type. See Tony Rothman, *Everything's Relative and Other Fables from Science and Technology* (Wiley, Hoboken, N.J, 2003).

never developed a fully fledged theory of calculus. Traditional Japanese mathematicians found the areas and volumes of geometric figures in much the same way Eudoxus and Archimedes did in ancient Greece (and much as we do numerically today with computers). For example, one can divide up a circle into rectangular strips, as in plate 1.10. The narrower the strips, the more closely the area of the strips will approximate that of the circle. By letting the width of the strips go to zero, one can get an exact formula for the circle's area. This idea served as the basis of the *Enri* ("Yenri"), a vague term meaning "circle principle," but which amounts to what calculus students know as definite integration. And, as students know, there are any number of methods for computing the area of geometric figures by slicing up those figures in a convenient way and letting the width of the slices go to zero. One can do this informally for each situation, without proving the theorems about limits that students detest, but unless you have those theorems, in particular the first and second fundamental theorems of calculus, you are restricted to performing so-called "definite" integrals, and do not have a theory for doing integration in general, that is, for performing "indefinite" integration. This was more or less the situation in traditional Japanese mathematics. We discuss it more fully in chapter 9.

Despite such drawbacks, one cannot accuse the Japanese mathematicians of lacking ingenuity. Seki developed a theory of determinants before Leibnitz, and other Japanese geometers proved a handful of famous theorems prior to their Western counterparts, or at least independently of them. We'll encounter some of these in chapter 8. They include the Descartes circle theorem, the Malfatti problem, the Casey theorem, the Soddy hexlet, and a few others.

Additionally, the Japanese were extremely skilful at handling equations of high degree. We do mean high degree. In Yamaguchi's diary, we will run across a famous problem, the Gion shrine problem, which involves an equation of the 1,024th degree. (And students fear quadratics!) The mathematician Ajima Naonobu[11] (1732–1798) became famous for reducing the problem to one of the tenth degree, which was then solved numerically. Ajima proved a number of difficult theorems in geometry, which we discuss in chapter 3, and also came the closest of the Japanese mathematicians to producing a full theory of definite integration.

Ajima's work built on that of his predecessor Matsunaga Yoshisuke (1692?–1744), who studied infinite series and their applicability to the calculation of

[11] Sometimes known as Chokuyen Ajima.

Plate 1.10. From Sawaguchi Kazuyuki's 1671 book *Kokon Sanpōki*, or *Old and New Mathematics*, this figure illustrates how to approximate the area of a circle by slicing it into rectangular strips. In a first-year calculus course one calculates the area of a circle in the same way—by slicing up the circle, and adding up the area of the strips in the limit that their width goes to zero. (Aichi University of Education.)

areas through integration. They were followed by Wada Yasushi (1787–1840), who lived in poverty and produced a number of tables of definite integrals. Uchida Kyō (1805–1882) studied integration in Wada's *juku*. He then produced a series of books that treat integration of solids, including areas formed by the intersection of cylinders, spheres, and so on. You will be challenged to try this sort of problem in chapters 5 and 6.

As we have said, many *sangaku* problems also appeared in traditional Japanese texts. Fujita Sadasuke (1734–1807) published a book *Seiyō Sanpō* (*Detailed Mathematics*), and his son, Fujita Kagen (1772–1828), carried on the tradition by publishing *Shinpeki Sanpō*, rendered sometimes as *Mathematics of Shrines and Temples* and sometimes as *Sacred Mathematics*, the first collection of *sangaku* problems. (See color plate 14 for a portrait of Fujita Kagen.) A few famous problems appearing in the present *Sacred Mathematics* have been taken from those works.

As the centuries progressed, a few hints of Occidental mathematics seeped in to Japan via China and the Dutch at Nagasaki. For example, the Japanese evidently learned of logarithms from a 1713 Chinese publication, the *Su-li Ching-Yin*. Nevertheless, even in 1824, a Japanese mathematician seemed surprised to learn of a drawing in a Dutch work that showed an ellipsograph—a mechanism for drawing an ellipse known in the West at least since Leonardo da Vinci. By the mid-nineteenth century one does find manuscripts containing both Eastern and Western notation.

But *wasan* held its ground until, as a direct consequence of the opening of Japan to the West by Perry, the Tokugawa family lost power in 1868. The new Meiji government decided that, in order for Japan to be an equal partner to foreign nations, it must rapidly modernize. Their program included mathematics. Governmental schools were established all over Japan and in the 1872 *Gakurei*, or "Fundamental Code of Education," the Meiji leaders decreed that "*wasan* was not to be taught at school, but Western mathematics only."

Due to the *juku*, mathematics had been flourishing in Japan and Western mathematics—*yosan*—proved easy to introduce and was quickly adopted. Of course, diehards fought back. One of the last samurai, Takaku Kenjirō (1821–1883), wrote, "Astronomy and the physical sciences as found in the West are truth eternal and unchangeable, and this we must learn; but

as to mathematics, there Japan is leader of the world."[12] In the end, resistance was futile. With the Meiji Fundamental Code, teachers of traditional mathematics lost their jobs and *wasan* was destined to perish. From a strictly mathematical point of view, its death is perhaps not to be mourned overmuch, but from an esthetic point of view we surely lost something when lovers of traditional mathematics finally ceased creating their beautiful problems and the tablets that they offered to the world. We can only be grateful for what remains.

[12]Smith and Mikami, p. 273 ("For Further Reading, Chapter 1," p. 338).

Plate 2.1. This illustration of a man measuring the height of a tree using basic trigonometry is from an edition of the *Jinkō-ki* published between 1818 and 1829, but, like most of the problems in the *Jinkō-ki*, it was passed down from Chinese sources. The problem asks for two ways a woodsman can use trigonometry and/or a stick of known length to measure the height of a tree. Compare problem 2-3 in this chapter. (Collection of Fukagawa Hidetoshi.)

Two

The Chinese Foundation of Japanese Mathematics

*I have heard that the Grand Prefect
is versed in the art of numbers, so let
me ask you: In times of old Fu-Hsi
measured the heavens and regulated
the calendar. But there are no steps
by which one may ascend the heav-
ens, and the earth is not measurable
with a foot-rule. I should like to ask,
what was the origin of these numbers?*
—From the *Zhou bi suan jing*

To understand the development of Japanese mathematics is to appreci-
ate the Chinese mathematics that so strongly influenced it. In this chapter
we give a brief survey of ancient and medieval Chinese mathematics, and
then present some problems from the classic Chinese texts. The problems
are of interest not only because they give an idea of the state of Chinese
mathematics of past ages, but because they offer a tantalizing glimpse into
a society whose daily life revolved around rice, horses, business, and the
abacus. There are occasional tricks to these problems, but for the most part
they should not be difficult for middle or high school students.

The earliest of the great books on mathematics is the *Zhou bi suan jing*,
loosely *The Arithmetical Classic of the Gnomon and the Circular Path of Heaven*.
The author and the date of the *Zhou bi* are unknown to us. All evidence in
fact indicates that scholars added to the original as it passed through the

centuries. A famous dialogue at the start of the *Zhou bi* takes place between a prince, Zhou-Kong, and his learned minister, Shang Kao. Zhou-Kong died in the year 1105 B.C., but his appearance as one of the participants in the dialogue is less an indication of the date of its composition than of poetic license. Most scholars have believed the book reached completion by the second or third century B.C., although some recent investigations have suggested that it did not assume its final form until the first century A.D.[1] The *Zhou bi* is not a mathematics text that today's students would recognize. Mathematical notation was almost nonexistent and most concepts are stated in words. There is some discussion of the gnomon, a vertical stake thrust into the ground whose shadows can be used to measure the height of the sun. Generally, the *Zhou bi* is much concerned with astronomy and calendar making, and it includes maps of the stars near the celestial Pole.

On the other hand, the *Zhou bi* does make use of fractions, discusses their multiplication and division, and, although the extraction of square roots is not explicitly worked out, the text makes it clear that square roots were used. Of greatest interest for us is that, at the beginning of the book, in the dialogue between Zhou-Kong and Shang Kao, one finds a discussion of the 3-4-5 right triangle. Although couched in difficult language, it is clear that the Chinese understood the Pythagorean theorem, that the sum of the squares of two sides of a right triangle equals the square of the hypotenuse. But there is no general proof of the theorem. This part of the *Zhou bi* is thought to be the oldest and dates from about the sixth century B.C.—roughly the same time Pythagoras is said to have discovered the theorem in Greece.

From our perspective a more substantial work is the *Jiu zhang Suanshu*, or *Nine Chapters on the Mathematical Art*. Once again, the date and author are unknown, although most experts seem to believe it was finished by the late second or early third century A.D. The nine chapters of the *Jiu zhang* chapters contain a total of 246 problems concerning surveying, engineering, and taxation, among other things, which employ fractions, "geometrical" and "arithmetic" progressions, and the solution of simultaneous equations. The eighth chapter, depending on the date, may contain the first mention of negative numbers, and the final chapter is "Gou Gu," or the "Width and Height of Right-Angled Triangles," in which twenty-four problems on the Pythagorean

[1] See "Further Reading," this chapter, Ronan, *Science and Civilization*, chap. 1; Cullen, *Astronomy and Mathematics*, chap. 3 ("For Further Reading, Chapter 2," p. 338).

Plate 2.2. This figure from the *Zhou bi suan jing* shows that the Chinese understood the Pythagorean theorem early on, but no general proof of the theorem appears.

theorem are introduced. We give a few of these below. In this chapter is also an early statement of the quadratic equation and the quadratic formula for solving them. It may not be the earliest, because according to some historians the Egyptians began studying quadratics prior to 2000 B.C.

It is worth mentioning that, although we speak of the the *Nine Chapters* as a "book," its contents were evidently recorded on bamboo sticks, each about 2 cm wide and 25 cm long. In July 2002 Japanese newspapers reported the excavation of about twenty thousand wooden and bamboo sticks dating from 221–206 B.C., on some of which were inscribed multiplication tables. The date makes them contemporaneous with the older *Zhou bi suan jing*. Nevertheless, although paper came into use in China after about A.D. 105, the later *Nine Chapters* also seems to have been "printed" on bamboo.

The *Jiu zhang Suanshu* was the most influential of the ancient Chinese texts, leading to a number of other books that acquired their own renown over the centuries. One of these was the *Sun-Tsu Suanjing,* or *Arithmetic Classic of Sun-Tsu.* (This Sun-Tsu (often Sun-Zi) is sometimes confused with the celebrated tactician who authored the military classic *The Art of War,* but that one is believed to have lived in the sixth to fourth century B.C., while Sun-Tsu the mathematician probably flourished in the fifth century A.D.) Between A.D. 618 and 901, the *Zhou bi,* the *Jiu zhang,* and the *Sun-Tsu* were, with seven other books, considered by the Chinese government to be textbooks, and from 1078 to 1085 they were published together as the *Ten Classics.*

Several more important Chinese books appeared in the thirteenth century. One, the 1247 *Shushu Jiuzhang*, or *Mathematical Treatise in Nine Chapters* of Qin Jiushao (Chin Chiu-Shao), contains the "heaven origin unit" 1, as well as the symbol zero and a clear distinction between positive and negative numbers. Although the title refers to the original *Nine Chapters*, Qin Jiushao's nine chapters are not the same. More important for traditional Japanese mathematics was the 1299 *Suanxue Qimeng*, or *Introduction to Mathematical Studies* by Zhu Shijie (Chu Shih-Chieh), from which we excerpt some problems as well.

As discussed in chapter 1, at the opening of the eighth century, the Japanese government introduced the *Nine Chapters* and eight other books into the university system as mathematics texts. Some of the later books may also have found their way to Japan before the seventeenth century, but there is little evidence one way or the other. It is only at the time of the importation of the Chinese abacus, the *suan phan*, that information becomes more definite. The origin of the *suan phan* is also shrouded in the mists of time and debate. The first complete modern description of the "calculating plate" is found in Cheng Da-Wei's 1593 *Suanfa Tong Zong*, or *Systematic Treatise on Arithmetic*. The late date has led some to historians to argue that the abacus was unknown in China until relatively modern times, but other convincing descriptions date from 1513, 1436, and even the sixth century or earlier. A figure of the *suan phan* was published in a Chinese mathematics book, the *KuiBen DiuXiang SiYan ZaZi*, or *Leading Book of Four Words in Verse* of 1371,[2] so it seems clear that the abacus was complete by that date. A reasonable hypothesis is that the calculating rods discussed in chapter 1, the *suanzi*, gradually morphed into the abacus.

Cheng Da-Wei's *Treatise* had a great impact on both Chinese and Japanese mathematics. Cheng (1533–1606) himself was a local government official who needed to know how to use the *suan phan*, and at the beginning of his book he included two chapters on basic calculations and use of the abacus. To the nine subsequent chapters he gave the same names as those of the nine chapters of the *Jiu zhang Suanshu*, although Cheng includes magic squares, musical tubes, formulas given in verse, and practically any-

[2]See Li Di, *Chinese Mathematics*. See also Martzloff, *Chinese Mathematics*, p. 215. He gives 1377 as the probable date. ("For Further Reading, Chapter 2," p. 338.)

thing else he can think of. The book remained popular in China for centuries, and was, apparently, still in print as late as 1964, when old people could still be found capable of reciting the versified formulas.[3]

With such renown in China, it is hardly surprising that Cheng's book soon changed the course of Japanese mathematics. We have already seen that the *Treatise* led directly to both Mōri Shigeyoshi's *Division Using the Soroban* and Yoshida's phenomenally successfully *Jinkō-ki*. The influence of Cheng's *Treatise*, as well as the other Chinese classics, continued well into the nineteenth century. In 1676 Yuasa Ichirōzaemon published a Japanese edition of the *Treatise*. Twenty years earlier, in 1658, Haji Dōun (?–?) published a Japanese edition of Zhu Shijie's 1299 *Introduction*, and in 1690 Takebe Katahiro (1664–1739) published an enlarged edition of the same work. He called it *Sangaku Keimō Genkai Taisei*, or *Annotation of the Suanxue Qimeng*. As late as 1824, the Japanese mathematician Kitagawa Mōko (1763–1833) intended to publish a translation of the original *Jiu zhang*, but he failed to do so, leaving only a manuscript.

To give a better idea of the flavor of the great Chinese works, which to this day are not well known in the West, we now present problems from several of them. A considerable amount of borrowing took place from one author to the next. We have eliminated most of the repetition, but that there remains some similarity among the problems across the centuries reflects the reality of the practice, not a lack of editing. You will also notice that chapter titles do not always correspond closely to the problems contained within them. When not with the problems themselves, the answers can be found at the end of the chapter.

1. Jiu zhang Suanshu, or Nine Chapters on the Mathematical Art

The nine chapters of this famous book contain a total of 246 problems. We present one from each chapter. Most of those below are very easy and

[3] Martzloff, *Chinese Mathematics*, p. 160 ("For Further Reading Chapter 2, p. 338). One should also point out that in the West as well, before equations became widespread, it was common to learn formulas or algorithms by memorizing verse.

we hope cause no great difficulty for modern students. In looking at the form of the solutions, which usually contain fractions, it helps to realize that, in ancient Chinese mathematics, fractions were used exclusively to represent nonintegral numbers; there were no decimals.

Problem 1-1

(From chapter 1 of the *Jiu zhang*: "On Measuring Various Fields.")

We walked around a circular field and obtained for the circumference 181 *bu* (= 208.15 m) and for the diameter is $(60 + 1/3)$ *bu* (= 69.38 m). Find the value of π = circumference/diameter and the area of the field in the form of fractions.[4]

Solution: Since $\pi = 181/(60+1/3) = 3$, the area is $A = \pi r^2 = 3 \times (181/6)^2 = 32761/12 = 2730 + 1/12$ *bu* $= (11 + 90/240)$ *se* $+ 1/12$ *bu* $= 11$ *se* $+ (90 + 1/12)$ *bu*.

In his A.D. 263 revision of the *Nine Chapters*, annotator Liu Hui (220–265?) noted that $\pi = 157/50 = 3.14$ was better than $\pi = 3$. Another problem from chapter 1 of the *Nine Chapters* was quoted by Yoshida in his *Jinkō-ki*, and we give it as problem 1 in chapter 3.

Problem 1-2

(From chapter 2 of the *Jiu zhang*: "Proportions.")

In general, a fair exchange is 50 *shō* of millet for 27 *shō* of rice. Here is 21 *shō* of millet. How many *shō* of rice will we obtain in exchange?

Solution on page 53.

[4]In this chapter we generally use original units, for example the *bu* rather than the meter. To change the original numbers into values consistent with modern units becomes very confusing. If readers wish, however, they can go from traditional Chinese units of the second century B.C. through the second century A.D to modern units by using the following conversions:

For lengths:	1 *sun* = 2.3 cm;	1 *syaku* = 10 *sun* = 23 cm;
	1 *bu* = 5 *syaku* = 1.15 m;	1 *jō* = 2 *bu* = 10 *syaku* = 2.3 m;
	1 *ri* = 360 *bu* = 414 m.	
For areas:	1 *bu* = 32 m²;	1 *se* = 10 *bu* = 240 *bu* = 317 m².
For volumes:	1 *shō* = 0.2 *l*	1 *to* = 10 *shō* = 2 *l*
	1 *koku* = 10 *to* = 20 *l*.	
For weights:	1 *shō* = 0.58 g;	1 *ryō* = 24 *shō* = 13.9 g;
	1 *kin* = 16 *ryō* = 222.4 g;	1 *koku* = 120 *kin* = 26.688 kg.

Problem 1-3

(From chapter 3 of the *Jiu zhang*: "Distribution.")

Here is an expert in weaving. She wove a certain amount of cloth on the first day, twice as much on the second day, double that on the third day, and so on. In five days she wove a total of 5 *syaku* of cloth. What was the length she wove on the first day?

This problem was quoted in the later *Sun-Tsu Suanjing*.

See page 53 for solution.

Problem 1-4

(From chapter 4 of the *Jiu zhang*: "On Calculating the Area of a Field.")

Let the area A of a rectangular field be 240 square *bu*, where x *bu* is the width and y *bu* is the length.[5] For each x below, find y in terms of fractions:

(1) $x = 1$
(2) $x = 1 + 1/2$.
(3) $x = 1 + 1/2 + 1/3$.
(4) $x = 1 + 1/2 + 1/3 + 1/4$
(5) $x = 1 + 1/2 + 1/3 + 1/4 + 1/5$
(6) $x = 1 + 1/2 + 1/3 + 1/4 + 1/5 + 1/6$.

The answers can be found on page 53.

Problem 1-5

(From chapter 5 of the *Jiu zhang*: "On Values of Various Solids.")

Next to the river, we raised a bank of earth 127 *syaku* long with a lower width of 20 *syaku*, an upper width of 8 *syaku* and a height of 4 *syaku*.

(1) Find the volume of the earth bank.
(2) In winter, one worker can carry in a total of 444 cubic *syaku* of earth. How many workers are needed to build the bank in one season?

Solution on page 53.

[5] Note in the conversions that *bu* was traditionally used as both a length and an area. We will refer to "square *bu*" for area, and similarly for other units.

Problem 1-6

(From chapter 6 of the *Jiu zhang*: "Wages.")

One day a traveler started off on a journey, bringing with him a certain amount of *kin*[6] for the purpose of paying taxes. As he traveled, he had to pass through five check points *A*, *B*, *C*, *D*, and *E*. Passing through point *A*, he paid half the money he had brought for taxes. When he passed the point *B*, he paid a third of what was left of his tax money. At C he paid a fourth of the tax money that remained after *B*, and similarly at check points *D*, and *E*. At the end he found he had paid a total of 1 *kin* as tax. How much tax money did he have to start with?

See page 53 for solution.

Problem 1-7

(From chapter 7 of the *Jiu zhang*: "Extra and Lack.")

A melon stem grows 7 *sun* a day. A creeper stem grows 10 *sun* per day. In the same day, the melon stem grows down from a point on a cliff that is 90 *sun* high, and the creeper grows up from the bottom of the cliff. After how many days will the two stems meet?

The solution can be found on page 53.

Problem 1-8

(From chapter 8 of the *Jiu zhang*: "Square," or "On Systems of Linear Equations.")

Assume that each stalk on rice plants *A*, *B*, and *C* produces *a*, *b*, and *c* to of rice, respectively. Now, the total amount of rice from three stalks of *A*, two stalks of of *B*, and one stalk of *C* is 39 *to*. The total amount from two stalks of *A*, three stalks of of *B*, and one stalk of *C* are 34 *to*, and the total amount from one stalk of *A*, two stalks of of *B*, and three stalks of *C* is 26 *to*. Find *a*, *b*, and *c*.

The solution can be found on page 54.

Problem 1-9

(From chapter 9 of the *Jiu zhang*: "Gou Gu," or "Right-Angled Triangles.")

[6] *kin* is the traditional unit of both money and weight (see previous footnote), but we do not know the value of one *kin* in terms of modern currency. In old China, 1 *kin* = 16 *ryō*, and 1 *ryō* = 24 *shō*, and the original result of problem 1-6, 6/5 *kin*, was represented as 1 *kin*, 3 *ryō*, and 4 + 4/5 *shō*, since $6/5 = 1 + 3/16 + (1/16)[(1/24)(4 + 4/5)]$.

Plate 2.3. Illustrating the Pythagorean theorem with a broken bamboo stalk, this famous problem from *Nine Chapters* was published in many subsequent books. The version shown here comes from Yang Hu's *Xiangjie Jiuzhang Suanfa* of A.D. 1261.

A bamboo stalk 10 *syaku* high is broken at a point *Q* so that the top of the stalk falls over and touches the ground at a point *T*. The distance from the root *P* to *T* is 3 *syaku*. Find the distance *PQ*.

This is a famous problem, which first appeared in the *Jiu zhang* and then in a number of Chinese books, including Yang Hu's *Xiangjie Jiuzhang Suanfa* of A.D. 1261, and Cheng Da-Wei's 1593 *Suanfa Tong Zong*.

The answer follows directly from the Pythagorean theorem: If *x* is the distance *PQ*, then $x^2 + 3^2 = (10 - x)^2$. Solving for *x* gives $x = 91/20 = 4 + 11/20$ *syaku*.

2. Sun-Tsu Suanjing, or the Arithmetic Classic of Sun-Tsu, c. Fifth Century A.D.

Sun-Tsu's book, whenever it was written, consisted of three volumes. The first is full of problems in elementary arithmetic, which we do not present here. We do, however, present a half-dozen interesting problems from the second and third volumes. One of these is famous as the "Chinese remainder theorem," which we give as problem 2-6 below.

Problem 2-1

We built an earth bank 5550 *syaku* long with an upper base 20 *syaku* long, a lower base 54 *syaku* long, and a height of 38 *syaku*. A worker can carry 300 cubic *syaku* of dirt in one season. How many workers are needed for building the bank?

As you can see, this problem was taken from the *Jiu zhang* (problem 1-5 above) and is solved in the same way. *The solution is on page 54.*

Problem 2-2

Some thieves stole a long roll of silk cloth from a warehouse. In a bush far from the warehouse, they counted the length of the cloth. If each thief gets 6 *hiki*, then 6 *hiki* is left over, but if each thief takes 7 *hiki* then the last thief get no cloth at all.[7] Find the number of thieves and the length of the cloth.

Answer: If N is the number of thieves and L is the length of the cloth, then the first condition tells us that $6N = L - 6$. The second condition says $L = 7(N - 1)$. Solving these two equations gives $N = 13$ and $L = 84$ *hiki*.

The problem of the silk thieves also appeared in Yoshida's *Jinkō-ki* of 1631.

Problem 2-3

We want to measure the height of a tree whose shadow is 15 *syaku* long. Near the tree, we erect a small stick 1.5 *syaku* tall and measure its shadow to be 0.5 *syaku* long. Find the height of the tree.

[7]The *hiki* is another traditional unit of length, used for measuring cloth; 1 *hiki* = 4.7 m.

Plate 2.4. Ruthless thieves stealing a roll of cloth appeared in the *Jinkō-ki* of 1643, but the problem was taken from the *Sun-Tsu Suanjing*. We present it here as problem 2-2.

This problem appeared in the original *Jinkō-ki* of 1627 as well. *The solution is on page 54.*

Problem 2-4

In a cage, there are some roosters and hares. The total number of necks is 35 and the total number of feet is 94. How many roosters and hares are in the cage?

The roosters and hares appeared in the *Inki Sanka* of 1640 (chapter 3) and as cranes and turtles in the 1815 Japanese book *Sanpō Tenzan Shinanroku* by Sakabe Kōhan (1759–1824). *The solution is on page* 54.

Problem 2-5

On the top of a gate, one can see nine banks; on each bank there are nine trees, each of which has nine branches. On each branch, there are nine nests, in each nest live nine adult crows, each of which has nine chicks. Each chick has nine feathers and each feather has nine colors. How many trees, branches, nests, crows, chicks, and colors are there?

Answer on page 54.

Problem 2-6

(This is the Chinese remainder theorem.)

Here is an unknown number of objects. If they are counted in threes, then two are left; if they are counted in fives, three are left; if they are counted in sevens, two are left. How many objects are there?

This is the prototype of a famous problem that appeared in many guises around the world. A typical, apparently medieval, version is: "An old woman goes to market and a horse steps on her basket and crushes the eggs. The rider offers to pay for the damages and asks her how many eggs she had brought. She does not remember the exact number, but when she had taken them out two at a time, there was one egg left. The same happened when she picked them out three, four, five, and six at a time, but when she took them seven at a time they came out even. What is the smallest number of eggs she could have had?"[8]

Sun-Tsu's version is important because it provides a method of solution equivalent to that given in modern number theory courses. His original solution[9] goes something like this:

Answer: 23.

Rule: If they are counted in threes, two are left: set 140. If they are counted in fives, three are left: set 63. If they are counted in sevens, two are left: set 30. Take the sum of these [three numbers] to obtain 233. Subtract 210 from this total; this gives the answer.

In general: For each remaining object when counting in threes, set 70. For each remaining object when counting in fives, set 21. For each remaining object when counting in sevens, set 15. If [the sum obtained in this way] is 106 or more, subtract 105 to obtain the answer.

Applying the general instructions to this case means that the answer is $2 \times 70 + 3 \times 21 + 2 \times 15 - 210 = 23$.

Let us decode Sun-Tsu's prescription. If there are N objects, then "counting in threes" means simply to subtract three at a time until, in this case, two remain. In other words, long division of N by 3 yields a remainder of 2. Students of algebra will know that a more sophisticated way of saying this is that $N = 2 \pmod 3$ (read "N equals 2 mod 3"). In general, $x = r \pmod m$, means that m goes into x an integral number of times with a remainder of r. For example, $38 = 2 \pmod{12}$, since 12 goes into 38 three times with a remainder of 2. By the same token, $50 = 2 \pmod{12}$, since 12 goes into 50 four times with a remainder of 2. In Sun Tsu's problem we have

[8] Oyestein Ore, *Number Theory and Its History* (Dover New York, 1976), p. 118.
[9] See Martzloff, *Chinese Mathematics*, p. 310. ("For Further Reading, Chapter 2," p. 338).

$$N = 2 \,(\mathrm{mod}\ 3),$$
$$N = 3 \,(\mathrm{mod}\ 5),$$
$$N = 2 \,(\mathrm{mod}\ 7). \tag{1}$$

Thus in modern guise the problem reduces to finding an integer solution N to three simultaneous equations in modular form. There may be (and in this case certainly are) more than one N that satisfies the three relationships; presumably we want the smallest.

We find the solution in a pedestrian manner. Notice that the first number in Sun Tsu's prescription is $2 \times 70 = 140 = 2\,(\mathrm{mod}\ 3)$. But notice also that $140 + 63 = 2\,(\mathrm{mod}\ 3)$ as well. That is, 63 is exactly divisible by 3, so adding 63 to 140 does not affect the remainder. For the same reason $140 + 63 + 30 = 2\,(\mathrm{mod}\ 3)$. Similarly $63 = 3\,(\mathrm{mod}\ 5)$, but since both 140 and 30 are divisible by 5, $140 + 63 + 30 = 3\,(\mathrm{mod}\ 5)$. Finally, $30 = 2\,(\mathrm{mod}\ 7) = 140 + 63 + 30$.

Thus, we see that the sum $N = 140 + 63 + 30 = 233$ satisfies all three equations (technically known as congruences). However, 233 is not the smallest possible N. The least common multiple of 3, 5, and 7 is 105, and so $2 \times 105 = 210$ is also divisible by all three factors; adding or subtracting it will not affect any remainder. Consequently, we want $N = 233 - 210 = 23$, Sun-Tsu's answer. The last step is what he meant when he said that if the answer is 106 or more, subtract 105; in fact subtract the nearest multiple of 105.

You are undoubtedly wondering where Sun-Tsu got the numbers 2×70, 3×21, and 2×15. This part is educated guesswork. First we multiply together the divisors of the last two of equations (1) to get $5 \times 7 = 35$. We then look for a multiple of 35 that satisfies the first equation. Clearly 140 does. (You might notice that 35 itself does; explain why we do not want this solution.) Next we search for multiples of $3 \times 7 = 21$ that satisfy the second equation, and multiples of $3 \times 5 = 15$ that satisfy the third equation. This explains the origins of Sun-Tsu's numbers.

Sun-Tsu's problem appeared in the 1631 edition of the *Jinkō-ki*, where it is called the "105-subtraction" problem.

3. Suanxue Qimeng, or Introduction to Mathematical Studies, by Zhu Shijie, 1299

As mentioned in the introduction to this chapter, the Japanese mathematician Haji Dōun (?–?) published a Japanese version of this important book in 1658. The original Chinese version consists of three volumes with a total of 259 problems.

In volume 1, the author discusses various values for π. Zhu Shijie refers to $\pi = 3$ as "old π" and goes on to survey some of the advances in the computation of π over the centuries. He mentions the mathematician Liu Hsin, who used a value of 3.154 in the first decade of the first century A.D., although there is no record of how he arrived at it.[10] Zhu Shijie also cites Liu Hui, who in A.D. 263 used a 192-sided polygon to arrive at a value of $\pi = 157/50 = 3.14$ (see problem 1-1).

In the fifth century Zu Chongzhi (429–500) and his son Zu Geng arrived at a value of π between 3.1415926 and 3.1415927. Although Zhu Shijie does not discuss all these studies in detail, later mathematicians confirmed the accuracy of the Zus' figure by using polygons of up to 16,384 sides. It was not until about 1600 that European values of π approached that of the Zus in the fifth century.

In Zhu Shijie's second volume, we find methods for calculating the area or volume of various figures. The third volume contains a numerical method for finding the roots of high-degree polynomial equations. Centuries later in the West, this procedure became known as "Horner's method," after an English school teacher William Horner (1786–1837), who published it in 1830. Horner, however, has been accused of plagiarizing the technique from a London watchmaker, Theophilius Holdred, who published it in 1820. In any case, both were preceded not only by Zhu Shijie but by the Italian pioneer of group theory, Paolo Ruffini, who developed the method in the nineteenth century.[11]

The following problems are from volumes two and three of Zhu Shijie's work.

[10] See Ronan, *Science and Civilization* ("For Further Reading, Chapter 2," p. 338).

[11] See http://www-groups.dcs.st-and.ac.uk/history/Mathematicians/Horner.html. See also Cooke, *History of Mathematics*, p. 415 ("For Further Reading, Chapter 2," p. 338).

Problem 3-1

 Find the volumes V of the following figures in terms of a, b and h.

(1) A truncated pyramid of height $h = 12$ *syaku* whose lower base is a square with sides $b = 6$ *syaku* in length, and whose upper base is a square with sides $a = 4$ *syaku* in length. (See figure 2.1.)

(2) A truncated cone, with height $h = 20$ *syaku* whose circumference for the lower base is $b = 72$ *syaku* and for the upper base is $a = 36$ *syaku*. (See figure 2.2.) Use $\pi = 3$.

Solutions can be found on page 54.

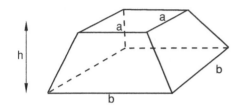

Figure 2.1. What is the volume of this frustrum, or truncated pyramid?

Figure 2.2. What is the volume of this frustrum, or truncated cone?

Problem 3-2

 A vigorous horse A can run 240 *ri* per day and a weak horse B can run 150 *ri* per day. If horse A started off twelve days after B, how many days does it take A to catch up with B?

 This problem, with the numbers changed, appeared in the 1815 Traditional Japanese Mathematics book *Sanpō Tenzan Shinanroku*, or *Guide to Algebraic Method of Geometry*, by Sakabe Kōhan (1759–1824). *The solution is on page 54.*

Problem 3-3A

 Solve the following system of equations:

(1) $xy = 1024$, where $y/x + x/y = 4.25$ and $x > y$;
(2) $xy = 4096$ where $x/y - y/x = 3.75$.

Solutions:

(1) By cross-multiplying, $x^2 + y^2 = 4.25\ xy = 4352$. But $(x + y)^2 = 4{,}352 + 2xy = 6{,}400$. Thus $x + y = 80$ and $xy = 1{,}024$. Together the two conditions imply that x and y are the roots of $t^2 - 80t + 1024 = (t - 16)(t - 64) = 0$. Since $x > y$, $x = 64$, $y = 16$.

(2) Similarly, $x^2 - y^2 = 3.75\ xy = 15{,}360$. But $x^2y^2 = 16{,}777{,}216$. Since $x^2y^2 = x^2[x^2 - (x^2 - y^2)]$, we have $x^2(x^2 - 15{,}360) = 16{,}777{,}216$. This gives a quadratic equation for x^2:
$$x^4 - 15{,}360x^2 - 16{,}777{,}216 = (x^2 + 1024)(x^2 - 16{,}384) = 0,$$
which shows that $x^2 = 16{,}384$, or $x = 128$ and $y = 32$.

Problem 3.3B

Solve the following system of equations for $x > y > z$:

(1) $x^2 + y^2 + z^2 = 14384$;

(2) $x + y + z = 204$;

(3) $x - y = y - z$.

We give the Suanxue Qimeng's original solution on page 54.

4. Suanfa Tong Zong, or Systematic Treatise on Mathematics, by Cheng Da-wei, 1592

Perhaps the most influential of the Chinese books on Japanese mathematics, Cheng Da-Wei's *Treatise* consists of 17 chapters. In the first and second he gives the fundamentals of calculations and introduces the *soroban*. There follow nine chapters that have the same titles as in the original *Nine Chapters*, although the subject matter is different and the fourth chapter has been divided into two. The remaining chapters consist of more advanced problems. Despite the considerable number of magic squares it contains, Cheng Da-Wei's book is a practical one. Apart from giving instructions on the use of the abacus, he discusses the mixing of alloys and the calculation of areas of various figures. In this context he discusses various approximations to π, although the values are the same as in the earlier *Suan-hsiao Chimeng*. We here sample a few problems from various chapters of Cheng's book. Problem 4-4 is particularly noteworthy in that it requests the use of "Pascal's triangle." The celebrated triangle appeared in an annotated version of the original Chinese *Nine Chapters*, which was published in 1261. It also appears to have been discussed even earlier by Al-Karaji (953–c. 1029)

in Baghdad.[12] In the West, the triangle first appeared in the 1527 *Cosmographia* of Petrus Apianus (1425–1552), although Blaise Pascal (1623–1662) exploited it more thoroughly a century later. Plenty about Pascal's triangle can be found on the Web. Its basic property is that the entries consist of the binomial coefficients useful in expanding polynomials, as required in problem 4-4. Traditional Japanese mathematicians learned of the triangle from the *Suanfa Tong Zong*.

Problem 4-1

 (From chapter 3 of the *Suanfa Tong Zong*: "Houden," or "Square Fields.")
 Show that the following facts are approximately true:

(1) The circumference of a circle with diameter 1 is about 3.
(2) The diagonal of a square whose sides are 5 is about 7.
(3) The height of an equilateral triangle with side 7 is about 6.
(4) If the area of a circle inscribed in a square is three-fourths the area of the square, then π is 3.
(5) The area of a square inscribed in a circle is about two-thirds the area of the circle.
(6) The area of a circle inscribed in an equilateral triangle is about four-sevenths the area of the triangle.
(7) The area of a regular hexagon inscribed in a circle is about six-sevenths the area of the circle.
(8) The area of a circle inscribed in a regular hexagon is about six-sevenths the hexagon's area.
(9) The area of an equilateral triangle inscribed in a circle is about seven-sixteenths the area of the circle.

The above problems concerning areas were quoted in Yoshida's *Jinkō-ki* of 1627. *Solutions to all can be found on page 55.*

Figure 2.3. Show that the area of the circle is about three-fourths the area of the square.

[12] See http://www-groups.dcs.st-and.ac.uk/history/Mathematicians/Al-Karaji.html

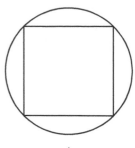

Figure 2.4. Show that the area of the square is about two-thirds the area of the circle.

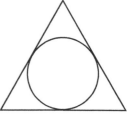

Figure 2.5. Show that the area of the circle is about four-sevenths the area of the equilateral triangle.

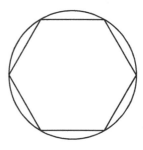

Figure 2.6. Show that the area of the regular hexagon is about six-sevenths the area of the circle.

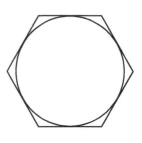

Figure 2.7. Show that the area of the circle is also about six-sevenths the area of the regular hexagon.

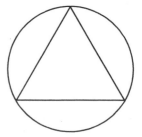

Figure 2.8. Show that the area of the equilateral triangle is about seven-sixteenths that of the circle.

Problem 4-2

(The final problem of chapter 4 of the *Suanfa Tong Zong*: "Zokufu," or "Rice and Money.")

We produced cloth with weight $43 + 3/4$ *kin*, which consists of two materials a and b. The weights of a and b in the material are in the ratio 4:1. Find the weights of a and b.

See page 55 for the solution.

Problem 4-3

(From chapter 5 of the *Suanfa Tong Zong*, On geometric and arithmetic sequences.)

(1) Here is 594 *mon*.[13] We want to divide them between two people A and B with the ratio of 1:2. How much money will A and B get?

(2) Here is 672 silver *ryō*. We want to divide it among A, B, and C with the ratio of 1:2:4. How much money will A, B, and C get?

(3) Here is 225.36 *koku* of rice.[14] The government wants to distribute it to five classes of homes. Each second-class home gets 0.8 the amount of each of the four first-class homes. Each third-class home gets 0.8 times as much rice as each of the eight second-class homes. Each of the fourth-class homes gets 0.8 times as much as each of the fifteen third-class homes. Each of the 120 fifth-class homes receives 0.8 times the amount of rice given to each of the 41 fourth-class homes. How much rice does each home and each class get in total?

The solutions are on page 55.

Problem 4-4

(From chapter 6 of the *Suanfa Tong Zong*, "On Pascal's triangle.")
Expand the following polynomials by using Pascal's triangle (figure 2.9).

(1) $(a + b)^3$,
(2) $(a + b)^4$,
(3) $(a + b)^5$.

Answers: Reading off from figure 2.9 gives

[13] We don't know how much 1 *mon* was worth in ancient China but, in seventeenth century Japan, 1 *mon* was about one-fourth of a dollar.

[14] By 1592, the value for the *koku* was about 71.616 kg and so the problem is talking about 16,139 kg total.

(1) $(a+b)^3 = a^3 + 3a^2b + 3ab^2 + b^3,$

(2) $(a+b)^4 = a^4 + 4a^3b + 6a^2b^2 + 4ab^3 + b^4,$

(3) $(a+b)^5 = a^5 + 5a^4b + 10a^3b^2 + 10a^2b^3 + 5ab^4 + b^5.$

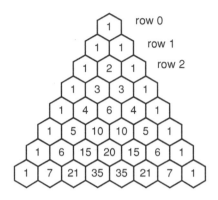

Figure 2.9. Pascal's triangle, invented hundreds of years earlier in China and Iraq, is a mnemonic device for the coefficients of the various terms when expanding an expression like $(a+b)^n$. Each element in the triangle is found by adding the two elements on each side diagonally above, with any element outside the triangle taken as 0. Thus the coefficients for $(a+b)^3$ can be read off from row 3, giving $a^3 + 3a^2b + 3b^2a + b^3$. If the leftmost element of a row is designated the zeroth element, then the rth element of the nth row will be recognized as the binomial coefficients "n-choose-r," or $n!/r!(n-r)!$.

Problem 4-5

(1) Find the two sides x *bu* and $x+15$ *bu* of a rectangle with area 1,750 square *bu*.

(2) Find the two sides x *bu* and $x+28$ *bu* of a rectangle with area 1,920 square *bu*.

The solutions are on page 56.

Problem 4-6

(From chapter 7 of the *Suanfa Tong Zong*: "On the Area of Fields.")

As shown in figure 2.10, we divide an equilateral triangle *ABC* into three quadrilaterals that all have the same area. If the triangle has sides of length 14 and *G* is the center of the triangle, find the area of *ABC* and the length of the sides of the small quadrilaterals.

The solution can be found on page 56.

Figure 2.10. The equilateral triangle is divided into three quadrilaterals of equal area, as shown. We are to find the area of *ABC* and the length of the sides of the small quadrilaterals. The length of each side of the triangle is 14.

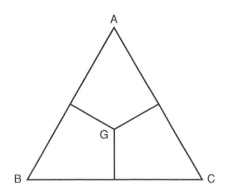

Problem 4-7

(From chapter 8 of the *Suanfa Tong Zong*: "Civil Engineer.")

(1) A horse was stolen. The owner found it and begin to chase the thief after the thief had already gone 37 *ri*. After the owner traveled 145 *ri*, he learned that the thief was still 23 *ri* ahead. After how many more *ri* did the owner catch up with the thief?

(2) A number of identical balls are arranged as shown in figure 2.11, where the base contains 7 balls and the top contains 3 balls. How many balls are there in total?

(3) As shown in figure 2.12, many identical balls are arranged in a pyramid, whose base is an equilateral triangle with a side of 7 balls. How many balls are there in total?

(4) Identical balls are arranged in pyramid, this time where as shown in figure 2.13, the base is a square of side 12 balls. How many balls are there in total?

Figure 2.11. How many balls are in this truncated pyramid?

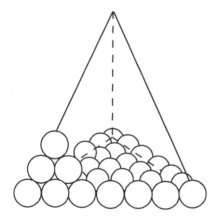

Figure 2.12. This pyramid has a triangular base with seven balls along each side. How may balls are in the pyramid?

The solution to problem 1 can be found on page 56. The solutions to problems 2–4 are as follows:

(2) The easiest way to do the problem is to count the balls. However, the sum of integers k from 1 to n is given by the famous formula

$$\sum_{1}^{n} k = \frac{n(n+1)}{2}.$$

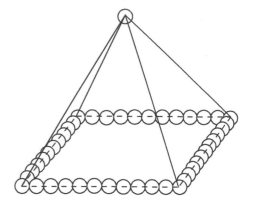

Figure 2.13. This pyramid has a square base with twelve balls along each side. How many balls are in the pyramid?

Thus, for this problem,

$$\sum_{3}^{7} k = \sum_{1}^{7} k - \sum_{1}^{2} k = \frac{7(7+1)}{2} - \frac{2(2+1)}{2} = 25,$$

which is easily generalized to any number of balls.

(3) From figure 2.12, you can convince yourself that, if there are p balls along each side of a layer in the pyramid, then the total number of balls in that layer is just $\sum_{1}^{p} k = p(p+1)/2$, or 28 for the base. But each successive layer above the base has one fewer ball along the side, until the top layer, which has only a single ball, and so the grand total number of balls N is just $N = \sum_{p=1}^{7} p(p+1)/2$. Using the famous formula

$$\sum_{1}^{n} k^2 = \frac{n(n+1)(2n+1)}{6},$$

one can easily show that

$$N = 7(7+1)(7+2)/3! = 84.$$

(4) Since the base is square, in this case there are just p^2 balls on each layer, with one fewer for each successive layer, and the total can be found directly as $\sum_{k=1}^{12} k^2 = 12(12+1)(24+1)/6 = 650$.

Problem 4-8

(From chapter 9 of the *Suanfa Tong Zong*: "Transportation.")

(1) Civil servants A and B work in the town office. A goes to work on every twelfth day and B goes to work on every fifteenth day. Today they meet each other in the office. In how many days will they meet for the next time?

Plate 2.5. How many barrels are in the stack? From the *Jinkō-ki*, c. 1818.
(Collection of Fukagawa Hidetoshi.)

(2) A boy saves money in the following way: On day one he saves 1 *mon,* on day two he saves 2 *mon,* and on day three he saves $2^2 = 4$ *mon.* How much money in total will he have saved after 30 days?

The answer to (1) *can be found on page 56.*

Answer 2: The boy's total savings amounts to a geometric series of the form

$$S = a + ar + ar^2 + \cdots + ar^n = a\sum_{k=0}^{n} r^k.$$

It is well known that such a series sums to

$$S = a(1 - r^{n+1})/(1 - r).$$

In our case $a = 1$, $r = 2$, and $n = 29$, and so $S = 2^{30} - 1 = 1{,}073{,}741{,}823$ *mon*.
Problem 2 was quoted in the *Jinkō-ki* of 1627.

Problem 4-9

(From chapter 10 of the *Suanfa Tong Zong*: "Excess and Lack.")

(1) Here are N persons and a long cloth of length G *hiki* with a constant width. When each person gets *8 hiki* of the cloth, 15 *hiki* are left over, but if each person wants 9 *hiki*, then 5 *hiki* is lacking. Find N, the number of persons, and G, the the length of the cloth.

(2) Here are N persons who have G *ryō* of money among them. If they are separated into groups of 3 members and each group takes 5 *ryō* for shopping, then 10 *ryō* is left over. On the other hand, if they are separated into groups of 5 and each group takes 9 *ryō* for shopping, then there is nothing left over. Find the total amount of money G, and the number of persons, N.[15]

See page 56 for the solutions.

Problem 4-10

(From chapter 11 of the *Suanfa Tong Zong*: "On Linear Equations.")
Here are a lot of squash, pears, peaches, and pomegranates. The price of two squash and four pears is 4 *bu*. The price of two pears and seven peaches is 4 *bu*. The price of four peaches and seven pomegranates is 3 *bu*. The price of eight pomegranates and one squash is 2.4 *bu*. Find the cost of each fruit.

The solution is on page 57.

Problem 4-11

(From chapter 12 of the *Suanfa Tong Zong*: "On the Pythagorean theorem.")

(1) Find the radius of a circle that is inscribed in a right triangle whose short sides are 36 and 27. (See figure 2.14.)

(2) If two sides of a right triangle are 12 and 6, then find the side of a square inscribed in it. (See figure 2.15.)

[15] Like the *mon*, the values of the monetary *ryō* and *bu* (next problem) in sixteenth century China are uncertain. The authors believe they may have been worth about 30 dollars and 3 dollars, respectively.

Figure 2.14. Find *r*.

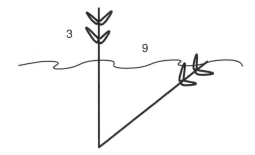

Figure 2.15. Find the length of the side of the square.

Figure 2.16. How deep is the pond?

Plate 2.6. Problem 4-11, part 3, as it appeared in the *Suanfa Tong Zong*.

(3) Two reeds of equal height project 3 *syaku* above the surface of a pond. If we draw the top of one reed 9 *syaku* in the direction of the shore so that the top is just touching the surface of the water, find the depth of the pond. (See figure 2.16.)

The answers are on page 57.

Answers and Solutions to Chapter 2
Problems

Problem 1-2

If x is the amount of rice, then $50/27 = 21/x$, or $x = 21 \times (27/50) = 11 + 17/50$ *shō* of rice.

Problem 1-3

If x is the amount of cloth the weaver wove on the first day, then $x + 2x + 4x + 8x + 16x = 5$ *syaku* or 50 *sun*. Thus $31x = 50$ *sun*, or $x = (1 + 19/31)$ *sun*.

Problem 1-4

(1) $y = 240$ *bu*; (2) $y = 160$ *bu*; (3) $y = 130 + 10/11$ *bu*; (4) $y = 115 + 1/5$ *bu*; (5) $y = 105 + 15/137$ *bu*; (6) $y = 97 + 47/49$ *bu*.

Problem 1-5

(1) To find the volume of the bank one needs to recall that the area of a trapezoid is one-half the product of the altitude and the sum of its bases. Thus $V = 4 \times (20 + 8)/2 \times 127 = 7{,}112$ cubic *syaku*.

(2) The number of workers is just the total volume divided by the volume each worker can carry, or $(4 \times 14 \times 127)/444 = 16 + 2/111$ workers. [One guesses the boss hired an extra laborer.]

Problem 1-6

If N is the original amount of the poor traveler's tax money, convince yourself that

$$
\begin{aligned}
1 &= N(1/2) + N(1/2)(1/3) + N(1/2)(2/3)(1/4) \\
&\quad + N(1/2)(2/3)(3/4)(1/5) + N(1/2)(2/3)(3/4)(4/5)(1/6) \\
&= N[1/2 + (1/2 - 1/3) + (1/3 - 1/4) \\
&\quad + (1/4 - 1/5) + (1/5 - 1/6)] = N(5/6)
\end{aligned}
$$

or $N = 6/5$ *kin*.

Problem 1-7

If t is the number of days when the two stems meet, then the total height must be $90 = (7 + 10)t$, which implies $t = 90/17 = 5 + 5/17$ days.

Problem 1-8

For a, b, c, the amounts of rice from plants A, B, C, we have $3a + 2b + c = 39$; $2a + 3b + c = 34$; $a + 2b + 3c = 26$. This system of equations can easily be solved simultaneously to get $a = 9.25$, $b = 4.25$, $c = 2.75$.

Problem 2-1

As in problem 1-5, the number of workers is the volume of the trapezoidal bank, divided by the volume each worker can carry per season, or $(20 + 54)/2 \times 38 \times 5{,}550 \div 300 = 26{,}011$.

Problem 2-3

If x is the height of the tree, then by similar triangles, $x/1.5 = 15/0.5$, and so $x = 45$ *syaku*.

Problem 2-4

If r is the number of roosters and h is the number of hares, then $r + h = 35$ and $2r + 4h = 94$. Solving these equations implies $h = 12$ and $r = 23$.

Problem 2-5

The number of trees is $9^2 = 81$; branches, $9^3 = 729$; nests, $9^4 = 6{,}561$; crows, $9^5 = 59{,}049$; chicks, $9^6 = 531{,}441$; feathers, $9^7 = 4{,}782{,}969$; colors, $9^8 = 43{,}046{,}721$.

Problem 3-1

(1) $V = (h/3)(a^2 + ab + b^2) = 304$ cubic *syaku*. (2) $V = (h/3)(a^2 + ab + b^2)(1/12) = 5040$ cubic *syaku*, where the radius of the lower base is $b/2\pi = b/6$.

Problem 3-2

Let n be the number of days it takes horse A to catch horse B. The distance both horses travel is the same, so $n \times 240 = (n + 12) \times 150$, which shows that A catches B in $n = 20$ days.

Problem 3-3B

The third equation gives $x + z = 2y$. Then from the second equation $y = 68$. Now let $k \equiv x - 68 = 68 - z$. Then $x = k + 68$ and $z = 68 - k$. From the first equation, $(68 + k)^2 + 68^2 + (68 - k)^2 = 14{,}384$. Solving for k^2 gives $k^2 = 256$, which implies $k = 16$, $x = 84$, $y = 68$ and $z = 52$.

Problem 4-1

(1) Cheng Da-Wei assumed that $\pi = 3$, which gives the answer directly. One can also inscribe a regular hexagon in a circle of diameter 1 and see immediately that the perimeter of the hexagon is exactly 3.

(2) The diagonal of the square is $5\sqrt{2} = 7.07106$.

(3) The height of the equilateral triangle follows from the Pythagorean theorem $h^2 = 7^2 - (7/2)^2$, or $h = \sqrt{147/4} \approx 6$.

(4) If the side of the square is a, then $\pi r^2 = (3/4)a^2$. But $a = 2r$, which immediately gives $\pi = 3$.

(5) If the diameter of the circle is $2r$, then a side of the square is $2r/\sqrt{2}$, and the square's area is $\left(2r/\sqrt{2}\right)^2 = \pi r^2 \times (2/3)$.

(6) The area of the equilateral triangle is $(3/2)\,ra$, where a is the side of the triangle, and r is the radius of the inscribed circle. But $a = 2r\tan 60 = 2\sqrt{3}\,r$, so the ratio of the areas is $1/\sqrt{3} \approx 4/7$.

(7) If the radius of the circle is r, then the area of the inscribed hexagon S' is six times the area of each triangle, with sides r and altitude $(\sqrt{3}/2)r$. So $S' = 6 \times (1/2)r \times (\sqrt{3}/2)r = (3\sqrt{3}/2)r^2$. Dividing by the area of the circle $S \approx 3r^2$ gives $S'/S \approx \sqrt{3}/2 \approx 6/7$.

(8) These triangles have side a and altitude $r = a\sqrt{3}/2$. So the area of the hexagon is $S' = 6 \times (1/2)r \times (2/\sqrt{3})r = 2\sqrt{3}r^2$. Dividing this into the area of the circle $S \approx 3r^2$ gives again $S/S' \approx \sqrt{3}/2 \approx 6/7$.

(9) The area of the equilateral triangle with side a is $S' = (1/2)a^2\sqrt{3}/2$. But $a = \sqrt{3}r$, so $S' = (3\sqrt{3}/4)r^2$. Dividing by the area of the circle, $S = \pi r^2 = 3r^2$ gives $S'/S = \sqrt{3}/4 \approx 7/16$.

Problem 4-2

We are told that the total weight of the cloth is a+b=43+3/4 and that $a/b = 4$. Solving these equations together gives $a = 35$ *kin* and $b = 8+3/4$ *kin*.

Problem 4-3

(1) If A gets k *mon* and B gets $2k$ *mon*, then $3k = 594$ and $k = 198$ and $2k = 396$.

(2) If A gets k *ryō*, B gets $2k$, and C gets $4k$, then $7k = 672$, $k = 96$, $2k = 192$ and $4k = 384$.

(3) Let x be the amount of rice for a first-class home and let $r = 0.8$. Then $(4 + 8r + 15r^2 + 41r^3 + 120r^4)x = 225.36$ and $x = 225.36/90.144 = 2.50$.

Thus, one first-class home gets 2.5 *koku* and the first-class homes get 10 all together. One second-class home gets $8 \times 2.5 = 2$ *koku*, and the second-class homes get 16 total. Similarly, a third-class home gets 1.6 *koku* and the third-class homes get 24.

A fourth-class home gets 1.28 *koku* and the fourth-class homes get 52.48. One fifth-class home gets 1.024 *koku* and 122.88 *koku* go to the fifth-class homes.

Problem 4-5

(1) For the first rectangle we have $x(x + 15) = 1,750$, which gives the quadratic equation $x^2 + 15x - 1,750 = 0$. This factors into $(x + 50)(x - 35) = 0$, yielding $x = 35$ and $x + 15 = 50$ *bu*.

(2) Similarly, for the second rectangle, $x(x + 28) = 1,920$, which can be written as $(x + 14)^2 = 1920 + 196 = 2,116 = 46^2$. Thus $x = 46 - 14$, or $x = 32$ and $x + 28 = 60$ *bu*.

Problem 4-6

The area of triangle $ABC = 1/2 \times 14 \times 7\sqrt{3} = 84.87$, and the area of each quadrilateral is therefore $84.87/3 = 28.29$. The sides of small quadrilaterals are thus 7 and $7\sqrt{3}/3 \approx 4$.

Problem 4-7

(1) When the owner had gone 145 *ri*, the thief had traveled $145 - 37 + 23 = 131$ *ri*. That means that, if s_t and s_o are the speeds of the thief and owner, their ratio is $s_t/s_o = 131/145$. The time it takes the owner to go another k *ri* is the same as the time it takes the thief to be caught after, say, another x *ri*. Since time is distance divided by speed, we have $(23 + x)/s_o = x/s_t$. Consequently $(s_t/s_o)(x + 23) = x$, implying $x = 215 + 3/14$ and $k = 238 + 3/14$.

Problem 4-8

(1) The number of days that go by before the civil servants meet again is the least common multiple of 12 and $15 = 60$ days after they meet.

Problem 4-9

(1) The first condition gives $G = 8N + 15$, while the second gives $G = 9N - 5$. Solving the equations simultaneously yields $N = 20$ and $G = 175$.

(2) Here, $G = (5/3) \times N + 10$ and $G = (9/5) \times N$, from which it follows that $N = 75$ and $G = 135$.

Problem 4-10

Let x be the price of a squash, y the price of a pear, z the price of a peach and w the price of a pomegranate. Then, $2x + 4y = 4$, $2y + 7z = 4$, $4z + 7w = 3$, and $8w + x = 2.4$. Solving these equations simultaneously gives $x = 0.8$ *bu* for one squash, $y = 0.6$ *bu* for one pear, $z = 0.4$ *bu* for one peach, and $w = 0.2$ *bu* for one pomegranate.

Problem 4-11

(1) The length of the hypotenuse is $\sqrt{36^2 + 27^2} = 45$. From figure 2.14 this msust also be $36 - r + 27 - r$, which implies $r = (36 + 27 - 45)/2 = 9$.

(2) If x is the side of the square, then similar triangles gives $12/6 = x/(6 - x)$, which implies $x = 4$.

(3) If x is the depth of the pond, then $x^2 + 9^2 = (x + 3)^2$, which gives $x = 12$ *syaku*.

Plate 3.1. This illustration comes from a 1715 edition of the *Jinkō-ki* and accompanies a problem dealing with the breeding habits of mice. We give it as problem 4 in this chapter. (Collection of Fukagawa Hidetoshi.)

THREE

Japanese Mathematics and Mathematicians of the Edo Period

> From a young age I have devoted much time to the study of mathematics and have read many books. I have visited my teacher, far from here, and have studied hard. But, lately, children are playing tricks and writing bad poetry. It is deplorable that they are wasting so much time. If they write and read any poetry, it is better that the poetry concerns mathematics. I shall write formulae in Jyugai-roku as poetry.
>
> —From the preface to Imamura Tomoaki's 1640 book for children, *Inki Sanka*, or *Poetry of Multiples and Divisions*

In chapter 1 we briefly recounted the genesis of traditional Japanese mathematics, *wasan*, how it arose with the appearance of the abacus in Japan and the 1627 publication of Yoshida Mitsuyoshi's *Jinkō-ki*, and how *wasan*'s evolution was very much shaped by the Tokugawa family's isolationist policies, which took hold in the early to mid-seventeenth century. En route we encountered a few samurai who, having received their Master of Mathematics licenses could teach at a *juku*, or start their own private schools

at home or nearby. Here we survey some of the more important mathematical works of the Edo period and the samurai-mathematicians who created them. As in the previous chapter, we attempt to impart their flavor through the problems they contain, which for the most part should be suitable for high school students.

Wasan of the Seventeenth Century

Yoshida Mitsuyoshi and the Jinkō-ki

Little can be added to the biography of the first identifiable Japanese mathematician, Mori Shigeyoshi, who in 1622 wrote a booklet about how to use

Plate 3.2. Another street scene from the *Jinkō-ki* illustrating the benefits of learning the *soroban* for business. This one is from an edition published between 1818 and 1829. (Collection of Fukagawa Hidetoshi.)

the *soroban*, except that he had three students, Imamura Tomoaki (?–1668), Takahara Yoshitane, and Yoshida Mitsuyoshi (1598–1672), the last of whom published the *Jinkō-ki*, which was responsible for much of what followed.

We know slightly more about Yoshida. Born in Kyoto in 1598, he was the grandchild of the merchant Suminokura Ryōi (1554–1614), who had become a millionaire through trade with China and the other East Asian countries, and so Yoshida would have had easy access to Chinese mathematics texts. He learned arithmetic from Mōri, and from the intellectual Suminokura Soan he learned the mathematics of Cheng Da-Wei's *Suanfa Tong Zong*. In later life Yoshida lost his eyesight, undoubtedly from making so many revisions on the *Jinkō-ki*, and he died at the age of seventy-five.

Most of the exercises in the three-hundred-plus editions of the *Jinkō-ki* are concerned with calculations useful for everyday life and business transactions. Here, we present a handful from the 1643 edition, which was published during Yoshida's lifetime. Of the 270 problems it contains, thirty-six are *soroban* exercises, twenty-eight concern exchange rates, and thirty-five more involve measuring the areas of fields. Almost all of them were lifted from Chinese texts.

Problem 1

This problem is quoted from the Chinese *Jiu zhang Suanshu*.

Here is a field shaped like a donut. The outer circumference is is 120 *ken*,[1] while the inner circumference is 84 *ken*. A house sits in the middle of the field so we cannot measure its diameter, but the distance between the two circumferences is 6 *ken*. Find the area of the field without using π.

Original answer: Area $= (120 + 84)/2 \times 6 = 612$ *tubo*.

Problem 2

This problem, *Nusubito San*, or "Thieves Arithmetic" was taken from the *Sun-Tsu Suanjing* (see chapter 2, problem 2-2).

One night, some thieves steal a roll of cloth from a shed. They are dividing up the cloth under a bridge when a passer-by overhears their conversation: "If each of us gets 7 *tan*, then

[1] One *ken* is 1.8 m. One square *ken*, 1 *ken* × 1 *ken* = 1 *tubo*.

Plate 3.3: The oil peddler in problem 3 must measure out an awkward amount of oil with only two ladles. From a 1643 edition of the *Jinkō-ki*. (Collection of Fukagawa Hidetoshi.)

8 *tan* are left over, but if each of us tries to take 8, then we're 7 *tan* short."[2] How many thieves were there, and how long was the cloth?

See chapter 2, problem 2–2 for the method of solution.

Problem 3

In the Edo period people used colza oil (similar to rapeseed or canola oil) for lighting their homes. Hence this *abura wake* or "oil distribution" problem:

A colza-oil peddler is hawking oil. One evening on the way home, a customer asks him for 5 *shō* of oil.[3] But the oil peddler only has 10 *shō* of oil left in his big tub, and no way to measure out oil except two empty ladles that can hold 3 and 7 *shō*. How does the oil peddler measure out five *shō* for the customer?

Original solution: Call the big tub *A*, the 3-*shō* ladle *B*, and the 7-*shō* ladle *C*.

[2]A *tan* is a unit for measuring a bolt of cloth about 34 cm wide. One *tan* of such a cloth is about 10 m.

[3]1 *shō* = 1.8 liter. Note: The Japanese *shō* differs from the Chinese *shō*.

First, with the *B* ladle, scoop out 3 cups from *A* and fill C as far as it goes. Then there is 1 *shō* in *A*, 7 *shō* in *C*, and 2 *shō* left over in *B*.

Next, pour everything in *C* back to *A*. Then there is 8 *shō* in *A*, 2 *shō* in *B*, and nothing in *C*.

Third, pour everything from *B* into *C*. Now there is 8 *shō* in *A*, 0 *shō* in *B*, and 2 *shō* in *C*.

Last, with the empty cup *B*, pour 3 *shō* from *A* into *C*. Now there is 5 *shō* in *A*, 5 in *C*, and the peddler can satisfy the customer.

The oil-distribution problem possibly originated with Yoshida himself; at least it appears not to have come from any Chinese source. It is also related to the problem known in the West as the three-jug problem.[4]

Problem 4

Yoshida presents this *Nezumi San*, or "Mice Problem," as an exercise for the *soroban*. Its kinship to problem 4-8 in the previous chapter is easy to see.

On January first, a pair of mice appeared in a house and bore 6 male mice and 6 female mice. At the end of January there are 14 mice, 7 male and 7 female.

On the first of February, each of the 7 pairs bore 6 male and 6 female mice, so that at the end of February, there are 98 mice in 49 pairs. From then on, each pair of mice bore six more pairs every month.

(1) Find the number of mice at the end of December.

(2) Assume that the length of each mouse is 4 *sun*, or 12 cm. If all the mice line up, each biting the tail of the one in front, find the total length of mice.

Original answers

(1) 27,682,574,402.

Also, the following was written in the book: At the end of each month, the number of mice is $2 \times 7 = 14$; $2 \times 7 \times 7 = 98$; $2 \times 7^3 = 686$; $2 \times 7^4 = 4802$; $2 \times 7^5 = 33,614$; $2 \times 7^6 = 235,298$; $2 \times 7^7 = 1,647,086$; $2 \times 7^8 = 11,529,602$; $2 \times 7^9 = 80,707,214$; $2 \times 7^{10} = 564,950,498$; $2 \times 7^{11} = 3,954,653,486$; $2 \times 7^{12} = 27,682,574,402$.

This is a geometric progression (see problem 4-8 in chapter 2).

[4] See Coxeter and Grietzer, *Geometry Revisited* ("For Further Reading, What Do I Need to Know . . .", p. 337. They also give another solution.

(2) The total length is $2 \times 7^{12} \times 12$ cm. The *Jinkō-ki* states, "The length is the same as the distance around Japan and China. In fact, the length is seven times the distance from the earth to the moon." The last estimate is actually not too far off.

Imamura Tomoaki (?–1668)

The *Jinkō-ki* spurred a great interest in problems that could be tackled numerically, including the calculation of areas of polygons, the volumes of solids, and in particular the calculation of π. One mathematician who wrote about such matters was Imamura Tomoaki from Osaka.[5] We have no information about him except that he was one of Mōri Shigeyoshi's "three honorable disciples" and that in 1639 he published *Jyugairoku*, whose title he appears to have taken from an old Chinese geography book, *Sengaikyō*. The following year he published a revised version for children, *Inki Sanka*, or *Poetry of Multiples and Divisions*. We quoted the beginning of Imamura's preface to the *Inki Sanka* at the head of the chapter. He goes on to say, "If any child reads any poem in this book and tries to do the calculation on the *soroban*, then the experience will be useful in his future. If any child wants to know the proofs of formulae, then see my book *Jyugairoku*."

In the *Jyugairoku*, Imamura determined that the square root of 152.2756 was 12.34, calculated the cube root of 1880, the areas of regular polygons with 3, 5, 6, 7, 8, 9, and 10 sides and provided many formulas for the volumes of solids. Here is an example of "poetry on the areas of regular polygons" from the *Inki Sanka*.

Problem 5

(1) For a regular polygon of side s, show that
 (a) The area of an equilateral triangle is the side multiplied by the side multiplied by 0.433. [in other words, $A = 0.433s^2$]
 (b) The area of a pentagon is $1.73s^2$
 (c) The area of a heptagon is $3.64s^2$
 (d) The area of an octagon is $4.828s^2$
 (e) The area of a nonagon is $6.093s^2$

[5] Sometimes Imamura Chisho.

(2) Why are the formulas of the square and hexagon missing?

(3) Show that the volume of a *sobagara* (buckwheat) grain, which is a tetrahedron, is "side, side, side, and 0.11783" [that is, $0.11783s^3$].

The solutions are given on page 84.

Muramatsu Shigekiyo (1608–1695)

Although the Chinese had a value for π better than 3.14 in the sixth century, for some reason at the onset of the Edo period Japanese mathematicians used $\pi = 3.16$. We find this value in Mōri Shigeyoshi's 1622 primer *Warizansyo*, in the first edition of the *Jinkō-ki*, as well as in Imamura's *Inki Sanka*. No one knows why this should be the case. In many traditional problems, circles were described by their diameter, not their radius, so the area is $A = (\pi/4)(\text{diameter})^2$ rather than $A = \pi r^2$. It happens that $3.16 = 4 \times 0.79$, exactly, so it may have been convenient to round off π and write $A = 0.79 (\text{diameter})^2$. But this is just a guess.

During this era of $\pi = 3.16$, Muramatsu Shigekiyo showed that the perimeter of a $2^{15} = 32{,}768$-sided polygon inscribed in a unit circle was $P = 3.141592648$. Muramatsu actually published his value to 22 digits in his 1663 book *Sanso*, or *Stack of Mathematics*, but got it right to only eight digits. Here we present the *Sanso*'s table of the perimeter $P(n)$ of 2^n-sided polygons inscribed in the unit circle. With the formula for the perimeter $P(n) = 2^n \sin(180/2^n)$ and a calculator, readers can confirm the correctness to eight digits.

$$P(3) = 3.061467458, \quad P(4) = 3.121445152, \quad P(5) = 3.136548490,$$
$$P(6) = 3.140331156, \quad P(7) = 3.141272509, \quad P(8) = 3.141513801,$$
$$P(9) = 3.141572940, \quad P(10) = 3.141587725, \quad P(11) = 3.141591421,$$
$$P(12) = 3.141592345, \quad P(13) = 3.141592576, \quad P(14) = 3.141592634,$$
$$P(15) = \underline{3.141592}648,$$

With the local value of π equal to 3.16, Muramatsu needed some courage to conclude that in fact $\pi = 3.1415926$, and he did back off slightly, claiming after comparison with the Chinese values only that $\pi = 3.14$. Nevertheless, it was a brave move that gained him an adherent, Isomura Yoshinori.

Plate 3.4. As did many other mathematicians, Muramatsu Shigekiyo (1608–1695) approximated π by constructing regular polygons in a unit circle. Shown here is an octagon, but Muramatsu considered up to 32,768-sided polygons and calculated π to twenty-two digits; however, only the first eight were correct. (Matsuzaki Toshio.)

Isomura Yoshinori (1630–1710)

Like the other mathematicians of the period, including Imamura, Isomura Yoshinori studied problems that had approximate solutions. Isomura was a samurai of the Nihonmatsu clan in Fukushima prefecture. In 1661 he published *Sanpō Ketsu Gishō*, or *Profound Mathematics*, in which he used π = 3.16. But in 1684 he published a second, annotated version, *Tohsyo Sanpō Ketsu Gishō*. By then, spurred on by the *Jinkō-ki*, as well as Muramatsu, Isomura employed a $2^{17} = 131,072$-sided polygon to calculate π = 3.141592653, confirming and extending the results of his predecessor.

Isomura also developed an approach to calculate the volume of simple solids by slicing them up into disks, then adding the volume of the disks together. This would give an approximate result, but calculus had only just been invented in the West and did not exist in Japan, and one could not expect anything more. We offer a noncalculus problem from the first edition.

Problem 6

(1) Find the volume of a regular tetrahedron of side 1.

(2) Given an equilateral triangle of side 1, as in figure 3.1, draw three lines to the center, construct three equal triangles, and draw three inscribed circles. Show that the diameter of the circles is $2r \cong 0.26794$.

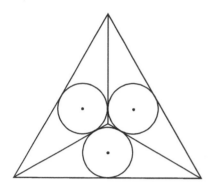

Figure 3.1. Show that the diameter of the circles is $2r \cong 0.26794$.

(3) Given a pentagon of side 1, as in figure 3.2, draw five triangles and five inscribed circles. Show that their diameter is $2r \cong 0.50952$.

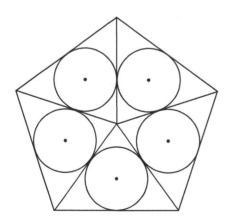

Figure 3.2. Show that $2r \cong 0.50952$.

Here is the original solution to part 1:

Solution to (1): Consider the cube shown in figure 3.3, with sides $1/\sqrt{2}$, which means the sides of the embedded tetrahedron equal 1. Cut out four pyramids from

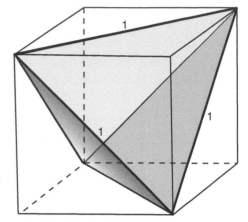

Figure 3.3. The sides of the tetrahedron = 1
and the sides of the cube = $1/\sqrt{2}$.

the cube. Convince yourself that each pyramid has sides $1/\sqrt{2}$, $1/\sqrt{2}$, hypotenuse 1, and altitude $1/\sqrt{2}$. Then the desired volume of the tetrahedron is

$$V = \left(\frac{1}{\sqrt{2}}\right)^3 - 4 \times \left(\frac{1}{3}\right)\left(\frac{1}{2}\right)\left(\frac{1}{\sqrt{2}}\right)^3 = \frac{1}{(6\sqrt{2})} = \frac{\sqrt{2}}{12}.$$

The solutions to parts 2 and 3 can be found on p. 84.

Seki Takakazu (1640?–1708)

The level of traditional Japanese mathematics took a sharp turn upward toward the end of the seventeenth century, largely due to the labors of Seki Takakazu, Japan's most celebrated mathematician. Many stories are told of Seki's powers, but like the stories about the youthful Gauss, they are to be treated with skepticism. Most of Seki's works were published posthumously by his disciples and, because Japanese mathematicians traditionally deferred to their masters, this has always made it difficult to know precisely what he did and did not do. Seki's exact birthdate and birthplace remain unknown, but he was a close contemporary of Newton. Of samurai descent, he was adopted in infancy by the noble family of Seki Gorozayemon and went by that surname. Later, he worked in the treasury of the Koufu clan, whose head was Lord Tokugawa Tsunashige. In 1704, Seki moved as a shogunate samurai into the Tokugawa government and worked for two years as a mid-level treasurer. He retired in 1706 and died in 1708.

関
先
生
之
御
像

Plate 3.5. A portrait of Japan's greatest mathematician, Seki Takakazu (1640?–1708), from the undated manuscript *Kosetsuki*, or *Ancestry of Mathematicians*. (Tsurumai library.)

Seki came of age at an opportune moment, exactly during the Genroku, and had ample opportunity to study the burgeoning number of mathematics books then being published. In 1672, when he was about thirty, he wrote a manuscript "Solutions to Unsolved Problems of the *Sanpō Ketsu Gishō*" by Isomura. Two years later he published the *Hatsubi Sanpō*, or *Detailed Mathematics*, which consists of solutions to fifteen unsolved problems in the 1671 *Kokon Sanpōki*, or *Old and New Mathematics*, by Sawaguchi Kazuyuki (?–?).

Hatsubi Sanpō was actually the only book published by Seki during his lifetime. At his death he left twenty-one books in manuscript, including seven on astronomy. In 1712 his disciple Araki Murahide published four volumes of Seki's works under the title *Katsuyō Sanpō*, or *Collection of Important Mathematical Results*. It is from this collection that many of Seki's contributions are known.

Although Seki's name is sometimes dubiously associated with the invention of the *Enri*, definite integration, there is no question that he was

the first to develop the theory of determinants, a decade before Leibnitz. He also discovered the so-called Bernoulli numbers before Jacob Bernoulli, and Horner's method 150 years before Horner, although in this he was anticipated by the Chinese. Here we begin by presenting a problem, *Kaifuku Dai no Hō*, "Determinants," dating from 1683. (One does not really need to know what a determinant is to follow the solutions.)

Problem 7

(1) Given two equations in y,

$$ay + b = 0,$$
$$cy + d = 0,$$

where the coefficients a, b, c, d may be nonzero constants or any functions in another variable x, eliminate y and find the condition on a, b, c, and d to give an equation in x alone.

(2) Given three equations in y,

$$ay^2 + by + c = 0, \tag{3.1}$$
$$dy^2 + ey + f = 0, \tag{3.2}$$
$$gy^2 + hy + j = 0, \tag{3.3}$$

where again the coefficients a, b, c, d, e, f, g, h, and j are functions in x, find the condition on a, b, c, d, e, f, g, h, and j to give an equation in x alone.

Solutions:

(1) We easily see that $y = -b/a = -d/c$, from which it follows that $ad - bc = 0$.

(2) Multiply Eq. (3.1) by d, and Eq. (3.2) by a, and subtract (3.1) from (3.2). This gives

$$y = \frac{af - dc}{bd - ae}.$$

Similarly, multiply the original equation (3.2) by g, equation (3.3) by d, and again subtract to find

$$y = \frac{dj - fg}{eg - dh}.$$

Together, these two expressions imply $(af - dc)(eg - dh) = (bd - ae)(dj - fg)$, or $aej + bfg + cdh - afh - bdj - ceg = 0$.

Seki displayed these relationships in a diagram (see plate 3.9), which readers familiar with linear algebra will recognize as equivalent to setting the modern determinant of a system of equations equal to zero (figure 3.4).

Plate 3.6. Seki's original notation for determinants from his 1633 manuscript *Kaifuku Dai.* (Japan Academy.)

$$\begin{bmatrix} a & b \\ c & d \end{bmatrix}$$

$$\begin{bmatrix} a & b & c \\ d & e & f \\ g & h & j \end{bmatrix}$$ Figure 3.4. Modern notation for determinants in problem 7.

Seki, like his contemporaries, was deeply concerned with determining π, but unlike the others devised an original method to do it. Following Muramatsu's method above, he calculated the perimeters of a 2^{15}-sided, a 2^{16}-sided, and a 2^{17}-sided polygon: $P(15) = 3.14159264$, $P(16) = 3.14159265$, and $P(17) = 3.141592653$. Then suddenly he claims

$$\pi = P(\infty) = P(16) + \frac{[P(16) - P(15)][P(17) - P(16)]}{[P(16) - P(15)] - [P(17) - P(16)]} = 3.14159265359.$$

That is, π should be equal to the perimeter of an infinitely sided polygon inscribed in a unit circle, yet he writes his result in terms of $P(15)$, $P(16)$, and $P(17)$. Moreover, this value has two more correct digits than the ten correct digits contained in $P(17)$. Seki did not reveal his thinking, but in this case we can reconstruct it. Let $a = a_1 = P(16) - P(15)$ and $a_2 = P(17) - P(16)$. In problem 4–8 from chapter 2 we discussed a geometric series, which is of the form $a + ar + ar^2 + ar^3 + ar^4 \cdots$, where r is the constant ratio between terms. For an infinite number of terms such a series sums to $a/(1 - r)$. Let $r = a_2/a_1$. If one assumes that π can be approximated as the sum of a geometric series, then

$$P(\infty) = P(15) + \frac{a}{(1 - r)} = P(16) + \frac{a_1 a_2}{(a_1 - a_2)},$$

Seki's result.

Seki's new value of π was published by his disciple Takebe Katahiro in the *Tetsujutsu Sankei*, where Seki had previously shown π = 355/113. Of this value Takebe remarked, "In the old days, my master Seki Takakazu found the value $\pi \cong 355/113$ by his own method. Then about twenty years later, he recognized that the same value π = 355/113 had already been obtained by Zu Chongzhi [chapter 2] in the *Zuishi* [*Records of Zui Era* (581–619)]. It is wonderful two prominent mathematicians got the same value in two separate countries and separate ages."

Plate 3.7. One of Seki's original drawings for a 15-sided polygon, from his book *Katsuyō Sanpō*. (Matsuzaki Toshio.)

Problem 8

As we have been discussing, for this calculation of π Seki was interested in the properties of *n*–sided polygons. For instance, in his *Kaku Hō*, or *Angles of Regular Polygons*, in volume 3 of *Katsuyō Sanpō*, he calculates the radii of the inscribed circle (incircle) and the circumscribed circle (circumcircle) of an *n*-gon, for *n* up to twenty. He does this for polygons to the accompaniment of complicated drawings (see plate 3.7) without trigonometric functions, but we can give an idea of the results through the following exercises.

(1) Given an equilateral triangle of side 1, find the equations giving the radius r_3 of the inscribed circle and R_3 of the circumcircle.

(2) Do the same for a square of side 1, and

(3) for a pentagon of side 1.

The solutions are on page 84.

Wasan of the Eighteenth Century

Takebe Katahiro (1664–1739)

Within a few decades of the time that Newton and Leibnitz developed calculus in the West, traditional Japanese mathematicians also began taking steps in that direction, although they did not progress to a full-fledged theory. The person from whom we know most about those initial efforts—and perhaps the greatest contributor to those efforts himself—is Seki's most illustrious disciple, Takebe Katahiro,[6] whom we just mentioned. Takebe became Seki's student at the age of thirteen and published his first book when only nineteen, the *Kenki Sanpō*, or *Study Mathematics Profoundly*. Later he became a shogunate samurai, a position equal to that of his former master. In 1719 the government commissioned Takebe to create a map of Japan, which was renowned for its detail; however, it has not survived. Although, as mentioned, Seki is sometimes credited with the invention of the *Enri*, more concrete evidence indicates that it was in fact Takebe.

Takebe published three books during his lifetime and left twelve other works behind in manuscript. The first of the manuscripts is *Taisei Sankei* from 1710, the *Comprehensive Book of Mathematics* in twenty volumes. The other, from 1722, was *Tetsujutsu Sankei*, or *Series*.

[6]Sometimes Takebe or Tatebe Kenko.

Plate 3.8. In the 1778 *Fuhki Jinkō-ki*, or *Riches of Jinkō-ki*, the anonymous author suggests weighing an elephant by bringing it onto a boat and marking the water line, removing the elephant, then bringing on stones of known weight until the water line reaches the same level it did with the elephant. (Collection of Fukagawa Hidetoshi.)

Using a 1,024-sided regular polygon inscribed in a circle, Takebe gave in the *Taisei Sankei* the approximation

$$\pi = \frac{5,419,351}{1,725,033},$$

from which he calculated that $\pi = 3.14159265358981538324194$4, noting that this value is bigger than the real π by 0.0000000000000022144779300. The reader can verify on a computer that $5,419,351/1,725,033 - \pi = 0.0000$ 0000000022144779300394, which demonstrates that Takebe's calculations were extraordinarily accurate.

In the *Tetsujutsu Sankei*, Takebe calculated π = 3.14159265358979323846 2 -64338327950288419712. . . . Once again, a computer gives π = 3.14159265-35897932384626433832795028841971693993751058 2, meaning that Takebe had 41 digits correct. Takebe's methods are rather complicated, utilizing infinite series, which did not appear in Chinese mathematics and which he introduced himself. We outline them in chapter 9.

Matsunaga Yoshisuke (1692?–1744)

Once you have a closed formula for π, like π/4 = \tan^{-1} (1/2) + \tan^{-1} (1/3), as was found in the West around the turn of the eighteenth century, the only limitation to computing as many digits of π as you want is sheer boredom. The Japanese, however, did not use trigonometric functions and did not have such formulas, although they did have series. In any case, in the seventeenth and early eighteenth centuries it was not yet understood that π was an irrational number, and so perhaps the traditional Japanese mathematicians, along with their Western counterparts, dreamed of finding the point at which π became a repeating decimal.

One of the π-digit hunters was Matsunaga Yoshisuke. Little about him has come down to us. Matsunaga was a samurai in the Iwaki clan, whose lord was also a mathematician, Naitō Masaki (1703–1766). Matsunaga wrote forty-two books in manuscript, the main one of being the *Hōen Sankei* of (1739), or *Mathematics of Circles and Squares*. In it he calculates π correctly to fifty digits. In an unpublished manuscript, *Hōen Zassan*, or *Essay on Mathematics of Circles and Squares*, he calculates π correctly to 52 digits, which is the longest value of π found in the *wasan*. We present one problem here concerning π that gives an idea of Matsunaga's methods.

Problem 9

Assume that 3.1415926 < π < 3.1415927. Show that we then have Seki's approximation π = 355/113.

Matsunaga's original solution can be found on page 85.

Matsunaga also presented many numerical methods for use with the *soroban*, in other words, computer programs. Some of these concerned the *Enri* and we discuss them in chapter 9.

Nakane Genjun (1701–1761)

As in the West, Japanese mathematicians like Seki and Isomura took an interest in "recreational pursuits," such as magic squares and circles. Indeed, the Japanese may have gone beyond their Western counterparts, constructing 20×20 squares, not to mention magic wheels, complete with epicycles. One mathematician who engaged in such activities was Nakane Genjun, the son of a famous Kyoto mathematician, Nakane Genkei (1662–1733), who himself had studied under Takebe. At age 60 in 1721, Genkei, considered one of the most learned men in Japan, received an invitation from Tokugawa Yoshimune to translate two Chinese astronomy books. A decade later he made a number of observations of the sun and moon and dedicated his record book, in manuscript, to Tokugawa Yoshimune. Nakane Genjun studied mathematics with his father in Kyoto and later in Edo with Takebe. Genjun's major work is the book *Kanjya Otogi Zōshi*, the *Collection of Interesting Results in Mathematics*, published in 1743. The book contains 69 problems of which we present two for amusement, "Paper Cutting" and "Magic Squares."

Problem 10

(1) How do you fold and/or cut with scissors a rectangular piece of paper composed of two unit squares such that you can construct a single square of side $\sqrt{2}$? (See figure 3.5.)

(2) How do you fold and/or cut a rectangular piece of paper with sides in the proportion 1:3 so that you can construct a square with side equal to $\sqrt{3}$? (figure 3.6.)

(3) How do you cut and fold a rectangular sheet composed of five unit squares so that for each case shown in figure 3.7 you can construct a square of side $\sqrt{5}$?

Answers and solutions can be found on page 85.

Figure 3.5. Cut and fold a rectangle to make a square of side $\sqrt{2}$.

Figure 3.6. Cut and fold a rectangle to make a square of side $\sqrt{3}$.

Plate 3.9. Original drawings for paper cutting from Nakane Genjun's 1743 book *Kanjya Otogi Zōshi*. (Masuzaki Toshio.)

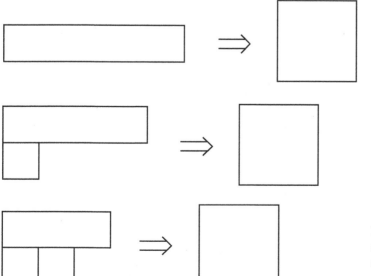

Figure 3.7. Cut the given configurations to make a square of side $\sqrt{5}$.

Problem 11

(1) Using the numbers 1,2,3 three times each, make a magic square such that the sum of each row, each column, and each diagonal equals 6.

(2) Using the the numbers 1,2,3,4 four times each, construct a magic square such that the sum of each row, each column, and each diagonal equals 10.

We give one solution for part 2 in figure 3.8. The others we leave to you.

4	1	1	4
3	2	2	3
2	3	3	2
1	4	4	1

Figure 3.8. Magic square with sums of rows, columns, and diagonals equal to 10.

Ajima Naonobu (1732–1798)

Throughout the eighteenth century, Japanese mathematicians devised geometry problems that resulted in high-degree equations. The most famous is the "Gion shrine problem," which consisted of an equation of 1024 degrees. (See chapter 7 for the problem itself.) No analytic—that is, exact—solution has ever been found for the Gion shrine problem, but, as mentioned in chapter 1, Ajima Naonobu became famous for simplifying it from an equation of 1024 degrees to one of ten degrees. He left his calculations in an unpublished manuscript of 1774, *Kyōto Gion Daitō jutsu* (*The Solution to the Gion Shrine Problem*).

The Gion shrine problem was only one contribution of many that Ajima made to several branches of mathematics, and, although he in fact published nothing during his lifetime, he is considered the greatest Japanese mathematician of the eighteenth century. Born in 1732 into the Edo branch of the Shinjō clan, Ajima became samurai when he was twenty-three[7]. At forty-two he attacked the Gion shrine problem; at forty-three he received the position *gun bugyō* or "country magistrate," and he died in Edo in 1798.

Apart from his official work, Ajima studied mathematics in the Seki school of Edo from which he received a license of Master of Mathematics.

[7]"Becoming samurai" basically means being appointed by a clan to some official position.

Generally, Ajima's work is marked by its originality, and it has been said that had he lived in the West he would have equaled Joseph Lagrange, perhaps the greatest mathematical physicist after Newton. In the forty-two books he left behind as manuscripts, which were later distributed largely in hand-written copies, Ajima comes closest of any Japanese mathematician to a full theory of integration. A year after Ajima's death, one of his students, Kusaka Makoto (1764–1839), prepared for publication (but did not in fact publish) a collection of Ajima's works, *Fukyū Sanpō*, or *Masterpieces of Mathematics*, which contains the "Malfatti problem," written down three decades before it was proposed by the Italian Gian Francesco Malfatti (see chapter 8).

In the course of solving a complicated problem in the *Fukyū Sanpō*, Ajima needed to find 10^n for $0 < n < 1$. He writes, "I have obtained a new method for finding the value of 10^n $(0 < n < 1)$, which is a difficult problem." This provides the basis for the exercise we present here, one that demonstrates Ajima's method.[8]

Problem 12

Solving the equation $x^{10} - 10 = 0$, Ajima shows that the root $10^{0.1} = 1.258925$. He next shows that $x^{10} - 10^{0.1} = x^{10} - 1.258925 = 0$ has the root $10^{0.01} = 1.023293$. Thus,

(1) Using $10^{0.1} = 1.258925$, find the values of $10^n (n = 0.9, 0.8, 0.7, \ldots, 0.2)$ to seven digits.

(2) Using $10^{0.01} = 1.023293$, find the values of $10^n (n = 0.09, 0.08, 0.07, \ldots, 0.02)$ to seven digits.

(3) From (1) and (2), find $10^{2.56}$ to seven digits.

The solution is on page 87.

Fujita Sadasuke (1734–1807) and Fujita Kagen (1772–1828)

The greater part of this book is devoted to *sangaku* problems, and such a collection would have been impossible without the work of our honorable ancestors the Fujita, briefly mentioned in Chapter 1. The elder, Sadasuke, was born in 1734 in Saitama province and studied at Seki's school. In 1762 he was appointed an assistant astronomer by the Tokugawa government,

[8] It is sometimes claimed, perhaps on the basis of this problem, that Ajima constructed tables of logarithms, but we have found no evidence of this in his books.

but due to eye problems—an occupational hazard of mathematicians—he resigned after five years. In 1768, he became the official mathematician for the Kurume clan, whose lord was also a famous mathematician, Arima Yoriyuki (1714–1783); Arima himself published *Shūki Sanpō* (1769), or *Gems of Mathematics*. Around 1780 Fujita became Seki's fourth successor as head of the Seki school.

Sadasuke is most remembered for his 1781 book *Seiyō Sanpō*, (*Detailed Mathematics*), but he also helped his son Kagen publish the first collection of *sangaku* problems *Shinpeki Sanpō*, (*Sacred Mathematics*), which appeared in 1789. We speak in more detail about the book in chapter 4 and, in the venerable tradition, have lifted a number of exercises from it. Kagen, who worked in the same Karume clan as his father, went on in 1807 to publish the second edition of *Sacred Mathematics*, the *Zoku Shinpeki Sanpō*.

Here we present a problem from Sadasuke's earlier *Seiyō Sanpō*.

Problem 13

(1) As shown in figure 3.9, two circles of radii a and b kiss each other, as well as touch the line l at points D and E, respectively. Show that $DE = 2\sqrt{ab}$.

(2) Three positive integers (p, q, r) are termed a Pythagorean triple if $p^2 + q^2 = r^2$, in other words, if you can associate them with the sides of a right triangle. The same integers form a "primitive" Pythagorean triple if p and q are relatively prime, meaning they have no common divisors other than 1.[9] Show that (p, q, r) is a primitive Pythagorean triple if

$$p = 2mn, \; q = m^2 - n^2, \; r = m^2 + n^2$$

for all integers m, n such that $m > n > 0$ (m and n not both odd).

(3) Find five primitive Pythagorean triples for $r \leq 41$.

Solutions:

(1) Draw the auxiliary lines shown in figure 3.10. Then use the Pythagorean theorem to get $(a + b)^2 = (b - a)^2 + DE^2$, or $DE = 2\sqrt{ab}$. (This result will be useful in many problems to come.)

(2) Suppose in the previous problem we want $DE = AC$ to be an integer. Since $DE = 2\sqrt{ab}$ it is sufficient that $\sqrt{a} = n$ and $\sqrt{b} = m$, where both m and n are integers. Hence $a = n^2$ and $b = m^2$. Let $BC = p$, another integer. The condition for a Pythagorean triple is then $p = b - a = m^2 - n^2$, $AC = 2mn$ and $AB = b + a = m^2 + n^2$. For a primitive Pythagorean triple, m and n should have no common devisor.

[9] If p and q are relatively prime, it follows that p and r and q and r are relatively prime.

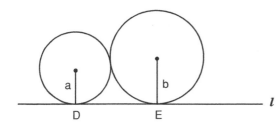

Figure 3.9. Show that $DE = 2\sqrt{ab}$.

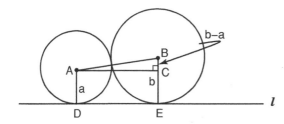

Figure 3.10. Use Pythagoras.

This is the simplest method in traditional Japanese mathematics for finding the conditions on a primitive Pythagorean triple.

(3) In the *Seiyō Sanpō*, Sadasuke gives all primitive Pythagorean triples (p, q, r) for $0 < r < 1000$. For $r < 45$ they are (3,4,5), (5,12,13), (8,15,17), (7,24,25), (12,35,37), (20, 21, 29), and (9, 40,41).

Wasan of the Nineteenth Century

Aida Yasuaki (1747–1817)

For many *sangaku* we are indebted to the students and followers of the geometer Aida Yasuaki,[10] a native of Yamagata province in Japan's northeast. Born in 1747, at the age of sixteen Aida enrolled in the nearby Okazaki school to study mathematics. At twenty-three, he went to Edo, working as a samurai road crew member on the construction of roads and levees. He seems to have kept this up, apparently writing nothing on mathematics, until the age of thirty-five when he hung a *sangaku* at the Atago shrine. Another fellow on the road crew turned out to be a student of Fujita Sadasuke, which led to an introduction with the master, then head of the Seki school. In a friendly manner Fujita advised Aida to correct a mistake on the tablet he had hung.

[10] In the West, sometimes Aida Ammei.

82

But Aida took offense at Fujita's warm advice and organized the *Saijyoh ryū*—"The Best Mathematics School"—to stand in opposition to the Seki *ryū*—the "Seki school." A protracted feud resulted, but Aida's ability in mathematics was not in doubt. To be sure, he went slightly mad over mathematics, writing about 1,300 books, of which eleven were published. "Books" may be stretching things—the unpublished 1,289, approximately, each consisted of about twenty pages.

Aida was highly skilled in geometry. His *Sanpō Tenshōhō*, or *Algebraic Geometry*, consists of 195 volumes, making it undoubtedly the longest mathematics textbook in history, while his *Sanpō Kantuh Jyutsu*, (*General Methods in Geometry*) consists of sixty-five volumes. Perhaps Aida's main contribution was that his Best Mathematics School did produce many mathematicians in the northeast of Japan, with the result that many *sangaku* survive to this day in that part of the country. Because the reader will encounter a number of *sangaku* problems from Aida's school throughout the book (in particular in chapter 4, problem 37, and chapter 5, problem 21), we do not present any here.

Other Mathematicians of the Late Edo Period

Many Japanese mathematicians contributed to the development of *wasan*, too many to name them all. For *Sacred Mathematics*, one of the most important is Yamaguchi Kanzan, who is little more than a shadow. He was born in Suibara, Niigata prefecture circa 1781, he studied mathematics in Edo and died in 1850. His main legacy is a voluminous travel diary, the result of six walking tours he took around Japan to record *sangaku* problems. Except for two of the tablets Yamaguchi records, all have been lost. Chapter 7 is devoted to an extended excerpt from his diary, including problems.

Equally important for us is Yoshida Tameyuki (1819–1892), who was a samurai in the Owari clan of Nagoya. Yoshida pursued his studies with many teachers and left numerous manuscripts containing solutions to temple geometry problems. His solutions are noteworthy for their simplicity, clarity, and beauty, and we present several of them throughout this book. Fukagawa Hidetoshi, one of the present authors, attempted to find the site of Yoshida's house in Nagoya, but in vain.

A fairly major figure was Uchida Kyō (1805–1882), a mathematical prodigy who entered the school of one of Seki's followers at age eleven and received a license to teach at age eighteen. He knew Dutch, and when he

started his own school he named it "Mathematica." Uchida's works covered many areas, including not only mathematics but astronomy, geography, and surveying. Renowned as a teacher, his students came from all over Japan. In 1879, he became a member of the Tokyo Academy under the new Meiji government. One of his main works was *Kokon Sankan* of 1832, or *Mathematics, Present and Past*, which is noteworthy as it included Soddy's famous hexlet theorem of 1937, a problem posted on a *sangaku* in 1822 (see problem 16, chapter 6).

Several other nineteenth-century mathematicians contributed to the further development of the *Enri*, including Wada Yasushi (1787–1840) and Uchida Kyūmei (?–1868), but because their contributions were mostly in the area of integration, we defer discussion of their work until chapter 9. We end this chapter with an elementary problem from Chiba Tanehide (1775–1849), who was born in a farmhouse but later studied mathematics in Hasegawa Hiroshi's school in Edo. At fifty-three, Chiba became a samurai in the Ichinoseki clan of Iwate province. When his book, *Sanpō Shinsyo*, or *New Mathematics*, appeared in 1830, it became one of Japan's best-selling mathematics books. It contains an exposition of almost all traditional Japanese mathematics, including the *Enri* and this exercise, whose solution will be extremely helpful in all that is to follow.

From figure 3.11, prove the Pythagorean theorem for the right triangle *ABC*.

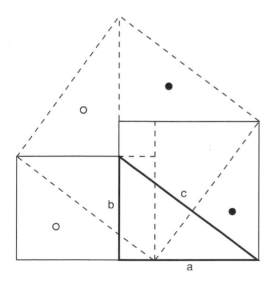

Figure 3.11. Prove the Pythagorean theorem.

Solutions to Selected Chapter 3 Problems

Problem 5

In Imamura's *Inki Sanka* there are no solutions, so we provide a modern confirmation of the results.

In any first-year geometry text it is shown that the area of a regular polygon is $A = n\frac{1}{2}sa$, where n is the number of sides, s is the length of the side, and a is the apothem, the perpendicular distance (altitude) from the center of the polygon to one of the sides. You can easily prove that

$$a = \frac{s/2}{\tan(180/n)},$$

and so the area of the polygon is

$$A = \frac{n}{4\,\tan(180/n)}s^2.$$

Plugging in $n = 1, \dots, 9$ gives the values for A near—but not quite the same as—those listed by Imamura.

For part 2, the reason the square is omitted is that it is trivial, $A = a^2$. The hexagon is merely six times the area of an equilateral triangle.

For part 3, the altitude of a regular tetrahedron of side s is $h = (\sqrt{6}/3)s$ and the volume is $(1/3) \times$ (area base) \times (altitude) $= (\sqrt{2}/12)s^3 = 0.11785113s^3$. The *Inki Sanka*'s numerical answer is of course approximate.

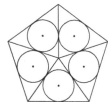

Problem 6

(2) Considering, say, the lower triangle, then from figure 3.1 we see that $15 = 2r$. From the half-angle formula $15 = (1 - \cos 30)/(\sin 30)$ and so $2r = 2 - \sqrt{3} = 0.26794$. This value was written in the book.

(3) In this case we have $2r = \tan 27 = (1 - \cos 54)/\sin 54 \cong 0.50952$. Again, this approximation was written in the book. (In chapter 4, problem 32, we show how to work out the trigonometric functions of such strange angles.)

Problem 8

If r_n, and R_n are the radii of the inscribed and circumscribed circles of an n-sided regular polygon of side 1, then it is easy to show that $\sin(180/n) = 1/(2R_n)$ and $R_n^2 = 1/4 + r_n^2$.

(1) For the triangle, we use the triple-angle formula $\sin 3\theta = -4\sin^3\theta + 3\sin\theta$, where $\theta = 180/3$. Plugging in $\sin\theta = 1/2R_3$ from above gives the formula $3R_3^2 - 1 = 0$, and with the Pythagorean theorem $12r_3^2 - 1 = 0$.

(2) Here we employ the quadruple-angle formula $\sin 4\theta = \cos \theta$ $(-8\sin^3\theta + 4\sin\theta)$. The same procedure yields $2R_4^2 - 1 = 0$ and $2r_4 - 1 = 0$.

(3) In this case the relevant quintuple-angle formula is $\sin 5\theta = 16\sin^5\theta - 20\sin^3\theta + 5\sin\theta$, from which you can show that $5R_5^4 - 5R_5^2 + 1 = 0$ and $80r_5^4 - 40r_5^2 + 1 = 0$.

Problem 9

We have approximately (Matsunaga's decimals are slightly off)

$$\pi = 3 + 0.1415926 = 3 + \cfrac{1}{1/0.1415926}$$

$$= 3 + \cfrac{1}{7 + 0.062515} = 3 + \cfrac{1}{7 + 1/(1/0.62515)}$$

$$= 3 + \cfrac{1}{7 + 1/15.99} = 3 + \cfrac{1}{7 + 1/16}$$

$$= \frac{355}{113},$$

where the last step follows from putting everything over a common denominator. In traditional Japanese mathematics this method was called *reiyaku-jyutsu,* or "dividing by zero." Well, if not zero, then very small numbers.

Problem 10

The original solution to this problem consisted only of drawings. We add a few details. The best way to follow the solutions is to try it with scissors. Part 1 has two solutions:

Solution A: First, fold the paper in half so that the midpoint *M* is marked by the crease (figure 3.12). Unfold. From the endpoints of the base, cut along the two indicated lines to *M*, and replace as shown.

Solution B: As in solution A, fold the paper in half to mark the midpoints *M* and *N* as in figure 3.13. Unfold. From the endpoints on the left-hand side, cut along the indicated dashed lines to *M* and *N*. Replace as shown.

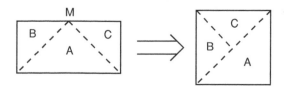

Figure 3.12. Cut on the dashed lines and replace.

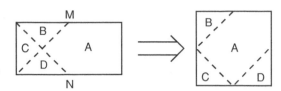

Figure 3.13. Cut on the dashed lines and replace.

(2) We are given that the sides of the rectangle are in the ratio 1:3, so referring to figure 3.14 we can assume $AD = 1$ and $AB = 3$. Hence we want to construct a side equal $\sqrt{3}$.

As before, fold the paper from left to right and mark the midpoints M and N. Unfold. Next fold the paper from bottom to top and mark the midpoints F and E. Now take a point G on the centerline FE such that $AG = AD$ and erect the perpendicular GH to AG, where H is a point on ND. (This can be done by folding the side AD such that vertex D sits on the centerline FE at G. The desired perpendicular is the edge along the paper from D to the crease. Unfold.) Finally, extend AG to K and mark the point J on MB such that $MJ = HD$.

By construction $AG = AD$ and, since G is on the centerline, $AG = AD = DG$, which implies that $\angle GAD = 60°$ and $\angle MAK = 30°$ Hence, $\triangle MAK$ is a 30–60–90 triangle and so $AM/AK = \sqrt{3}/2$. Since we folded the paper such that $AM = 3/2$, we get $AK = \sqrt{3}$, the side length of the desired square. Moreover, all the triangles in the figure are 30-60-90. With this fact you can convince yourself that $JN + HG = \sqrt{3}$ as well, which allows construction of the square on the right of figure 3.14.

(3) For this part we want to construct a square of side $\sqrt{5}$ from the five unit squares in figure 3.7. We present the original diagram solutions in figure 3.15 and leave the detailed proofs to the reader.

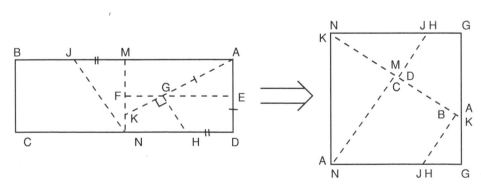

Figure 3.14. Cut and replace as shown.

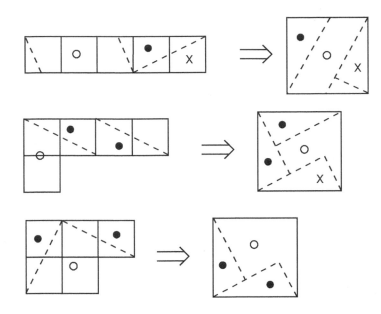

Figure 3.15. The dashed hypotenuses of the right triangles have length $\sqrt{5}$.

Problem 12

 We give Ajima's original solution without comment, except to say that he actually carried out his calculations to fourteen digits, which a scientific software package shows are correct!

(1)

$$10^{0.9} = 10^{1.0}/10^{0.1} = 7.943285; \quad 10^{0.8} = 10^{0.9}/10^{0.1} = 6.309578;$$
$$10^{0.7} = 10^{0.8}/10^{0.1} = 5.011878; \quad 10^{0.6} = 10^{0.7}/10^{0.1} = 3.981078;$$
$$10^{0.5} = 10^{0.6}/10^{0.1} = 3.162284; \quad 10^{0.4} = 10^{0.5}/10^{0.1} = 2.511892;$$
$$10^{0.3} = 10^{0.4}/10^{0.1} = 1.995267; \quad 10^{0.2} = 10^{0.3}/10^{0.1} = 1.584897.$$

(2)

$$10^{0.09} = 10^{0.10}/10^{0.01} = 1.230268; \quad 10^{0.08} = 10^{0.09}/10^{0.01} = 1.202264;$$
$$10^{0.07} = 10^{0.08}/10^{0.01} = 1.174897; \quad 10^{0.06} = 10^{0.07}/10^{0.01} = 1.148153;$$
$$10^{0.05} = 10^{0.06}/10^{0.01} = 1.122018; \quad 10^{0.04} = 10^{0.05}/10^{0.01} = 1.096478;$$
$$10^{0.03} = 10^{0.04}/10^{0.01} = 1.071519; \quad 10^{0.02} = 10^{0.03}/10^{0.01} = 1.047128.$$

(3)

$$10^{2.56} = 10^2 \times 10^{0.5} \times 10^{0.06} = 100 \times 3.162284 \times 1.148152 = 363.0786.$$

Plate 4.1. A replica of a *sangaku* that was hung in 1879 in the Aga shrine and measures 163 cm by 58 cm. It contains several problems quite similar to several of those in this chapter (see problems 30–35).

FOUR

Easier Temple Geometry Problems

Confucius says, "You should devote all your time to study, forgetting to have meals and going without sleep." His words are precious to us. Since I was a boy, I have been studying mathematics and read many books on mathematics. When I had any questions, I visited and asked mathematician Ono Eijyu. I appreciate my master's teachings. For his kindness, I will hang a sangaku in this temple.

—Inscription on a *sangaku* hung in 1828 by Saitō Kuninori at the Kitamuki Kannon temple

Temple geometry problems, as may now be evident, are not found in temples alone. During the Edo period, twelve collections of *sangaku* problems appeared in print and hundreds of other problems were recorded in unpublished manuscripts. What's more, some devotees who hung *sangaku* unrepentantly swiped problems from earlier collections. Neither the tablets nor many of the books are to be thought of as texts in the modern sense; they do not in any way constitute a coherent exposition of traditional Japanese mathematics. On a single *sangaku*, a problem that a twelve-year-old might solve can be found next to one that would stop a graduate student in his or her tracks. In part this is because *sangaku* were frequently

created by whole groups of people, perhaps an entire class at a *juku*, and undoubtedly the students were at many different levels.

This state of affairs makes selecting and presenting *sangaku* problems something of a challenge. We have chosen to arrange the problems more or less in order of difficulty rather than by source, and, where possible, to group similar problems together. Again, these exercises were not "problem sets" developed by an instructor for a mathematics curriculum, but are largely the random result of the labors of aficionados solving geometrical riddles that pleased them.

In chapters 4 through 6, we present a selection of about ninety temple geometry problems, ranging from the trivial to the nearly impossible. Most of those in this particular chapter, devoted to easier problems, come from the tablets themselves, a few of which can be seen in the color section of the book. These tablets were among over one hundred displayed at the first exhibit of *sangaku*, discussed in the Preface. The remainder of the problems come from some of the collections and manuscripts just mentioned. Of the published collections of *sangaku*, the first and probably the most famous is that of Fujita Kagen. Fujita's book, *Shinpeki Sanpō*, or *Sacred Mathematics*, appeared in 1789 and contains problems from twenty-six tablets hung between 1767 and 1789. For a second edition of 1796, Fujita added problems from twenty-two tablets hung between 1790 and 1796. The shrines in which the tablets were found were located over a wide area in Japan, with the consequence that the name of Fujita spread over an equally wide area. In an 1807 sequel, Fujita recorded fifty tablets hung from 1796 to 1806. Of the 48 *sangaku* recorded in the first book, all but one, from the Sakurai shrine in Aichi prefecture, have been destroyed or lost. Of the fifty recorded in the second, only one tablet hung in the Isaniha shrine in Ehime prefecture has survived.

In terms of the remaining collections, although one of the books appeared in 1873, after the fall of the Tokugawa shogunate, all the problems date from the earlier Edo period, before Western influence made itself felt. We also quote a number of problems from unpublished manuscripts. For each of the problems and solutions, we indicate the author—if a name has come down to us—and the source, whether a tablet, book, or manuscript. The books, in the Genroku spirit, are all printed on rice paper with wooden blocks and are themselves works of art. Most of them are quite rare and the solutions we present from them have generally never been seen in the West.

Plate 4.2. Another woodblock print from the *Jinkō-ki*, this time from
a 1778 edition.

The first three exercises in this chapter do not actually involve geometry
but are so-called diophantine problems—algebraic problems that require
integer solutions.[1] They are much in the spirit of some of the Chinese prob-
lems from chapter 2. The remaining problems virtually all deal in plain
plane geometry, although a few of the final ones additionally require sim-
ple calculus. We trust that most will be suitable for high school students.
They also provide a useful "warmup" for the more difficult puzzles of chap-
ters 5 and 6, as they utilize some of the same basic techniques found every-
where in geometry, East and West. For the first problems, we often supply
the required "auxiliary lines" in the solution figures, to get readers going.
But we do not do this all the time, and somewhat less frequently as the

[1] Named after Diophantus of Alexandria (c. A.D. 200–c. 284), sometimes called the
"father of algebra."

chapter progresses. Our hope is that diligent students will take up the task themselves.

In doing the exercises, readers may occasionally wonder where the strange numbers come from: "If $2r = 35.5$, find a." "If $d = 3.62438$ and $2t = 0.34$, find $2r$." Many of the *sangaku* posters chose seemingly bizarre parameters in order to simplify computation of the final answer. A good example is problem 13 in chapter 6. Finally, a word about significant figures. Although teachers always admonish students not to engage in "meaningless precision" by using too many significant figures, when there has been no disagreement between our answer and the original, we often display a large number of significant figures in the answers to numerical problems. In such cases, the number of significant figures is that found on the original tablet.

Answers and solutions can be found at the end of the chapter.

Problem 1

The tablet on which this problem was written was hung by Ufu Chōsaburō in 1743 at the Kurasako Kannon temple. Its size is 76 cm by 33 cm.

There are 50 chickens and rabbits. The total number of feet is 122. How many chickens and how many rabbits are there?

The original solution can be found on page 121.

Problem 2

Tanikawa Taizō hung the tablet containing this problem in 1846 at the Yuisin temple of Chita-gun, Aichi prefecture. It is 98 cm wide and 48 cm high. The *sangaku* was unknown until 1979 when someone visited the temple, found it empty and abandoned, and discovered the tablet.

A circular road A that is 48 km in circumference touches at point P another circular road B of circumference 32 km. (See Figure 4.1.) A cow and a horse start walking from the point P along the road A and B, respectively. The cow walks 8 km per day and the horse walks 12 km per day. How many days later days later do the cow and horse meet again at P?

The solution is on page 121.

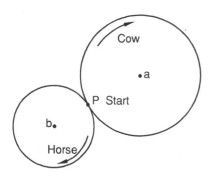

Figure 4.1. How many days after starting out from *P* will the horse and cow meet?

Problem 3

The tablet on which this problem was written was hung by Hara Toyokatsu in 1829 at the Katsurahama shrine in Akigun of Hiroshima prefecture and measures 81 cm by 46 cm. The problem itself was quoted from the 1797 book *Saitei Sanpō*, or *Revision of Certain Problems*, by Fujita Kagen.

As shown in figure 4.2, three circles *A*, *B*, and *C* of circumference $56 + 2/3$ km, $30 + 5/7$ km, and $13 + 3/4$ kilometer, respectively, all pass through point *P*. Three horses *a*, *b*, and *c* start to walk around *A*, *B*, and *C* from *P* simultaneously. Horse *a*'s speed is $8 + 41/1{,}000$ km per day, *b*'s is $6 + 123/4{,}000$ km per day, and *c*'s is $4 + 41/2{,}000$ km per day. How many days will pass before the three horses meet again at *P*?

Answer: The horses meet again 20,000 days after they set out. *The solution can be found on page 121.*

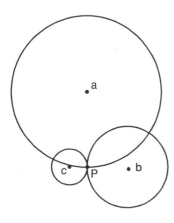

Figure 4.2. How many days will pass before the horses meet again at *P*?

Problem 4

This problem comes from the collection *Sūri Shinpen,* or *Mathematics of Shrines and Temples* by Saitō Gigi (1816–1889). In this 1860 book, Saitō records thirty-four tablets that were hung between 1843 and 1860. Most of the problems involved high-level calculus. This easy one was originally proposed by Nakasone Munekuni and hung in 1856 at the Haruna shrine in Haruna town, Gumma prefecture.

The centers of a loop of n circles of radius r form the vertices of an n-gon, as shown in figure 4.3. Let S_1 be the sum of the areas of the circles inside, and S_2 the sum of the areas of circles outside. Show that $S_2 - S_1 = 2\pi r^2$.

The solution is left as an exercise for the reader.

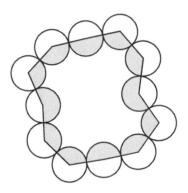

Figure 4.3. Show that white − grey $= 2\pi r^2$.

Problem 5

This elementary exercise can be seen as the second one from the bottom left corner on the *sangaku* of the the Katayamahiko shrine, color plate 5.

A circle of radius r is inscribed in an isosceles triangle with sides $a = 12$ and $b = 10$ (see figure 4.4). Find r.

Answer: $2r = 6$.

The solution is on page 122.

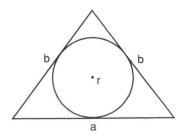

Figure 4.4. If $a = 12$ and $b = 10$, find r.

Problem 6

We know of this problem from the unpublished manuscript *Jinbyō Bukkaku Sangakushū*, or *Collection of Sangaku from the Aida School*, written by Aida Yasuaki (1747–1817) at an unknown date. The problem was originally proposed in 1800 by Kobata Atsukuni, a student of the Aida school, and presented on a tablet to the Kanzeondō temple of Toba castle town.

A big circle of diameter $2R = 100$ inscribes a large and small equilateral triangle, as shown in figure 4.5. Find the side q (in terms of R) of the small equilateral triangle *ABC* if *A* is the midpoint of one side of the large triangle.

See page 123 for a solution.

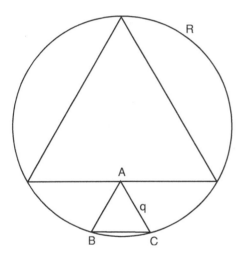

Figure 4.5. Find q in terms of R.

Problem 7

This problem can be seen as the second on the top left of the Katayamahiko shrine *sangaku*, color plate 5.

Two circles of radius r are tangent to the line l. As shown in figure 4.6, a square of side t touches both circles. Find t in terms of r.

The answer is given on page 123.

Figure 4.6. Find t in terms of r.

Problem 8

This problem is the second from the bottom right corner on the Katayamahiko shrine tablet, color plate 5.

A circle of radius r inscribes three circles of radius t, the centers of which form an equilateral triangle of side $2t$ (figure 4.7). Find t in terms of r.

Example: If $r = 10$, then $t = 4.64$.

The answer and solution are on page 123.

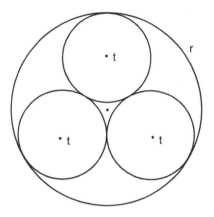

Figure 4.7. Find t in terms of r.

Problem 9

Kobayashi Syouta proposed this problem on a tablet that was hung in the Shimizu shrine, Nagano prefecture, in 1828.

In a big square of side a, a smaller square of side $2r$, and a circle of radius r touch the big square, as shown in figure 4.8. Find r in terms of a.

The answer and solution can be found on page 124.

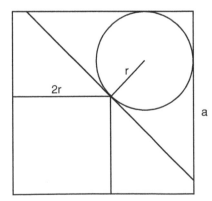

Figure 4.8. Find r in terms of a.

Problem 10

This problem is the third from the left on the Meiseirinji *sangaku*, color plate 8. It was proposed by Tanabe Shigetoshi, aged fifteen.

In a blue equilateral triangle, three "green" (light) circles of radius a, four "red" (dark) circles of radius b, and six white circles of radius c touch each other as shown in Figure 4.9. If R is the radius of the outer circle, and r is the radius of dashed circle, find c in terms of r.

A solution can be found on page 124.

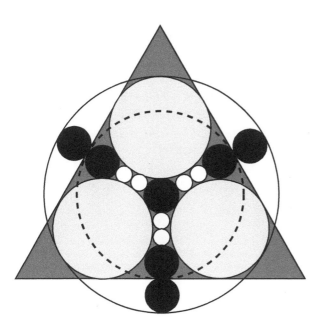

Figure 4.9. Find the radius of the small white circles in terms of r, the radius of the dashed circle.

Problem 11

This problem is the leftmost problem on the gilded Sugawara *sangaku*, color plate 7.

As shown in figure 4.10, a square of side t is inscribed in a given right triangle with sides a, b, c. If the area of triangle is $S = 163,350$ and the hypotenuse $c = 825$, then find a, b, t, n, and the distance d.

The answer and solution can be found on page 124.

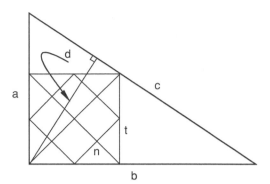

Figure 4.10. Given the area S and hypotenuse c, find
a, b, t, n, and d.

Problem 12

This is the rightmost problem on the Sugawara tablet, color plate 7.

As shown in figure 4.11, we have one circle inscribed in the outer square, a rhombus, two larger circles of radius R, and two smaller circles of radius r. The side of the rhombus b is the same length as the distance between the two horizontal lines drawn in the square. If $2r = 35.5$, find a, $a\pi$, b, R, and d. (As in traditional Japanese mathematics,[2] take $\pi = 3.16$.)

Answer: $a = 319.507$; $a\pi = 1,009.6428$; $b = 184.472$; $2R = 106.5$; $d = 67.5172$.

The full solution can be found on page 124.

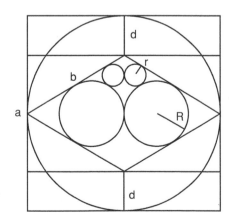

Figure 4.11. Find a, b, d, r, and R.

[2]Although we saw in chapter 2 that ancient Chinese and Japanese mathematicians had calculated π to many decimal places, traditional Japanese mathematicians found it simpler to use $\pi = 3.16$.

Problem 13

Watanabe Kiichi proposed this problem, which is the twelfth from the right on the Abe no Monjuin *sangaku*, color plate 11.

As shown in figure 4.12, an equilateral triangle with side t, a square of side s and a circle touch each other in a right triangle ABC with vertical side a. Find t in terms of a.

Answer: $t = (\sqrt{3} - 1)a$.

The solution can be found on page 124.

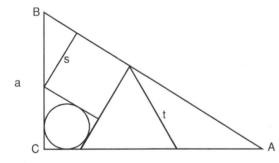

Figure 4.12. Find t in terms of a.

Problem 14

Proposed by Yamasaki Tsugujirou, this problem is the second problem from the right on the Meiseirinji tablet, color plate 8.

In a rhombus, there are two red circles of radius r, two white circles of radius r_1, and five blue circles of radius r_2 (see figure 4.13.). Show that $r_2 = r_1/2$, or blue = white/2.

A full solution to the problem is given on page 124.

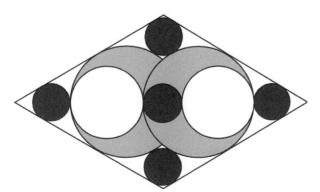

Figure 4.13. Show that the radius of the "blue" circles (dark) is one-half the radius of the "white" circles (white).

Problem 15

This problem is the third from the bottom right corner on the Katayamahiko shrine *sangaku*, color plate 5. It also appears on the newly discovered tablet from the Ubara shrine (see problem 31).

As shown in figure 4.14, two circles of radius r are inscribed in a square and touch each other at the center. Each of two smaller circles with radius t touches two sides of the square as well as the common tangent between the two larger circles. Find t in terms of r.

The answer and solution can be found on page 125.

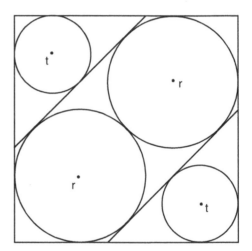

Figure 4.14. Find t in terms of r.

Problem 16

This problem, written on a tablet presented in 1837 to the Ohsu Kannon temple of Nagoya city, Aichi prefecture, was originally proposed by Mizuno Tsuneyuki and recorded in the unpublished manuscript, *Sangaku of Ohsu Kannon* by Nagata Toshimasa, 1837.

Four circles of radius r, whose centers form a rectangle with one side equal to $2r$, are inscribed in a big circle of radius R. As shown in figure 4.15, draw one small circle of radius p that touches the four circles r, and draw two small circles of radius q that touch two of the circles r externally and touch R internally. Find p in terms of q.

A solution can be found on page 125.

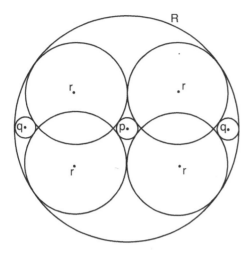

Figure 4.15. Find *p* in terms of *q*.

Problem 17

This problem, presented by Kobayashi Nobutomo, also comes from the Shimizu shrine *sangaku*, 1828.

As shown in figure 4.16, a small circle of radius *b* sits on the point of contact between two squares of side 2*b* that in turn sit on a line *l*. A big circle of radius *a* touches the line *l*, the nearest square, and the small circle. Find *a* in terms of *b*.

The answer and solution are on page 126.

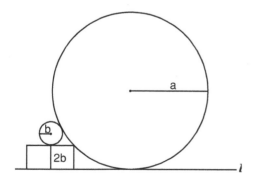

Figure 4.16. Find *a* in terms of *b*.

Problem 18

Gunji Senuemon was the proposer of this problem, which is the sixth from the left on the Abe no Monjuin *sangaku*, color plate 11.

From point O, the center of a circle with radius c, draw two tangents to the circle O', which also has radius c and which touches circle O externally. Then, as shown in figure 4.17, draw a large circle of radius R that passes through O and touches O' internally. Draw two more circles of radius b and a small circle of radius a. Find R, b, and c in terms of a.

A solution is on page 127.

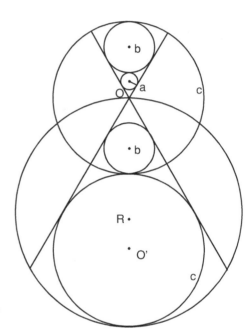

Figure 4.17. Find R, b, and c in terms of a.

Problem 19

This problem was written on a tablet hung in 1842 at the Atsuta shrine of Nagoya city, Aichi prefecture. It was proposed by Nagata Takamichi and recorded in the manuscript *Atsutamiya Hōnō Sandai*, or *Sangaku of Atsuta Shrine*, whose date and author are unknown.

Take any point C on the segment AB shown in figure 4.18 and draw two circles of diameters AC and BC that are tangent at C. From point A, draw two tangents to circle s, and from point B draw two tangents to circle t. Now consider two circles of radius p and q that touch the tangents and pass through point C. Show $p = q$ for any C.

A proof is left as an exercise for the reader.

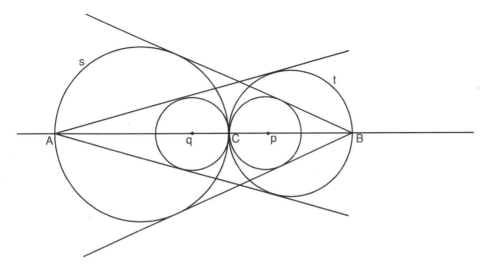

Figure 4.18. Show $p = q$ for any C.

Problem 20

This problem can be seen as the second from the right top corner of the Katayama-hiko shrine *sangaku*, color plate 5.

We have a field in the shape of a right triangle ABC with $AC = 30$ m and $BC = 40$ m. As shown in figure 4.19, we want to plow a path *DEFGHIJ* of width 2 m so that the three remaining interior sections have the same area. Find BE, DE, HC, JC, AI, and FG.

Answer: BE = 21.7743; *DE* = 16.331; *HC* = 16.2255; *JC* = 10.9577; *AI* = 17.0423 and *FG* = 4.873.

See page 127 for a solution.

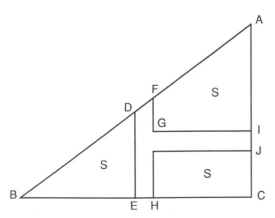

Figure 4.19. Find *BE*, *DE*, *HC*, *JC*, *AI*, and *FG*.

Problem 21

 This problem is the fourth from the right top corner on the *sangaku* of Katayamahiko shrine, color plate 5.

 On a circular field of diameter $2r = 100$ m, we make four lines of length t such that they divide the circle into five equal areas S, one of which is a square of side d (see figure 4.20). Find t and d, using $\pi = 3.16$.

 Answer on tablet: $t = 69.75494$ and $d = 39.7494$.

 The solution is on page 128.

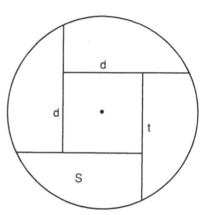

Figure 4.20. Find t and d in terms of the radius of the circle, r.

Problem 22

 The tablet from which this problem was taken was hung in 1847 in the Akahagi Kannon temple in Ichinoseki city. Its size is 188 cm by 61 cm. The problem itself was proposed by Satō Naosue, a thirteen-year-old boy.

 Two circles of radius r and two of radius t are inscribed in a square, as shown in figure 4.21. The square itself is inscribed in a large right triangle and, as illustrated, two circles of radii R and r are inscribed in the small right triangles outside the square. Show that $R = 2t$.

 See page 128 for the solution.

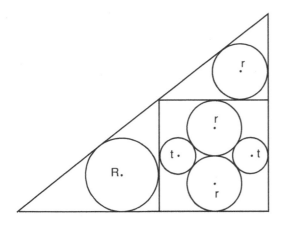

Figure 4.21. Show that $R = 2t$.

Problem 23

This problem is the fourth from the right on the Sugawara tablet, color plate 7.

As shown in figure 4.22, a square of side c is inscribed in an equilateral triangle of side k. Two smaller squares of sides a and b are inscribed between the equilateral triangle and square c. A smaller equilateral triangle of side d is inscribed within square c and a circle of radius r is inscribed within square d. If $a = 7.8179$, find b, c, d, k, and r.

The answer and solution can be found on page 128.

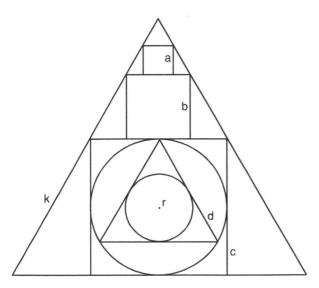

Figure 4.22. Find b, c, d, k, and r in terms of a.

Problem 24

This problem is the fifth from the right on the Sugawara *sangaku*, color plate 7.

In a circle of radius R, a rectangle of width $a + b$ and height t is inscribed (figure 4.23). Inscribed in the rectangle is a rhombus with short diagonal d. The diameter of the circle inscribed in the right triangles is $2r = 30$ and $a = 45$. Find b, d, $2R$, $2\pi R$ (circumference), and e, where $\pi = 3.16$.

The answer and solution can be found on page 129.

Caution: *From approximately this point on the problems become slightly more difficult, involving more trigonometry.*

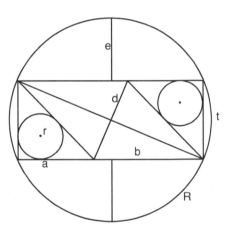

Figure 4.23. Given a and r, find b, d, e, t, and R.

Problem 25

Here we have a rare example of a problem proposed by a woman, Okuda Tsume. It can be seen as the sixth problem from the right on the Meiseirinji *sangaku*, color plate 8.

In a circle of diameter $AB = 2R$, draw two arcs of radius R with centers A and B, respectively, and ten inscribed circles, two of diameter R (light); four "red" (dark) of radius t, and four "blue" (lighter) of radius t' (figure 4.24). Show that $t = t' = R/6$.

A solution is on page 129.

Problem 26

During the later Edo period it became popular to consider problems that could be drawn upon folding fans, that is, upon a sector of an annulus. This example can be found on the top right corner of the Katayamahiko shrine tablet, color plate 5.

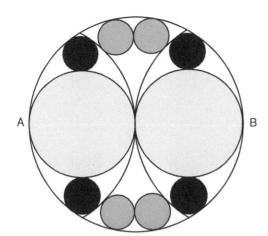

Figure 4.24. If R is the radius of the large circle, show that the radius t of the small "red" (dark) circles and the radius t' of the small "blue" circles (lighter) is $t = t' = R/6$.

As shown in figure 4.25, in a sector of radius R, two circles of radius r are tangent to each other and touch the sector internally. A small circle of radius t touches both the sector and a chord of length d. If $d = 3.62438$ and $2t = 0.34$, find $2r$.

Answer on tablet: $2r = 3.025$.

The solution can be found on page 129.

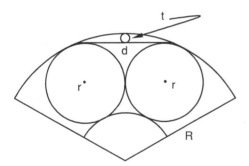

Figure 4.25. Given d, find the radii t and r.

Problem 27

This problem was originally proposed by Takeda Sadatada on a tablet hung at the Atago shrine of Tokyo in 1830. Our knowledge of it comes from the 1832 book *Kokon Sankan*, or *Mathematics, Past and Present*, by Uchida Kyō (1805–1882). In this work, Uchida recorded problems from twenty-three tablets hung between 1820 and 1830. Generally the problems are difficult; this one is not so hard.

Two squares of sides b and d touch each other at a vertex, as shown in figure 4.26. Each of the squares b and d also touches two other squares with sides a and c, as shown. Find d in terms of a, b and c.

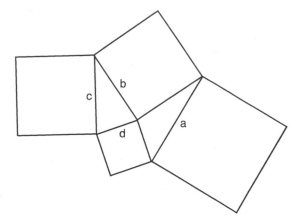

Figure 4.26. Find *d* in terms of *a*, *b*, and *c*.

Answer:

$$d = \sqrt{\frac{a^2 + c^2}{2} - b^2}.$$

Example: If *a* = 13, *b* = 9, *c* = 11, then *d* = 8.

The solution is on page 130.

Problem 28

The tablet on which this problem was found was hung by a twelve-year-old boy, Imahori Yakichi, in 1790 at the Nagaoka Tenman shrine of Kyoto and measures 58 cm by 24 cm.

As shown in figure 4.27, four circles of radius *a* and four circles of radius *b* touch a square of side *k*. Find *k* in terms of *a* and *b*.

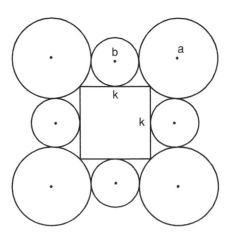

Figure 4.27. Find *k* in terms of *a* and *b*.

径今所文羽内餘衛術答方
寸有揭政州田平日日面
一如于十山恭方甲丁十
問圖長三形門開丙方寸
交球州年宮人之方面問
周穿萩庚町 得面八丁
幾去宮寅 丁冪寸方
何橢市九 方和 面
 圓大月 面半幾
 満 合而何
 宮 問内
 者 減
 一 乙
 事 方
 面
 冪

Plate 4.3. The original illustration for
problem 27, from Uchida Kyō's 1832
book, *Kokon Sankan*, or Mathematics,
Past and Present. (Aichi University of
Education Library.)

Example: If $2a = 5, 2b = 3$, then $k = 4.4465$, which is not written on the tablet.

See page 131 for the solution.

Problem 29

Itō Tsunehiro of the Itō Sōtarō school, proposed this problem in 1849.
The tablet, which measures 245 cm by 47 cm, was hung in Senhoku city's Kumano shrine.

Triangle *ABC* is inscribed in a circle of diameter $2r$ (see figure 4.28). *CH* is perpendicular to *AB*. Find r in terms of *BC*, *AC*, and *CH*.

Example: If $BC = 5$, $AC = 8$, and $CH = 4$, then $2r = 10$.

See page 131 for the answer and a solution.

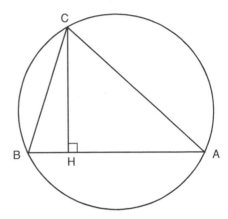

Figure 4.28. Find the radius of the circle r in terms of BC, AC, and CH

Problem 30

This problem can be seen as the third from the right top corner of the Katayamahiko shrine *sangaku*, color plate 5.

A regular hexagon *ABCDEF* inscribes two equilateral triangles *ACE* and *BDF*, which in turn inscribe a circle of radius r. Six smaller circles of radius t are inscribed in, for example, *AFE*, as shown in figure 4.29. Find t in terms of r.

Result on tablet: If $r = 10$ then $t = 4.226$.

The answer and a solution can be found on page 132.

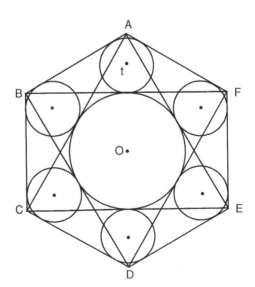

Figure 4.29. Find t in terms of r, the radius of the inner circle.

Problem 31

We present here a problem from the most recently discovered *sangaku*, which was found by Mr. Hori Yoji at the Ubara shrine of Toyama in 2005. It dates from 1879 and measures 76 cm by 26 cm. (See color plate 13.)

As shown in figure 4.30, a ring of eight small circles of radius t, whose centers lie on the vertices of a regular octagon, is circumscribed by a circle of radius R and circumscribes a circle of radius r. Find R and r in terms of t.

The solution is given on page 132.

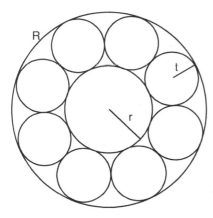

Figure 4.30. Find R and r in terms of t.

Problem 32

The tablet containing this problem was hung in the Kitano shrine of Gumma's Fujioka city in 1891 by the Kishi Mitsutomo school. Its width is 121 cm and height 186 cm.

As shown in figure 4.31, a circle of radius r is surrounded by a loop of five equal circles of radius R. Find r in terms of R.

Example: If $2R = 1.8$, then $2r = 1.26. \ldots$

The solution is given on page 133.

Problem 33

This problem, proposed by Shirakawa Katsunao, can be seen as the fifth one from the right on the Mizuho *sangaku*, color plate 9. *Advice: Do the previous problem first.*

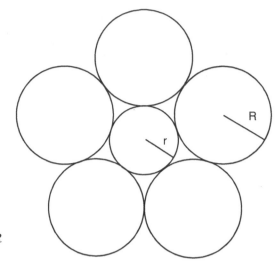

Figure 4.31. Find r in terms of R

As shown in figure 4.32, five circles of radius t touch the large circle of radius R internally. A circle of radius r is inscribed in the pentagram. Show that $t = \sqrt{0.8}r$.

The answer and a solution can be found on page 133.

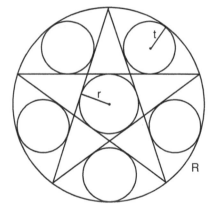

Figure 4.32. Show that $t = \sqrt{0.8}r$.

Problem 34

This is the fifth problem from the left on the Abe no Monjuin *sangaku*, color plate 11. *Advice: Follow the previous advice.*

A big circle inscribes two equilateral triangles, each of side $3a$. As shown in figure 4.33 six small circles of radius r touch the big circle and the two triangles. Find r in terms of a.

Answer: $r = (9 - 5\sqrt{3})a$.

See page 134 for a solution.

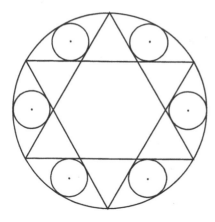

Figure 4.33. Find the radius of the small circles, r, in terms of the sides of the equilateral triangles, a.

Problem 35

This problem can be seen as the one on the top left of the Katayamahiko shrine *sangaku*, color plate 5. *Advice: ditto.*

As shown in figure 4.34, four circles of radius r and four congruent equilateral triangles of side a touch a big circle of radius R internally and also touch a small square of the side a. Find r in terms of R.

Answer:

$$r = \left(\frac{\sqrt{3} - \sqrt{2} + 1}{\sqrt{3} + 2\sqrt{2} + 1} \right) R.$$

Example: If $R = 10$, then $r = 2.37$.

Turn to page 135 for the solution.

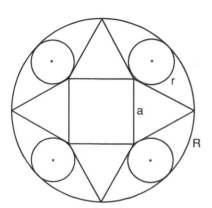

Figure 4.34. Find r in terms of R.

Problem 36

This problem is the one on the bottom left corner of the Katayamahiko shrine *sangaku*, color plate 5.

As shown in figure 4.35, an equilateral triangle with side *a* is inscribed in a square also of side *a*, along with and four circles, including two of radius *t* and one of radius *r*. Find *t* in terms of *r*.

The answer and solution can be found on page 135.

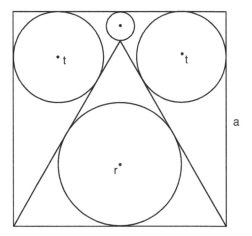

Figure 4.35. Find *t* in terms of *r*.

Problem 37

This problem, dating from 1805, comes from the Suwa shrine *sangaku* and is mentioned in the diary of Yamaguchi Kanzan (chapter 7).

We are given a rectangle *ABCD*, as shown in figure 4.36, with *AB* > *BC*. A circle is inscribed such that it touches three sides of the rectangle, *AB*, *AD*, and *DC*. The diagonal *BD* intersects the circle at two points *P* and *Q*. Find *PQ* in terms of *AB* and *BC*.

See page 136 for the solution and an example.

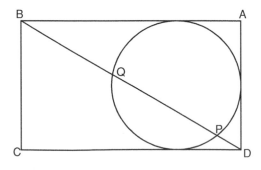

Figure 4.36. Find *PQ* in terms of *AB* and *BC*.

Problem 38

Dating from 1819, this problem comes from Yamaguchi Kanzan's diary (chapter 7).

We stick pins into the position of each vertex of a regular dodecagon (twelve sides), as shown figure 4.37. Then we take a string of length $l = 150$ cm and wrap it around the pins, as shown. This forms a small regular dodecahedron in the center. Find the length of the side s of the small dodecahedron.

The solution is on page 136.

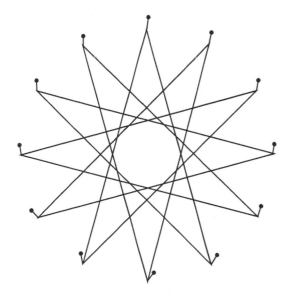

Figure 4.37. Find the side-length of the central dodecahedron in terms of the total length of the string.

Problem 39

This problem is the third one from the bottom left of the Katayamahiko shrine *sangaku*, color plate 5.

A circle of radius $R = 5$ inscribes a regular pentagon of side a. Find a.

Answer: $a = 5.87$.

On page 137 we give a traditional solution from the 1810 book Sanpō Tenshōhō Shinan, *or* Guidebook to Algebra and Geometry, *by Aida Yasuaki (chapter 3).*

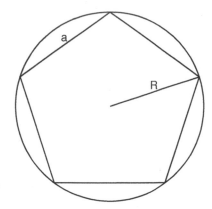

Figure 4.38. Find *a* in terms of *R*.

Problem 40

The tablet containing this problem was hung in Senhoku city's Kumano shrine in 1858 by Nagayoshi Nobuhiro of the Itō Yasusada school. The *sangaku* is 89 cm wide and 38 cm high. For decades the tablet had gone unrecognized as a *sangaku* and was on the verge of being discarded when, in 2005, Fukagawa Hidetoshi visited the shrine, and, recognizing its value, had the tablet restored.

We have *N* balls. First, we stack them with 19 balls on the top and *m* balls on the bottom, as on the left side of figure 4.39. Then we can stack them with 6 balls on top and *n* on the bottom, as on the right side of the figure. Find *N*, *m*, and *n*.

The solution is on page 138.

Figure 4.39. Find *N*, *m*, and *n*.
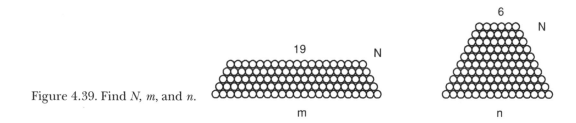

Problem 41

This problem is the second from the right on the Sugawara *sangaku*, color plate 7.

A wine vat in the form of a big triangular pyramid of height *a* whose base is an equilateral triangle of side *a* is full (see figure 4.40). A man takes away wine from the pyramid using a cask of 125 liters and then adds as much water to the vat as the remaining wine.

He now takes away one cask of the watered wine and again adds as much water as the remaining mixture. After the tenth trial the man takes all that remains. Find the volume V_0 of the vat, and a.

Answer: $V_0 = 249.75508592 \ldots$ liters; $a = 12.00549 \ldots$ cm.

The full solution can be found on page 138.

Figure 4.40. A pyramidical wine vat has a base in the form of an equilateral triangle with side a. The volume of the vat is V_0.

Caution: *Calculus begins here.*

Problem 42

We know of this problem through Fujita Kagen's book *Zoku Shinpeki Sanpō*. The problem was originally proposed 1806 by Hotta Sensuke, a student of the Fujita school, and written on a tablet hung in the Gikyōsha shrine of Niikappugun, Hokkaidō.

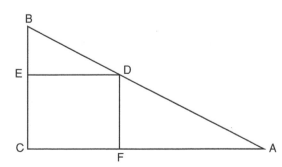

Figure 4.41. Maximize the area of the rectangle.

Take a point D on the hypotenuse AB of the right triangle shown in figure 4.41. Assuming the position of D can be varied along AB, find DE and DF in terms of AC and BC such that the area of rectangle $DECF$ is maximized.

Turn to page 139 for the answer and a traditional solution.

Problem 43

This problem was hung in 1909 by Kojima Yōkichi and found in the Tozōji temple of Kakuda city, Miyagi prefecture. The tablet is 72 cm high and 162 cm wide.

A right triangle ABC with side $AB = x$ and $BC = c$ intersects a square with side AC at the point t. (See figure 4.42). Assuming x is variable, find the value of x in terms of c that maximizes the shaded portion of the triangle.

Example: If $c = 12$, then $x = 4$.

You can find the full solution on page 139.

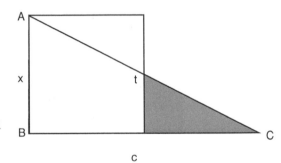

Figure 4.42. Find x in terms of c such that the shaded area is a maximum.

Problem 44

This problem was written on a tablet hung in 1821 at the Ohma Shinmeisya shrine of Yamada gun (village), Gumma prefecture, and later recorded in *Saishi Shinzan*, an unpublished manuscript edited by Nakamura Tokikazu that contains a record of 208 *sangaku* dating from 1731 to 1828.

As shown in figure 4.43 we are given a rhombus $ABCD$ with side a. Its diagonal $BD \equiv 2t$ is considered variable. Let $S(t)$ be the area of the rhombus minus the area of the white square whose diagonal is $BD = 2t$. Find the side x of the square in terms of a when $S(t)$ is a maximum.

A solution can be found on page 139.

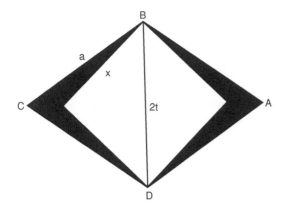

Figure 4.43. Find *x* in terms of *a* when the area of the rhombus minus the area of the square is maximized.

Problem 45

We know of this problem from the 1873 book *Juntendō Sanpu*, or *The Fukuda School of Mathematics*, by Fukuda Riken (1815–1889). In his book, Fukuda records problems from fifteen *sangaku*, most of which are very difficult. This selection, proposed by Fukuda's disciple Murai Sukehisa, was originally written on a tablet hung around 1846 at the Sumiyoshi shrine of Osaka.

As shown in figure 4.44, a square *ABCD* with side *a* sits on a line *l*. An identical square *EFGH* touches *l* at a point *E*, which is considered variable, and also touches square *ABCD* at a point *F* on *CD*. Draw *PH* perpendicular to *l* such that the extensions of *BG* and *PH* meet at *T*. Maximize *PT* in terms of *a*.

Answer: $PT = (\sqrt{10\sqrt{5} - 22} + 1)a.$

We give a solution on page 140.

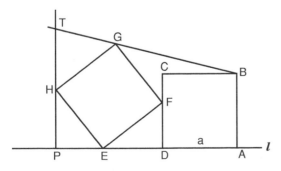

Figure 4.44. Maximize *PT* in terms of *a*.

Problem 46

 Hung by three merchants in the Yukyuzan shrine of Nagaoka in 1801, this problem survives today and is mentioned by Yamaguchi Kanzan in his diary (chapter 7).

 We are given a circle with diameter $2r$ and chord AB, as shown in figure 4.45. The segment MN is the perpendicular bisector of AB. From A and B, draw two lines through the midpoint of MN and inscribe four circles, two of radius s and two of radius t. Find t in terms of r when $AB - MN$ is maximized.

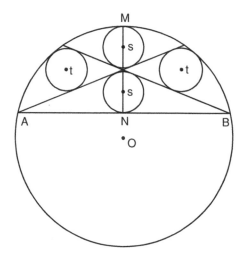

Figure 4.45. Find t in terms of r for $(AB - MN)$ maximized.

Turn to page 141 for a solution.

Problem 47

 The problem presented here was drawn on a tiny panel placed in the eaves of a small temple that was destroyed around 1864. Someone managed to save the panel, setting it in the ceiling of another room of the Shiokawa Kōkaidō building in Nagano's Susaka city.

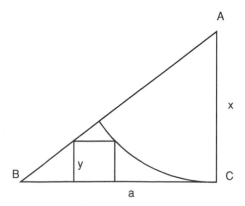

Figure 4.46. Maximize y as a function of x assuming $BC = a$ is constant.

No one realized that the panel was a *sangaku* until 1997, when Mr. Kitahara Isao noticed the beautiful problem on it. The size of the panel is only 41 cm by 38 cm.

In a given right triangle ABC, draw a circle of radius $x = AC$ whose center is the vertex A (see figure 4.46). Consider a square, one of whose sides lies on BC and touches both the circle and AB. If y is the length of the side of the square, and BC is taken to be the constant a, find the maximum value of y as a function of x.

Answer:

$$y_{\max} = \frac{\sqrt{2}-1}{2}\, a.$$

Both the original and a modern solution to the problem are given on page 142.

Solutions to Chapter 4 Problems

Problem 1
Here is the original solution to the problem:

If rabbits were chickens then the total number of feet would be 100, so we know that the extra 22 feet are all from the rabbits, which implies 11 rabbits and 39 chickens.

Algebraically, the solution can be expressed as follows: If x is the number of chickens and y is the number of rabbits, then $122 = 2x + 4y = 2x + 2y + 2y = 2(x+y) + 2y = 100 + 2y$; hence $2y = 22$ and $y = 11$.

Problem 2
Assume that d days after starting out, the cow and the horse meet again at P. Then, because the cow is walking at 8 km per day and completes a whole number of revolutions, we must have $8d = 48m$, where m is an integer. Similarly, for the horse, $12d = 32n$, where n is another integer. Dividing the two equations gives $m/n = 4/9$. But since we are looking for the smallest possible integers, we have simply $m = 4$ and $n = 9$. Thus $d = 24$ days.

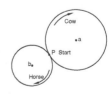

Problem 3
Here is the original solution:

Assume that, n days after they set out, the three horses meet at point P. Then, similarly to the previous problem,

$$\left(8 + \frac{41}{1{,}000}\right) n = \left(56 + \frac{2}{3}\right) a,$$

$$\left(6 + \frac{123}{4{,}000}\right) n = \left(30 + \frac{5}{7}\right) b,$$

$$\left(4 + \frac{41}{2{,}000}\right) n = \left(13 + \frac{3}{4}\right) c,$$

where a, b, and c are the numbers of revolutions each horse makes. Multiplying out these equations gives $1{,}419n = 10{,}000a$, $3{,}927n = 20{,}000b$, and $731n = 2{,}500c$. Consequently, n is the least common multiple of 10,000, 20,000, and 2,500, or $n = 20{,}000$.

[Another way of saying this is that because 3,927 and 20,000 have no common divisors, and similarly for the other coefficients, we have $n = 20{,}000b' = 10{,}000a' = 2{,}500c'$, where $b' = b/3{,}927$, $a' = a/1{,}419$, and $c' = c/731$ must be integers. The smallest possible integral value of n is obtained by setting $b' = 1$, giving $n = 20{,}000$.]

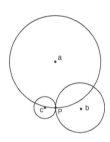

Problem 4
The solution is left to the reader.

Problem 5
Draw the auxiliary lines shown in figure 4.47. Then, if h is the altitude of the triangle, similar triangles shows that $r/(h-r) = a/2b$, and so $2r = 2ah/(a+2b)$. From the Pythagorean theorem, $h = 8$, giving $2r = 6$.

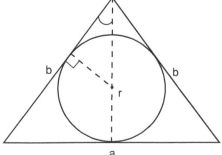

Figure 4.47. Draw the altitude, and drop a perpendicular to a side b. Consider similar triangles.

Problem 6

Call the center of the circle O, as in figure 4.48. Since the big triangle is equilateral, $OA = R/2$. Also, $OB = R$ and so by Pythagoras $R^2 = (R/2 + (\sqrt{3}/2)q)^2 + (q/2)^2$. Solving for q quickly yields, $q = ((\sqrt{15} - \sqrt{3})/4)R = 26.7$ which was written on the tablet.

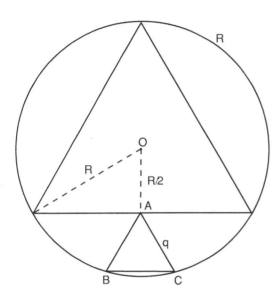

Figure 4.48. Draw the radius of the circle.

Problem 7

A single application of the Pythagorean theorem yields a quadratic equation with one solution consistent with the figure: $t = 2r/5$.

Figure 4.49. Consider Pythagoras.

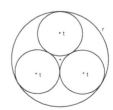

Problem 8

By inspection of figure 4.7, the distance between the center of circle r and one of the smaller circles t is $r - t$. Since the centers of the circles t lie on an equilateral triangle, we then have $\cos 30° = t/(r - t)$, which gives $t = \sqrt{3}r/(2 + \sqrt{3}) = (2\sqrt{3} - 3)r = 0.464r$.

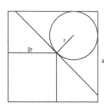

Problem 9

Draw in a diagonal from the southwest to the northeast corner of the large square a in figure 4.8. Then we see that $\sqrt{2}a = 2\sqrt{2}r + r + \sqrt{2}r$, or, solving for r,

$$r = \frac{\sqrt{2}a}{3\sqrt{2}+1}.$$

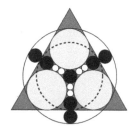

Problem 10

By inspection of figure 4.9 one easily sees that $r = 3b + 4c$, $R = b + 2a$, $R = 5b + 4c$, and $a + b = 2b + 4c$. Solving these equations simultaneously yields $b = 2c$, $a = 6c$, and $r = 10c$.

Problem 11

We notice that $S = 6 \times 165^2$ and $c = 5 \times 165$. Thus, we have a right triangle with sides 3, 4, and 5 (in units of 165). Hence $a = 495$ and $b = 660$. By similar triangles, we have $b:a = (b - t):t$, which gives $t = ab/(a + b) = 282.85$. By inspection of figure 4.10 $n = t/\sqrt{2} = 200.01$, and because d is an altitude, $d = 2S/c = 396$.

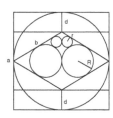

Problem 12

Since the side of the rhombus is equal to the distance between the two horizontal lines, each half of the rhombus consists of an equilateral triangle. Then $b = 2\sqrt{3}R$ and with the Pythagorean theorem, $R = 3r$. Hence $2R = 6r = 106.5$ and $b = 184.4$. The Pythagorean theorem also gives directly $a = \sqrt{3}b = 6R = 18r = 319.5$ and thus $a\pi = 1009.6$. Also, $d = (a - b)/2 = 67.5$.

Problem 13

The angles of the square and equilateral triangle in figure 4.12 force triangle ABC to be a 30-60-90 triangle with $\angle A = 30°$ and $\angle B = 60°$. Hence, $AB = 2a$. Examining the other interior angles shows $AB = 2a = \sqrt{3}t + s + s/\sqrt{3}$. Also we see that $BC = a = 2s/\sqrt{3} + s$. Eliminating s quickly yields $t = (\sqrt{3} - 1)a$.

Problem 14

Draw the auxiliary lines shown in figure 4.50 to get an equilateral triangle. Thus r_{red} is the radius of the inscribed circle. By inspection $r_{red} = r_{white} + r_{blue}$ and by the Pythagorean theorem $r_{red} = 3r_{blue}$ (see problem 12). Therefore $r_{white} = 2r_{blue}$ and $r_{blue} = r_{white}/2$.

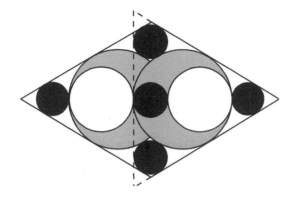

Figure 4.50. Construct an equilateral triangle.

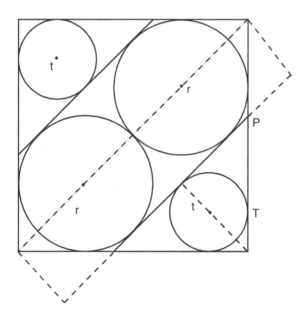

Figure 4.51. Draw the dashed lines and contemplate the length of the tangents.

Problem 15

From figure 4.51 we see that, on the one hand, the length of the central diagonal is $2r + 2\sqrt{2}r$. On the other hand, it is also equal to $2PT + 2r$. However, $PT = t(1 + \sqrt{2})$. Equating the two expressions gives

$$t = \frac{\sqrt{2}}{\sqrt{2}+1}r = (2 - \sqrt{2})r = 0.585786r.$$

Problem 16

We are given that $2r$ equals one side of the rectangle. Let $2t$ equal the other side of rectangle. Then, as shown in figure 4.52 draw a line

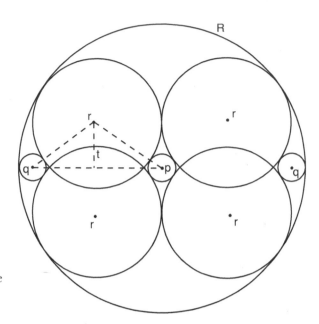

Figure 4.52. Draw the auxiliary lines and invoke
Pythagoras.

from the center of one of the circles r to the center of circle p. The
Pythagorean theorem then gives $(r+p)^2 = t^2 + r^2$. Similarly,
$(r+q)^2 = t^2 + (R-r-q)^2$.

However, $R = 2r + p$, and so subtracting the first expression from
the second gives $(r+q)^2 - (r+p)^2 = (r+p-q)^2 - r^2$. After expand-
ing and canceling, one is left with $p^2 + 2rp - 2rq - pq = 0$, or
$(p-q)(2r+p) = 0$. Thus $p = q$, a relationship that holds
even if $t > r$.

Problem 17

Draw the auxiliary lines shown in figure 4.53. Then, by Pythagoras,
$(a+b)^2 = (a-3b)^2 + (t+2b)^2$, or

$$8ab - 8b^2 = (t+2b)^2. \tag{1}$$

From figure 4.53 one can also see that $a^2 = (a-2b)^2 + t^2$, or

$$4ab - 4b^2 = t^2 \tag{2}$$

Solving equation (1) and (2) together gives $2t^2 = (t+2b)^2$ or $t = 2b/(\sqrt{2}-1)$

Reinserting this expression for t into equation (2) gives

$$4ab - 4b^2 = \left(\frac{2}{\sqrt{2}-1}\right)^2 b^2$$

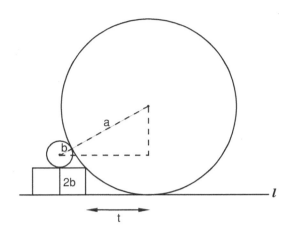

Figure 4.53. Each block has side *2b* and *t* is the distance between the point of contact of circle *a* and the nearest block.

and

$$a = \frac{b}{(\sqrt{2}-1)^2} + b.$$

Rationalizing the denominator yields the final result

$$a = 2(2+\sqrt{2})b.$$

Problem 18

Draw an auxiliary line connecting O and O' on figure 4.17 and drop a perpendicular from O' to one of the tangents. This forms a 30-60-90 triangle, and we see that the angle between the two tangents is 60°. Similar triangles immediately gives $c = 3b$, as well as $b = 3a$. By inspection $2R = 3c$, and hence

$$R = \frac{3}{2}c = \frac{27}{2}a.$$

Problem 19

The solution is left to the reader.

Problem 20

Because $AC = 30$ m and $BC = 40$ m in figure 4.19, we recognize $\triangle ABC$ as a 3-4-5 triangle. Letting $BE = t$, $CH = x$, and $JC = y$, one easily sees by applying similar triangles to figure 4.19 that $DE = (3/4)t$, $x = 38 - t$, $AI = 28 - y$, and $FG = (3/4)t + (3/4) \times 2 - (y + 2)$.

Since the areas of triangle BDE, the rectangle, and the trapezoid must all be equal, we have

$$S = \frac{1}{2}t \times \frac{3}{4}t = xy = \frac{x}{2}(FG + AI) = \frac{x}{2}\left(\frac{3t}{4} - 2y + \frac{55}{2}\right),$$

128

Chapter 4

$$16y = 3t + 110$$

and

$$\frac{3}{8}t^2 = (38 - t)\left(\frac{3t + 110}{16}\right).$$

The second is a quadratic for t. Solving it yields $t = 21.7743$. This in turn implies $DE = 16.331$, $CH = 16.2257$, $JC = 10.9576$, $AI = 17.0424$, and $FG = 4.873125$, as stated.

Problem 21

In figure 4.20 each area $S = \pi r^2/5 = d^2$, so that $d = \sqrt{\pi/5}\,r = 39.749$.

Further, draw one line from the center of the circle perpendicular to one of the segments t and another from the center of the circle to the point at which t intersects the circle. The Pythagorean theorem then gives $r^2 = (d/2)^2 + (t - d/2)^2$. Solving this quadratic for t yields

$$t = \sqrt{r^2 - \frac{d^2}{4}} + \frac{d}{2} = 65.7548,$$

which is slightly different from the result found on the tablet. We have not been able to discover the reason for the traditional geometer's mistake.

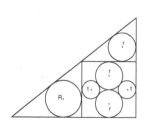

Problem 22

The side of the square in figure 4.21 has length $4r$. Use the Pythagorean theorem once on the circles inside the square to show that $r = (3/2)t$. Use the Pythagorean theorem again to show that the small upper triangle is a 3-4-5 triangle with height $3r$. The upper triangle and the lower triangle containing the circle R are similar, so $4r = 3R$. Thus $R = (4r/3) = 2t$.

Problem 23

Draw in the altitude of the largest triangle in figure 4.22. Considering the equilateral triangle that sits on top of square c and contains squares a and b, one easily gets by similar triangles that $\sqrt{3} = a/[(b - a)/2]$, or $b = (2/\sqrt{3} + 1)a$. In the same way, $c = (2/\sqrt{3} + 1)b$ and $k = (2/\sqrt{3} + 1)c$.

The fact that the inner triangle is equilateral tells us that $d = 2\sqrt{3}r$ and the Pythagorean theorem used on this triangle gives in turn $r = c/4$.

With the provided value of $a = 7.8179$, we then have $b = 16.8452 \ldots$, $c = 36.2964 \ldots$, $k = 78.20 \ldots$, $d = 31.4336 \ldots$, and $r = 9.074 \ldots$.

Problem 24

All sides of a rhombus are equal, so figure 4.23 shows that $b^2 = a^2 + t^2$. Furthermore, considering the length of the tangent from, say, the top left corner of the rectangle to the circle r shows that $b = (a - r) + (t - r) = a + t - 2r$. Eliminating b gives $t = (2ar - 2r^2)/(a - 2r)$. We are given that the width of the rectangle is $a + b$. By the Pythagorean theorem, we then get $4R^2 = t^2 + (a + b)^2$. Because the diagonals of a rhombus intersect each other at $90°$, the Pythagorean theorem also gives $d^2 = 4(b^2 - R^2)$.

We are told $a = 45$ and $2r = 30$. Inserting these values into the previous expressions yields $t = 60$, $b = 75$, $2R = 134.1640 \ldots$, $d = 67.082$, and $2R\pi = 423.9584$. Figure 4.23 also shows that $e = (R - t)/2 = 37.08$.

Problem 25

In figure 4.24 the lightest circles have radius $r = R/2$. Form a right triangle by drawing a line from point A to the center of the nearest circle t, and from the center of r to the center of t. Then, by the Pythagorean theorem, $(R - t)^2 = (t + r)^2 + r^2$, or

$$R^2 - 2Rt + t^2 = t^2 + Rt + \frac{R^2}{2},$$

and $t = R/6$.

To find t', draw a line from point A to the center of the nearest circle t' and from the center of the large circle R to the center of t'. Then the law of cosines gives $(t' + R)^2 = (R - t')^2 + R^2 - 2Rt'$, which also yields $t' = R/6$.

Problem 26

Draw the auxiliary lines shown in figure 4.54. Applying the Pythagorean theorem on the left gives

$$R^2 = \left(\frac{d}{2}\right)^2 + (R - 2t)^2,$$

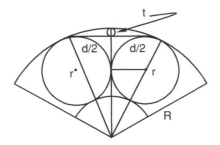

Figure 4.54. Draw the asymmetric auxiliary lines shown.

which implies

$$R = \frac{d^2}{16t} + t.$$

Applying the Pythagorean theorem on the right shows that $(R-r)^2 = r^2 + (R-2t-r)^2$, yielding

$$R = r + t + \frac{r^2}{4t}.$$

Equating the two expressions for R and solving the resulting quadratic for r gives

$$r = \sqrt{4t^2 + \frac{d^2}{4}} - 2t.$$

If $d = 3.62438$ and $2t = 0.34$, then $r = 1.5038$ or $2r = 3.0076$, which is a slightly different result from the one on the tablet. Once again, we cannot determine exactly why the wrong answer is written on the *sangaku*.

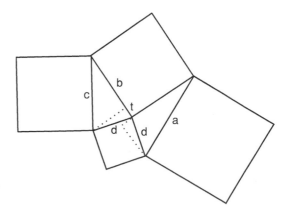

Figure 4.55. Draw the auxiliary lines shown.

Problem 27

We present the original solution:

Referring to figure 4.55, we have by the law of cosines

$$b^2 + d^2 - c^2 = 2bt \quad \text{and} \quad b^2 + d^2 - a^2 = -(2bt).$$

Together they imply $b^2 + d^2 - c^2 + b^2 + d^2 - a^2 = 0$, or

$$d = \sqrt{\frac{a^2 + c^2}{2} - b^2}.$$

This result was written on the tablet.

Problem 28

Draw in the auxiliary dashed lines as in figure 4.56. We must have $\theta = 45°$ and Cosine $\theta = 1/\sqrt{2}$. Then, by the law of cosines,

$$(a + b)^2 = \left(a + \frac{k}{\sqrt{2}}\right)^2 + \left(b + \frac{k}{2}\right)^2 - 2\left(a + \frac{k}{\sqrt{2}}\right)\left(b + \frac{k}{2}\right)\frac{1}{\sqrt{2}}.$$

Multiplying everything out gives the quadratic equation $k^2 + 2\sqrt{2}ak - 4(2 + \sqrt{2})ab = 0$, which has the solution $k = \sqrt{4(\sqrt{2}a + 2a)b + 2a^2} - \sqrt{2}a$.

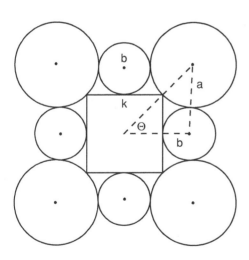

Figure 4.56. Find k in terms of a and b. Notice that the dashed lines do not form a right triangle, but $\theta = 45°$.

Problem 29

Draw the triangle *ACE* as shown in figure 4.57. It must be a right triangle. (Why?) The two marked angles are also equal. (Why?) Therefore the two right triangles *ACE* and *CBH* are similar, and so $2r/BC = CA/CH$ or $r = BC \cdot CA/2CH$.

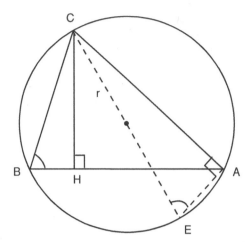

Figure 4.57. Draw in the right triangle *ACE*. The two indicated non-right angles are equal and therefore *ACE* is similar to *CBH*.

Problem 30

Since triangle *ACE* in figure 4.29 is equilateral, $AO = 2r$, where r is the radius of the inner circle. But because *ABCDE* is a regular hexagon, we also easily find $AO = 2t/\sqrt{3} + t + r$, giving

$$t = (2\sqrt{3} - 3)r.$$

If $r = 10$, then $t = 4.641$.

As it turns out, the results on the tablet, $r = 10$, $t = 4.266$, are wrong, which yet again shows that even traditional Japanese geometers made mistakes.

Problem 31

The tablet gives the result

$$R = \left(\frac{1}{k} + 1\right)t, \quad r = \left(\frac{1}{k} - 1\right)t, \quad \frac{1}{k} = \sqrt{4 + \sqrt{8}},$$

which can be easily derived as follows:

From figure 4.30, the angle between the centers of any two of the small circles is $360°/8$, and the angle between the center of a circle and the point at which it touches its neighbor is $180°/8$. Drawing a line from the center of the large circle to the point where two small circles touch shows that

$$\sin(180°/8) = \frac{t}{R - t} = \frac{t}{r + t}.$$

Let $k \equiv \sin(180°/8) = \sin(45°/2) = \sqrt{2 - \sqrt{2}}/2 = 1/\sqrt{4 + 2\sqrt{2}}$. Solving the above equation for R and r gives the result on the tablet.

Problem 32

This problem is similar to the previous one. From figure 4.31, the angle between the centers of the outer circles is $72°$, and so the angle between the center of a circle and the point at which it touches its neighbor is $36°$. Drawing a line from the center of circle r to this point shows that

$$\sin 36° = \frac{R}{R + r} \quad \text{or} \quad r = \frac{1}{\sin 36° - 1}R.$$

Now, $\sin 36° = \sqrt{10 - 2\sqrt{5}}/4$. Rationalizing the numerator gives $1/\sin 36° = \sqrt{10 + 2\sqrt{5}}/5 = \sqrt{2 + \sqrt{4/5}}$, which implies $r = (\sqrt{2 + \sqrt{0.8}} - 1)R$.

The most difficult part of the problem is finding the expression for $\sin 36°$. Although one can look this up in standard tables of trigonometric formulas, exact values for such "odd" angles no longer seem to be derived in high school geometry texts. One way of doing it relies on the following trick: Use the double-angle formulas for sine and cosine to write

$$\sin 72° = 2 \sin 36° \cos 36°$$
$$= 2[2\sin 18° \cos 18°][\cos^2 18° - \sin^2 18°],$$
$$\cos 18° = 4[\sin 18° \cos 18°][1 - 2\sin^2 18°],$$

where we have noticed that $\sin 72° = \cos 18°$, which conveniently cancels from both sides of the equation. Letting $\sin 18° = x$ gives a cubic equation for x: $8x^3 - 4x + 1 = 0$. This equation easily factors, yielding three solutions. Convince yourself that the only possible one is $\sin 18° = (\sqrt{5} - 1)/4$.

Now use the half-angle formula $\sin^2 18 = \frac{1}{2}(1 - \cos 36°) = \frac{1}{2}(1 - \sqrt{1 - \sin^2 36°})$. Solving this equation for $\sin 36°$ gives the above result.

Problem 33

From figure 4.58, $r = R \cos 72° = R \sin 18°$, and $R = t + (1/\sin 54°)\,(t + r)$. In the previous problem, we showed that $\sin 18° = (\sqrt{5} - 1)/4$, from which it quickly follows that $\sin 54° = (\sqrt{5} + 1)/4$. Eliminating R gives $t = 2r/\sqrt{5} = \sqrt{0.8}r$.

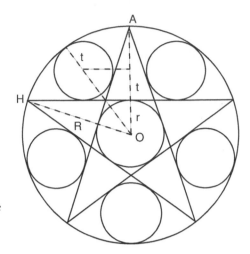

Figure 4.58. R is the radius of the large circle. The angle $AOH = 72°$.

Problem 34

This problem is similar to the previous three and can be solved by drawing similar auxiliary lines on figure 4.33, one from the center of the large circle to the tip of one of the triangles, and a second from the center of the large circle through the center of one of the small circles of radius r. If a is the side of a small triangle and R is the radius of the large circle, then $R = \sqrt{3}a$. With the auxiliary lines it is also easily shown that $R = r + (2/\sqrt{3})r + a$. Eliminating R gives

$$r = \frac{3 - \sqrt{3}}{2 + \sqrt{3}}a = (9 - 5\sqrt{3})a,$$

as stated.

Problem 35

In a manner similar to the solutions of previous problems, draw one line from the center of figure 4.34 to the tip of one of the triangles, and draw an adjacent line from the center of the figure, through the corner of the square, and to the large circle. This gives a drawing like figure 4.59. Then we have both

$$R = \frac{\sqrt{3}}{2}a + \frac{a}{2} \tag{1}$$

and

$$R = \frac{\sqrt{2}}{2}a + x + r.$$

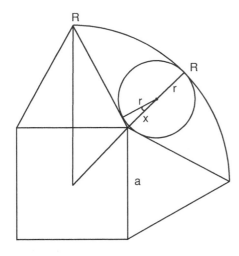

Figure 4.59. Notice that the indicated angle is 15° and that $\cos 15° = r/x$.

Notice from figure 4.59 that $r = x\cos 15°$, so

$$R = \frac{\sqrt{2}}{2}a + \left(1 + \frac{1}{\cos 15°}\right)r. \tag{2}$$

The value of $\cos 15°$ can be easily derived from the double-angle formula $\cos 30° = 2\cos^2 15° - 1$, which gives $\cos^2 15° = (\sqrt{3} + 2)/4$. This is turn can be recognized as the perfect square of $\cos 15° = (\sqrt{6} + \sqrt{2})/4$.

Inserting this value into Eq. (2) and eliminating a by Eq. (1) gives the result

$$r = \frac{\sqrt{3} - \sqrt{2} + 1}{\sqrt{3} + 2\sqrt{2} + 1}R.$$

If $R = 10$, then $r = 2.37$ which is slightly different from the answer written on the tablet $r = 2.32$.

Problem 36

Since the triangle is equilateral, figure 4.35 shows that $\tan 30° = 2r/a = 1/\sqrt{3}$. Drawing a line from, say, the center of the right circle t to the lower right-hand corner shows also that $\tan 15° = t/(a - t)$. A good half-angle formula for tangent in this case is $\tan(\theta/2) = (1 - \cos\theta)/\sin\theta$, giving $\tan 15° = 2 - \sqrt{3}$. Eliminating a from the two expressions yields

$$t = (\sqrt{3} - 1)r.$$

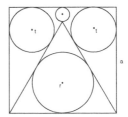

Problem 37

Draw the auxiliary lines shown in figure 4.60. Let $AB \equiv a$, $BC \equiv b$, $BD \equiv c$, and $\angle BDC \equiv \theta$. Since $l = \sqrt{2}(b/2)$, we have with the trig identity $\sin(\alpha - \beta) = \sin\alpha\cos\beta - \cos\alpha\sin\beta$,

$$OH = \frac{\sqrt{2}}{2} b \sin(45° - \theta) = \frac{\sqrt{2}}{2} b [\sin(45°)\cos(\theta) - \cos(45°)\sin(\theta)]$$
$$= \frac{b}{2}(a/c - b/c).$$

The radius of the circle OP is just $b/2$, so by the Pythagorean theorem

$$PQ = 2\sqrt{b^2/4 - (OH)^2} = \sqrt{b^2 - b^2(a/c - b/c)^2} = (b/c)\sqrt{2ab}.$$

Apart from the general case, an example was written on the tablet: If $a = 185$, and $b = 80$, then $PQ = 68 + 625/179$.

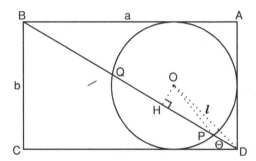

Figure 4.60. Draw in radius OP and $\ell = \sqrt{2}(b/2)$.

Problem 38

On the tablet, the result $s = 0.897459621556135$ was written. The proposer, a Mr. Kitani, wrote, "This value is correct to fifteen digits." Since Kitani did not write a solution, we give one here:

Draw figure 4.61. The angle α is one-half the inscribed angle between nearest nonadjacent pins and thus $\alpha = (1/2) \times (1/2) \times 60° = 15°$. The angle β is one-half the central angle between two adjacent pins and thus $\beta = 15°$. We also have $\tan\beta = s/(2a)$ and $\tan\alpha = a/(l/24)$, since half the length of the string between two pins is $l/24$. Eliminating a gives

$$s = \frac{l\tan^2 15°}{12}.$$

Plugging in $l = 150$ on a PC gives $s = 0.897459621556135323627$, which shows that Kitani's boast was correct—and he did it by hand with a *soroban*!

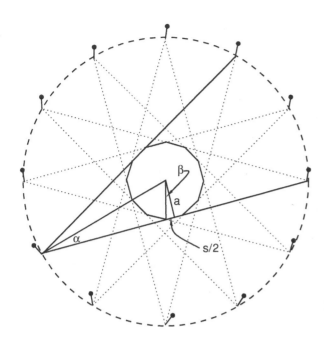

Figure 4.61. Notice that $\alpha = \beta = 15°$.

Problem 39

Aida Yasuaki's solution begins by noting that in figure 4.62, $\triangle ABC$ is similar to $\triangle BCF$. Thus, $a/(a + t) = t/a$, or $t^2 + at - a^2 = 0$. Solving for t gives

$$t = \frac{\sqrt{5} - 1}{2} a.$$

But $a + t = AC = BD$, and so $BD = (\sqrt{5} + 1)a/2$.

Then, by Pythagoras,

$$BH = \sqrt{(BD)^2 - \frac{a^2}{4}} = \frac{\sqrt{5 + 2\sqrt{5}}}{2} a.$$

We also have

$$R^2 = (BH - R)^2 + \left(\frac{a}{2}\right)^2,$$

which with the previous expression yields

$$R = \frac{3 + \sqrt{5}}{2\sqrt{5 + 2\sqrt{5}}} a = \sqrt{\frac{5 + \sqrt{5}}{10}} a.$$

In this case, a modern solution is faster: From the diagram $a/2R = \sin(\pi/5) = \sin 36° = \left(\sqrt{10 - 2\sqrt{5}}\right)/4,$ from which it follows that $a = 5.877$. However, this solution assumes that, if you are stranded

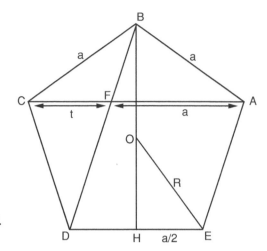

Figure 4.62. Notice that angle *DBH* is 18°.

on a desert island without a calculator, you know the expression for
sin 36°. We derived this formula in the solution to problem 32.

Problem 40

Using the summation formula from chapter 2, problem 4-7, we have

$$N = \sum_{k=19}^{m} k = \sum_{k=1}^{m} k - \sum_{k=1}^{18} k$$

$$= \sum_{k=6}^{n} k = \sum_{k=1}^{n} k - \sum_{k=1}^{5} k,$$

or

$$N = \frac{1}{2}(m^2 + m - 18 \cdot 19) = \frac{1}{2}(n^2 + n - 5 \cdot 6).$$

Rearranging the terms and factoring gives $(m - n)(m + n + 1) = 8 \cdot 39$.
Setting $m - n = 8$ and $m + n + 1 = 39$ yields $m = 23$, $n = 15$, and $N = 105$.

(Notice that $8 \cdot 39$ can also be factored into, for example, $6 \cdot 52$ or
$24 \cdot 13$, but these do not give a solution in positive integers. The
factorization $1 \cdot 312$ gives another solution, $m - n = 1$ and $m + n +$
$1 = 312$, which yields $m = 156$, $n = 155$, and $N = 12{,}075$. This solution is
not written on the tablet. Convince yourself that $8 \cdot 39$ and $1 \cdot 312$ are
the only correct possibilities.)

Problem 41

After one trial, the remaining volume of watered wine is
$V = 2[V_0 - 125]$. After two trials the remaining volume is

$V = 2[2[V_0 - 125] - 125] = 2^2 V_0 - (2 + 2^2) \times 125$. After the tenth trial, we have $V = 2^{10} V_0 - (2 + 2^2 + 2^3 + \cdots + 2^{10}) \times 125 = 0$. The summation of powers of two in the parentheses is a geometric series $= 2(1 - 2^{10})$ (see chapter 2, problem 4-8). Thus

$$V_0 = \frac{1}{2^{10}} \times 2(2^{10} - 1) \times 125 = 249.7558594.$$

Also, the volume of the pyramid is $V_0 = (1/3)(\sqrt{3}/4)a^3$, which gives $a^3 = 1{,}730.359552$, or $a = 12.00549$ cm.

Problem 42

Here is a traditional solution from the manuscript *Solutions to Problems of Zoku Shinpeki Sanpō* by Kitagawa Mōko (1763–1833). In this case the traditional solution is pretty much what any calculus student would do (but see chapter 9).

In figure 4.41 let $ED = x$, $DF = y$, $BC = a$, and $AC = b$. By similar triangles $a/b = y/(b - x)$. Thus if S is the area of the rectangle, $S = xy = (abx - ax^2)/b$. Setting the derivative $dS/dx = 0$ gives $x = b/2$ and $y = a/2$.

Problem 43

Referring to figure 4.42, similar triangles gives $x/c = t/(c - x)$, or $t = x(c - x)/c$. For $0 < x < c$, the shaded region S has area

$$S(x) = \frac{1}{2}t(c - x) = \frac{x(c - x)^2}{2c} = \frac{c^2 x - 2cx^2 + x^3}{2c}.$$

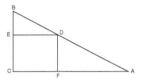

Taking the derivative of $S(x)$ gives $S'(x) = (c^2 - 4cx + 3x^2)/2c = (3x - c)(x - c)/2c$, which maximizes S when the numerator vanishes. Hence, $S = S_{max}$ when $x = c/3$.

Problem 44

The area of a rhombus is one-half the product of its diagonals, in this case, $S_r = 2t\sqrt{a^2 - t^2}$. The side of the square $x = \sqrt{2}t$, and so the desired area is $S_r - S_s = S(t) = 2t\sqrt{a^2 - t^2} - 2t^2$.

Taking the derivative yields

$$\frac{S'(t)}{2} = \sqrt{a^2 - t^2} - \frac{t^2}{\sqrt{a^2 - t^2}} - 2t.$$

Setting this to zero gives $a^2 - 2t^2 = 2t\sqrt{a^2 - t^2}$, which upon squaring results in a quadratic equation for t^2 in terms of a^2. After a little algebra, the solution is $t^2 = [(4 - \sqrt{8})/8]a^2$, or in terms of x,

$$x = \sqrt{1 - \frac{1}{\sqrt{2}}}\, a,$$

which was written on the tablet.

Problem 45

We have not found a traditional solution, so here is a modern one:

Consider figure 4.63. We are to maximize PT given that point E can be moved. Shifting E is equivalent to changing the angle θ; we therefore take θ as the variable and write the slope of BT in terms of it. Focusing on the dashed lines, it is not difficult to show that the slope m of BT is

$$m = \frac{a\sin\theta + a\cos\theta - a}{a + a\sin\theta} = \frac{TP - a}{AP}.$$

But $AP = a + a\cos\theta + a\sin\theta$ and with the help of a double-angle formula we can show that therefore

$$TP = \frac{a\sin 2\theta}{1 + \sin\theta} + a.$$

The derivative of TP with respect to θ is

$$TP' = \frac{2a\cos(2\theta)(1 + \sin\theta) - a\sin(2\theta)\cos\theta}{(1 + \sin\theta)^2}.$$

Since we want $TP' = 0$, we require the numerator to vanish. With the help of a few double-angle formulas we get (see problem 32 this chapter) $\sin\theta = (\sqrt{5} - 1)/2$ and $\cos\theta = (\sqrt{2\sqrt{5} - 2})/2$.

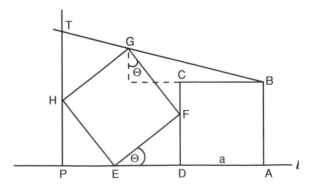

Figure 4.63. Consider θ variable. The dashed lines give the slope of BT.

Plugging back into the expression for *TP* gives

$$TP_{max} = \left[\frac{(\sqrt{5}-1)\sqrt{2\sqrt{5}-2}}{\sqrt{5}+1} + 1 \right] a.$$

After rationalizing the denominator and a little more algebra this expression reduces to

$$TP_{max} = \left[\sqrt{10\sqrt{5}-22} + 1 \right] a \cong 1.6,$$

which is the value written on the tablet.

Problem 46

Referring to figure 4.64, let $ON = x$. Then we wish to maximize $AB - MN = 2\sqrt{r^2 - x^2} - (r - x)$. Taking the derivative with respect to x and setting it to zero gives $x = r/\sqrt{5}$, or $MN = (1 - 1/\sqrt{5})r$.

If *P* is the midpoint of *MN* and we let $NP = y$, then from the figure we also have

$$l^2 + (y + x)^2 = (r - t)^2,$$
$$L^2 = r^2 - x^2. \tag{1}$$

But $x = r - 2y$ and so the above expressions become

$$l^2 - 2ry + y^2 = -2rt + t^2.$$
$$L^2 = 4y(r - y). \tag{2}$$

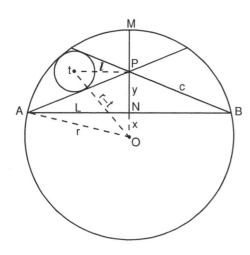

Figure 4.64. Note that the angled chords intersect at *P*, the midpoint of *MN*.

Similar triangles shows that $l^2 = c^2t^2/y^2$, where $c^2 = y^2 + L^2$ from the Pythagorean theorem. Plugging all this into Eq. (1) with L given by Eq. (2) leads to

$$y^3 - 4yt^2 + 4rt^2 - 2ry^2 + 2rty = 0.$$

This equation can in turn be factored into

$$(y - 2t)[y(y + 2t) - 2r(y + t)] = 0.$$

The only positive solution is $y = 2t$, a result that is independent of r. Thus, at the desired maximum, $MN = 2y = 4t = (1 - 1/\sqrt{5})r$, or

$$t = \frac{\sqrt{5} - 1}{4\sqrt{5}} r = \frac{r}{5 + \sqrt{5}}.$$

Problem 47

We give two solutions to this problem. The first is a solution following the original method with somewhat expanded explanation:

Referring to figure 4.65, we see that, by similar triangles, $x/a = y/b$. But $b = a - y - c$. Furthermore, by the Pythagorean theorem, $c = \sqrt{2xy - y^2}$, which gives

$$\sqrt{2xy - y^2} = a - \frac{(x + a)}{x} y.$$

Squaring both sides yields a quadratic equation for y in terms of x and a, which after some algebra yields two solutions, the relevant one being the smaller one:

$$y = \frac{a^2 x}{2x^2 + 2ax + a^2}.$$

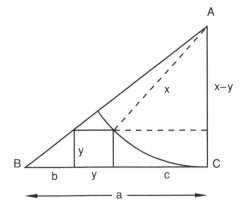

Figure 4.65. The dashed lines make it clear that $c^2 + (x - y)^2 = x^2$.

The derivative of y with respect to x is

$$y' = \frac{-a^2(2x^2 - a^2)}{(2x^2 + 2ax + a^2)^2},$$

which vanishes when $x = a/\sqrt{2}$, giving a maximum for y of $y_{\max} = [(\sqrt{2} - 1)/2]a$.

The following is a modern solution to the same problem by J. F. Rigby, Cardiff University Wales:

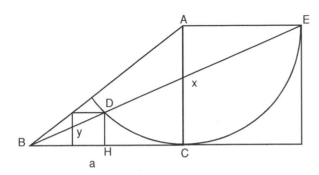

Figure 4.66. Extend the circular arc to point E. This shows that angle $CDE = 45°$ and that angle $BDC = 135°$.

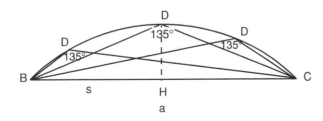

Figure 4.67. All the angles BDC intercept the same arc and so are equal, but the height y of the triangle is maximized when point H falls on the midpoint of a. One can show this analytically by, for example, using the law of cosines to write an expression for y in terms of a and the distance of H along the x-axis; call it s. Setting $dy/ds = 0$ shows that y reaches a maximum when $s = a/2$.

Extend the circular arc in the original figure 4.46 to point E, creating a large square with side $AE = x$, as in figure 4.66. Also draw the line BD and extend it to point E. (Convince yourself that the extension of BD intersects the square at E.) Notice that the inscribed angle CDE (not drawn) subtends the arc CE, which is $90°$, and so $\angle CDE = 45°$. Consequently, $\angle BDC = 135°$. Figure 4.67 then shows that y attains its maximum when H is the midpoint of the side BC. From figure 4.66, we then have $x/(a + x) = \tan(45/2) = \sqrt{2} - 1$, from which it follows that $x = a/\sqrt{2}$ and $y_{\max} = (\sqrt{2} - 1)a/2$, as above.

Plate 5.1. Saitō Kuninori, a disciple of the famous mathematician Ono Eijyu (1763–1831), hung this tablet in 1828 at the Kitamuki Kannon temple of Ueda city, Nagano prefecture. The *sangaku* is 115 cm wide and 85 cm high and on it is the inscription that we have used as an epigraph for chapter 4. The problem depicted is given in this chapter as problem 23. Also shown (b) is the solution as it appeared in the 1844 book *Sanpō Kyūseki Tsu-ko* of Uchida Kyumei.

FIVE

Harder Temple Geometry Problems

Mathematics is profound. People have their methods for solving problems. This is true in the West as well as in China and Japan. Those who do not study hard cannot solve any problems. I have not mastered mathematics yet, even though I have been studying from youth. And so I have not become a teacher for anyone, but some people have asked me to teach mathematics to them. I showed them the solutions to the problems and will hang a sangaku at the Katayamahiko shrine nearby, on which sixteen problems are written. I dedicate this tablet to the shrine in the hope that my students may get more scholarship in mathematics.

—Preface to the *sangaku* hung in the Katayamahiko shrine in 1873 by Irie Shinjyun, aged seventy-eight

In this chapter we present two dozen more problems from the same sources as those in chapter 4: tablets, books, and manuscripts. Again we begin with a diophantine problem and then progress from the easier geometric puzzles to the frustrating. These problems are generally at a higher level than the previous ones, the main distinction being that the required

algebra is often more involved and that they sometimes require an uncomfortable degree of "lateral thinking." Many of them, nevertheless, can be solved by little more than the Pythagorean theorem. Problems 22–25 do require serious calculus and will challenge even college students, but they also give a good illustration of the integration techniques employed in traditional Japanese mathematics, which are often easier than those we are taught in school, forcing one to wonder how much of our mathematical education is mere convention.

Problem 1

Here is the rightmost problem on the *sangaku* of the Abe no Monjuin temple, color plate 11. This diophantine problem was proposed by Tomitsuka Yukō.

A number of visitors, N, visit the shrine. We know only that

(1) $\frac{7}{9}N$ is an integer and the last two digits are 68;
(2) $\frac{5}{8}N$ is integer and last two digits are 60.

Find the least possible value for N.

Answer: $\frac{7}{9}N = 1,568$; $\frac{5}{8}N = 1,260$; and $N = 2,016$.

The solution is on page 162.

Problem 2

Proposed by Hosaka Nobuyoshi in 1800, this problem is the third one from the right on the *sangaku* of the Mizuho shrine, color plate 9.

A trapezoid has lower side b, upper side a, and height h (see figure 5.1). Divide the area of the trapezoid into n small trapezoids with equal areas, as shown. Call the lower side of the smallest trapezoid k. Find n in terms of a, b, and k.

Example: If $a = 1$, $b = 7$, and $k = 3$, then $n = 6$.

Turn to page 163 for a solution.

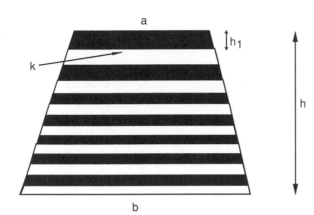

Figure 5.1. Find the number of small trapezoids of equal area.

Problem 3

This problem can be seen on the bottom right of the *sangaku* in the Katayamahiko shrine, color plate 5.

The rhombus *ABCD* inscribes two circles of radius r and two smaller circles of radius t (figure 5.2). We are given $AC = 2a = 85$ and $BD = 2b = 42$. Find r and t.

Answer on tablet: $2r = 21.559$ and $2t = 19.854$, which is wrong.

A solution—and the surprise explanation of the wrong answer—can be found on page 164.

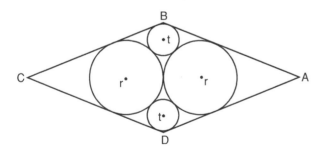

Figure 5.2. Find r and t.

Problem 4

This problem is the fifth one from the bottom left corner on the Katayamahiko shrine *sangaku*, color plate 5.

As shown in figure 5.3, a rhombus of side k and a small circle of radius r are inscribed in a right triangle with sides a, b, and c. Find $2r$ in terms of a, b and c.

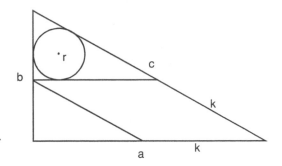

Figure 5.3. Find $2r$ in terms of a, b, and c.

Answer:

$$2r = \left(\frac{2a+b}{a+c} - 1\right)c = \left(\frac{a+b-c}{a+c}\right)c.$$

A solution can be found on page 165.

Problem 5

In 1819, Ishiguro Nobuyoshi (1760–1836) published a book, *Sangaku Kōchi*, where in this case *sangaku* connotes "study of math," not tablet, and so the title may be rendered as *Study of Mathematics*. In the third of three volumes, Ishiguro records forty-one tablets hung from 1783 to 1814. The author was a disciple of the Nakata school and all the tablets were hung by disciples of Nakata Kōkan (1739–1802). The problem presented here was originally proposed by Batsui Mitsunao, a fifteen-year-old boy, and written on a tablet hung in 1812 at the Nishihirokami Hachiman shrine in Izumi city, Toyama prefecture. Like all the tablets recorded in Ishiguro's book, this one has been lost.

As shown in figure 5.4, a number of circles of radius t form a pyramid with sides consisting of n circles. (The figure illustrates $n = 4$.) A large circle of radius r circumscribes this pyramid. If S is the area of the large circle minus the area of small circles, find t in terms of S and n.

Figure 5.4. Find the radius of the small circle in terms of the number of circles and the area of the large circle minus the area of the small circles.

Answer:

$$t = \sqrt{\frac{6S}{\pi(n-1)\left[5n - (14 - 8\sqrt{3})\right]}}.$$

A solution by traditional methods is given on page 165.

Problem 6

This problem was proposed by Ikeda Sadakazu in 1826 and hung in a shrine in Azabu town, Tokyo. The tablet on which it appears is among the 25 hung between 1808 and 1826 that were recorded in the 1827 book, *Shamei Sanpu*, or *Sacred Mathematics*, by Shiraishi Nagatada (1795–1862). These *sangaku* problems are generally of a high level of difficulty, containing complicated integrations that, for example, ask for the area of a general elliptic solid.[1] Another problem (problem 18, chapter 6), asking for the area of a spherical triangle, is identical to the one treated by Leonard Euler, although the methods are different. Here is one of the easier problems:

Three squares of sides *a*, *c*, and *d* touch the line *l*, and they each have one vertex in common with a square of the side *b*, as shown in figure 5.5. Show that $b = 2d$.

The solution is on page 166.

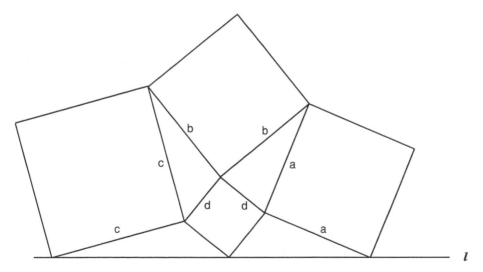

Figure 5.5. Show $b = 2d$.

[1] A general elliptic solid here refers to one described by the equation $x^2/a^2 + y^2/b^2 + z^2/c^2 = 1$, with $a > b > c$.

Plate 5.2. Original illustration for
problem 6, from Shiraishi
Nagatada's 1827 *Shamei Sanpu*.
(Aichi University of Education
Library.)

Problem 7

Kawano Michimuku, a student of the Fujita school, proposed this problem, which was written on a tablet hung in 1804 at the Udo shrine in Miyazaki prefecture. We know of it from Fujita Kagen's 1807 version of the *Zoku Shinpeki Sanpō*.

As shown in figure 5.6, ten circles of radius r touch each other externally and touch the large circle internally. If S is the area of the big circle minus the area of the ten little circles, find r in terms of S.

Answer:

$$2r = \sqrt{\frac{4S}{\pi(2\sqrt{8}-1)}}.$$

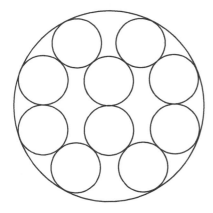

Figure 5.6. Find the radius of the small circles, r, in terms of S, the area of the large circle minus the area of the ten small circles.

Example: If $S = 234.09$, then $2r = 8$. . . .

A traditional solution can be found on page 167.

Problem 8

This problem was proposed by Suzuki Satarō and is found on a tablet containing twenty-four problems hung in 1891 at the Shinohasawa shrine of Fukushima city. The tablet measures 273 cm by 98 cm.

Let A and B be any two points on one chord of a given circle. Draw four inscribed circles with radii a, b, c, and d, which touch the chord at A and B. (See figure 5.7.) Draw the tangent to two of the inscribed circles, which touches them at points C and D. At this

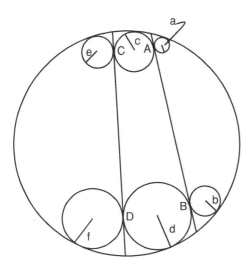

Figure 5.7. Show that $a/b = c/d = e/f$.

second chord, draw two more inscribed circles of radii e and f, which touch the tangent at C and D and the original circle internally. Show that $a/b = c/d = e/f$.

Turn to page 168 for a traditional solution.

Problem 9

Nakazawa Yasumitsu proposed this problem, which is the the fourth from the right on the *sangaku* of the Mizuho shrine, color plate 9.

Given the right triangle ABC (see figure 5.8), draw the lines AD and BE, from the two vertices A and B, such that two circles of radius r can be inscribed in the resulting configuration, as shown. Find the radius r in terms of three sides a, b and c.

The original solution can be found on page 169.

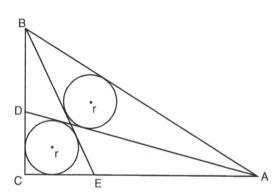

Figure 5.8. Find r in terms of sides a, b, and c.

Problem 10

This problem can be seen as the third from the top left corner of the Katayamahiko shrine *sangaku*, color plate 5. *Advice: Do the previous problem first.*

In an equilateral triangle ABC of side $2a$, two lines CE and BD touch two inscribed circles of radius r (figure 5.9). Find r in terms of a.

Answer: $r = (\sqrt{3} - \sqrt{2})a$.

A traditional solution is given on page 170.

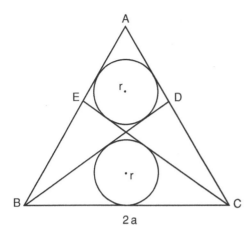

Figure 5.9. Find *r* in terms of *a*.

Problem 11

Proposed by Abe Hidenaka, this is the ninth problem from the right on the Dewasan-zan tablet, color plate 10.

Five circles, two of radius *a*, one of radius *b* and two of radius *c*, touch each other and a trapezoid *ABCD*, as shown in figure 5.10. The trapezoid is isosceles, so that *AD* = *BC*. Find *b* in terms of *a* and *c*.

Example: If *a* = 36 and *c* = 16, then *b* = 49.

The answer and a solution can be found on page 171.

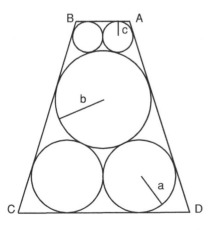

Figure 5.10. Find *b* in terms of *a* and *c*.

Problem 12

Here is another problem from the Shimizu shrine tablet, 1828, proposed by Kobayashi Nobutomo.

Given a right triangle ABC, draw a line from vertex C to the hypotenuse, which is perpendicular to the hypotenuse at point H (see figure 5.11). A circle of radius r is inscribed in the triangle. Two more circles of radi r_1 and r_2 are inscribed between the triangle, the line CH, and the circle r. Find r_1 in terms of r and $b = AC$, and r_2 in terms of r and $a = BC$.

Answer:

$$r_1 = \left(\frac{r}{\sqrt{b} + \sqrt{r}}\right)^2 \text{ and } r_2 = \left(\frac{r}{\sqrt{a} + \sqrt{r}}\right)^2.$$

A full solution can be found on page 172.

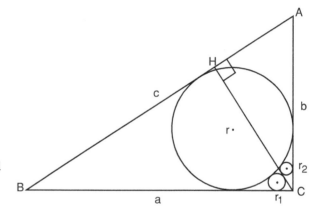

Figure 5.11. Find r_1 in terms of r and b. Find r_2 in terms of r and a.

Problem 13

This problem, proposed by Aotsuka Naomasa, can be seen as the seventh from the right on the *sangaku* of the Dewasanzan shrine, color plate 10.

Two large intersecting circles of radius R are inscribed in a square in the manner shown in figure 5.12. Six smaller circles of equal radius r are inscribed in the larger circles as shown. Two circles of radius t touch the square as well as the large circles. Find r in terms of t.

Answer:

$$r = \frac{0.4t}{\sqrt{0.4} + 3 - \sqrt{4(\sqrt{0.4} + 2)}}.$$

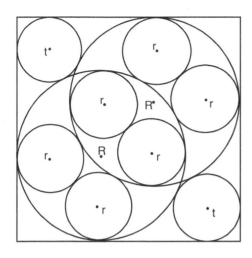

Figure 5.12. Find r in terms of t.

Example: If $t = 1$, then $r = 1.03228896$.

The solution can be found on page 173.

Problem 14

Motoyama Nobutomo proposed this problem, the sixth from the right on the Mizuho tablet, color plate 9.

Five squares with sides t, t_1, t_2, t'_1, and t'_2 are inscribed in a right triangle ABC, as shown in figure 5.13. Find $a = BC$ in terms of t_2 and t'_2.

The answer and a solution can be found on page 174.

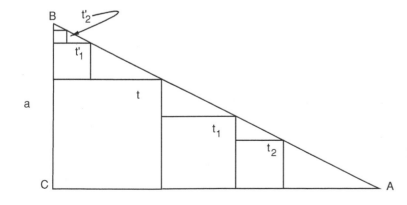

Figure 5.13. Find $a = BC$ in terms of t_2 and t'_2.

Problem 15

Saishi Shinzan is an unpublished manuscript edited by Nakamura Tokikazu, which contains a record of 208 *sangaku* dating from 1731 to 1828. One of the problems contained in *Saishi Shinzan* is this one, proposed in 1821 by Adachi Mitsuaki, and dedicated to the Asakusa Kanzeondō temple, Tokyo. *Advice: Do the previous problem first.*

Consider an infinite number of connected squares with sides l_n ($n = 1, 2, 3, \ldots$) in a right triangle (see figure 5.14). Let L be the total length of the sides, $L = \sum_{n=1}^{\infty} l_n$, and S be the area of the triangle minus the total area of the squares. Find l_1 in terms of L and S.

The solution is on page 175.

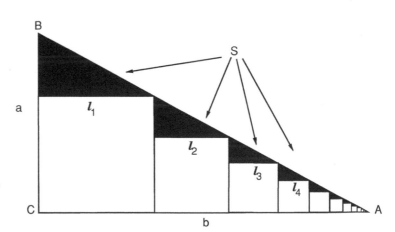

Figure 5.14. Find l_1 in terms of $L = \Sigma l_n$ and S.

Problem 16

This problem can be seen as the fifth from the right top corner of the Katayamahiko shrine *sangaku*, color plate 5.

A chain of circles of radii r_1, r_2, r_3, and r_4 is inscribed in the right triangle ABC, as shown in figure 5.15. Between the circles of radius r_n are three smaller circles, t_1, t_2 and t_3, each of which touches two of the larger circles and is tangent to BC. Show that $t_1 t_3 = t_2^2$

See page 176 for a solution.

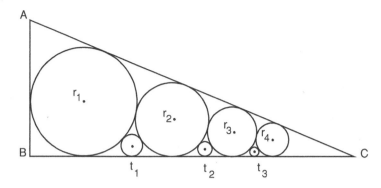

Figure 5.15. Find the relationship between the radii t.

Problem 17

Proposed by Miyazawa Bunzaemon in 1828, this problem comes from the *sangaku* of the Shimizu shrine.

A chain of five circles of radii $r_n (n = 1, 2, 3, 4, 5)$ is inscribed in the right triangle ABC, as shown in figure 5.16. Find a and b in terms of r_1 and r_5. *Advice: Do problem 14 first.*

Answer:

$$a = \frac{2r_1}{T - r_5}\sqrt{Tr_5} + r_1 \quad \text{and} \quad b = \frac{2r_1(a - r_1)}{a - 2r_1}, \quad \text{where } T = \sqrt[4]{r_1 r_5^3}.$$

Example: If $2r_1 = 50$ and $2r_5 = 20.048$, then $a = 248.6$ and $b = 56.29$.

A full solution is given on page 177.

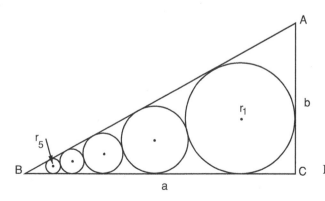

Figure 5.16. Find a and b in terms of r_1 and r_5.

Problem 18

This problem was hung in 1850 at the Ushikawa Inari shrine of Toyohashi city, Aichi prefecture. It was originally proposed by Imaizumi Seishichi and recorded in the unpublished manuscript *Record of the Ushikawa Inari Shrine Sangaku*.

Two right triangles ABC and $A'B'C'$, such that A, C', C, and A' lie on the same line, inscribe the same circle of radius r. As shown in figure 5.17, draw four inscribed circles of radii r_1, r_2, r_3, and r_4, and then show that $r_1 r_3 = r_2 r_4$.

The solution is left as an exercise for the reader.

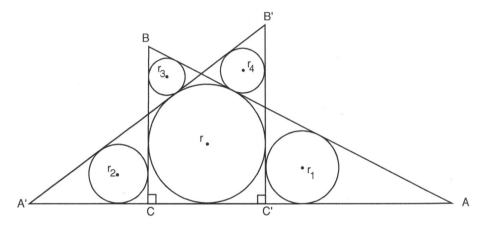

Figure 5.17. Show that $r_1 r_3 = r_2 r_4$.

Problem 19

Honma Masayoshi proposed this problem, the leftmost on the Dewasanzan *sangaku*, color plate 10.

Two identical ellipses of major axis $2a$ and minor axis $2b$ touch a circle of radius R internally, as shown in figure 5.18. Find b in terms of a and R.

The full solution is on page 178.

Answer: $b = \sqrt{1 - (a/R)^2}\, a$.

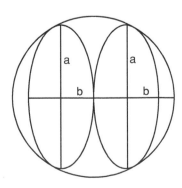

Figure 5.18. Find b in terms of a and R, the radius of the circle.

Problem 20

Proposed by Sugano Teizou, this problem can be seen as the tenth one from the right on the Abe no Monjuin tablet, color plate 11.

A chain of four circles of radii r_1, r_2, r_3, and r_4 are touched on one side by the line l and on the other side by a circular arc of radius r, which in sumo wrestling is called the "Gunpai" or "umpire's fan" (see figure 5.19.) Find r_4 in terms of r_1, r_2, and r_3.

Answer:

$$r_4 = \frac{r_2 r_3^2}{[(\sqrt{r_3/r_1} + 1)r_2 - r_3]^2}.$$

A solution can be found on page *179*.

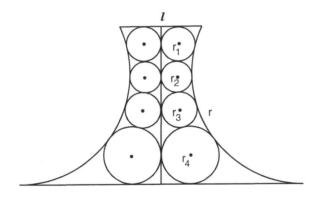

Figure 5.19. Find r_4 in terms of r_1, r_2, and r_3.

Caution: *Serious calculus required for the remaining problems.*

Problem 21

This college-level problem comes to us through Kobayashi Tadayoshi (1796–1871), a student of the Takeuchi school, who in 1836 published a collection of *sangaku* problems called *Sanpō Koren*, or *Mathematical Gems*. The collection records only five tablets, dating from 1824 to 1834, but the problems are all extremely difficult, asking for the area of ellipsoids and so forth. To calculate such quantities was the purpose of the *Enri*, discussed in chapter 9.

The problem itself was originally proposed by Kobayashi himself on a tablet hung in 1824 at Konpira shrine in Komoro city, Nagano prefecture. Like all the other tablets contained in the *Sanpō Koren*, this one has been lost.

As shown in figure 5.20 three identical ellipses of major axis $2a$ are inscribed in a large circle of radius r. Find a in terms of r when the area S of the ellipse is a maximum.

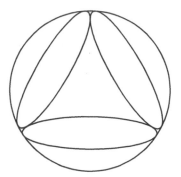

Figure 5.20. Find the semimajor axis of an ellipse in terms of the radius of the circle when the area of each ellipse is maximized.

Answer: $a = r/\sqrt{2}$.

Example: If $r = 99$, then $a = 70.0035$. (Kobayashi had recognized $\sqrt{2} = 99/70.0035 \cong 1.414215004$.)

Turn to page 181 for a full solution.

Problem 22

This problem, proposed by Kuno Hirotomo, can be seen as the third from the right on the second Atsuta tablet, color plate 12. Hung in 1844 by Takeuchi Shūkei (1815–1873), the tablet was lost. More recently, the shrine constructed a replica based on the anonymous and undated note, "Sandai Gakumen Sya," or "Record of Sangaku."

Two parallel planes, separated by a distance d, cut a sphere of radius r (see figure 5.21). Find the surface area S of the cut-out section in terms of d and r.

Answer: $S = 2\pi rd$.

A solution can be found on page 182.

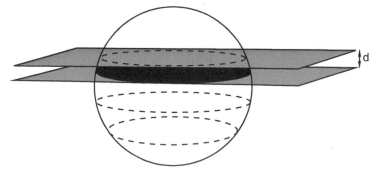

Figure 5.21. Find the surface area of the slice (black) in terms of d and the radius of the sphere.

Problem 23

This is the sole problem on a tablet that was hung in 1828 by Saitō Kuninori at the Kitamuki Kannon temple of Ueda city, Nagano prefecture. We have used Saitou's inscription as the epigraph for the previous chapter. The problem was originally recorded by Iwai Shigetō (1804–1878), in his book *Sanpō Zasso*, or *Collection of Sangaku*, published in 1830. In his book, Iwai records twenty-three tablets dating from 1811 to 1828. Of these tablets, two, the Kitamuki *sangaku* and that of the Bandō temple in Saitama prefecture, have survived.

The tablets of Nagano prefecture, including this one, have been presented in *Sangaku e no Shōtai*, or *Invitation to Sangaku*, by Nakamura Nobuya who has extensively studied the tablets.[2]

We are given a right circular cylinder with base of radius r and height h. We cut the cylinder by three planes. The first is plane *BCDE*, which as shown in figure 5.22, is perpendicular to the base. We then cut the cylinder with two more planes, one containing points B and D and the other containing points C and E. The intersections of these planes with the cylinder are curves on the cylinder's lateral surface. Find the surface area A of the shaded area between the curves in terms of r, h, and d.

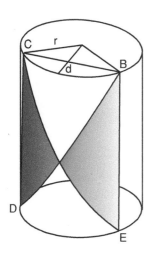

Figure 5.22. Find the shaded area in terms of r, d, and the height of the cylinder h.

Answer: $A = 2rh / \sqrt{(2r/d) - 1}$.

Example: If $d = 1$, $2r = 10$, and $h = 9$, then $A = 30$.

A full solution is given on page 183.

[2] Kyouiku Syokan, 2004, out of print.

Problem 24

Sugimoto Kōzen proposed this problem in 1826; it was hung in a shrine of Yotsuya, Tokyo, and recorded the following year in *Shamei Sanpu* by Shiraishi Nagatada.

Two identical and parallel right circular cylinders of radius r pass through a sphere such that the line of contact between the cylinders passes through the center of the sphere (see figure 5.23.) For the special case when the radius of the sphere is $2r$, find the volume V cut out of the sphere. Also, find the area of the surface cut out by the cylinders.

Answer: $V = \frac{16}{9}(2r)^3$; $A = 8(2r)^2$.

A modern solution is given on page 186.

Figure 5.23. Find the volume of the sphere remaining after two cylinders intersect it. Find the area of intersection.

Solutions to Chapter 5 Problems

Problem 1

If $(7/9)N$ equals a number whose last two digits are 68, then we can write $(7/9)N = 100a + 68$, where a is some integer ≥ 0. Hence

$$7N = 900a + 9 \times 68.$$

Similarly, we have $(5/8)N = 100b + 60$, where b is another integer, or

$$5N = 800b + 8 \times 60.$$

Multiplying the first equation by 5 and the second by 7 gives $35N = 4,500a + 3,060 = 5,600b + 3360$, and so $45a - 56b = 3$.

Since from the last equation $15a - (56/3)b = 1$ and $56/3 = 18\,2/3$, one sees that b must be a multiple of three. One easily finds that the least integers a and b solving this equation are $a = 15$ and $b = 12$. Substituting into either of the above equations gives $N = 2016$.

We can, however, make an easy problem more difficult. The two integers 45 and 56 have no common divisor except 1, and so they are called "relatively prime." In general, dividing a number a by a number b gives a quotient and a remainder, in other words, $a = q \times b + r$. In our case

$$56 = 1 \times 45 + 11,$$

where $q = 1$ and $r = 11$. Similarly,

$$45 = 4 \times 11 + 1$$

and

$$11 = 11 \times 1 + 0.$$

This sequence of successive divisions is an example of Euclid's algorithm.[3] One can easily show that the last nonzero remainder is always the greatest common divisor of a and b, in our case 1. We can also reverse the procedure and solve for the remainders:
$1 = 45 - 4 \times 11 = 45 - 4(56 - 45) = 5 \times 45 - 4 \times 56$, which is the same as $15 \times 45 - 12 \times 56 = 3$. Notice that 15 and 12 provide the answer to the problem. The moral of this shaggy-dog story is that, any time the greatest common divisor of a and b is 1, one can write $a \times c - b \times d = 1$, where c and d are the given coefficients to a and b.

The Japanese learned of this algorithm through the Chinese, independently of the West.

Problem 2

The area of the original trapezoid is $S = [(a + b)/2]h$, and so the area of the smallest trapezoid is $S/n = [(a + k)/2]h_1$, where h_1 is its height. Dropping the dashed perpendicular as shown in figure 5.24, we then have by similar triangles

$$h_1 = \left(\frac{k - a}{b - a} \right) h.$$

Solving these equations for n in terms of h, a and b gives the result

$$n = \left(\frac{a + b}{a + k} \right) \left(\frac{h}{h_1} \right) = \frac{b^2 - a^2}{k^2 - a^2}.$$

[3] For more on Euclid's algorithm, see, for example, Oystein Ore, *Number Theory and Its History* (Dover, New York, 1988).

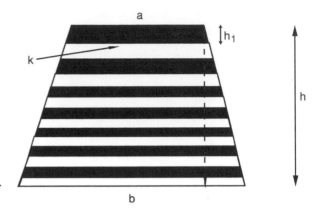

Figure 5.24. Drop the indicated dashed line.

Problem 3

We are given that $AC = 2a = 85$ in figure 5.2 and that $BD = 2b = 42$. Let $c = AB$, and so $c = \sqrt{a^2 + b^2} = 47.40516$. Further, if $\angle A = 2\theta$, then $\sin\theta = r/(a - r) = b/c$. Solving for r gives

$$r = \frac{ab}{b + c} = 13.04726 \quad \text{or} \quad 2r = 26.0945.$$

To find t, let k be the distance from the center of the rhombus to the upper small circle, in which case $k = \sqrt{(t + r)^2 - r^2}$. Then, similarly to what we just did, $t/(b - k) = a/c$. Substituting for k gives, after a bit of algebra, the quadratic in t:

$$b^2 t^2 - 2a(bc + ar)t + a^2 b^2 = 0,$$

with solution

$$t = a(ar + bc)\frac{[1 \pm \sqrt{1 - b^4/(ar + bc)^2}\,]}{b^2}.$$

In this case the relevant root is the smaller one, which is numerically $2t = 12.34694$.

You might notice that we have obtained different values from those on the tablet, the ones given on page 147. Those who have done the chapter 4 problems know that such mistakes happen often in traditional Japanese mathematics, and the reason is typical: The proposer of the problem was actually copying the figure from a book, one by Miyake Chikataka (1662–1745), called *Guō Sanpō*, or *Concise Mathematics*, which was published in 1699. Unfortunately, the eager disciple got the figure wrong. The correct diagram is shown in figure 5.25.

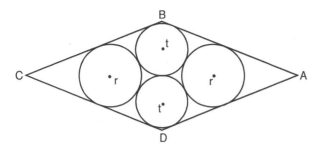

Figure 5.25. The original figure for problem 3.

In this case, $t/(b - t) = a/c$, which leads to $t = ab/(a + c) = 9.927$ or $2t = 19.854$, the answer that was stated on page 147. Thus, the student wrote down the right answer but for the wrong reason. An instructor grading the tablet would take off points for not showing the work. Students, it seems, have not changed.

Problem 4

Call p the altitude of the small right triangle on the lower left-hand corner of figure 5.3. Then, from similar triangles, we have the ratios $(a - k)/k = a/c$ and $p/k = b/c$, which in turns gives $k = ac/(a + c)$ and $p = (b/c)k = ab/(a + c)$.

Next consider the hypotenuse of the small right triangle containing the inscribed circle. From the equality of external tangents, $c - k = (k - r) + (b - p - r)$, which implies $2r = b - p + 2k - c$, or upon simplification,

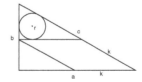

$$2r = \frac{(a + b - c)c}{a + c}.$$

If, for example, $a = 36$, $b = 15$, then $c = 39$ and $2r = 6.24$.

Problem 5

Here is a solution by traditional methods:

The total number of small circles is $n(n + 1)/2$. (See chapter 2, problem 4-7.)

If t is the radius of one of the small circles, then the side of the equilateral triangle formed by the pyramid (with vertices at the center of the corner circles) has length $2(n - 1)t$. The radius r of the circumscribed circle is thus

$$r = t + \frac{2(n - 1)}{\sqrt{3}}t.$$

The required area is $S = \pi r^2 - [n(n+1)/2]\pi t^2$, or, substituting for r,

$$S = \pi\left[\left(1 + \frac{2(n-1)}{\sqrt{3}}\right)^2 - \frac{n(n+1)}{2}\right]t^2.$$

Solving for t gives

$$t = \sqrt{\frac{6S}{\pi(n-1)(5n-14+8\sqrt{3})}}.$$

Problem 6

The original solution from the 1840 book by Heinouchi Masaomi (?–?) *Sanpō Chokujutsu Seikai, Mathematics without Proof,* says: Draw the three dashed squares (figure 5.26) and contemplate the figure in detail; the result is trivial.

Actually, it is almost trivial. Figure 5.27, which contains a few labels, shows directly that $q = q_1 = q_2 = q_3 = q_4$ and that therefore point M is the midpoint of the side. Thus, $MD = b/2$.

Similarly, $p = p_1 = p_2 = p_3 = p_4$ implies that N is the midpoint of the side and that $ND = b/2$.

So, we know that $\triangle MSD$ and $\triangle NDT$ are congruent with $MS = p$ and $NT = q$. Hence S is the midpoint of MD_1 and $MS = SD_1 = p$. But this means that triangles MDS and DSD_1 are congruent, which immediately implies $b = 2d$.

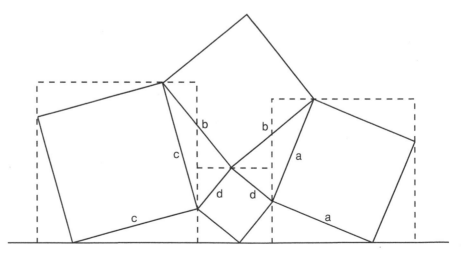

Figure 5.26. "The solution is trivial."

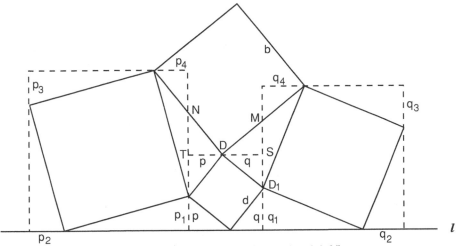

Figure 5.27. "Now the solution is trivial."

Problem 7

We offer a traditional solution from the manuscript, *Zoku Shinpeki Sanpō Kai*, or *Solutions to the Zoku Shinpeki Sanpō*, by Okayu Yasumoto (1794–1862).

Referring to figure 5.28, let R be the radius of the large outer circle, $p = R - r$ and $q = AB$. The marked angles [Exercise: show they are equal] allow us to use similar triangles, such that

$$\frac{n}{q} = \frac{r}{p}; \quad \frac{2n}{p} = \frac{q/2}{2r}.$$

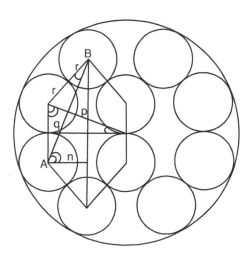

Figure 5.28. Similar triangles.

Hence, $pq = 8nr = 8qr^2/p$, which immediately yields $(R - r)^2 = p^2 = 8r^2$, or $R = (1 + \sqrt{8})r$.

S is defined as the area of the large circle minus the area of the ten small circles, so $S = \pi R^2 - 10\pi r^2 = \pi(2\sqrt{8} - 1)r^2$, which gives the desired result

$$r = \sqrt{\frac{S}{\pi(2\sqrt{8} - 1)}}.$$

In his example, Kawano, who hung the tablet, showed exacting work, stating that, if $\pi = 3.1416$, then $S = 234.09$ and $2r = 8.000178177$.

This problem is interesting because we can pack nine circles of radius r into a circle of the same radius $R = (1 + \sqrt{8})r$, as shown in figure 5.29. (The algebra is left as an exercise.)

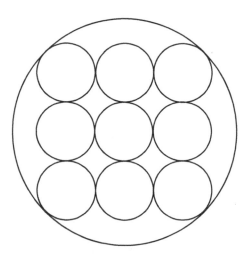

Figure 5.29. Nine circles of radius r can also be packed into the same circle of radius R.

In 1717, Minami Koushin hung a tablet in a small shrine in the samurai Egawa's garden, which is located in Shizuoka prefecture. On the tablet were two figures, the same as figures 5.28 and 5.29, which asked for R for nine and ten circles when r is given. The problem was recorded in the unpublished 1830 manuscript of Nakamura Tokikazu (?–?) *Saishi Shinzan*, or *The Mathematics of Shrines*.

Problem 8

This beautiful solution is quoted from Furuya Michio's 1854 book, *Sanpō Tsūsho*, or *Mathematics*.

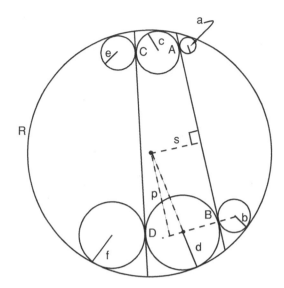

Figure 5.30. If R is the radius of the outer circle, s is the perpendicular distance from the center of R to the chord on the right, and p is the perpendicular distance from the center of R to the line joining the centers of circles b and d.

Let R be the radius of the big outer circle and s be the perpendicular distance from the center of R to the common tangent between the two circles a and b (see figure 5.30). Then by Pythagoras we have $(R-d)^2 = p^2 + (s-d)^2$, or $d = (R^2 - p^2 - s^2)/2(R-s)$, where p is the perpendicular distance between the center of R and the line connecting the centers of circles b and d.

Similarly, $b = (R^2 - p^2 - s^2)/2(R+s)$, and dividing by the previous expression gives $d/b = (R+s)/(R-s)$. Because the circle R and the initial chord were given, this ratio is a constant, and by symmetry it must apply to the other side of the diagram. Thus $c/a = d/b$. Repeating the argument with circles e and f gives $d/f = c/e$. Therefore $b/a = d/c = f/e$.

Problem 9

The answer is

$$r = \frac{a + b + c - \sqrt{2c(a + b + c)}}{2}.$$

We here quote the original solution from the 1837 book *Keibi Sanpō* or *Hanging Mathematics* by Horiike Hisamichi (?–?).

Draw the auxiliary lines shown in figure 5.31. Now just add up the areas of the triangles in the figure. We have

$$\triangle ABC = \frac{1}{2} ab = r^2 + 2 \times \frac{1}{2}(a-r)r + 2 \times \frac{1}{2}(b-r)r - \Delta + 2 \times \frac{1}{2}cr + \Delta,$$

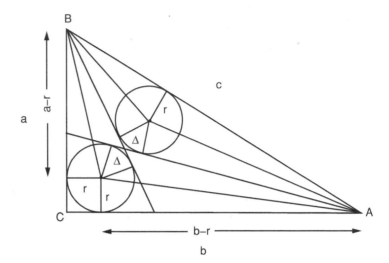

Figure 5.31. Draw in the auxiliary lines shown. Bear in mind that two tangents to a circle originating from the same point *P* are the same length

where Δ is the small area shown. Thus $2r^2 - 2(a+b+c)r + ab = 0$, or by the quadratic formula

$$r = \frac{a+b+c - \sqrt{(a+b+c)^2 - 2ab}}{2} = \frac{a+b+c - \sqrt{2c(a+b+c)}}{2}.$$

QED. One could hardly ask for a simpler solution.

Problem 10

We present a traditional solution from the (1879) book *Meiji Shōgaku Jinkō-ki*, or the *Jinkō-ki of the Meiji Era*, by Fukuda Riken (1815–1889). Referring to figure 5.32 and equating areas,

$$\Delta AH'C = \Delta AOH + (2\Delta OHC - \Delta OKF) + 2\Delta O'H'C + \Delta O'K'F).$$

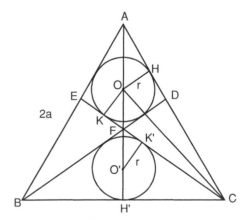

Figure 5.32. Draw the auxiliary lines shown. Note that $FK = FK'$.

But ΔOKF and $\Delta O'K'F$ are congruent, and so their contributions cancel out. With the side of the equilateral triangle $= 2a$, the above expression amounts to

$$\frac{1}{2}a\sqrt{3}a = \frac{1}{2}r\sqrt{3}r + r(2a - \sqrt{3}r) + ra.$$

Simplifying gives $\sqrt{3}r^2 - 6ar + \sqrt{3}a^2 = 0,$ or $(r - \sqrt{3}a)^2 = 2a^2,$ which immediately yields

$$r = (\sqrt{3} - \sqrt{2})a.$$

Notice that the method of solution is essentially the same as in problem 9.

Problem 11

The answer is

$$b = \frac{a + 6\sqrt{ac} + c}{4}.$$

To solve the problem we realize that the diagram is symmetrical around the centerline and so we only need to concentrate on one side, as in figure 5.33. From the drawing, convince yourself that

$$v + w = x + y.$$

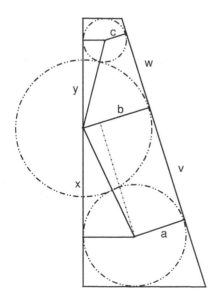

Figure 5.33. The auxiliary lines help find b in terms of a and c.

The Pythagorean theorem applied to the obvious triangles in the figure then gives

$$2\sqrt{bc} + 2\sqrt{ab} = \sqrt{(b+c)^2 - c^2} + \sqrt{(a+b)^2 - a^2},$$

or

$$2(\sqrt{a} + \sqrt{c}) - \sqrt{b+2c} = \sqrt{b+2a}.$$

Squaring both sides and factoring, one finds

$$2\sqrt{b+2c} = \sqrt{a} + 3\sqrt{c}.$$

Solving for b yields the result stated above.

Problem 12

From figure 5.34, we see that $r = l + h$. Furthermore, triangles ADE and CFG are similar, so the marked angles are both $A/2$, while $\tan(A/2) = r/(b-r)$. Then, using the Pythagorean theorem on triangle DFK gives

$$r = l + h = 2\sqrt{rr_1} + \frac{r_1(b-r)}{r},$$

or

$$r_1 + \frac{2r\sqrt{r}}{b-r}\sqrt{r_1} = \frac{r^2}{b-r},$$

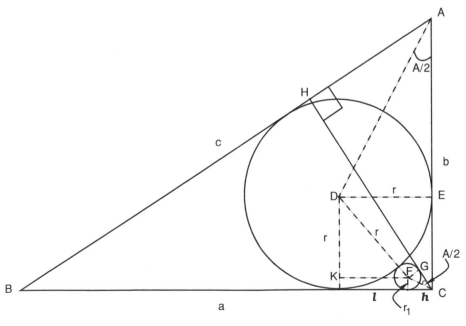

Figure 5.34. Draw the dashed lines and use similar triangles.

which is a quadratic equation in $\sqrt{r_1}$. Completing the square yields

$$\left(\sqrt{r_1} + \frac{r\sqrt{r}}{b-r}\right)^2 = \frac{br^2}{(b-r)^2}.$$

Solving for r_1 gives

$$r_1 = r^2 \left(\frac{\sqrt{b} - \sqrt{r}}{b-r}\right)^2,$$

or

$$\sqrt{r_1} = \frac{r}{\sqrt{b} + \sqrt{r}}; \quad r_1 = \frac{r^2}{(\sqrt{b} + \sqrt{r})^2}.$$

Using the same method gives

$$\sqrt{r_2} = \frac{r}{\sqrt{a} + \sqrt{r}}; \quad r_2 = \frac{r^2}{(\sqrt{a} + \sqrt{r})^2}.$$

Problem 13

Let p be the distance from the center of either of the large circles R to the point where the radius R is tangent to one of the circles r (see figure 5.35). Then we have both $(R - r)^2 = r^2 + p^2$ and $(R + r)^2 = r^2 + (3p)^2$. Solving these equations simultaneously yields

$$r = \frac{2}{5}R \quad \text{and} \quad p = \frac{1}{\sqrt{5}}R. \tag{1}$$

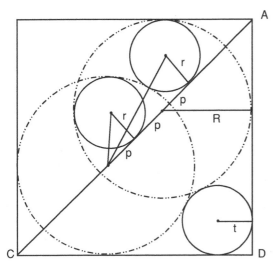

Figure 5.35. First find p in terms of R.

Figure 5.35 also shows directly that $AC = 2\sqrt{2}R + 2p$, or

$$AC = (2\sqrt{2} + 2/\sqrt{5})R. \tag{2}$$

One can also easily get

$$AD = R + 2\sqrt{Rt} + t = (\sqrt{R} + \sqrt{t})^2. \tag{3}$$

Because we also have $AC = \sqrt{2}AD,$ equations (2) and (3) give

$$\left(\frac{2\sqrt{10} + 2}{\sqrt{5}}\right)R = \sqrt{2}(\sqrt{R} + \sqrt{t})^2,$$

which is a quadratic equation in $\sqrt{t}.$ Solving it in the usual manner gives, after some algebra,

$$t = \left(\sqrt{2 + 2/\sqrt{10}} - 1\right)^2 \frac{5}{2}r.$$

(There is another root, but you can easily convince yourself that it cannot be reconciled with the figure.)

The problem is essentially solved, but the quantity in parentheses can be written as

$$\left(\sqrt{2 + 2/\sqrt{10}} - 1\right)^2 = 3 + 2/\sqrt{10} - 2\sqrt{2 + 2/\sqrt{10}} = 3 + \sqrt{0.4} - 2\sqrt{2 + \sqrt{0.4}}.$$

We are asked to find r in terms of t, and so

$$r = \frac{0.4t}{(\sqrt{0.4} + 3) - \sqrt{4(\sqrt{0.4} + 2)}},$$

as stated.

Problem 14

The answer is

$$a = (1 + k)^3 \frac{t_2'}{k}, \quad \text{where} \quad k = \sqrt{\frac{t_2}{t_2'}}.$$

The problem is easily solved. Call θ the vertex angle CAB. Then, by similar triangles, figure 5.13 shows that

$$\tan\theta \equiv \frac{1}{k} = \frac{a - t}{t} = \frac{t_1 - t_2}{t_2} = \frac{t - t_1}{t_1} = \frac{t_1'}{t - t_1'} = \frac{t_2'}{t_1' - t_2'}.$$

Solving each equality gives

$$a = t\left(\frac{1+k}{k}\right); \qquad (1)$$

$$t_1 = \left(\frac{1+k}{k}\right)t_2; \quad t = \left(\frac{1+k}{k}\right)t_1 = \left(\frac{1+k}{k}\right)^2 t_2; \qquad (2)$$

$$t_1' = \left(\frac{1}{1+k}\right)t; \quad t_2' = \left(\frac{1}{1+k}\right)t_1' = \left(\frac{1}{1+k}\right)^2 t. \qquad (3)$$

Eliminating t between equations (2) and (3) gives $k = \sqrt{t_2/t_2'}$. Substituting $t = (1+k)^2 t_2'$ from equation (3) into the expression for a in equation (1) yields the stated answer.

One incidentally finds the simple relationship $\sqrt{t} = \sqrt{t_2} + \sqrt{t_2'}$, which was written in the 1834 manuscript *Yusai Sangaku*, or *Mathematics of Yusai*, by Tani Yusai (1802–1841).

Problem 15

We follow basically the same procedure as in the solution to the previous problem. Figure 5.14 shows that

$$\tan A = \frac{a}{b} = \frac{a - l_1}{l_1} = \frac{l_1 - l_2}{l_2} = \frac{l_2 - l_3}{l_3} = \cdots.$$

Multiplying these out shows that $al_2 = l_1^2$, $l_1 l_3 = l_2^2$, $l_2 l_4 = l_3^2$, and so on, which also means that

$$\frac{l_1}{a} = \frac{l_2}{l_1} = \frac{l_3}{l_2} = \cdots = \text{constant} \equiv k.$$

With this definition, $l_1 = ak$, $l_2 = kl_1 = ak^2$, $l_3 = kl_2 = ak^3$, etc. The total length of the sides of the squares is therefore

$$L = \sum_1^\infty l_n = a\sum_1^\infty k^n,$$

which we recognize as a geometric series from problem 4-8 in chapter 2. This sums to

$$L = \frac{a}{1-k} - a = \frac{l_1}{1-k}.$$

Notice also that $\tan A \equiv a/b = (a - l_1)/l_1$, which implies $b = l_1/(1-k)$. Further, the area of the squares, $\sum_1^\infty l_n^2$, can be obtained merely by substituting a^2k^2 for ak into equation (1). Then the desired area, the area of the triangle minus that of the squares, becomes

$$S = \frac{1}{2}ab - \sum_{n=1}^{\infty} l_n^2 = \frac{l_1^2}{2k(1-k)} - \frac{l_1^2}{1-k^2} = \frac{l_1^2}{2k(1+k)}.$$

From Eq. (2), $k = 1 - l_1/L$. Plugging into the expression we just got for S, gives, after a little algebra,

$$l_1 = \left[\frac{\frac{3}{2} - \sqrt{L^2/S + 1/4}}{1 - L^2/2S}\right] L = \frac{2L}{3/2 + \sqrt{L^2/S + 1/4}},$$

the last of which was written on the tablet. The following example was written too: If $L = 308$ and $S = 9702$, then $l_1 = 132$.

Problem 16

Draw the bisector of $\angle C$ in figure 5.15. Then, similarly to the situation in figure 5.36,

$$\sin(\angle ACB/2) = \frac{r_1 - r_2}{r_1 + r_2} = \frac{r_2 - r_3}{r_2 + r_3},$$

which implies that $r_2^2 = r_1 r_3$, or that r_2 is the geometric mean of r_1 and r_3. In the same way, $r_3^2 = r_2 r_4$, and so

$$\frac{r_1}{r_2} = \frac{r_2}{r_3} = \frac{r_3}{r_4} = k, \tag{1}$$

where k is a constant.

By connecting the centers of r_1, r_2, and t_1, applying the Pythagorean theorem, and then doing the same for the other sets of circles, one easily shows that

$$\frac{1}{\sqrt{t_1}} = \frac{1}{\sqrt{r_1}} + \frac{1}{\sqrt{r_2}} = \frac{1}{\sqrt{r_2}}\left(1 + \frac{1}{\sqrt{k}}\right),$$

$$\frac{1}{\sqrt{t_2}} = \frac{1}{\sqrt{r_2}} + \frac{1}{\sqrt{r_3}} = \frac{1}{\sqrt{r_3}}\left(1 + \frac{1}{\sqrt{k}}\right),$$

$$\frac{1}{\sqrt{t_3}} = \frac{1}{\sqrt{r_3}} + \frac{1}{\sqrt{r_4}} = \frac{1}{\sqrt{r_4}}\left(1 + \frac{1}{\sqrt{k}}\right). \tag{2}$$

From this set of equalities and equation (1) we have

$$\frac{1}{\sqrt{t_1}}\frac{1}{\sqrt{t_3}} = \frac{1}{\sqrt{r_2}}\frac{1}{\sqrt{r_4}}\left(1 + \frac{1}{\sqrt{k}}\right)^2 = \frac{1}{t_2},$$

which immediately yields the final result $t_2^2 = t_1 t_3$.

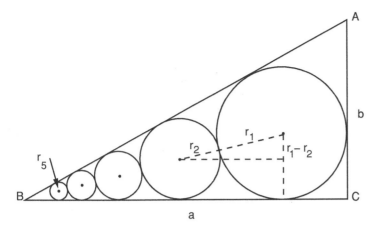

Figure 5.36. The dashed lines give $\sin(B/2) = (r_1 - r_2)/(r_1 + r_2)$.

Problem 17

Considering $\angle B$, figure 5.36 shows that $\sin(B/2) = (r_1 - r_2)/(r_1 + r_2)$, or, letting $k \equiv \sin(B/2)$,

$$r_2 = \frac{1-k}{1+k}\, r_1.$$

Similarly,

$$r_3 = \frac{1-k}{1+k}\, r_2 = \left(\frac{1-k}{1+k}\right)^2 r_1,$$

and so forth. Hence,

$$r_5 = \left(\frac{1-k}{1+k}\right)^4 r_1.$$

Solving this equation for k gives

$$k = \sin(B/2) = \frac{\sqrt[4]{r_1} - \sqrt[4]{r_5}}{\sqrt[4]{r_1} + \sqrt[4]{r_5}}. \tag{1}$$

Notice also from figure 5.36 that

$$\tan(B/2) = \frac{r_1}{a - r_1}. \tag{2}$$

Write the basic trigonometric identity $\cos^2(B/2) + \sin^2(B/2) = 1$ as

$$1 + \frac{1}{\tan^2(B/2)} = \frac{1}{\sin^2(B/2)}.$$

Then, inserting the expressions from equations (1) and (2) gives

$$\frac{a - r_1}{r_1} = \sqrt{\left(\frac{\sqrt[4]{r_1} + \sqrt[4]{r_5}}{\sqrt[4]{r_1} - \sqrt[4]{r_5}}\right)^2 - 1} = \frac{2\sqrt{\sqrt[4]{r_1 r_5}}}{\sqrt[4]{r_1} - \sqrt[4]{r_5}},$$

or, solving for a,

$$a = \frac{2r_1}{\sqrt[4]{r_1}\sqrt[4]{r_5^3} - r_5}\sqrt{\sqrt[4]{r_1}\sqrt[4]{r_5^3}r_5} + r_1 = \frac{2r_1}{T - r_5}\sqrt{Tr_5} + r_1,$$

where we have multiplied the top and bottom of the first term by $r_5^{3/4}$ and let $T \equiv \sqrt[4]{r_1 r_5^3}$. We have thus found a in terms of r_1 and r_5, as required.

At the same time, since $A = 90° - B$,

$$\tan(A/2) = \tan(45° - B/2) = \frac{1 - \tan(B/2)}{1 + \tan(B/2)},$$

or, from the figure and the expression in equation (2) for $\tan(B/2)$,

$$\frac{r_1}{b - r_1} = \frac{1 - r_1/(a - r_1)}{1 + r_1/(a - r_1)} = \frac{a - 2r_1}{a}.$$

Thus, finally,

$$b = \frac{2r_1(a - r_1)}{a - 2r_1},$$

and the problem is solved.

Problem 18

The solution is left to the reader.

Problem 19

To solve this problem we need consider only one of the ellipses, say the one on the right. The equation for a vertical ellipse displaced a distance b along the x axis is $(x - b)^2/b^2 + y^2/a^2 = 1$, and the equation of the circle is $x^2 + y^2 = R^2$. Eliminating y^2 yields a quadratic for the two points of intersection:

$$\left(\frac{1}{b^2} - \frac{1}{a^2}\right)x^2 - \frac{2}{b}x + \frac{R^2}{a^2} = 0,$$

which has roots

$$x_{\pm} = \left\{\frac{1}{b}\left[1 \pm \sqrt{1 - \frac{R^2(a^2 - b^2)}{a^4}}\right]\right\}\frac{a^2 b^2}{a^2 - b^2}.$$

However, from the symmetry of figure 5.18, we see that the two roots x_\pm must be the same, which implies that the discriminant (the quantity under the radical) must vanish. Setting it equal to zero and solving for b yields the result

$$b = a\sqrt{1 - (a/R)^2}.$$

Problem 20

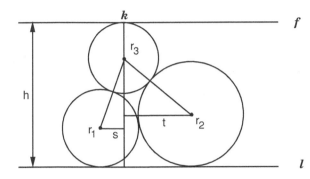

Figure 5.37. Drop a perpendicular k through the center of r_3.

We first prove the following little theorem quoted from Aida Yasua-ki's book, *Sanpō Tenshōhō Shinan* (chapter 3):

Three circles r_1, r_2 and r_3 touch each other externally (see figure 5.37). Two of the circles, r_1 and r_2, are tangent to the line l, while the third circle, r_3, is tangent to a parallel line f. Then,

$$r_3 = \frac{[h(r_1 + r_2) - 2r_1r_2]^2}{8r_1r_2}, \tag{1}$$

where h is the distance between l and k.

To prove this theorem, first drop a perpendicular line k from f through the center of r_3 to l. The distance between the center of r_1 and k is s; the distance between the center of r_2 and k is t. As in many other *sangaku* problems (e.g. problem 12), from figure 5.37 we see that by the Pythagorean theorem the horizontal distance between the centers of r_1 and r_2 is

$$s + t = 2\sqrt{r_1 r_2}. \tag{2}$$

But Pythagoras also tell us that

$$s^2 = (r_1 + r_3)^2 - (h - r_3 - r_1)^2 \text{ and } t^2 = (r_2 + r_3)^2 - (h - r_3 - r_2)^2. \tag{3}$$

Expand these expressions, take roots to get s and t, and insert the results into Eq. (2). After some tedious algebra, one gets

$$8hr_1r_2r_3 = 4r_1^2r_2^2 - 4hr_1r_2(r_1 + r_2) + h^2(r_1 + r_2)^2,$$

which is equivalent to (1).

We now solve problem 20 proper. Applying the above theorem to r_1, r_2, and r in figure 5.19, we have

$$r = \frac{[h(r_1 + r_2) - 2r_1r_2]^2}{8hr_1r_2},$$

where h is considered unknown. But, from figure 5.19 we also have

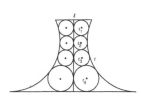

$$r = \frac{[h(r_2 + r_3) - 2r_2r_3]^2}{8hr_2r_3}.$$

Equating the two expressions and solving for h gives

$$h = \frac{2r_2\sqrt{r_1r_3}(\sqrt{r_1} - \sqrt{r_3})}{[(r_1 + r_2)\sqrt{r_3} - (r_2 + r_3)\sqrt{r_1}]} = \frac{2r_2\sqrt{r_1r_3}}{\sqrt{r_1r_3} - r_2}.$$

But if this is true, then again the figure shows we must have

$$h = \frac{2r_3\sqrt{r_2r_4}}{\sqrt{r_2r_4} - r_3}.$$

Eliminating h yields

$$\frac{\sqrt{r_1r_2}}{\sqrt{r_1r_3} - r_2} = \frac{\sqrt{r_3r_4}}{\sqrt{r_2r_4} - r_3}.$$

Solving for $\sqrt{r_4}$ is straightforward and gives

$$\sqrt{r_4} = \frac{r_3\sqrt{r_1r_2}}{(\sqrt{r_1} + \sqrt{r_3})r_2 - r_3\sqrt{r_1}},$$

or finally

$$r_4 = \frac{r_2r_3^2}{[(\sqrt{r_3/r_1} + 1)r_2 - r_3]^2},$$

as stated.

Problem 21

 As we could not find a traditional solution, we present a modern one. The strategy is to find the area of one of the ellipses in terms of r, the radius of the large circle. We choose the coordinate axes to lie along the major and minor axes of the horizontal ellipse, $2a$ and $2b$, as in figure 5.38.

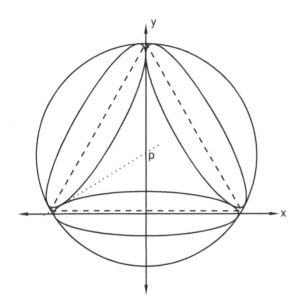

Figure 5.38. Choose these coordinate axes.

The equation of the horizontal ellipse is

$$\frac{x^2}{a^2} + \frac{y^2}{b^2} = 1. \tag{1}$$

The equation of the large circle with center at $(0, p)$ is

$$x^2 + (y - p)^2 = r^2. \tag{2}$$

By considering the dashed equilateral triangle shown in figure 5.38, one sees that the equation of the dotted tangent is

$$y = \frac{1}{\sqrt{3}} x + p. \tag{3}$$

Inserting equation (3) for y into equation (1) gives

$$\frac{x^2}{a^2} + \frac{[(1/\sqrt{3})x + p]^2}{b^2} = 1,$$

which has solution

$$x = \left[-p \pm \sqrt{ p^2 - (p^2 - b^2)\frac{(3b^2 + a^2)}{a^2} } \right] \frac{\sqrt{3}a^2}{(3b^2 + a^2)}.$$

However, because the dotted tangent intersects the ellipse at only one point, the roots must be the same, implying vanishing of the discriminant. This gives a relationship between a, b, and p:

$$p^2 = \frac{a^2 + 3b^2}{3}. \tag{4}$$

We also have from equations (1) and (2) for the intersection of the circle and the ellipse

$$\frac{r^2 - (y - p)^2}{a^2} + \frac{y^2}{b^2} = 1,$$

or

$$\left(\frac{a^2 - b^2}{b^2} \right) y^2 + 2py + (r^2 - p^2 - a^2) = 0.$$

As before, the discriminant of this equation must vanish. With expression (4) for p^2, one easily finds

$$4a^4 = 3r^2(a^2 - b^2),$$

yielding an area for each ellipse of

$$A = \pi a b = \pi \sqrt{a^2 b^2} = \pi \sqrt{ a^4 - \frac{4a^6}{3r^2} }.$$

The area will be maximized when the quantity under the radical is maximized. Taking the derivative and setting it to zero gives $4a^3 - 8a^5/r^2 = 0$, which means the maximum is attained when $a^2 = r^2/2$ and $S = \pi r^2/2\sqrt{3}$.

Problem 22

We give an original solution from Uchida Kyūmei's 1844 book *Sanpō Kyūseki Tsu-ko*, or *A General Course of Calculus*, which is a good textbook on integration. Uchida's dates are unknown.

Let x be the variable of integration. For small increments Δx, the arc segment Δl in Figure 5.39 can be considered a straight line. Then $\Delta x / \Delta l = p/r$.

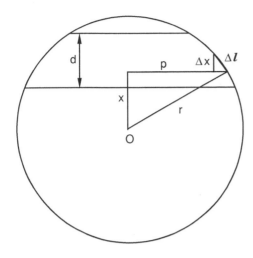

Figure 5.39. The large and small right triangles are similar (see figure 5.41).

The area element is $\Delta s = 2\pi p \Delta l = 2\pi r \Delta x$. Integrating x from 0 to d gives the desired area $S = 2\pi r d$.

Notice that the traditional Japanese method is slightly simpler than a typical first-year calculus approach, which might go like this: $dA = 2\pi x \, dl$, where here $x = r\cos\theta$ is the usual x coordinate and θ the usual angle in polar coordinates. Since $dl = r\, d\theta$, we get $dA = 2\pi r^2 \cos\theta \, d\theta$ and

$$A = 2\pi r^2 \sin\theta \big|_{\theta_1}^{\theta_2},$$

where $\theta = \sin^{-1}(y/r)$. With $d = y_2 - y_1$ we get the same result, but with the explicit introduction of trigonometric and inverse trigonometric functions.

Problem 23

We give two solutions. The first is a traditional solution in the book *Sanpō Kyūseki Tsu-ko* (see solution to problem 22).

As shown in figure 5.40, the surface area element $\Delta A = z(x)\Delta s$, where $z(x)/x = h/k$ and $k = \sqrt{r^2 - (r-d)^2}$. (If you are having difficulty with this step, see the next solution.) Figure 5.41 shows that by similar triangles $\Delta s = (r/\sqrt{r^2 - x^2})\Delta x$.

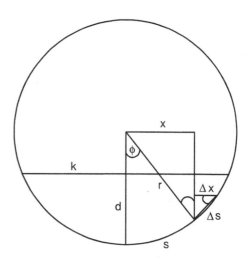

Figure 5.40. The linear increment along x is Δx; the curved increment along the surface is Δs; the area element is ΔA. By Pythagoras, $k = \sqrt{r^2 - (r-d)^2}$.

Figure 5.41. By similar triangles the two indicated angles at the lower right are equal. Therefore

$\Delta s = \left(r/\sqrt{r^2 - x^2} \right) \Delta \Delta x.$

Going to the limit, the desired area is

$$A = 2 \int dA = 2 \int z(x)\,ds$$

$$= 2 \int_0^k \frac{hr}{k} \frac{x}{\sqrt{r^2 - x^2}}\,dx = \frac{2hr}{k}\left[-\sqrt{r^2 - x^2} \right]_0^k$$

$$= \frac{2hrd}{\sqrt{2rd - d^2}} = \frac{2hr}{\sqrt{2r/d - 1}}. \tag{5}$$

In regard to this solution, we first point out that traditional Japanese mathematics did not contain the idea of indefinite integration, only

definite integration, and so integrals were used only for finding areas, volumes, and surfaces of certain figures. Often, practitioners used mechanical means to get numerical answers. (We discuss this more fully in chapter 9.) What's more, the above answer is surprising because it does not contain π, that is, it is not an obvious fraction of the surface area of a cylinder, $2\pi rh$. We now give a modern derivation that may be more convincing.

Imagine that a plane slices a cylinder to form an ellipse, as in figure 5.42. In spherical coordinates one can show[4] what is fairly evident from the figure, that the height of the point at which the plane intersects the cylinder surface is $z(\phi) = \text{const} \times \sin \phi$. To determine the constant, in this problem we have a boundary condition

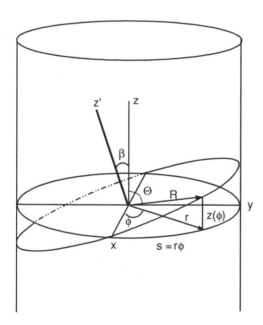

Figure 5.42. A plane slices the cylinder at an arbitrary angle θ. The section is an ellipse. We see that $z(\phi) = \text{const} \times \sin(\phi)$.

[4] In spherical coordinates, the unit vector in the \mathbf{R} direction is $\hat{\mathbf{R}} = \hat{\mathbf{i}}\sin\theta\cos\phi + \hat{\mathbf{j}}\sin\theta\sin\phi + \hat{\mathbf{k}}\cos\theta$. The height z of a point above the x-y plane is just $z = R\cos\theta$. To find this as a function of ϕ, note that if, as in figure 5.42, the plane containing \mathbf{R} is tilted in the y-z plane at an angle β from the z axis, then the unit vector in the \mathbf{z}' direction has components $\hat{\mathbf{z}}' = -\hat{\mathbf{j}}\sin\beta + \hat{\mathbf{k}}\cos\beta$. \mathbf{R} rotates in a plane perpendicular to $\hat{\mathbf{z}}'$, so $\hat{\mathbf{z}}' \cdot \hat{\mathbf{R}} = \mathbf{0}$. Working out the dot product gives $\cot\theta = \tan\beta\sin\phi$. But $z = R\cos\theta = r\cot\theta$, and therefore $z = r\tan\beta\sin\phi$, or $z = \text{const} \times \sin\phi$.

that the point at which the plane intersects the cylinder marks the maximum angle $\phi = \phi_{\mathrm{max}}$. At that point we are given $z = h/2$. Hence const $= h/2 \sin \phi_{\mathrm{max}}$ and

$$z = \frac{h}{2\sin \phi_{\mathrm{max}}} \sin \phi.$$

But by definition Δs along the cylinder surface is $r\Delta\phi$. Hence $dA = rzd\phi$ and the desired area is simply

$$\frac{S}{4} = \frac{rh}{2\sin \phi_{\mathrm{max}}} \int_0^{\phi\mathrm{max}} \sin \phi d\phi$$

$$= \frac{h}{2\sin \phi_{\mathrm{max}}}[1 - \cos \phi_{\mathrm{max}}] \tag{6}$$

But from figure 5.40 or 5.41 we see that $\sin \phi_{max} = k/r$ and $\cos \phi_{max} = (r - d)/r$, so

$$\frac{S}{4} = \frac{hr}{2\sqrt{2r/d - 1}},$$

in agreement with the traditional method. Notice that the traditional solution uses the fact that the slope of the plane cutting the cylinder is a constant, and thus z as a function of x is a straight line: $z(x)/x = h/k$, as stated above. The increment Δs is then found in terms of Δx, giving the area element $z\Delta s$. The modern version gets Δs directly in terms of ϕ, but z becomes a more complicated function of ϕ.

Problem 24

We present a solution by standard modern calculus. To find the volume cut out of the sphere by two cylinders, we find the volume cut out of a hemisphere by one cylinder and multiply by four. We build the volume element as $zdxdy$, as shown in figure 5.43. The equation of the sphere is $4r^2 = x^2 + y^2 + z^2$, so we can eliminate z by writing $z = \sqrt{4r^2 - x^2 - y^2}$. Further, the equation of the cylinder is $r^2 = x^2 + (y - r)^2$. Thus, the domain of integration over, say, x is bounded by $x = \sqrt{2yr - y^2}$, or

$$V = 4\int\int_D zdxdy = 8\int_0^{2r} dy \int_0^{\sqrt{2yr-y^2}} \sqrt{(2r)^2 - x^2 - y^2}\,dx.$$

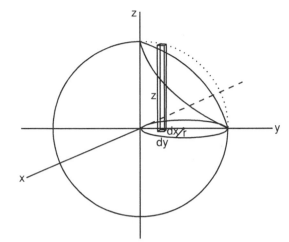

Figure 5.43. The volume element of the sphere is *zdxdy* and is integrated over the circle in the *x-y* plane.

We now shift to polar coordinates *t,θ*, with $x \equiv t \cos \theta$, $y \equiv t \sin \theta$, $t^2 = x^2 + y^2$, $dxdy = tdtd\theta$. Then, with limits of integration given by figure 5.44,

$$V = 4 \int_{-\pi/2}^{\pi/2} d\theta \int_{0}^{2r\sin\theta} \sqrt{(2r)^2 - t^2}\, tdt.$$

This is a standard integral that gives the result

$$V = \frac{8}{3}(2r)^3 \left(\frac{\pi}{2} - \frac{2}{3} \right).$$

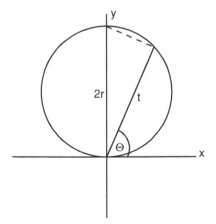

Figure 5.44. Note that $t_{\max} = 2r \sin \theta$.

However, we notice that the first term is the volume of the sphere itself, and so the desired volume is the somewhat surprising answer, again lacking in π's,

$$V_{\text{sphere}} - V = \frac{16}{9}(2r)^3,$$

which was written on the tablet.

There are several ways to find the area. Perhaps the most straight-forward is to write

$$A = \int \int z \, ds,$$

where in figure 5.43, $ds^2 = dx^2 + dy^2$ is the square of the infinitesimal arc length along the curved surface of the cylinder (see problems 22 and 23) and where z is the height above the x-y plane of the curve of intersection between the cylinder and the sphere (the solid curve in the figure). We already know from the volume calculation that along the cylinder surface $x^2 = 2yr - y^2$, which gives $x\,dx = [r - y]\,dy$, and so

$$ds = \sqrt{dx^2 + dy^2} = \left[\frac{(r-y)^2}{x^2} + 1 \right]^{1/2} dy$$

$$= \left[\frac{r^2}{2yr - y^2} \right]^{1/2} dy.$$

However, by inserting the above expression for x^2 into the equation for the sphere $4r^2 = x^2 + y^2 + z^2$ and solving for z, we get the height of the curve of intersection in terms of y: $z = \sqrt{4r^2 - 2yr}$. Thus

$$A = \int z \, ds = \sqrt{2}\,r^{3/2} \int_0^{2r} \left[\frac{2r - y}{2yr - y^2} \right]^{1/2} dy = \sqrt{2}\,r^{3/2} \int_0^{2r} \frac{1}{y^{1/2}} \, dy.$$

The integral is elementary and gives the result $A = 4r^2$. But this is for the area of one-half a cylinder over one-half a hemisphere, so the total area we want is eight times this, or $A = 32r^2$. Notice once more that no π figures in the result.

This problem appears in many modern calculus texts as the solid of Viviani (1622–1703). In Japan, the theorem was written down in the

1844 book *Sanpō Kyūseki Tsu-ko*, or *Theory of Integrations*, by Uchida Kyūmei (?–1868). His solution, however, while employing only elementary methods, is extremely complicated and we do not present it. It can be found in Fukagawa and Rigby, *Traditional Japanese Mathematics Problems* ("For Further Reading: Chapter 6," p. 339)

Plate 6.1. The original illustration from problem 12, originally proposed by Hotta Jinsuke in 1788, as it appears in Fujita Kagen's 1789 book, *Shinpeki Sanpō*. (Collection of Fukagawa Hidetoshi.)

Still Harder Temple Geometry Problems

I have been studying this problem for four or five years and, at last, this spring, I succeeded in solving it. But the problem is no good. I recommend that every student study more mathematics books rather than try to solve such a problem.

—From the Diary of Yamaguchi Kanzan

The problems that find their way into this chapter are distinguished from those of the previous ones by three non-mutually-exclusive criteria: The algebra may be considerably more involved than for the problems of chapters 4 and 5; the solutions may require a higher degree of insight, as well as a familiarity with the properties of three-dimensional solids; and finally, to make tractable some of the solutions requires techniques generally no longer taught at the high school—or even college—level. We speak specifically of inversion and affine transformations. These techniques, which are actually not difficult to master, make solving some of the problems quite easy, almost trivial; without them, solutions are nearly impossible.

Problems 1–4 fall into the first category. The individual steps are not difficult, but the algebra quotient may easily surpass what most students are willing to endure. Problem 4 is of considerable historical interest, however, and not as hard as it seems at first glance. Problems 5–8 may prove particularly difficult because they involve ellipses, which are not commonly found in Western problems. In traditional Japanese mathematics, on the other

hand, problems involving ellipses are commonplace. The reason is that Japanese geometers had a very simple way of looking at an ellipse—as a slice out of a right circular cylinder, rather than as a conic section. Problem 5 explores the Japanese view in detail and problems 6–8 exploit the results. You will notice the striking lack of mention of foci. Indeed, in all traditional Japanese mathematics, the only mention of the string-and-foci method universally taught to Western students for generating an ellipse occurs in Ishiguro Nobuyoshi's unpublished 1815 manuscript "Sokuen Shūkihō," or "Method for Describing the Ellipse."

Problem 8 is fairly simple and could have been included in the previous chapter, but it has direct bearing on the problems following it and so we include it here. Problems 9–11, involving multitudes of circles, are simply difficult.

The three-dimensional problems 14 and 15 are not computationally intensive, but two of them do require knowing the properties of many-sided solids, while the remaining problems require mastering the inversion technique.

We would not expect many readers to tackle the conundrums in this chapter, but we hope that everyone will glance at the extraordinary solutions.

Problem 1

This problem, proposed by Maruyama Ryoukan in 1800, was written on a tablet hung at the Sannōsha shrine in Tsuruoka city of Yamagata prefecture and later recorded in the 1807 book *Zoku Shinpeki Sanpō* by Fujita Kagen.

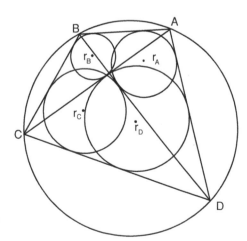

Figure 6.1. Find r_C in terms of r_A, r_B, and r_D.

Quadrilateral *ABCD* is inscribed in a circle, as shown in figure 6.1. Let r_A, r_B, r_C, and r_D be the radii of circles inscribed in triangles $\triangle DAB$, $\triangle ABC$, $\triangle BCD$, and $\triangle CDA$, respectively. Find r_C in terms of r_A, r_B, and r_D.

Answer: $r_C = r_B + r_D - r_A$ or $r_A + r_C = r_B + r_D$.

Example: $r_A = 1$, $r_B = 2$, and $r_D = 3$; then $r_C = 4$.

A detailed solution is given on page 208.

Problem 2

This problem was originally proposed by Sugita Naotake on a *sangaku* hung in 1835 at the Izanagi shrine in Mie prefecture. We have taken it from the 1837 collection *Kakki Sanpō*, or *Concise Mathematics*, by Shino Chigyō (?–?). In his book, Shino records problems on twelve tablets hung between 1832 and 1836. They are all lost.

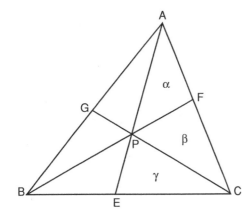

Figure 6.2. Find the area of $\triangle ABC$ in terms of α, β, and γ.

As shown in figure 6.2, draw three lines *AE*, *BF*, and *CG* that pass through *any* point *P* inside a triangle *ABC*.[1] Consider the three indicated areas $\alpha = \triangle APF$, $\beta = \triangle FPC$, and $\gamma = \triangle CPE$. Find the area *S* of $\triangle ABC$ in terms of α, β and γ.

Answer:

$$S = \frac{\beta(\alpha + \beta)(\alpha + \beta + \gamma)}{\beta(\alpha + \beta + \gamma) - \gamma(\alpha + \beta)}.$$

[1] Lines drawn from the vertex of a triangle to the opposite side with no other restriction are known as Cevians, after the the seventeenth-century mathematician Giovanni Ceva.

Plate 6.2. The original illustration for problem 2, originally proposed by Sugita Naotaki, as it appears in Shino Chigyō's 1837 book *Kakki Sanpō*. On the same page can be seen a drawing for a more advanced problem, similar to problems 16 and 17. (Aichi University of Education Library.)

Example: If $\alpha = 35$, $\beta = 28$, and $\gamma = 21$, then $S = 144$.

We give both a traditional and a modern solution on page 210.

Problem 3

This problem was originally hung in 1806 in the Atsuta shrine by Ehara Masanori, a disciple of Kusaka Makoto (1764–1839). The tablet, which contained only this problem and no solution, was subsequently lost. However, at an unknown date the mathematician Kitagawa Mōko (1763–1833) visited the shrine and recorded the *sangaku* in his note "Kyuka Sankei," or "Nine Flowers Mathematics," along with his solution. More recently, the shrine constructed a replica from Kitagawa's manuscripts (see plate 6.3). *Warning: This may be the most involved exploitation of the Pythagorean theorem you have ever seen.*

Plate 6.3. Measuring only 45 by 30 cm, this tablet is a replica of one that was originally hung in 1806 in the Atsuta shrine and subsequently lost (see problem 3). The shrine reconstructed the replica shown here from the manuscript of mathematician Kitagawa Mōko. The actual replica is in color and another replica from the shrine with the same color scheme can be seen in color plate 12. (© Asahi Shinbun.)

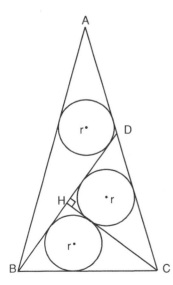

Figure 6.3. Find r in terms of CH.

As shown in figure 6.3, the triangle *ABC* is isosceles. Two lines *BD* and *CH* divide it into three smaller triangles, each of which circumscribes a circle of the same radius *r*. Find *r* in terms of *CH*.

Answer: r = CH/4.

We give Kitagawa Mōko's original solution from his notebook on page 212.

Problem 4

Proposed by Shichi Takatada, this is the second problem from the left on the Meiseirinji tablet (color plate 8) and is connected with the problem known in the West as the Malfatti problem. *Caution: This is a long problem, but the solution is relatively straightforward.*

As shown in figure 6.4, r_1, r_2, and r_3 are the radii of three circles that touch each other externally. Construct a triangle that inscribes the circles and find the radius *r* of the triangle's inscribed circle (incircle) in terms of r_1, r_2, and r_3.

Answer:

$$r = \frac{2\sqrt{r_1 r_2 r_3}}{\sqrt{r_1} + \sqrt{r_2} + \sqrt{r_3} - \sqrt{r_1 + r_2 + r_3}}.$$

We give a traditional solution on page 216 and a discussion in chapter 8.

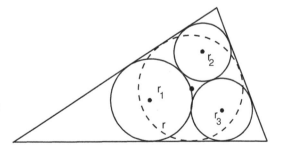

Figure 6.4. Find the radius of the dashed circle *r* in terms of r_1, r_2, and r_3.

Problem 5

This problem is the third from the right in the photo of the Meiseirinji tablet, color plate 8. It was proposed by Kawai Sawame, a sixteen-year-old girl. *Warning: This is a very long problem.*

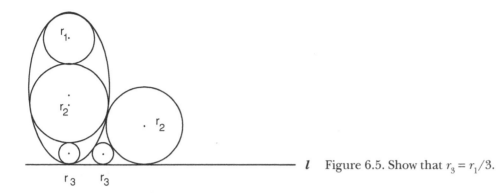

l Figure 6.5. Show that $r_3 = r_1/3$.

Here we have one ellipse and five circles of radii r_1, r_2, and r_3. Two circles of radius r_3 and one of r_2 are tangent to the line l, as shown in figure 6.5. Assume r_1 is the radius of curvature of the ellipse at the end of the major axis. Show that $r_3 = r_1/3$.

A traditional solution to the problem is given on page 218.

Problem 6

This problem was written on a *sangaku,* now lost, dedicated in 1850 to the Ushikawa shrine, Aichi prefecture. *Caution: This problem is easy but requires advanced techniques.*

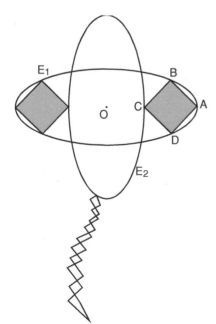

Figure 6.6. Show that the side of one of the squares equals the minor axis of the ellipse.

As shown in figure 6.6, the major axes of two identical ellipses E_1 and E_2, which have a common center O, are perpendicular. The vertices A, B, and D of square $ABCD$ lie on E_1, while vertex C lies on the major axis of E_1 and also touches E_2. Show that the side of the square is equal to the length of the semi-minor axis.

Because this problem was on a *sangaku*, the author, wanting to make it attractive and interesting to passers-by, originally asked for the lengths of squares in a kite flying in the sky, a kite formed by the two ellipses.

A solution can be found on page 222.

Problem 7

This problem was written in 1822 on a tablet in Iwate prefecture. The tablet is now lost. *Advice: Do the previous problem first.*

On the ellipse shown in figure 6.7, mark three points A, B, and C such that the areas of the curved sectors S_1, S_2, S_3 are equal. Show that the area of triangle $ABC = (3/4)\sqrt{3}ab$, where a and b are the semimajor and semiminor axes of the ellipse.

Turn to page 223 for a solution.

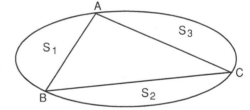

Figure 6.7. Find the area of the triangle when the areas of the curved sectors are equal.

Problem 8

Also from a lost *sangaku*, this problem was originally presented in 1842 by Kato Yoshiaki, Yoshida Tameyuki's student, who hung the tablet in the Ohsu Kanon temple of Nagoya. *Advice: Do problem 5 first.*

Figure 6.8. Show that $r_7(r_1 + r_7) = r_4(r_4 + r_{10})$.

As shown in figure 6.8, a chain of ten circles with radii r_1, \ldots, r_{10} is inscribed in an ellipse, such that each circle touches its two neighbors as well as the ellipse at two distinct points. Shown that $r_7(r_1 + r_7) = r_4(r_4 + r_{10})$.

A traditional solution is outlined on page 224.

Problem 9

This problem was proposed in 1828 by Tomita Atsutada, a student of Ono Eijyū's school, and hung in the Shiroyama Inari shrine of Annaka city in Gumma prefecture. We know of it from the 1830 book *Sanpō Zasso*, or *Concise Mathematics*, by Iwai Shigetō.

Two circles of radii a and b touch each other externally at a point P and also touch a larger circle O internally (see figure 6.9). Two others circles of radii c and d touch each other externally at P as well, and also touch circle O internally. Find b in terms of a, c, and d.

Example: $a = 2$, $c = 3$, and $d = 4$; then $b = 12$.

The answer and a solution by traditional methods can be found on page 225.

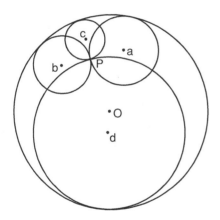

Figure 6.9. Find b in terms of a, c, and d.

Problem 10

We mentioned in connection with problem 26 in chapter 4 that during the later Edo period it became popular to consider problems that could be drawn upon folding fans. Here is another and more difficult example, dating from 1865; it is the rightmost problem in the photo of the Meiseirinji temple *sangaku*, color plate 8, and was presented by Sawa Keisaku.

As shown in figure 6.10, inside a fan-shaped sector five circles touch each other; one is a "red" circle of radius r_1, two are "green" circles of radius r_2, and two are "white" circles

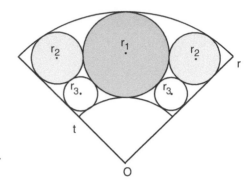

Figure 6.10. Show that $2(r_1 + r_3) = r$ when r_3 is maximized.

of radius r_3. The radius of the sector is r, and the circles touch each other symmetrically about the center O. We take the angle of the sector to be variable and r constant. As the angle is varied, the inner radius of the sector t is adjusted so that the five circles continue to touch; r_3 is also allowed to vary, while the other radii remain constant. Show that $2(r_1 + r_3) = r$ when r_3 is a maximum.

A full solution to the problem is given on page 226.

Problem 11

Proposed by Matsuoka Makoto, this is the second problem from the left on the second Atsuta tablet, color plate 12. *Warning: This is a difficult problem.*

A small circle of radius r sits in a big circle of radius R such that four circles of radii a, b, c, and d touch it externally, as shown in figure 6.11. Moreover, eight other circles are arrayed among a, b, c, d, r, and R as shown. Prove the following simple relation:

$$\frac{1}{a} + \frac{1}{b} = \frac{1}{c} + \frac{1}{d}.$$

Turn to page 227 when you need a solution.

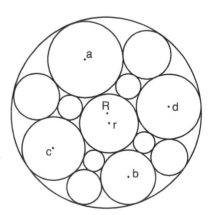

Figure 6.11. Find the relationship between a, b, c, and d.

Problem 12

This problem was originally proposed by Hotta Jinsuke of the Fujita school and written on a tablet that was hung in 1788 at the Yanagijima Myōkendō temple of Honjyo, Tokyo. It was later recorded in Fujita's book, *Shinpeki Sanpō*.[2]

As shown in figure 6.12, a large circle of radius r contains two circles r_1 and r_1', each of radius $r_1 = r/2$, which are both tangent to each other and touch circle r internally. The bottom circle, r_1', also touches a chain of circles r_n, as illustrated. Further, a chain of circles with radius t_n is placed between the circles r_n and r_1' such that each t_n touches r_1' as well as circles r_n and r_{n+1}. Find n in terms of r and t_n. (Equivalently, find r_n and t_n in terms of n.)

Answer:

$$n = \frac{1}{2}\left(\sqrt{\frac{r}{t_n} - 14} + 1\right).$$

Example: If $r = 97.5$ and $t_n = 0.1$, then $n = 16$.

We give a traditional solution on page 228, and also devote much of chapter 10 to a solution using the method of inversion.

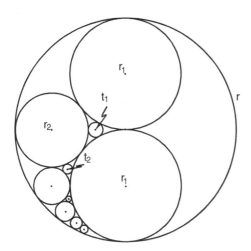

Figure 6.12. Find the index n of the nth circle in terms of r_n or t_n.

Problem 13

Yamamoto Kazutake proposed this problem, which was written in 1806 on a tablet hung in the Iwaseo shrine of Takamatsu city, Kagawa prefecture. It was later recorded in

[2] This problem also served as the opening illustration for the *Scientific American* (vol. 278, p. 62, 1998).

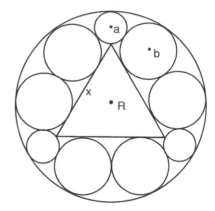

Figure 6.13. Find *x* in terms of *R*.

Fujita's book *Zoku Shinpeki Sanpō*. Note that this is the same as problem 5 in Yamaguchi's Diary, chapter 7. *Warning: This is not easy.*

In a large circle of radius *R*, an equilateral triangle of side *x*, three circles of radius *a* and six circles of radius *b* touch internally as shown in figure 6.13. Find *x* in terms of *R*.

Answer: $x = (57\sqrt{3} + 102 - \sqrt{11,364\sqrt{3} + 19,695})R/2.$

Example: If $2R = 103.5$, then $x = 59.20. \dots$

A traditional solution can be found on page 231.

Problem 14

We know of this problem from the 1830 book *Sanpō Kishō*, or *Enjoy Mathematics Tablets*, by Baba Seitoku (1801–1860). In the book, Baba records thirty-six *sangaku* from Tokyo shrines. The problem was originally proposed by Ishikawa Nagamasa, a student of the

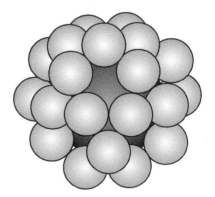

Figure 6.14. Find the radius of the large ball, *R*, in terms of the radius of the small spheres, *r*.

今有如圖以小球二十箇各圍大球小球
者各切隣球與大球上球
三箇與大球
小球徑一十零寸三分三
釐問大球徑幾何

答曰大球徑一十八寸六分二釐有奇

Plate 6.4. The original illustration from problem 15 as it
appears in Fujita Kagen's 1796 edition of *Shinpeki Sanpō*.
(Collection of Fukagawa Hidetoshi.)

school of Baba Seitō (1777–1843), Seitoku's father, and written on a tablet hung in 1798 in Tokyo's Gyūtō Tennōsha shrine.

As shown in figure 6.14, 30 small balls of radius r cover one large ball of radius R, in such a way that each small ball touches four other small balls. Find R in terms of r.

Answer: $R = \sqrt{5}\,r$.

A traditional solution is on page 234.

Problem 15

Kimura Sadamasa, a student of the Fujita school, proposed this problem, which was written on a tablet in 1795 and hung in Kawahara Taishi temple, Kawasaki city, Kanagawa prefecture. It was recorded by Fujita in his *Shinpeki Sanpō*, second edition of 1796. *Advice: Do the previous problem first.*

Twenty small balls of radius r cover one big ball of radius R where each small ball touches three other small balls (see figure 6.15). Find R in terms of r.

The answer and a traditional solution can be found on page 234.

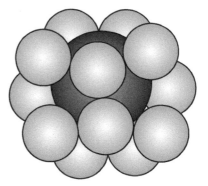

Figure 6.15. Find the radius of the large ball, R, in terms of the radius of the small spheres, r.

Problem 16

This problem comes to us from the book *Kokon Sankan* mentioned in problem 27, chapter 4. It was originally proposed by Teramoto Yohachirō and hung in 1823 on a tablet in the Nishikannta shrine, Ohita prefecture. *Warning: This is an advanced problem.*

As shown in figure 6.16, a necklace of four small spheres r_1, r_2, r_3, r_4 touches a large sphere of radius R. The necklace also touches two spheres of radii a and b, which in turn touch sphere R internally. Find r_4 in terms of r_1, r_2, and r_3.

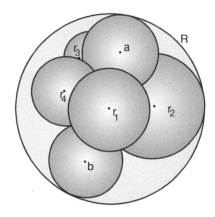

Figure 6.16. Find the relationship between the radii of spheres r_1, r_2, r_3, and r_4.

Plate 6.5. An illustration for a problem similar to problem 16, from Uchida Kyō's 1832 book, *Kokon Sankan*. (Aichi University of Education Library.)

Answer:

$$r_4 = \frac{r_1 r_3}{r_1 + r_3 - (r_1 r_3 / r_2)} \quad \text{or} \quad \frac{1}{r_1} + \frac{1}{r_3} = \frac{1}{r_2} + \frac{1}{r_4}.$$

Example: $r_1 = 1$, $r_2 = 2$, $r_3 = 3$; then $r_4 = 1.2$.

We give a modern solution on page 236.

Problem 17

This problem, famous in the West as the 1937 "hexlet theorem" of Frederick Soddy, also comes from Uchida Kyō's collection *Kokon Sankan*, having been originally proposed in 1822 by Yazawa Hiroatsu, a disciple of the Uchida school. The tablet on which the problem was written was hung in the Samukawa shrine of Kōzagun, Kanagawa prefecture. *Warning: The problem is either extremely difficult or extremely easy, depending on the method of solution.*

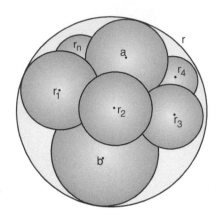

Figure 6.17. Find r_i in terms of a, b, r, and r_1.

As shown in figure 6.17, two spheres of radii a and b lie inside a large sphere of radius r, touching each other and sphere r internally. A loop of n spheres of radii r_1, \ldots, r_n circles the neck between a and b. Each of the spheres r_i touches its nearest neighbors, as well as spheres a, b, and r. Find r_i in terms of a, b, r, and r_1.

We give a traditional solution on page 236 and discuss the problem further in chapter 8.

Problem 18

This problem was written on a tablet hung in 1804 at the Daikokutendō temple, Koishikawa, Tokyo. It was proposed by a student of Ichino Shigetaka and recorded in the book *Shamei Sanpu*.

As shown in figure 6.18, on a sphere of radius r, draw three circular arcs $\overset{\frown}{AB}$, $\overset{\frown}{BC}$, and $\overset{\frown}{CA}$, and let the straight-line segments $AB = c$, $BC = a$, and $CA = b$. Find the area S of the spherical triangle ABC in terms of a, b, c, and r.

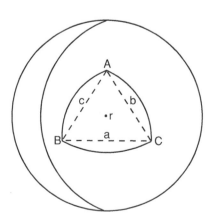

Figure 6.18. Find the area of the spherical triangle ABC in terms of a, b, c, and r.

Answer

$$S = 2r^2 \cos^{-1}\left\{ \frac{1 - (1/2)\left[(a/2r)^2 + (b/2r)^2 + (c/2r)^2\right]}{\sqrt{[1-(a/2r)^2][1-(b/2r)^2][1-(c/2r)^2]}} \right\}.$$

Example: $2r = 10$, $a = 12$, $b = 9$, and $c = 5$; then $S = 37.761708184578$.

The original solution involved the calculation of a definite integral with the help of numerous illustrations, and was so complicated that we do not reproduce it. The theorem, however, was the same as that obtained by Leonard Euler (1707–1783), which can be found in his *Opera Omnia Series Prima*, volume 29, page 253, "Variae Speculations Super Area Triangulorum Sphaerocorum." We say a few more words about it in chapter 8.

Problem 19

This is the leftmost problem on the second Atsuta tablet (color plate 12) and was also proposed by Matsuoka Makoto. *Warning: This is a difficult problem.*

Find the surface area S on an elliptic cylinder with major axis $2a$ and minor axis $2b$ that is defined when the elliptic cylinder intersects perpendicularly two sectors of a right circular cylinder of diameter D and height d. It is assumed that the two sectors touch at point T, which is aligned with the origin of the ellipse. (See figure 6.19.)

The rather involved solution is given on page 238.

Answer: We guess that the area is close to the areas of the two sectors themselves:

$$S = 2S_1 = 4\int_0^d \sqrt{Dx - x^2}\, dx.$$

A discussion is given on page 238.

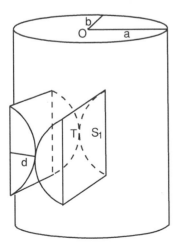

Figure 6.19. Find the area A on an elliptic cylinder that intersects two sectors of a right circular cylinder. The diameter of the cylinder is D and the depth of the sector is d.

Solutions for Chapter 6 Problems

Problem 1

We quote an original solution from Okayu Yasumoto's unpublished manuscript "Solutions to Problems of Zoku Shinpeki Sanpō." First, three lemmas, which Okayu does not prove, are required:

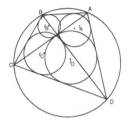

(1) The area of a triangle ABC can be expressed as $S_{ABC} = rs = (abc)/4R$, where a, b, and c are the sides of the triangle; $s \equiv (a + b + c)/2$ is the semiperimeter of $\triangle ABC$; and r and R are the radii of the inscribed and circumscribed circles of the triangle (see figure 6.20). This lemma follows directly from two elementary theorems: one, that the area of a triangle ABC can be written as $S_{ABC} = rs$, where r is the radius of the triangle's incircle and is its semiperimeter; and two, that the radius R of the circumcircle is $R = abc/4S_{ABC}$.

(2) In figure 6.1, $AB \cdot CD + AD \cdot BC = AC \cdot BD$. This is known as Ptolemy's theorem in the West: "The sum of the products of the opposite sides of a cyclic quadrilateral is equal to the product of the diagonals."[3] Ptolemy's theorem is proven in any high school geometry text and so we leave it as an exercise. Note: From this point on we will use the following designations: $AB \equiv a$, $BC \equiv b$, $CD \equiv c$, $AD \equiv d$, $AC \equiv e$, $BD \equiv f$. Thus Ptolemy's theorem for this problem becomes $ac + bd = ef$.

(3) With these designations, $abe + cde = bcf + adf$. To prove this lemma, refer to figure 6.1. We see that if S is the area of the quadrilateral, then

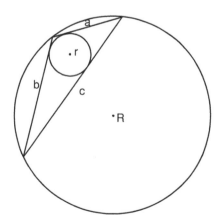

Figure 6.20. The area of the triangle can be written as $A = rs$ and $R = abc/4A$, for sides a, b, c and semiperimeter s.

[3] A cyclic quadrilateral is one that can be inscribed in a circle.

$S = \frac{1}{2}ad \sin A + \frac{1}{2}bc \sin C$. But $\angle A$ and $\angle C$ are supplementary and so $S = \frac{1}{2}(ad + bc) \sin A$. Similarly, $S = \frac{1}{2}ab \sin B + \frac{1}{2}cd \sin D = \frac{1}{2}(ab + cd) \sin B$.

On the other hand, $\triangle ABD$ is inscribed in circle R, so by lemma 1, $S_{ABD} = adf/4R$. But also $S_{ABD} = (1/2)\ ad \sin A$, giving $\sin A = f/(2R)$. Similarly, $\sin B = e/(2R)$. Eliminating $\sin A$ and $\sin B$ from the previous two expressions immediately yields $f(ad + bc) = e(ab + cd)$.

Okayu's proof is as follows.

By lemma 1, $S_{ABD} = adf/(4R) = r_A(a + d + f)/2$, with similar expressions for S_{BCD}, S_{ACD} and S_{ABC}. Therefore

$$r_A = \frac{adf}{2R(a + d + f)}; \quad r_B = \frac{abe}{2R(a + b + e)};$$
$$r_C = \frac{bcf}{2R(b + c + f)}; \quad r_D = \frac{cde}{2R(c + d + e)}. \tag{1}$$

We have

$$2R(r_A + r_C) = \frac{bcf(a + d + f) + adf(b + c + f)}{(b + c + f)(a + d + f)}. \tag{2}$$

The numerator of the right-hand side of this equation is

$$(a + d)bcf + (b + c)adf + f^2(bc + ad) = f[ab(c + d + e) + cd(a + b + e)],$$

since $f^2(bc + ad) = ef(ab + cd)$ by lemma 3).

The denominator is $f^2 + f(a + b + c + d) + (b + c)(a + d)$. But, by lemmas 2 and 3,

$$(b + c)(a + d) = (ac + bd) + (ab + cd) = ef + (f/e)(ad + bc),$$

and so

denominator =

$$\frac{f}{e}[ef + e(a + b + c + d) + e^2 + bc + ad] = \frac{f}{e}[(a + b + e)(c + d + e)],$$

where lemma 2 has been used again to get the second equality. Equation (2) then becomes

$$2R(r_A + r_C) = \frac{e[ab(c + d + e) + cd(a + b + e)]}{(a + b + e)(c + d + e)}$$
$$= \frac{abe}{a + b + e} + \frac{cde}{c + d + e},$$

or from equation (1) the beautiful result

$$r_A + r_C = r_B + r_D.$$

Problem 2

We first quote a traditional solution from the manuscript *Solutions to Kakki Sanpō* by Furuya Michio(?–?). The date is unknown.

First we rotate the figure and label some points and segments as shown in figure 6.21. Then, using area = (1/2) base × altitude,

$$S = \frac{1}{2} b h_2; \tag{3}$$

$$\alpha = \frac{1}{2} b_1 h_1; \tag{4}$$

$$\beta = \frac{1}{2} b_2 h_1; \tag{5}$$

$$\alpha + \beta = \frac{1}{2} b h_1; \tag{6}$$

$$\alpha + \beta + \gamma = \frac{1}{2} b h_3. \tag{7}$$

Also, by similar triangles,

$$l_3 = \frac{h_3 l_2}{h_2}; \tag{8}$$

$$t_1 = \frac{h_1 t_2}{h_2}; \tag{9}$$

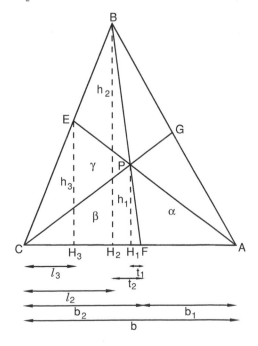

Figure 6.21. Note: $l_2 = CH_2$, $l_3 = CH_3$, $t_1 = FH_1$, $t_2 = FH_2$, $b = AC$, $b_1 = AF$, $b_2 = CF$.

$$\frac{h_3}{h_1} = \frac{b - l_3}{b_1 + t_1}.\qquad(10)$$

The last equation can be rewritten as $h_3(b_1 + t_1) - h_1(b - l_3) = 0$. Eliminating t_1 and l_3 by equations (8) and (9) gives

$$h_3\left(b_1 + \frac{h_1 t_2}{h_2}\right) - h_1\left(b - \frac{h_3 l_2}{h_2}\right) = 0.$$

However, we also see from the figure that $t_2 = b_2 - l_2$. Substituting for t_2 yields

$$b_1 h_3 + \frac{h_1 h_3 b_2}{h_2} - b h_1 = 0.$$

Now, eliminating all the h's with equations (3)–(7), we quickly get

$$\frac{\alpha(\alpha + \beta + \gamma)}{\alpha + \beta} + \frac{\beta(\alpha + \beta + \gamma)}{S} - (\alpha + \beta) = 0,$$

and solving for S gives

$$S = \frac{\beta(\alpha + \beta)(\alpha + \beta + \gamma)}{(\alpha + \beta)^2 - \alpha(\alpha + \beta + \gamma)} = \frac{\beta(\alpha + \beta)(\alpha + \beta + \gamma)}{\beta(\alpha + \beta + \gamma) - \gamma(\alpha + \beta)},$$

as stated on the tablet. The quoted example was also found on the tablet.

The solution just given is somewhat cumbersome, and so here is a slightly more elegant one, which is quite similar to a standard proof of Ceva's theorem.[4]

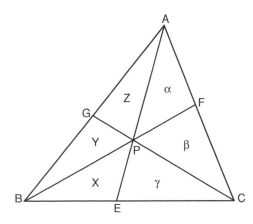

Figure 6.22. Define the areas $X = \triangle BPE$, $Y = \triangle PGB$, and $Z = \triangle APG$.

[4] Proofs of Ceva's theorem can be found in some elementary texts, in any more advanced text, and on dozens of websites. Ceva's theorem is not necessary for this problem.

Referring to areas, let $X = \Delta BPE$, $Y = \Delta PGB$ and $Z = \Delta APG$, as in figure 6.22. Then, from the figure, $S = X + Y + Z + \alpha + \beta + \gamma$. The strategy is to find $X + Y + Z$. Recalling that the areas of triangles with equal altitudes are proportional to the bases of the triangles,

$$\frac{CE}{BE} = \frac{\gamma}{X} = \frac{\alpha + \beta + \gamma}{X + Y + Z},$$

and

$$\frac{AF}{FC} = \frac{\alpha}{\beta} = \frac{\alpha + Y + Z}{\beta + X + \gamma} = \frac{Y + Z}{X + \gamma},$$

where the last equality follows because if $a/b = c/d$ then $a/b = (a \pm c)/(b \pm d)$.

The two expressions imply

$$X + Y + Z = \frac{\alpha + \beta + \gamma}{\gamma} X,$$

$$Y + Z = \frac{\alpha(X + \gamma)}{\beta}.$$

Solving these equations simultaneously gives

$$X = \frac{\alpha\gamma^2}{\beta(\alpha + \beta) - \alpha\gamma}$$

and

$$X + Y + Z = \frac{\alpha\gamma(\alpha + \beta + \gamma)}{\beta(\alpha + \beta) - \alpha\gamma}.$$

Finally,

$$S = X + Y + Z + \alpha + \beta + \gamma = \frac{\beta(\alpha + \beta)(\alpha + \beta + \gamma)}{\beta(\alpha + \beta) - \alpha\gamma}$$

as before.

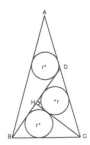

Problem 3

We give an original solution by Kitagawa Mōko. It is somewhat complicated and we hope that readers can find a simpler one.

First, notice from figure 6.23 that triangle CDB is isosceles. Therefore let $b \equiv BC = CD$, as indicated. We also let $a \equiv BD$ and $k \equiv CH$. Next, as shown in figure 6.24, mark with a compass two points D' on AB and D'' on AC such that $BD = BD' = CD'' = a$. Because ΔABC is isosceles, $D'T' = D''T''$ and by construction $D'T' = DT$; consequently $DT = D''T''$.

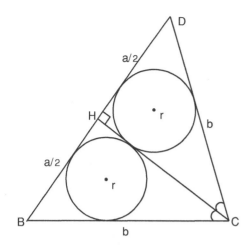

Figure 6.23. The tangents from vertex C intercept identical circles at identical distances. Therefore angle HCB and angle HCD are equal, and triangles CHB and CHD are congruent. Hence triangle BCD is isosceles. We define $BC = CD = b$, $BD = a$, and $CH = k$ (see figure 6.24).

T and T'' are equidistant from D and therefore $DT'' = D''T''$. Defining $s = DT = DT''$ we can write

$$s = \frac{CD'' - CD}{2} = \frac{a - b}{2}. \tag{1}$$

Further, by examining the tangents in figure 6.24, we see that

$$b = (k - r) + \left(\frac{a}{2} - r\right) = \frac{a}{2} + k - 2r. \tag{2}$$

Hence, from equation (1)

$$s = \frac{a}{4} - \frac{k - 2r}{2}. \tag{3}$$

Also, with the Pythagorean theorem, figure 6.23 shows that $b^2 = (a/2)^2 + k^2$. Squaring equation (2) and equating the two expressions quickly yields

$$a = \frac{4r(k - r)}{k - 2r}. \tag{4}$$

Next, as shown in figure 6.25, inscribe a circle of radius R in triangle BCD. With the help of the figure it is easy to show that

$$CQ = \sqrt{(k - R)^2 - R^2} = \sqrt{k^2 - 2Rk} = b - \frac{a}{2} = k - 2r, \tag{5}$$

where the last equality follows from equation (2). Squaring equation (5) gives $2Rk = (4kr) - 4r^2$, or

$$R = \frac{2r(k - r)}{k}. \tag{6}$$

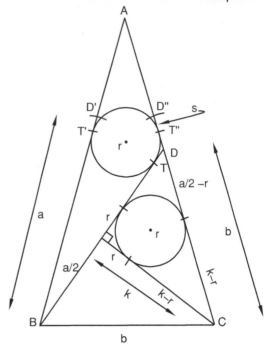

Figure 6.24. Let $a \equiv BD$ and $b \equiv CD$. For $\triangle ABC$ isosceles, we have by construction $D'T' = DT = DT'' = D''T''$. Therefore $2D''T'' \equiv 2s = a - b$.

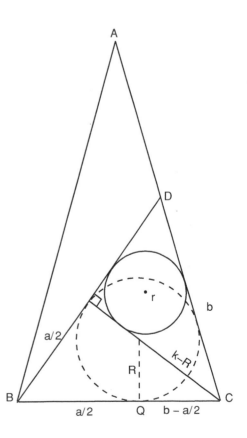

Figure 6.25. With equation (2), the Pythagorean theorem gives R in terms of r and k.

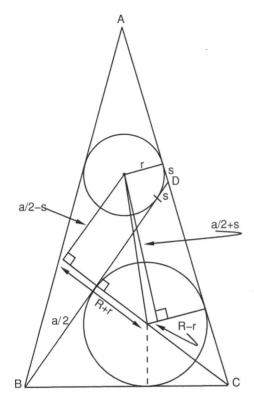

Figure 6.26. The Pythagorean theorem can now be used on the two right triangles in the center.

The strategy is now to eliminate R in favor of r and k. Applying the Pythagorean theorem directly to figure 6.26 gives

$$(R+r)^2 + \left(\frac{a}{2} - s\right)^2 = (R-r)^2 + \left(s + \frac{a}{2}\right)^2,$$

or, after simplifying,

$$2Rr = as. \tag{7}$$

The problem is almost solved. We now replace R on the left of equation (7) by equation (6) and as on the right by the expressions in equations (3) and (4) to get

$$2\frac{2r(k-r)}{k}\, r = \frac{4r(k-r)}{k-2r}\left(\frac{r(k-r)}{k-2r} - \frac{k-2r}{2}\right),$$

which gives the cubic

$$k^3 - 4rk^2 - 2kr^2 + 8r^3 = (k^2 - 2r^2)(k - 4r) = 0.$$

From any of the figures, the relevant root is $k = 4r$, and thus we have the final result

$$r = \frac{CH}{4}.$$

Problem 4

This solution is by Ōmura Kazuhide (1824–1891), from his 1841 book *Sanpō Tenzan Tebikigusa*, or *Algebraic Methods in Geometry*.

First we draw figure 6.27. The radii of circles O, O_1, O_2, and O_3 are r, r_1, r_2, and r_3, respectively. The basic approach will be to calculate a number of relevant areas as functions of the four radii, then eliminate the areas to get r in terms of r_1, r_2, and r_3.

To do this, start by the same method employed in many of this book's problems (e.g., chapter 3, problem 13) to find that the lengths are

$$GD = 2\sqrt{r_1 r_3}; \quad D'E' = 2\sqrt{r_1 r_2}; \quad EF = 2\sqrt{r_2 r_3}. \tag{1}$$

By using the equality of tangents from vertices A, B, and C to their respective inscribed circles, one also sees that $E'C' = EA'$, $GB' = FA'$, etc. With these one can establish

$$GD + D'E' - EF = 2B'D; \ D'E' + EF - GD = 2C'E'; \ GD + EF - D'E' = 2GB'. \tag{2}$$

The area of the quadrilaterals formed by the auxiliary lines can easily be calculated by the trapezoid formula and equation (1):

$$GO_3O_1D = \frac{1}{2}(r_1 + r_3)GD = (r_1 + r_3)\sqrt{r_1 r_3},$$

$$D'O_1O_2E' = \frac{1}{2}(r_1 + r_2)D'E' = (r_1 + r_2)\sqrt{r_1 r_2},$$

$$EO_2O_3F = \frac{1}{2}(r_2 + r_3)EF = (r_2 + r_3)\sqrt{r_2 r_3}. \tag{3}$$

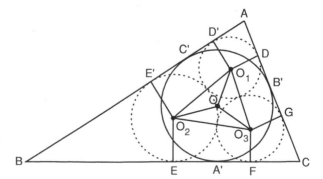

Figure 6.27. Mark the important points and draw the auxiliary lines shown.

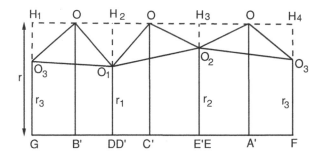

Figure 6.28. The central figure in the triangle cut out, unfolded, and joined together such that the end points F and G match, as well as intermediate points DD' and EE'. The points H_i are the endpoints ("perpendicular feet") of the radii of each circle, e.g., GO_3, extended to the height of O.

We now, hopefully, simplify by drawing a second diagram, figure 6.28, which represents the central figure ($EFO_3GDO_1D'E'O_2$) cut out from the triangle and unfolded. (In other words, this is the figure that remains after cutting away the three quadrilaterals at the vertices of the triangle.) The points H_1, \ldots, H_4 are the points at which extensions of the radii GO_3 etc. reach the height O

From figure 6.28 and equations (1) and (2) we see that the areas of the missing triangles are

$$\Delta O_3 H_1 O = \frac{1}{2}(r - r_3)GB' = \frac{1}{2}(r - r_3)\left(\sqrt{r_1 r_3} + \sqrt{r_2 r_3} - \sqrt{r_1 r_2}\right),$$

$$\Delta O O_1 H_2 = \frac{1}{2}(r - r_1)B'D = \frac{1}{2}(r - r_1)\left(\sqrt{r_1 r_3} + \sqrt{r_1 r_2} - \sqrt{r_2 r_3}\right),$$

$$\Delta O_2 H_2 O = \frac{1}{2}(r - r_2)C'E = \frac{1}{2}(r - r_2)\left(\sqrt{r_1 r_2} + \sqrt{r_2 r_3} - \sqrt{r_1 r_3}\right). \quad (4)$$

It is now convenient to employ Heron's formula, which gives the area of a triangle in terms of its sides and semiperimeter[5]:

$$\text{Area}_\Delta = \sqrt{s(s-a)(s-b)(s-c)} = \frac{1}{4}\sqrt{(a+b+c)(a+b-c)(a+c-b)(b+c-a)}.$$

Focusing on the central triangle $O_1 O_2 O_3$, we have $a = r_1 + r_2$, $b = r_1 + r_3$, $c = r_2 + r_3$, and get for the area

$$\Delta O_1 O_2 O_3 = \sqrt{(r_1 + r_2 + r_3)(r_1 r_2 r_3)} = \Delta O O_1 O_2 + \Delta O O_1 O_3 + \Delta O O_2 O_3, \quad (5)$$

where the last three triangles are shown on figure 6.28.

Of course, the area of the big rectangle $GH_1 H_4 F$ in figure 6.28 is just rGF, which with the help of equation (1) is

$$GH_1 H_4 F = 2r\left(\sqrt{r_1 r_3} + \sqrt{r_1 r_2} + \sqrt{r_2 r_3}\right). \quad (6)$$

[5] See problem 1, this chapter. Heron's formula is discussed in most elementary geometry texts and on many websites.

From equations (3)–(5) we now have all the component parts of the rectangle's area. We simply add them all up and equate them to the area from equation (6):

$$2r(\sqrt{r_1 r_3} + \sqrt{r_1 r_2} + \sqrt{r_2 r_3}) = \sqrt{(r_1 + r_2 + r_3)(r_1 r_2 r_3)}$$
$$+ (r - r_3)(\sqrt{r_1 r_3} + \sqrt{r_2 r_3} - \sqrt{r_1 r_2})$$
$$+ (r - r_1)(\sqrt{r_1 r_3} + \sqrt{r_1 r_2} - \sqrt{r_2 r_3})$$
$$+ (r - r_2)(\sqrt{r_1 r_2} + \sqrt{r_2 r_3} - \sqrt{r_1 r_3})$$
$$+ (r_1 + r_3)\sqrt{r_1 r_3} + (r_1 + r_2)\sqrt{r_1 r_2} + (r_2 + r_3)\sqrt{r_2 r_3}.$$

Canceling many terms leaves

$$r(\sqrt{r_1 r_2} + \sqrt{r_1 r_3} + \sqrt{r_2 r_3}) = \sqrt{(r_1 + r_2 + r_3)(r_1 r_2 r_3)}$$
$$+ r_1\sqrt{r_2 r_3} + r_2\sqrt{r_1 r_3} + r_3\sqrt{r_1 r_2},$$

or, finally,

$$r = \frac{\sqrt{r_1 r_2 r_3}\left[\sqrt{r_1} + \sqrt{r_2} + \sqrt{r_3} + \sqrt{(r_1 + r_2 + r_3)}\right]}{\sqrt{r_1 r_2} + \sqrt{r_1 r_3} + \sqrt{r_2 r_3}}$$
$$= \frac{2\sqrt{r_1 r_2 r_3}}{\sqrt{r_1} + \sqrt{r_2} + \sqrt{r_3} - \sqrt{(r_1 + r_2 + r_3)}}.$$

We will speak more about this problem in chapter 8.

Problem 5

The solution to this problem is not written on the tablet, but mathematician Yoshida Tameyuki (chapter 3) gave a solution in his notebook *Chōshū Shinpeki*, or *Sangaku from the Chōshū Region*.

Yoshida set the following three lemmas without proof. If $2a$ and $2b$ are the major and minor axes of the ellipse, respectively, then

(1) $r_1 = b^2/a$.
(2) $r_2 = 3r_1 - 4r_1^2/a$.
(3) $p^2 = b^2(b^2 - r_2^2)/(a^2 - b^2)$,

where p is the distance in y from the center of the internal circle r_2 to the point of tangency with the external circle r_2 (see figure 6.31 below).

To prove lemma 1, refer to figures 6.29 and 6.30. An ellipse is to be regarded as the section of a right circular cylinder cut by a plane. The minor axis $2b$ is simply the diameter of the cylinder. A circle inscribed

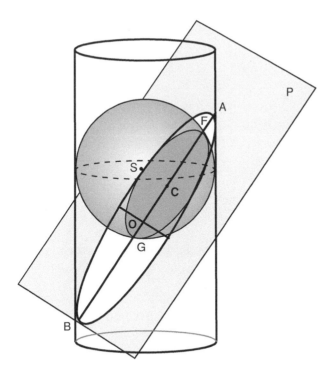

Figure 6.29. A plane *P* cuts a right circular cylinder, producing an ellipse with major axis *AB*. The center of the ellipse is *O*. A sphere with center *S* intersects the plane containing the ellipse, producing a circle with center *C*. The points of tangency between the circle and the ellipse are where the "equator" of the sphere (dashed circle) intersects the ellipse.

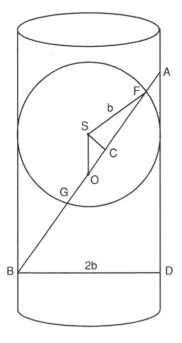

Figure 6.30. Side view of plane *P* cutting cylinder. The segment *AB* is the major axis of ellipse = 2*a*. The diameter of the cylinder is the minor axis of the ellipse = 2*b*.

within the ellipse is the intersection of a sphere of radius b with the plane containing the ellipse. Figure 6.30 represents a side view of plane AB slicing the cylinder. Therefore $AB = 2a$, $BD = 2b$ and $AD = 2\sqrt{a^2 - b^2}$.

Now, if O is the center of the ellipse, S is the center of the sphere, and C is the center of the projected circle with diameter FG, we see that triangles ABD and SCO are similar, and so $OC = SC \cdot AD/BD$. But since b is the radius of sphere S, $SC = \sqrt{b^2 - r^2}$. Hence, the distance between the center of the ellipse O and the center of the circle C is

$$OC = \frac{\sqrt{(a^2 - b^2)(b^2 - r^2)}}{b}. \tag{1}$$

As circle C moves towards one end of the ellipse and shrinks, the maximum distance it can attain while still being inscribed in the ellipse is

$$OC = a - r.$$

Inserting this into equation (1) gives, after squaring both sides, $(ar - b^2) = 0$, or

$$r = \frac{b^2}{a}. \tag{2}$$

This is the radius of curvature at one end of the ellipse.[6] In our case $r = r_1$ and Lemma 1 is proven.

To prove lemma 2, equation (1) shows that, if two inscribed circles of radii r_1 and r_2 are touching each other externally, then for $r_2 > r_1$ the distance between the centers is

$$r_1 + r_2 = \frac{\sqrt{(a^2 - b^2)(b^2 - r_1^2)}}{b} - \frac{\sqrt{(a^2 - b^2)(b^2 - r_2^2)}}{b}. \tag{3}$$

From equation (2) let $b^2 = ar_1$ in this expression. A page or so of straightforward algebra yields

$$(r_1 + r_2)(4r_1^2 + ar_2 - 3ar_1) = 0.$$

Because we require $r_2 > 0$, we get Yoshida's lemma 2:

$$r_2 = 3r_1 - \frac{4r_1^2}{a}.$$

To prove lemma 3, note from figure 6.31 that $CY = p$ and from figure 6.32 that triangles SCY and ABD are similar. Thus, $p/SC = BD/AD$.

[6] The radius of curvature of an arbitrary figure is the radius of a circle that "matches" (is tangent to and has same curvature as) the figure at the point in question.

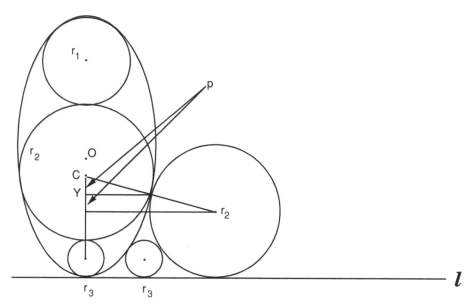

Figure 6.31. Similar triangles shows that the two segments indicated by the arrows are equal. The point Y has the same y-coordinate as the point of tangency between the circles r_2 and the ellipse.

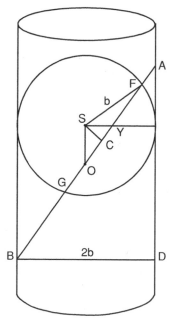

Figure 6.32. Point Y lies on the "equatorial plane" of the sphere and therefore is connected to S by a horizontal line (see figure 6.29). This means that triangles SCY and ABD are similar.

From above we have $SC = \sqrt{b^2 - r^2}$, $AD = 2\sqrt{a^2 - b^2}$ and $BD = 2b$. With $r = r_2$ we immediately get Yoshida's lemma 3:

$$p^2 = \frac{b^2(b^2 - r_2^2)}{a^2 - b^2} \tag{4}$$

We can now proceed to Yoshida's original solution to the problem:

Into equation (4) substitute $b^2 = ar_1$ from lemma 1 and r_2 in terms of r_1 from lemma 2. A bit of algebra gives

$$p = \frac{r_1(4r_1 - a)}{a}. \tag{5}$$

From figure 6.31 we see that $2p = 2r_3 + r_2 - r_2$, or $p = r_3$. Equation (5) then gives

$$a = \frac{4r_1^2}{r_1 + r_3}. \tag{6}$$

Lemma 2 then immediately yields $r_2 = 2r_1 - r_3$. By inspection of figure 6.31 we also have $a = r_1 + r_2 + r_3$, and so $a = 3r_1$. Inserting this into equation (6) gives the final result

$$r_1 = 3r_3.$$

Notice that nowhere in this solution did we use the standard equation for an ellipse!

Problem 6

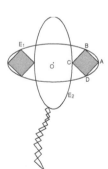

From figure 6.6, we see that $AC = a - b$, where $2a$ and $2b$ are the major and minor axes of the ellipse. Also, if M is the midpoint of BD, then since $AC = BD$, we have $BD = 2BM = a - b$, and so the side of the square is $\sqrt{2}BM = \sqrt{2}(a - b)/2$. However, not any a and b will do for the kite problem.

To determine the relationship between a and b for the kite, we perform what geometers term an affine transformation on ellipse E_1. That is, as discussed more fully in the solution to problem 19, the change of variables $u = x$ and $v = (a/b)y$ transforms the ellipse $x^2/a^2 + y^2/b^2 = 1$ into the circle $u^2 + v^2 = a^2$. Figure 6.33 shows that this transformation has the effect of leaving the x-coordinates (and the major axis) unchanged, but stretching the y-coordinates (and hence the minor axis) by the factor (a/b). As we will see in the next problem, such a transformation can also be viewed as a projection of an ellipse onto a circle, very much in the spirit of what was done in the solution to problem 5.

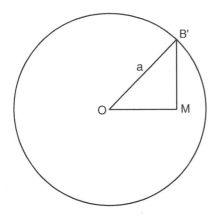

Figure 6.33. The ellipse E_1 has been stretched in the y-direction to a circle. The length OM remains unchanged $= (a + b)/2$ but the length BM has become $B'M = [(a - b)/2](a/b)$.

In the case of the kite, this transformation therefore leaves $OM = (a + b)/2$ invariant, since it is a distance along the x-axis. On the other hand $BM = (a - b)/2$, being a vertical segment, is stretched into a chord $B'M$ of length $[(a - b)/2](a/b)$. Applying the Pythagorean theorem to the triangle OMB' in figure 6.33 gives

$$a^2 = OM^2 + \left(\frac{a - b}{2}\right)^2 \left(\frac{a}{b}\right)^2,$$

which results in the fourth-order equation

$$a^4 - 2a^3b - 2a^2b^2 + 2ab^3 + b^4 = 0.$$

This expression in turn factors into

$$(a - b)(b + a)(a^2 - 2ab - b^2) = 0,$$

which for $a > b$ has the solution $a - b = \sqrt{2}\,b$. We already know from above that the side of the square is $\sqrt{2}\,(a - b)/2$ and so we have simply that the side of the square in the kite is

$$\frac{\sqrt{2}\,(a - b)}{2} = \frac{\sqrt{2}\,\sqrt{2}}{2}\,b = b,$$

the minor axis. One must be amazed.

Problem 7

We follow much the same procedure as in the previous problem. As discussed in problem 5 (in particular figure 6.29), traditional Japanese geometers viewed an ellipse as a section cut from a right circular cylinder. Conversely, they could view a circle as the projection of an ellipse onto the top of a cylinder. The affine transformation mentioned

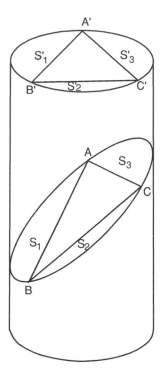

Figure 6.34. Project the triangle in the ellipse into a triangle in the circle; it becomes equilateral.

in problem 19 can be seen in the same way, not only as a stretching or shrinking of an axis of the ellipse, but as the projection of an ellipse onto the top of a cylinder. Thus, as shown in figure 6.34, we can imagine triangle ABC to be embedded in an ellipse within a cylinder. Projecting it onto the top of the cylinder has the effect of shrinking the major axis of the ellipse by an amount b/a, while leaving the minor axis constant. The result is $\triangle A'B'C'$. Because the areas S_1, S_2, S_3 were assumed equal, $\triangle A'B'C'$ must be equilateral. Furthermore, the diameter of the circle circumscribing this triangle is the minor axis of the ellipse, and so area $\triangle A'B'C' = (3/4)\sqrt{3}b^2$. Triangle ABC is merely $\triangle A'B'C'$ stretched in one direction; consequently, the area is

$$\frac{a}{b}\left(\frac{3}{4}\sqrt{3}b^2\right).$$

Problem 8

We outline a traditional solution from Aida Yasuaki's 1810 book *Sanpō Tenshōhō Shinan*, or *Guide Book to Algebra and Geometry*. The problem is not too difficult if one understands the solution to problem 5. We follow the method used to prove Yoshida's lemma 2, in

particular equation (3). Squaring out that equation leads to a quadratic in r_1:

$$r_1^2 - 2\frac{(a^2 - 2b^2)r_1 r_2}{a^2} + r_2^2 - 4b^4 \frac{(a^2 - b^2)}{a^4} = 0.$$

In a way similar to several other problems encountered in this book (see in particular chapter 7, problem 1, and problem 12 in this chapter), one root of this quadratic is the one we are looking for (in this case, the smaller root), while the larger root turns out to be r_3. (Convince yourself of this by doing the first few cases explicitly.) Since for any quadratic equation $ax^2 + bx + c = 0$, the sum of the roots $x_+ + x_- = -b/a$, we get from above

$$r_1 + r_3 = 2\frac{(a^2 - 2b^2)r_2}{a^2}.$$

This relationship holds for any triplet of circles, and so one has the recursion relationship

$$r_n + r_{n+2} = kr_{n+1},$$

where $k \equiv 2(a^2 - 2b^2)r_2/a^2$. By tediously writing out the radii of all ten circles in terms of r_1 and r_2, one easily establishes the desired relationship $r_7(r_1 + r_7) = r_4(r_4 + r_{10})$. On the tablet, an example was written: $r_1 = 18$, $r_4 = 32$, $r_7 = 30$, and $r_{10} = 13$.

For a further challenge, one can place smaller circles in the interstices of the larger ones and find the relationships among *those*.

Problem 9

We give a solution in the traditional spirit:

Let the radius of circle $O = r$. Referring to figure 6.35, we have by the law of cosines

$$(r - a)^2 = a^2 + p^2 - 2ap \cos \alpha,$$
$$(r - b)^2 = b^2 + p^2 - 2bp \cos \beta,$$

where $p \equiv OP$. However, α and β are supplementary angles, and so $\cos \alpha = -\cos \beta$. Thus,

$$\frac{(r - a)^2 - a^2 - p^2}{2ap} + \frac{(r - b)^2 - b^2 - p^2}{2bp} = 0.$$

Putting this over a common denominator shows that

$$\frac{1}{a} + \frac{1}{b} = \frac{4r}{r^2 - p^2}.$$

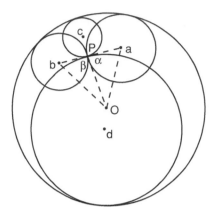

Figure 6.35. Draw the auxiliary lines shown and mark angles α and β.

But r and p for this problem are fixed, so the right-hand side of this equation is a constant. The analysis must also hold for circles c and d. Therefore

$$\frac{1}{a}+\frac{1}{b}=\frac{1}{c}+\frac{1}{d}.$$

This simple exercise gives a good idea of why in so many problems solvable by inversion (for example, problem 10) give results of the form "sum of reciprocal radii = constant."

Problem 10

We only need to consider the one-half of the diagram. For the moment, assume that the centers of circles r, r_2, and r_3 are colinear. Then, figure 6.36 shows that $r = t + 2r_1 = t + 2r_3 + 2r_2$, or

$$r_1 = r_2 + r_3.$$

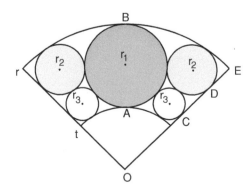

Figure 6.36. Choose k to invert r_3 into r_2, and vice versa.

similar triangles gives

$$\frac{r_3}{t + r_3} = \frac{r_2}{t + 2r_3 + r_2},$$

or eliminating t by the previous expression,

$$\frac{r_3}{r - 2r_2 - r_3} = \frac{r_2}{r - r_2}.$$

Consequently,

$$r_3 = \frac{1}{r}(-2r_2^2 + rr_2). \qquad (1)$$

Since r is assumed constant, we can take the derivative of r_3 with respect to r_2 and set it to zero to immediately get $r_2 = r/4$ and $r_3 = r/8$. Hence, $2r_1 + 2r_3 = 2r_2 + 4r_3 = r$, as stated.

This can also be done without calculus by rewriting equation (1) as

$$r_3 = \frac{1}{r}\left[-2\left(r_2 - \frac{r}{4} \right)^2 + \frac{r^2}{8} \right].$$

Notice that the first term is negative definite. Thus r_3 is maximized when $r_2 = r/4$, as before.

We need to establish that O, the center of circle r_2 and the center of circle r_3 are colinear. Here we make the first use of the inversion technique (see chapter 10). Theorem M, which was stated without proof, says that a circle, its inverse, and the circle of inversion all have centers that are colinear. Thus, choosing O as the center of inversion, if we can invert r_2 into r_3 and vice versa, we have shown that the two circles are colinear with O, and the rest of the proof follows.

To do this, notice that if in figure 6.36 we invert circle t into circle r, and vice versa, then circle r_1 must invert into itself in order to keep the points of tangency A and B invariant. Similarly, r_3 and r_2 are tangent to r_1 and to the line OE at the points C and D. In order that all points of tangency are preserved, in particular that C inverts into D and vice versa, then r_2 must invert into r_3, and the reverse. To do this, merely choose the radius of inversion k such that $k^2 = rt$.

Problem 11

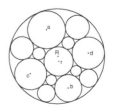

No solution is written on the tablet. We give a modern one based on the technique of inversion; with this the problem is easy, without it almost impossible. Readers not familiar with inversion should study chapter 10 first, in particular Theorems N and P.

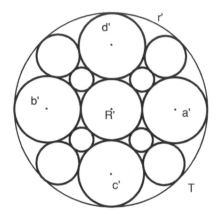

Figure 6.37. The inverse of figure 6.11.

Theorem N tells us that, by a proper choice of the center of inversion we can invert any two nonintersecting circles into a pair of concentric circles. Thus, consistent with the discussion of Theorem N, choose T outside R in figure 6.11 and on the line segment joining the centers of r and R. Theorem N then tells us that r and R will be mapped into the concentric circles r' and R', as shown in figure 6.37. Because, by Theorem K, points of tangency are preserved under inversion, a', b', c', and d' must all be tangent to r' as shown, and hence all have the same radius! In that case their centers form a square. (We leave it as an exercise to construct the details of the figure.) From Theorem P, it immediately follows that the relation between the radii of the original circles is

$$\frac{1}{a} + \frac{1}{b} = \frac{1}{c} + \frac{1}{d}.$$

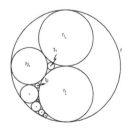

Problem 12

Here, we give a traditional solution by Yoshida Tameyuki from his unpublished and undated manuscript "Solutions to *Shinpeki Sanpō* Problems."

To solve Hotta's problem, Yoshida repeatedly employs a theorem known in the West as the "Descartes circle theorem" (DCT). We discuss and prove it in chapter 8. For now we just state the result:

If three circles of radii r_1, r_2, and r_3 touch each other, touch a small circle of radius t externally and touch a circle of radius r internally, as shown in figure 6.38, then the following relationships hold:

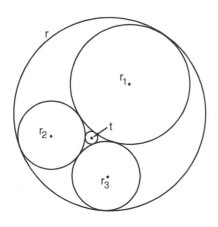

Figure 6.38. The Descartes circle theorem gives the relationships among the circles.

$$2\left(\frac{1}{r_1^2}+\frac{1}{r_2^2}+\frac{1}{r_3^2}+\frac{1}{t^2}\right)=\left(\frac{1}{r_1}+\frac{1}{r_2}+\frac{1}{r_3}+\frac{1}{t}\right)^2,$$

$$2\left(\frac{1}{r_1^2}+\frac{1}{r_2^2}+\frac{1}{r_3^2}+\frac{1}{r^2}\right)=\left(\frac{1}{r_1}+\frac{1}{r_2}+\frac{1}{r_3}-\frac{1}{r}\right)^2. \tag{2}$$

Yoshida's plan is quite simple. He uses the DCT on successive triplets of circles to inductively establish a recursion relationship for the r_n and t_n.

To begin, let $a \equiv 1/r$ and $p_n \equiv 1/r_n$. Then examine each r_n in turn:

$[r_1]$: $r_1 = r/2$, or $p_1 = 2a$.

$[r_2]$: Use DCT for $\{r_1, r_1, r_2, r\}$ in figure 6.12 to get

$$2\left(\frac{1}{r_1^2}+\frac{1}{r_1^2}+\frac{1}{r_2^2}+\frac{1}{r^2}\right)=\left(\frac{1}{r_1}+\frac{1}{r_1}+\frac{1}{r_2}-\frac{1}{r}\right)^2,$$

or

$$2(4a^2 + 4a^2 + p_2^2 + a^2) = (2a + 2a + p_2 - a)^2.$$

Solving for p_2 gives $p_2 = 3a$ or $r_2 = r/3$.

$[r_3]$: Use DCT for $\{r_1, r_2, r_3, r\}$ to get

$$2\left(\frac{1}{r_1^2}+\frac{1}{r_2^2}+\frac{1}{r_3^2}+\frac{1}{r^2}\right)=\left(\frac{1}{r_1}+\frac{1}{r_2}+\frac{1}{r_3}-\frac{1}{r}\right)^2,$$

or, from the previous steps,

$$2(4a^2 + 9a^2 + p_3^2 + a^2) = (2a + 3a + p_3 - a)^2.$$

Hence, $p_3 = 6a$ or $r_3 = r/6$. [This is the larger root of the quadratic. The small root is $p_{3-} = 2a = p_1$, which we discard.]

$[r_4]$ Use the DCT for $\{r_1, r_3, r_4, r\}$ to get

$$2\left(\frac{1}{r_1^2} + \frac{1}{r_3^2} + \frac{1}{r_4^2} + \frac{1}{r^2}\right) = \left(\frac{1}{r_1} + \frac{1}{r_3} + \frac{1}{r_4} - \frac{1}{r}\right)^2,$$

or from the previous,

$$82\,a^2 + 2\,p_4^2 = (7\,a + p_4)^2.$$

Thus $p_4 = 11a$ or $r_4 = r/11$. [The small root is $p_{4-} = p_2$, which we discard.]

$[r_n]$ Use the DCT $\{r_1, r_n, r_{n+1}, r\}$ in the general case to get

$$2(p_1^2 + p_n^2 + p_{n+1}^2 + a^2) = (p_1 + p_n + p_{n+1} - a)^2$$

or

$$p_{n+1}^2 - 2(a + p_n)p_{n+1} + 10\,a^2 + 2p_n^2 - (a + p_n)^2 = 0.$$

Regarding this as a quadratic in $x = p_{n+1}$, the two solutions are $x_+ = p_{n+1}$ and $x_- = p_{n-1}$. [See the remarks above. Also compare Yoshida's solution for chapter 7, problem 1.] Then $x_+ + x_- = p_{n+1} + p_{n-1} = 2(a + p_n)$, or

$$p_{n+1} - 2p_n + p_{n-1} = 2a,$$

which is the desired recursion relationship.

We thus deduce the general solution

$$
\begin{aligned}
p_1 &= 2a,\\
p_2 &= 3a = 2a + a,\\
p_3 &= 6a = 2a + 4a,\\
p_4 &= 11a = 2a + 9a,\\
p_5 &= 18a = 2a + 16a,
\end{aligned}
$$

or $p_n = 2a + (n-1)^2 a$, which yields

$$r_n = \frac{r}{2 + (n-1)^2}.$$

To find t_n, use the DCT for $\{r_n, r_{n+1}, t_n, r_1\}$. Then, with $q_n \equiv 1/t_n$

$$2(p_n^2 + p_{n+1}^2 + q_n^2 + p_1^2) = (p_n + p_{n+1} + q_n + p_1)^2.$$

Letting $p_n = 2a + (n-1)^2 a$ from above, we get the quadratic in q_n,

$$q_n^2 - 2\,a(2n^2 - 2n + 7)q_n - (4n^2 - 4n + 15)a^2 = \{q_n - (4n^2 - 4n + 15)a\}\{q_n + a\} = 0.$$

By inspection, either $q_n = (4n^2 - 4n + 15)a = \{(2n-1)^2 + 14\}a$, or $q_n = -a$. We discard the latter solution to get the final result

$$t_n = \frac{r}{(2n-1)^2 + 14},$$

or

$$n = \frac{1}{2}\left[\sqrt{\frac{r}{t_n} - 14} + 1\right],$$

which was written on the tablet.

In chapter 10 we obtain this result by the method of inversion.

Problem 13

We follow Hiroe Nagasada's original 1833 solution from his book *Zoku Shinpeki Sanpō Kigen, Solutions to the Zoku Shinpeki Sanpō*. It is from this solution that we have taken the answer to problem 5 in Yamaguchi's diary, chapter 7.

From figure 6.39,

$$R = \frac{x}{\sqrt{3}} + 2a,$$

$$p^2 + b^2 = (R - b)^2,$$

$$p = \frac{x}{2\sqrt{3}} + b. \tag{1}$$

The last two equations imply that $x^2/12 + bx/\sqrt{3} + b^2 = R^2 - 2Rb$, or

$$-12R^2 + 24bR + x^2 + 4\sqrt{3}\,bx + 12b^2 = 0. \tag{2}$$

Also from the figure, $q = (R - a)(\sqrt{3}/2) - b$ [consider the segment containing q that extends from the center of a to segment p] and

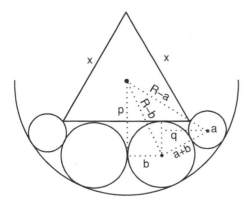

Figure 6.39. R is the radius of the outer circle, x the side of the equilateral triangle, b and a the radii of the large and small circles, respectively. Further, p is the perpendicular distance from the center of R to the indicated horizontal radius of b, whereas q is the perpendicular distance from the center of a to the indicated vertical radius of b.

$q^2 + (b - a/2)^2 = (a + b)^2$. Eliminating a with the first of equations (1) yields

$$\sqrt{3}\,xR - 2\sqrt{3}\,Rb - 6\,Rb + 2(\sqrt{3} - 1)\,bx + 4b^2 = 0, \qquad (3)$$

To eliminate b^2, subtract equation (2) from $3 \times$ [equation (3)] to get

$$12R^2 - 6\sqrt{3}\,Rb - 42Rb + 3\sqrt{3}\,xR + 2\sqrt{3}\,bx - 6bx - x^2 = 0,$$

which yields

$$b = \frac{12R^2 + 3\sqrt{3}\,xR - x^2}{6(7 + \sqrt{3})R + 2(3 - \sqrt{3})x}.$$

Substitute this expression into equation (2) to get a fourth-degree equation for x:

$$(8{,}640 + 4{,}320\sqrt{3})R^4 + (1{,}296 - 6{,}480\sqrt{3})R^3 x - (1{,}116 + 1{,}584\sqrt{3})R^2 x^2$$
$$- (432 - 360\sqrt{3})Rx^3 + (48\sqrt{3} - 84)x^4 = 0. \qquad (4)$$

[The last step is rather difficult. Substituting b into equation (2) initially gives

$$(-12R^2 + x^2)\,[3(7 + \sqrt{3})R + (3 - \sqrt{3})x]^2$$
$$+ (6R + \sqrt{3}x)\,(12R^2 + 3\sqrt{3}xR - x^2)\,[6(7 + \sqrt{3})R + 2(3 - \sqrt{3})x]$$
$$+ 3[12R^2 + 3\sqrt{3}xR - x^2]^2 = 0.$$

To save hours of tedious work, the authors cheated and used scientific software packages to put this equation into Hiroe's form. The problem is now "in principle" solved: all we need to do is solve equation (4) for x. We return to Hiroe's calculation, and show how he did it.]

Divide (4) by -3 and set $2R = d$ to get

$$(28 - 16\sqrt{3})x^4 + (72 - 60\sqrt{3})dx^3 + (93 + 132\sqrt{3})d^2 x^2$$
$$+ (270\sqrt{3} - 54)d^3 x - (180 + 90\sqrt{3})d^4 = 0. \qquad (5)$$

Next factor this equation. [The method by which Hiroe does this is peculiar to traditional Japanese mathematics and so we examine it in detail.] First rewrite equation (5) as

$$(28 - 16\sqrt{3})x^4 + (72 - 60\sqrt{3})dx^3 + (669 + 132\sqrt{3})d^2 x^2 - (306\sqrt{3} + 54)d^3 x$$
$$+ (252 - 90\sqrt{3})d^4 = (576\,x^2 - 2 \times 288 \times \sqrt{3}xd + 432d^2)d^2. \qquad (6)$$

Factor all the coefficients as follows:

$$(16 - 2 \times 8\sqrt{3} + 4 \times 3)x^4$$

$$+ (-2 \times 9 \times 4 - 2 \times 12 \times \sqrt{3} \times 4 + 4 \times 9 \times \sqrt{3} + 4 \times 3 \times 12)dx^3$$

$$+ (-2 \times 4 \times \sqrt{3} \times 3 + 2 \times 3 \times 2 \times 3 + 2 \times 4 \times 15$$

$$- 2 \times \sqrt{3} \times 2 \times 15 + 81 + 2 \times 12 \times 9 \times \sqrt{3} + 3 \times 144)d^2x^2$$

$$+ (2 \times 9 \times \sqrt{3} \times 3 + 2 \times 3 \times 12 \times 3 - 2 \times 9 \times 12 - 2 \times \sqrt{3} \times 12 \times 15)d^3x$$

$$+ (27 - 2 \times 45 \times \sqrt{3} + 225)d^4 = (24x - 12\sqrt{3}d)^2 d^2.$$

This can be recognized as a perfect square[7]:

$$[(4 - 2\sqrt{3})x^2 - (12\sqrt{3} + 9)\,dx + (15 - 3\sqrt{3})d^2]^2 = (24x - 12\sqrt{3}d)^2 d^2,$$

giving

$$(4 - 2\sqrt{3})x^2 - (33 + 12\sqrt{3})dx + (15 + 9\sqrt{3})d^2 = 0.$$

Multiply this equation by $(4 + 2\sqrt{3})$ to find

$$4x^2 - (204 + 114\sqrt{3})\,dx + (114 + 66\sqrt{3})\,d^2 = 0,$$

or

$$x = \frac{1}{4}\left[102 + 57\sqrt{3} - \sqrt{(102 + 57\sqrt{3})^2 - 4(114 + 66\sqrt{3})}\right]d$$

$$= \frac{R}{2}\left[102 + 57\sqrt{3} - \sqrt{19,695 + 11,364\sqrt{3}}\right]. \qquad (7)$$

If $d = 103.5$, then $x = 59.20004939$.[8] That complete Hiroe's proof. The above result and this example were written on the tablet.

For Yamaguchi's diary problem, chapter 7, problem 5, we want the radius a. From equation (1) above,

$$R = 2a + \frac{x}{\sqrt{3}},$$

or $a \cong 0.169766527R$.

[7] To see this admittedly requires some vision, but if Hiroe is searching for a perfect square of the form $(ax^2 + bdx + cd)^2$, he knows that expanding this expression gives $a^2x^4 + 2bdx^3 + (2ac + b^2)\,d^2x^2 + 2bcd^3x + c^2d^4$. This means that the coefficient of the x^4 term is a^2, and we immediately see from his "list" that $a = 4 - 2\sqrt{3}$. Similarly for c. He can then search among the x^2 terms for a coefficient of the form $(2ac + b^2)\,d^2$, etc.

[8] Here is a case where the traditional mathematician picked the parameters of the problem, d, to simplify computation of the answer. Hiroe calculates $(102 + 57\sqrt{3} - \sqrt{19,695 + 11,364\sqrt{3}}) \cong 0.571981153 \cong 592/1,035$. Thus choosing $d = 103.5$ means the answer is merely $592 \ldots /10$.

Problem 14

This solution is from Yoshida's unpublished manuscript *Solutions to Sanpō Kishō Problems.*

The centers of ten appropriately chosen small balls form a regular decagon, the center of which is the center of the big ball. (See figures 6.40 and 6.41.) Then $\sin 18° = r/(R + r)$, which implies $R = \sqrt{5}r$.

(For $\sin 18°$, see chapter 4, problem 32.)

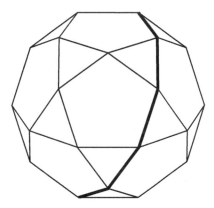

Figure 6.40. The heavy line traces out a regular decagon.

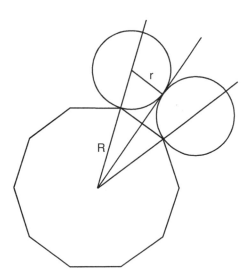

Figure 6.41. The angle between the centers of the two small balls is $36°$.

Problem 15

We follow Yoshida's solution, quoted from his manuscript, *Solutions to Shinpeki Sanpō.* It may help to refer to chapter 4, problem 39.

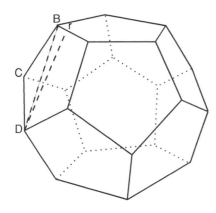

Figure 6.42. Note that angle $BCD = 108°$ and angle $CDB = 36°$.

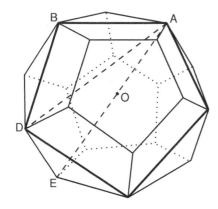

Figure 6.43. Cutting a cross section out of the dodecahedron as shown gives a large pentagon. Note that angle $ABD = 108°$ and angle $BDA = 36°$.

As shown in figure 6.42, connecting the centers of the small balls gives a regular dodecahedron with twelve pentagonal faces each of side $2r$. [Note that $r/BD = \sin 18°$, which immediately implies $BD = (\sqrt{5} + 1)r$.]

Now cut a slice out of the dodecahedron as shown in figure 6.43. The cross section forms another pentagon with sides ABD. . . . The law of sines gives

$$AD = \frac{\sin 108°}{\sin 36°} BD = (3 + \sqrt{5})r.$$

Figure 6.43 also shows that $(AE)^2 = (ED)^2 + (AD)^2$, where $AE = 2(R + r)$, $AD = (3 + \sqrt{5})r$, and $ED = 2r$. Solving the resulting quadratic for R gives the desired result

$$R = \left(\sqrt{\frac{3}{2}(\sqrt{5} + 3)} - 1 \right)r.$$

Kimura Sadamasa, who proposed the problem, gave the approximation $R \cong (1,862/1,033)r$.

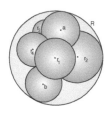

Problem 16

We give a modern solution by the method of inversion, one quite similar to that employed to solve problems 10 and 11 above. Once you have gone through those solutions, you will find this one quite simple.

Invert figure 6.16 with respect to a point T chosen to be the contact point between sphere a and the outer sphere R. Because spheres R and a *pass through* the center of inversion T, they must be mapped into two parallel planes R' and a'. Because the four spheres r_1, \ldots, r_4 are tangent to both sphere R and a they must be inverted into a loop of spheres of equal radii r' between planes R' and a'. Further, sphere b, which does *not* pass through the center of inversion, must be mapped into another sphere b'. Because b is tangent to r_1, \ldots, r_4, its inverse b' sits in the middle of the spheres r'_1, \ldots, r'_4. Thus the centers of r'_1, \ldots, r'_4 form a square, and by Theorem P in chapter 10, we immediately have the result

$$\frac{1}{r_1} + \frac{1}{r_3} = \frac{1}{r_2} + \frac{1}{r_4}.$$

Problem 17

The easy way to solve this problem is by the method of inversion. Frederick Soddy (1877–1956), a physical chemist who with Rutherford discovered the transmutation of the elements, did not do it the easy way. Neither did Yazawa Hiroatsu, who posted the problem in 1822, 124 years before Soddy. We can be sure of this because traditional Japanese geometers did not know of inversion, which was only invented in the West around 1825. We here give a traditional solution from the second volume of *Sanpō Tenzan Tebikigusa* (1841), or *Algebraic Methods in Geometry*, by Ōmura Kazuhide (1824–1891).

In Yoshida Tameyuki's solution to Hotta's problem (problem 12) we made use of the Japanese version of the Descartes circle theorem, which gave the relationship between a chain of three circles that touched a fourth circle. By enormous labor traditional Japanese geometers also obtained the three-dimensional version of the theorem:

If five spheres of radii r_1, r_2, r_3, r_4, and r_5 touch each other, then

$$3\sum_{i=1}^{5}\left(\frac{1}{r_i}\right)^2 = \left(\sum_{i=1}^{5}\frac{1}{r_i}\right)^2.$$

In this problem, let $\alpha \equiv 1/a$, $\beta \equiv 1/b$, $\gamma \equiv 1/r$, and $t_i \equiv 1/r_i$. Then

$$3(\alpha^2 + \beta^2 + \gamma^2 + t_1^2 + t_2^2) = (\alpha + \beta - \gamma + t_1 + t_2)^2. \tag{1}$$

As in the Descartes circle theorem, the term containing r comes in with a minus sign because sphere r inscribes the other spheres and so is taken to have negative curvature.

Next solve for t_2 in terms of α, β, γ, and t_1. This gives a quadratic

$$t_2^2 - (\alpha + \beta - \gamma + t_1)t_2 + (\alpha^2 + \beta^2 + \gamma^2 + t_1^2) - \alpha\beta - \alpha t_1 - \beta t_1 + \beta\gamma + \gamma t_1 + \alpha\gamma = 0,$$

or

$$t_2 = \tfrac{1}{2}\Big[(\alpha + \beta + t_1 - \gamma)$$

$$\pm \sqrt{(\alpha + \beta + t_1 - \gamma)^2 - 4(\alpha^2 + \beta^2 + t_1^2 + \gamma^2 - \alpha\beta - \alpha t_1 - \beta t_1 + \alpha\gamma + \beta\gamma + t_1\gamma)}\Big]$$

$$= \tfrac{1}{2}\Big[(\alpha + \beta + t_1 - \gamma) \pm \sqrt{12(\alpha\beta + \alpha t_1 + \beta t_1 - \alpha\gamma - \beta\gamma - \gamma t_1) - 3(\alpha + \beta + t_1 - \gamma)^2}\Big] \tag{2}$$

Notice, however, that equation (1) is absolutely symmetric in the variables t_1 and t_2. Thus, by swapping the labels t_1 and t_2, equation (2) also holds as a solution for t_1. Now replace t_1 by t_2, and t_2 by t_3 in equation (2). We then see that one solution of the quadratic is the value of t_3 we are looking for, while the other root is t_1, a situation that is the same as in problem 12 above and problem 1 of chapter 7. Since $x_+ + x_- = -b/a$ for any quadratic equation $ax^2 + bx + c = 0$, we obtain $t_3 + t_1 = \alpha + \beta + t_2 - \gamma$, or

$$t_3 = t_2 - t_1 + \alpha + \beta - \gamma = t_2 - t_1 + k,$$

where $k \equiv \alpha + \beta - \gamma$.

Following the same prescription for the next spheres, we get

$$\begin{aligned}
t_4 &= t_3 - t_2 + k = -t_1 + 2k, \\
t_5 &= t_4 - t_3 + k = -t_2 + 2k, \\
t_6 &= t_5 - t_4 + k = -t_2 + t_1 + k,
\end{aligned} \tag{3}$$

and, remarkably,

$$t_7 = t_6 - t_5 + k = t_1.$$

We have therefore proven that six—and only six—spheres can be fitted inside the outer sphere in the given configuration. Hence the name "hexlet theorem." By the method of inversion it is quite simple to get this result. Invert figure 6.17 with respect to, say, the point of

contact between spheres b and r. As in problem 16, these spheres must invert into two parallel planes. Because sphere a is tangent to both b and r, it must invert into a ball between the two planes and touching them. Because the remaining spheres are *all* tangent to a, b, and r, they can map only into a ring surrounding sphere a'. Thus we have n spheres of equal radii surrounding another sphere of the same radius. A moment's reflection shows that the only way this can be accomplished is if there are six balls surrounding a seventh, just as you can place only six ping-pong balls around a given one.[9]

The author of our solution, Ōmura, also says that that answer $n = 6$ is trivial, since if we let both r and a go to ∞, we have two parallel planes, with ball b in between, implying that only six other balls of the same radius can surround it.

It also follows immediately from equations (3) that

$$\frac{1}{r_1} + \frac{1}{r_4} = \frac{1}{r_2} + \frac{1}{r_5} = \frac{1}{r_3} + \frac{1}{r_6}.$$

Problem 18

We discuss this problem in chapter 8.

Problem 19

The original solution is not written on the tablet, but a similar traditional solution, which required numerical calculation by the *soroban*, is found in Uchida Kyūmei's *Sanpō Kyūseki Tsu-ko*.

As discussed in the solution to problem 5, traditional Japanese mathematicians regarded an ellipse as an oblique section cut from a right circular cylinder, rather than as a conic section. This in turn led traditional mathematicians to view an ellipse as a circle that was stretched or shrunk in one direction. That is, in basic geometry we learn that any point P on an ellipse centered at the origin O must satisfy the equation

$$\frac{x^2}{a^2} + \frac{y^2}{b^2} = 1,$$

where x and y are the usual x and y coordinates of point P.

[9] Stanley Ogilvy devotes a chapter to the hexlet in *Excursions in Geometry* (Dover, New York, 1990).

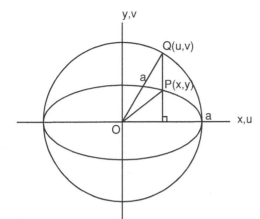

Figure 6.44. A point $Q(u, v)$ on a circle can be transformed into a point $P(x, y)$ on an ellipse by making the transformation $x = u$ and $y = (b/a)v$.

If, on the other hand, we define two new variables u and v such that $u = x$ and $v = (a/b)y$, then this equation becomes simply

$$u^2 + v^2 = a^2,$$

which we recognize as the equation of a circle of radius a centered on the origin. In this case, we can regard the ellipse as a circle that has been shrunk by an amount b/a in the y direction. As mentioned in problem 6, we have just made what modern mathematicians call an affine transformation. The idea of shrinking a circle along one axis into an ellipse is illustrated in figure 6.44 and is the central idea employed in the traditional solution to this problem.

We first apply the same method that was used to find the area element in problems 22 and 23 of chapter 5. Focusing attention on the small triangle at the top of figure 6.45, in which we consider the short

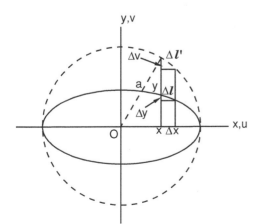

Figure 6.45. For small enough triangles, the segments $\Delta l'$ and Δl can be considered straight lines.

segment $\Delta l'$ to be the hypotenuse of the right triangle, then similar triangles gives

$$\frac{\Delta v}{\Delta x} = \frac{x}{v},$$

or, with the change of variable $v = (a/b)y$,

$$\frac{\Delta v}{\Delta x} = \frac{bx}{ay}.$$

Also, since Δv is merely the difference in two values of v, $\Delta v = (a/b)$ Δy and so

$$\frac{\Delta y}{\Delta x} = \frac{b^2 x}{a^2 y}.$$

As is in ordinary calculus, The Pythagorean theorem is employed to find the line element Δl:

$$\Delta l = \sqrt{(\Delta x)^2 + (\Delta y)^2} = \sqrt{1 + \left(\frac{\Delta y}{\Delta x}\right)^2} \, \Delta x$$

$$= \sqrt{1 + \left(\frac{b^2 x}{a^2 y}\right)^2} \, \Delta x = \sqrt{1 + \frac{b^2 x^2}{a^2(a^2 - x^2)}} \Delta x. \tag{1}$$

where the last equality follows because $a^2 = v^2 + x^2 = (a/b)^2 y^2 + x^2$ in figure 6.44.

The area element can be found by examining figure 6.46, which gives a head-on view of one of the cylinder sectors. The area element is $\Delta s = z(x)\Delta l$, where $z(x)$ is the height of the cylinder cut out on the elliptical surface at a point x. The Pythagorean theorem applied to the figure gives

$$z(x) = \sqrt{D^2 - (D - 2x)^2} = 2\sqrt{Dx - x^2},$$

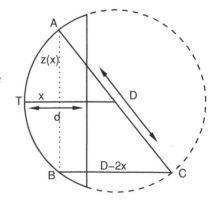

Figure 6.46. This figure represents a head-on view of one of the cylinder sectors. Point T is where the two sectors touch in figure 6.19, and is assumed to be located at $x = 0$. D is the diameter of the cylinder; d is the depth of the sector, which is the limit of integration. At a given x, the full height of $\triangle ABC$ is $z(x)$. Similar triangles shows that $BC = D - 2x$. The area element for integration is thus $z(x)\Delta l(x)$, where $\Delta l(x)$ is the line element along the surface of the elliptical cylinder.

where D is the diameter of one of the cylinders, and thus, from equation (1),

$$\Delta s = z(x)\Delta l = 2\sqrt{Dx - x^2}\sqrt{1 + \frac{b^2 x^2}{a^2(a^2 - x^2)}}\Delta x.$$

The full area $S = 2S_1$ is therefore given by

$$S = 2a \int_0^d 2\sqrt{Dx - x^2}\, \frac{\sqrt{1 - [(a^2 - b^2)/a^4]x^2}}{\sqrt{a^2 - x^2}}\, dx. \qquad (2)$$

The problem, as is traditionally said in mathematics, has been "reduced to quadratures"—it has been formally solved assuming one can do the integral. Unfortunately, this integral appears to have no analytic solution and so must be tackled numerically. To do so, it is convenient to change the limits of integration to $[0, 1]$, which can be easily accomplished by the change of variable $x \equiv d \cdot t$. Then,

$$S = 4d\sqrt{Dd} \int_0^1 \sqrt{t - (d/D)t^2}\, \sqrt{\frac{1 - (1 - b^2/a^2)(d^2/a^2)t^2}{1 - (d^2/a^2)t^2}}\, dt. \qquad (3)$$

It is possible to evaluate the integral by any number of numerical techniques. Before one does that, however, we guess that the first factor in equation (2) or (3) is the important one, because it just assumes the surface of the elliptic cylinder is flat and thus gives the area of the sectors themselves. Consequently, we expect

$$S \cong 4 \int_0^d \sqrt{Dx - x^2}\, dx,$$

the stated answer. Indeed, assuming, for example, $D = 1$, $b/a = 0.5$, $d/a = 0.25$, and $d/D = 0.25$, we find with a standard software package that the integral of the first term alone is 0.307 and the complete integral is 0.308.[10]

How did traditional Japanese mathematicians evaluate such integrals? Briefly, they used numerical tables based on infinite series. Such tables were known as "*Enri* tables," which we discuss in more detail in chapter 9. There we give a few more gory details of this problem.

[10] Readers familiar with series expansions can expand the second square root in equation (3) and easily convince themselves that, as long as $d/a < 0.15$, the error in ignoring this factor will always be less than about 1%.

Plate 7.1. "Oiwake" by the *ukiyo-e* artist Keisei Eisen (1790–1848). This print is from the series "Sixty-Nine Stations of Kisokaido," which Eisen produced with Utagawa Hiroshige between 1834 and 1842. Depicted here are packhorses and drivers near Oiwake, below Mt. Asama, which mathematician Yamaguchi climbed during his travels (see diary entry for 28 July). (Nakasendo Hiroshige Bijutsukan.)

SEVEN

The Travel Diary of Mathematician Yamaguchi Kanzan

Mathematics developed from the relations of circles and squares. Mathematics is one of the six educations: manners, music, archery, riding, writing and mathematics. These educations are peculiar to human beings and are not necessary for animals. The teacher Takeda has been studying mathematics since he was young. In this shrine, his disciples ask God for progress in their mathematical ability and dedicate a *sangaku*.

—Preface to a *sangaku* hung in 1815 by Kakuyu, a disciple of Takeda

Due to the policy of *sakoku*, Japan experienced no major external conflicts for nearly three hundred years. Although the country was periodically wracked by peasant uprisings, the Edo period was by world standards peaceful, and travel extremely popular. People toured widely, taking sightseeing trips, or making pilgrimages to various shrines and temples. Usually the Japanese traveled on foot, seldom on horseback, and, as in the West, put up at inns or rested with friends, sometimes at the temples themselves.

The poet Matsuo Bashō was almost as famous for his wanderings as his haiku, and we know from his books and poems that he stayed with many of his friends while on his journeys.

Geometers did not cede place to poets. A number of nineteenth-century mathematicians, including Hōdōji Zen (1820–1868), and Sakuma Yōken (1819–1896) took "*sangaku* pilgrimages" to teach mathematics, encourage amateurs and lovers of geometry, and to hang *sangaku* in temples around the country. Among these itinerants was Yamaguchi Kanzan. The known biography of Yamaguchi is this: He was born about 1781 in Suibara of Niigata province, studied mathematics in Edo at the school of Hasegawa Hiroshi, and died in 1850. In contrast to how little we know about Yamaguchi himself, however, much of our knowledge of *sangaku* comes from a diary he kept of six journeys undertaken between 1817 and 1828.

Yamaguchi's travel diary is substantial, comprising about seven hundred pages all told. In it he describes the sights, speaks of meetings with friends and other mathematicians, and also records problems from eighty-seven *sangaku*, only two of which survive to the present. The fate of the diary is as obscure as that of its author. Apparently, Yamaguchi attempted to publish part of it under the title *Syuyuu Sanpō*, or *Travel Mathematics*. At least in the book *Kakki Sanpō* (*Concise Mathematics*) by Shino Chigyō, which was published in 1837, we find the following advertisement:

> Mathematician Yamaguchi has traveled all over Japan for six years, from the spring of 1816[7] to the winter of 1821. With many distant mathematicians, he has discussed new technical methods of solving mathematical problems. If you buy this book, then you will be able to know and obtain without traveling the new technical methods of solving problems of far-away mathematicians.

Despite the promises of the author, *Syuyuu Sanpō* remained unpublished.

Nevertheless, the original diary has survived and currently resides in the city of Agano as a declared cultural asset. Because we often have no other information on the tablets Yamaguchi describes, his journal is a unique resource for historians attempting to piece together the history of Japanese mathematics. The book has never been fully translated, even into modern Japanese, and what has been published is without the mathematical sections. We are pleased here to be able to introduce Western readers for the first time to this remarkable document. At seven hundred pages, it is far too long to present in its entirety. Instead, we have excerpted

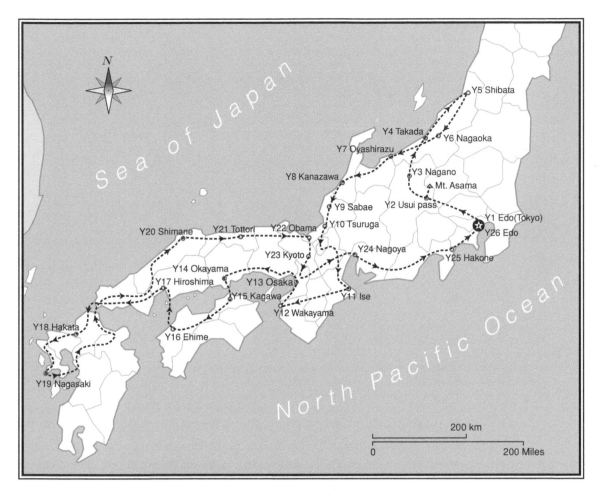

Plate 7.2. Yamaguchi Kanzan traveled along this route for his third *sangaku* journey, which took over two years in 1820–1822. Y1, . . . , Y26 indicate the main stopping points Yamaguchi mentions in the text.

a few passages from Yamaguchi's third journey, 1820–1822, in which he recorded more *sangaku* problems than in his five other trips combined. Along with the excerpts we present a number of the problems Yamaguchi describes. A few of them are fairly simple and the solutions should be accessible to high school or college students. Most, we concede, are extremely difficult and one or two remain unsolved to the present day. Resolute geometers may gird their loins; others may simply marvel at the beauty and ingenuity of the problems. Interested readers can also follow the mathematician's itinerary on the map (plate 7.2), where Y1, Y2, . . . indicate Yamaguchi's stopping points.

Plate 7.3. Two pages from Yamaguchi's diary, showing several problems, including the one given as problem 10 in this chapter. (Agano City.)

22nd of July, 1820 to 21st of August, 1820

Y1

22nd of July, 1820: "Many friends came to see me off in Edo for my long travels and left me send-off haiku . . . After 10 *ri* [40 km], I arrived in Fuchu and visited the Roku shrine. At night, I stayed at a farmer Yohachi's house."

26th of July: "I passed the castle town[1] of Takasaki and I remembered that a mathematician Ono Eijyu lived there."[2]

Y2

27th of July: "I have visited the Hakuunsan Myoujin shrine and walked across a river nearby since there was little water in the river. After passing

[1] Although "castle towns" had their origins as military strongholds, as discussed in chapter 1 the Tokugawa shogunate limited the local warlords to one castle per domain. With little fighting during the entire Edo period, the castle towns became administrative centers and the castle took on the aspect of "city hall." "Castle town" thus has a connotation closer to "provincial capital" than to "fortified town."

[2] Mathematician Ono Eijyu (1763–1831), a student of Fujita Sadasuke's school (chapter 3) had been training many students to be mathematicians and sometimes helped geographer Inō Tadataka (1745–1818) to produce his map of Japan.

through the guard station,[3] I arrived at the steep Usui pass and visited the Kumano shrine above the tea house of the pass and enjoyed viewing a *sangaku* in it. I have written down the *sangaku* problems of the Kumano shrine in my diary. In particular, the preface on the tablet is interesting."

The tablet Yamaguchi describes was hung in the Kumano shrine in 1801 by Ono Eijyu, who wrote the preface: "Mr. Tsunoda, who hung this *sangaku*, was born blind. He visited me and he told me that he eagerly wanted to study mathematics and so I introduced him to my teacher Fujita Sadasuke in Edo.[4] Tsunoda studied mathematics and hung this *sangaku* in this Kumano Jinjya."

28th of July: "There is the beautiful mountain, Mt. Asama.[5] When I looked up Mt. Asama, I wanted to ascend it. It is 5 *ri* [20 km] away from my friend Jinzaemon's house where I stayed last night. Climbing down the mountain, I took the wrong way but didn't have any trouble."

2nd of August: "I visited the Suwa shrine in Sakashiro village and found a *sangaku*."

Yamaguchi recorded all of the problems on the Suwa *sangaku*, which was hung by Kaji and Kobayashi in 1805. Kobayashi wrote, "I have discussed mathematics problems with my friend all day and enjoyed it very much. Then we decided to hang a *sangaku* in this shrine. We hope that the visitors will look at this tablet and ask for any opinions about the problem."

We have included one of the problems on the Suwa sangaku as problem 37 in chapter 4.

14th of August: "Crossing the big river Chikuma by boat, I could visit the village Hachiman, where a festival is being held, and there are many people in the precinct. In the small village nearby, I found and recorded a *sangaku* hung by Okuma in 1795, and that night I stayed in the house of my friend Kitamura, who is a farmer."

15th of August: "With my friend Kitamura, I went to see the festival in Matsushiro of Nagano province. This area is so beautiful that I have drawn the scene in my diary. Afterwards, I came near the big Zenkoji temple, which is one *ri* [4 km] away from here. Worshipping at Zenkoji is one aim of my travels."

[3] During the Edo period, travelers were required to carry permits and stop at checkpoint barriers (*sekisho*) along major highways.

[4] See chapter 3 for more on Fujita.

[5] 2,560 m.

Y3

17th of August: "At last I could visit the big Zenkoji temple in Nagano and enjoyed looking at it. Today, when I arrived at Zenkoji, is a holiday, so there are many visitors in the precinct. In the evening I entered the inn at Fujinoya. Going out from the inn at mid-night I entered the guest house of Zenkoji. I could stay the night with the other visitors because I had gotten a pass from the Fujinoya inn to enter the Zenkoji guest house, but some of the others didn't get passes so they had to come back from the temple. This morning I recorded four *sangaku* of the Zenkoji."

We present three problems from the Zenkoji *sangaku* as problems 1–3.

Plate 7.4. The original illustration for problem 2, as it appears in Fujita Kagen's 1789 book, *Shinpeki Sanpō*. (Collection of Fukagawa Hidetoshi.)

Problem 1

This problem was hung by Seki Terutoshi at the Zenkoji Temple in 1804. We have a regular n-sided polygon, with length of side a. From the vertex A we draw the chords, as shown, as well as $n-2$ inscribed circles with radii r_k ($k = 1, 2, \ldots, n-2$). Find the radii r_k of all the inscribed circles in terms of a. Yamaguchi didn't record the answer because it was too complicated.

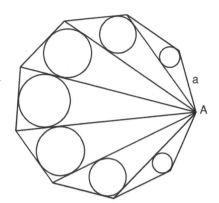

We have found a traditional solution, which is on page 266.

Problem 2

This problem is from the second *sangaku* at the Zenkoji temple, which was hung by Kobayashi in 1796. A quadrilateral $ABCD$ is inscribed in the larger circle of radius R and touches the smaller circle of radius r. Find r in terms of R and $AC \times BD$. (Hint: The tablet gives the solution for a specific case: If $2R = 12$ and $AC \times BD = 112$, then $2r = 7$.)

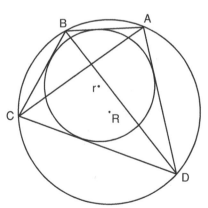

The general solution can be found on page 271.

Y4

20th of August: "Entering the castle town of Takada in Niigata, which is near the port, I visited the Suwa shrine and recorded *sangaku* problems proposed by Yoshizawa in 1803. That day I stayed at my friend Yoichi's home in Ima town."

Problem 3

This problem is from the third *sangaku* at the Zenkoji temple, which was hung by Saito Mitsukuni in 1815. We have a segment of a circle. The line segment *m* bisects the arc and chord *AB*. As shown, we draw a square with side *d* and an inscribed circle of the radius *r*.

Let the length $AB = a$. Then, if $p = a + m + d + r$ and $q = m/a + r/m + d/r$, find *a*, *m*, *d*, and *r* in terms of *p* and *q*. We have not been able to solve this problem.

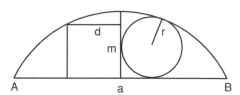

On the tablet, Saito wrote: "This problem was first proposed by Tsuda Nobuhisa in 1749 on a *sangaku* of the Gion shrine of Kyoto. Tsuda derived the answer with a high-degree equation, one of one thousand twenty-four degrees. But the famous mathematician Ajima Naonobu showed how to solve it with an equation of only the tenth degree in the variable *a*. On this tablet, I will show Ajima's equation." Yamaguchi, however, did not record the equation.

This celebrated problem is known in standard histories of Japanese mathematics as the Gion shrine problem, because it was found on Tsuda's *sangaku* in Kyoto's Gion, or Yasaka, shrine. As just mentioned, the original solution was of 1024 degrees in terms of the length of the chord, but in 1774 Ajima Naonobu (chapter 3) reduced it to a problem of the tenth degree by the same method Laplace used in 1772 to expand determinants. Ajima's feat, performed at age 42, brought him great fame as a mathematician. The main aim of the problem was to find a high-degree equation in one variable, whose roots could then be determined numerically by the painstaking use of *sangi* (chapter 1). Ajima's equation takes a full page to write out, so we do not include it in the solutions, but will provide it upon request.

Plate 7.5. The Zenkoji temple as it appears today. (Photo Fukagawa Hidetoshi.)

12th of September: "I will stay here, in Yada village, to the 19th of Jan, next year."

19th of January, 1821 to
19th of November, 1821

19th of January, 1821: "I have started from Yada village and am going to Haruta village."

22nd of February: "While I have been staying with my friend Eguchi Shinpachi, his son Tamekichi has asked me to teach him math and to make him a student of the Yamaguchi school."

Y5

21st of March: "After arriving in Shibata city, I have stayed with my friend Minagawa Eisai."

24th of April: "In Suibara village, the place of my birth, I have spent over twenty days. Now I will go to Nagaoka city."

Y6

26th of April: "Arriving in Nagaoka city, I visited the Yukyuzan shrine and recorded two *sangaku*. One was proposed by a disciple of Fujita in 1798 and the other is as follows: . . ."

This tablet was hung by three merchants in 1801. It survives today and is 105 cm by 57 cm. We have offered one of the problems as problem 46 in chapter 4.

16th of September: "I have been staying in my friend Arakawa's home for some months in Yamadani village and, today, I set off. I visited the Gochinyorai temple and recorded *sangaku* problems proposed by Ohta Sadaharu in 1806."

Y7

25th of September: "While passing the famous and dangerous coast of Oyashirazu, I have become careful."

30th of September: "There is a big river the Kurobe near the inn and I looked at the beautiful bridge 36 *ken* [70 m] long, which crosses the river without any supports in the middle."

Y8

3rd of October: "I have arrived at the big castle town of Kanazawa. This town is so big that it had hundred thousand houses. However, on the first of October, I stayed in the castle town of Toyama where there are ten thousand houses."

Y9

7th of October: "I have arrived and visited the Asahikanzeon temple in Sabae and recorded the *sangaku* as follows: . . ."

Plate 1. Battle of Sekigahara. In 1600 Tokugawa Ieyasu defeated his rival warlords at the battle of Sekigahara, which established Tokugawa rule for the next 250 years. The battle is depicted on a series of folding screens, painted by court artists on hammered gold. Ieyasu presented the screens to his adopted daughter in 1610 as part of her dowry. (© Sekigahara Museum.)

Plate 2. The Island of Deshima. For over 200 years, the tiny island of Deshima in Nagasaki harbor was Japan's sole gateway to the West. Built by the Portuguese at their own expense between 1634 and 1636, the island remained vacant after the expulsion of the Portuguese in 1639 until it was taken over by the Dutch East India Company in 1641. Deshima's area was only 4,000 *tsubo*, approximately 15,500 square meters, and consisted of 44 taxed houses (mostly warehouses) and 21 untaxed houses. The population was limited to 25 merchants. Deshima is here depicted by an unknown artist in the oldest painting in the city of Nagasaki, part of a screen dating from the late seventeenth century. At the foot of the bridge leading to the island were posted the famous prohibitions:

Prohibited Are:
That women except courtesans enter;
That monks and mountain priests, except itinerant Koya monks, enter;
That those soliciting contributions and begging enter;
That boats venture within the marked poles surrounding Deshima and pass under the bridge;
That Hollanders leave Deshima without notice.

These articles are to be strictly observed.
The year of the Horse, 8th month.

(© Nagasaki Museum of History and Culture.)

Plate 3. *Sangi*. *Sangi*, calculating rods, were placed on a ruled sheet of paper to form numerals and, with a prescribed series of operations, intricate arithmetic calculations could be performed. *Sangi* gradually lost out to the Japanese abacus, the *soroban*, although professional mathematicians used them well into the nineteenth century because they were better suited to complex calculations. (Photo: Fukagawa Hidetoshi.)

Plate 4. *Sangaku* of the Sozūme shrine. Dedicated in 1861 by a group of mathematics lovers to the Sozūme shrine of Okayama city, this *sangaku* depicts a teacher sitting before his pupils, who include two women and a child learning to do calculations on the *soroban*. On the right, people are discussing—we presume—how to solve high-degree equations. On the left side of the tablet, three problems are inscribed:

 1. Find the side of the square having an area 85,000 square units, in other words, solve the equation $x^2 - 85,000 = 0$. (*Answer: x = 291:5*)
 2. Find the diameter $2r$ of circle inscribed in a triangle with sides 10, 17 and 21. (*Answer: 2r = 7*)
 3. Find the side x of a cube having the volume 1,881,676,371,789,154,860,897,069 cubic units, or solve the equation $x^3 - 1,881,676,371,789,154,860,897,069 = 0$. (*Answer: x = 123,456,789*)

The tablet measures 170 cm by 93 cm. (© Asahi Shinbun.)

Plate 5. *Sangaku* of the Katayamahiko shrine. One of the most beautiful *sangaku*, this dragon-framed tablet was dedicated by Irie Shinjun in 1873 to the Katayamahiko shrine of Murahisagun Okayama city. We have used Irie's inscription on the tablet as the preface to chapter 5. The *sangaku* measures 162 cm by 88 cm.

Plate 6. Portrait of Irie Shinjun. Irie Shinjun (1796–1879) dedicated the dragon-framed *sangaku* to the Katayamahiko shrine (color plate 5). In this portrait Irie is shown seated on the right as he learns how to solve the high-degree equation $x^4 - 614{,}656 = 0$ from his teacher Okura Kido (1800–1869). The dates show that the student was older than the master. Irie was a poet as well as an amateur mathematician, and so the artist has drawn some haiku on the scroll, which is visible in the background. The scroll measures 75 cm by 193 cm and belongs to Mr. Nishii Hiroyuki. (Photo: Igarashi.)

Plate 7. *Sangaku* **of the Sugawara shrine.** Probably unique in its gilding, this *sangaku* was hung by Hōjiroya Shoemon in 1854 at the Sugawara Tenman shrine of Ueno city, Mie prefecture. It measures 173 cm by 82 cm. (© Asahi Shinbun.)

Plate 8. *Sangaku* of the Meiseirinji temple. Hung in 1865 at the Meiseirinji temple in Ogaki city, Gifu, this tablet measures 58 cm by 224 cm. On the right-hand side are names of disciples of the Asano school who offered the tablet to the temple. It is an unusual *sangaku* in that one problem was presented by a sixteen-year-old girl, another was presented by a woman, which is very rare, and a third was presented by a fifteen-year-old boy. The answers are also curious: The first problem has an answer $r_1 = 1 \times c_1$, for a given constant c_1. The second problem has an answer $r_2 = 2 \times c_2$. The third problem has an answer $r_3 = 3 \times c_3$. The sixth problem has an answer $r_6 = 6 \times c_6$. The tenth problem has an answer $r_{10} = 10 \times c_{10}$. One guesses that the students enjoyed solving geometry problems rather than studying mathematics seriously. (© Asahi Shinbun.)

Plate 9. *Sangaku* of the Mizuho shrine. This *sangaku* was hung by the Noguchi school in 1800 at the Mizuho shrine in Shimotakaigun, a town in Nagano prefecture. Seven problems are drawn on the tablet, which measures 160 cm by 58 cm. (© Asahi Shinbun.)

Plate 10. *Sangaku* of the Dewasanzan shrine. A large and beautiful *sangaku*, this tablet from the Dewasanzan shrine in Yamagata prefecture measures 453 cm in width and 151 cm in height. What remains is moreover only half the original tablet; the other half was lost. It was hung in 1823 by the Saito school. (© Asahi Shinbun.)

Plate 11. *Sangaku* of the Abe no Monjyuin temple. This tablet, from the Fukushima prefecture, is the largest known *sangaku*, measuring 620 cm by 140 cm and containing twenty-one problems. It was hung in 1877 by the pupils of Sakuma Yōken (chapter 1), a mathematician who published four books and left sixty-three manuscripts. In 1840–1842 he traveled around Japan, as did Yamaguchi Kanzan, to record *sangaku* problems. Even as the Tokugawa government lay in ruins in 1876 he established his school the Yōken *juku*, which still stands today. Weather damage has made many of the problems indistinct. (© Asahi Shinbun.)

Plate 12. Second *sangaku* of the Atsuta shrine. In 1844, the original of this tablet was hung in the Atsuta shrine by Takeuchi Syukei (1815–1873) and subsequently lost. The *sangaku* shown here is a replica made by the shrine based on the anonymous note *Bishu Kannondo Gakūmenkai*, or "Solutions of Sangaku in Nagoya," written at an unknown date. The tablet measures 240 cm by 60 cm. A black and white image of the older, first *sangaku* at the Atsuta shrine can be found in chapter 6, plate 6.3. (© Asahi Shinbun.)

Plate 13. The most recently discovered *sangaku*. The "newest" *sangaku* was discovered in 2005 by Mr. Hori Yoji at the Ubara shrine, Toyama prefecture, and dates from 1879 (see chapter 4, problems 15 and 31). The tablet measures 76 cm by 26 cm. (Photo: Fukagawa Hidetoshi.)

Plate 14. Portrait of Fujita Kagen. A well-known mathematician, Fujita Kagen (1772–1828) published the first collection of *sangaku* problems, *Shinpeki Sanpō*, or "Sacred Mathematics," in 1789 (see chapter 3). The artist and date of the portrait are unknown. (© Japan Academy.)

Plate 15. The plum blossom garden at Kameido Tenjin shrine. This *ukiyo-e*, or "floating world," print belongs to the series "One hundred famous views of Edo" by the renowned *ukiyo-e* artist Utagawa Hiroshige (1797–1858). Vincent Van Gogh (1853–1890) made a reproduction of this picture. (© NagoyaTV-Japan.)

Plate 16. Gion shrine. In 1749 Tsuda Nobuhisa hung a *sangaku* in the Gion shrine, Kyoto, on which he proposed a celebrated problem (chapters 3 and 7) that resulted in an equation of the 1,024th degree. No exact solution has ever been found for Tsuda's equation but Ajima Naonobu (1732–1798) became famous for reducing it to one of 10 degrees. Tsuda's tablet has been lost but the shrine has an older *sangaku* from 1691 that survives. (Photo: Fukagawa Hidetoshi.)

This *sangaku*, presented by Momota, is extant. We give one of the problems here as problem 4.

Problem 4

From the Asahikanzeon temple *sangaku*, this problem was presented by Momota in 1807. It asks us to solve the given system of equations for x, y, and z. For the special case above, the table gives $x = 78{,}125 = 5^7$, $y = 16{,}384 = 4^7$, and $z = 2{,}187 = 3^7$. It also gives the answer for the general case of any integers, which involves a 49th-degree equation. We have been unable to derive it.

$$x - y = 61741$$
$$y - z = 14197$$
$$\sqrt[7]{x} + \sqrt[7]{y} + \sqrt[7]{z} = 12$$

Y10

8th of November: Yamaguchi arrived in the town of Tsuruga, which is 25 *ri* [100 km] from Kyoto. "In the town, I met with a mathematician Masuda Koujirou who brought three problems and asked me for the solutions. I could answer his requests and showed him the solutions. I have recorded the problems in my diary."

We give two of these problems here as problems 5 and 6.

14th of November: "I have stayed in Kanbe's home in Minamishinho village of Takashima. At his house, Kanbe showed me a problem sent by Enoki in Kyoto. The problem was made by someone in Osaka."

This problem can be seen as problem 7.

16th of November: "Walking along the side of the biggest lake in Japan, Biwako, I stopped at the sight-seeing place, Ukimidō."

19th of November: "I have entered the big city of Kyoto. In this city, there are a great many temples and shrines. I will spend the rest of the year in this city and enjoy it."

Problem 5

As shown above, six circles of radius r and three circles of radius t are inscribed in the large outer circle such that they are tangent to this circle and also touch the equilateral triangle. If the radius of the outer circle is R, Find t in terms of R.

Masuda asked Yamaguchi for the answer to this problem because he could not not work it out. Yamaguchi showed him the answer that can be found on page 275. We also give it as problem 13 in chapter 6 with a traditional solution by Hiroe Nagasada.

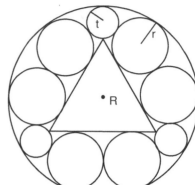

Problem 6

One day, Inō Shūjiro, aged 35, second son of the famous surveyor Inō Tadataka (1745–1818), who made the first detailed map of Japan for the ruling Tokugawa family, visited Masuda and posed the following problem:

The small circle inscribed in the right triangle *ABC* touches side *AB* at *Q*. A larger circle passes through the vertices *A* and *B* and touches the inscribed circle as shown above. If the line segment *p* bisects the chord *AB*, and *q* is the length *AQ*, find the relation between *p* and *q*.

Masuda was able to solve this straightforward problem, which requires only high school geometry and gave Inō the answer; our solution can be found on page 275.

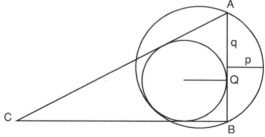

Problem 7

Of the problem below, Kanbe said to Yamaguchi, "Someone in Osaka is boasting about this problem to Enoki." Yamaguchi answered Kanbe, "I have been studying this problem for four or five years and, at last, this spring, I succeeded in solving it.

But the problem is no good. I recommend that every student study more mathematics books rather than try to solve such a problem."

The reader may not want to spend four or five years working on the exercise, but here it is: Three circles, one of radius a and two of radius b, are inscribed in the arc, as shown. Two

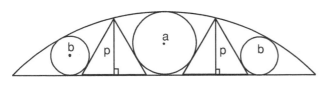

equilateral triangles of the height p are also inscribed in the arc, tangent to the circles. Find p in terms of a and b. The Osaka proposer gave an example: If $a = 3$ and $b = 1.5$ then $p = 5.25$.

The general result and a fairly easy proof can be found on page 276.

2nd of February 1822
to 1st of December, 1822

2nd of February, 1822: "I paid the fee 120 *mon* [about 5 dollars] to board a boat, and enjoyed visiting a small island Chikubu in lake Biwako. Later, I entered the castle town of Hikone, where I visited a mathematician Matsumiya Kiheiji and stayed in his house. He showed me an unsolved problem and a *sangaku* problem of the Taga shrine as follows: . . ."

These two problems are given as problems 8 and 9.

Problem 8

This is a previously unsolved problem proposed by Matsumiya. An arc of a circle passes through vertices A and B of right triangle ABC and is tangent to the triangle at B. The sides a and b of the curved sector ABC are congruent with two sides of the triangle, as shown.

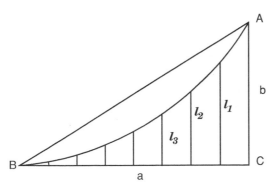

Divide side BC into eight equal parts and erect perpendiculars l_k ($k = 1, 2, \ldots, 8$). Find the lengths of l_k ($k = 1, 2, \ldots, 8$) in terms of $a = BC$ and $b = AC$.

The problem turns out to be not so difficult and solution is given on page 277.

Problem 9

Here is another *sangaku* problem originally drawn on a fan, one from the Taga shrine, proposed by Katori Zentarō. The date is unknown. The large circle of radius *r* touches three sides of the rectangle *ABCD*, as shown. Note *AB* < *BC*. We draw a line from *D* tangent to the large circle and one of the small circles to the other side of the rectangle. Assume that the two small circles both have radius *t*. Find the shaded area S_1 in terms of the black area S_2.

The solution can be found on page 278.

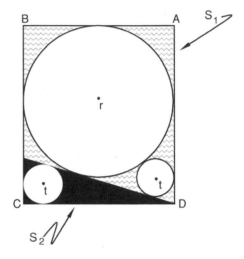

Y11

6th of February: "I went to the big Ise shrine and stayed at an inn. I heard that a mathematician Koyama Kaname in Sendai city is staying at an inn nearby, so I visited the inn but I could not meet with him, because then he was out, unfortunately." Yamaguchi then visited the Seihoji temple, where he found two *sangaku*, noting, "I have recorded one *sangaku* hung by Sawai in 1786 and the other *sangaku* hung by Koyama in 1819, which criticized an incorrect solution on Sawai's *sangaku*."

18th of February: "I went to Wakayama and stayed at mathematician Nunomura Jingorō's home. His teacher is one of the second generation of disciples of the famous mathematician Fujita Sadasuke. Nunomura showed me *sangaku* problems of Kofukuji temple in Nara."

Y12

24th of February: "I have visited a big Himae shrine in Wakayama and recorded the *sangaku* problems proposed by Shintani Benjirō in 1806." Later

that day, Yamaguchi arrived at Ki-Miidera town and stayed at a carpenter Benzō's home.

28th of February: "When I entered Osaka, I visited a mathematician Takeda Atsunoshin, who was a disciple of Ban Shinsuke. Takeda is an astronomer, too. In the town, I saw leaflets (the size is 7 *sun* [about 20 cm] long and 3 *sun* [9 cm] wide) about an astronomy lecture by Takeda. In his home, Takeda showed me his mathematics problem."

Y13

29th of February: "I visited Osaka castle, which is beautiful beyond description. Afterwards I visited the Tenman shrine and recorded three *sangaku*, one of which has two problems."

On the first tablet was a preface that we have quoted at the head of this chapter. We give one problem from the third of the Tenman *sangaku* as problem 10.

Problem 10

The third *sangaku* in the Tenman shrine was hung in 1822 by the mathematician Takeda Atsunoshin. Takeda wrote a preface:

"My disciples are studying every day in order to solve the many problems given to them

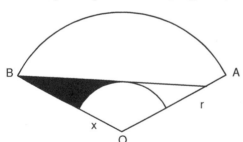

by myself. I want to publish some of the good solutions under the title *Kyokusu Binran (Survey of Maxima and Minima Problems)*. On this tablet, I have selected and written some good problems on maxima and minima and dedicate the sangaku to this shrine so that my students will become more advanced in mathematics."

Of the fourteen problems on the tablet, the following was proposed by Hayashi Nobuyoshi a disciple of Takeda: In a sector *AOB* of radius *r*, draw a small circle of radius *x* with center *O*. Draw the tangent to the small circle from the vertex *B*, as shown. (See also the original illustration, plate 7.16.) As *x* is varied, the area $S(x)$ of the black part of the figure will also vary. Show that $S(x)$ is a maximum when $x \cong (293/744)r$.

Plate 7.6. The original illustration for problem 10 as it appeared in Takeda's 1826 book *Sanpō Binran*. (Collection of Fukagawa Hidetoshi.)

4th of March: "I have arrived at Tatsuno city near Himeji and visited the Syosya temple to record a *sangaku* proposed by Sawa in 1821. In the evening, Sawa visited me and he showed me an unsolved problem and two *sangaku* problems of the Syosya temple. I have written them down in my diary as follows: . . ."

Two problems from the Syosya temple can be found as problems 11 and 12.

Problem 11

This problem, proposed by Sawa Masayoshi in 1821, is from the *sangaku* of the Syosya temple. As shown in the figure, five circles of radii a, b, and c are inscribed in a segment of a large circle. If $a = 72$ and $b = 32$, then find c.

The result for the general case is on page 280.

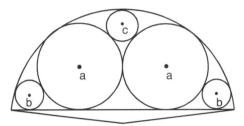

Problem 12

Also proposed by Sawa Masayoshi, this problem remains unsolved. As shown below, an ellipse is inscribed in a right triangle with its major axis parallel to the hypotenuse. Within the ellipse are inscribed two circles of radius r. A third circle of radius r touches the ellipse and the two shorter sides of the triangle, a and b. Find r in terms of a and b.

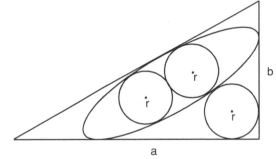

Y14

7th of March: The mathematician Horiike Hisamichi hung several *sangaku*, one of which was in the Kibitsu shrine in Okayama and another in the Suzuka in Ise, far from Okayama. (Neither of these tablets survives.) Yamaguchi wrote, "I have visited the Kibitsu shrine in Okayama and found a *sangaku* problem proposed by mathematician Horiike in 1804, which I have recorded in my diary."

Y15

8th of March: "Seto Nai Kai [the Inland Sea] is very beautiful and I crossed it by ferry. I ascended a steep, tall hill in Kagawa and visited the Kotohira shrine sitting on top of it."

Y16

21st of March: "The Dōgo hot spring in Ehime is one aim of my travel and when I arrived, I found many people having baths in the hot spring."

The Isaniha shrine in Dōgo has twenty-two surviving *sangaku.* When visiting Dōgo, Yamaguchi could have seen two of these tablets in the nearby Isaniha shrine. However, he makes no mention of them.

Plate 7.7. The Isaniha shrine today. The monkeys are not studying mathematics. They are admonishing tourists to "See no evil, hear no evil, speak no evil." (Photo Fukagawa Hidetoshi.)

Y17

22nd of March: "Once more, by ferry, I crossed the Inland Sea and arrived in the evening at the traditional shrine Itsukushima in Hiroshima."

Y18

11th of April: "Passing many cities, I have come near Hakata. I did some sight-seeing at the big Kashii shrine and visited the Hakozaki shrine, where I recorded *sangaku* problems proposed by Narazaki Hozuke in 1807. Afterward, I visited mathematician Hiroha and enjoyed discussing math with him. He showed me the following problem."

We give Hiroha's problem as problem 13. On the same day, Yamaguchi arrived in Hakata of Fukuoka province.

15th of April: "When I stopped at administrator Harada Futoshi's house in Shima village near Hakata, I was shown some unsolved problems which were sent by Harada Danbe in Hamamatsu city."

Harada Danbe in Hamamatsu hung a *sangaku* in the Akiha shrine there.

3rd of May: As we discussed in chapter 1, during the Edo period, only one city was open to the West, Nagasaki, and so Nagasaki was flourishing as the center of international trade.[6]

"When I arrived at Nagasaki, I saw so many interesting things that I could stay for some days here. I visited the Suwa shrine where I recorded a *sangaku.*"

This problem was proposed by Kitani Tadahide in 1819. We give it as problem 37, chapter 4.

Y19

21st of June: "As much as I am leaving my heart with Nagasaki, I have set off to Kurume where I visited the Takarao shrine and recorded a *sangaku* problem."

[6]Agencies in several other locations were open for trade with China and Korea.

The *sangaku* problem at the Takarao shrine was proposed by Ukawa Tsuguroku in 1808. We present it here as problem 14.

Problem 13

One day, Hiroha said to Yamaguchi that he could not solve this problem and asked Yamaguchi for the solution, but Yamaguchi doesn't say anything about a solution in his diary, and so we have no further information about it. Triangle ABC is inscribed between the arc AC of a circle of radius R and the chord AC. A circle of radius r is inscribed between the triangle and the chord. Two other circles, of radius s and t, touch the circle r as well as the external circle R and the chord, as shown. Given that $m = |t - r|$, $n = |t - s|$, and $p = |r - s|$, find R in terms of m, n, and p.

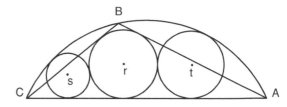

Problem 14

Ukawa Jiroku proposed this problem in 1808 on a *sangaku* at the Takarao shrine. A cone with base of radius r and height h stands perpendicularly to a plane, as shown. The vertex of the cone touches the plane. A chain of n small balls of radius r surround the tip of the cone. Find the integer n in terms of r and h.

The answer is on page 280.

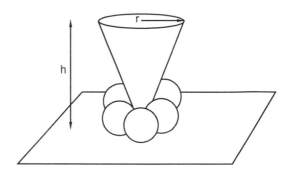

Y20

11th of July: "After much walking, I reached Shimane and worshipped at the big Izumo Oyashiro shrine which is the largest shrine after the one at Ise. I have been very impressed by it."

Y21

15th of July: "I have arrived at Tottori and stayed with Kitarō. I met two aged persons who enjoy studying mathematics and astronomy."

Y22

24th of July: "After entering Obama, I visited a mathematician Matsumoto Einosuke who is a disciple of Kurihara in Obama."

7th of September: Yamaguchi visited a shrine, Tenman, in Hirokawa village in Takashima of Shiga. There he heard that a *sangaku* from 1748 was hanging in the shrine and recorded it in his diary. Two problems from this *sangaku*, which were proposed by Kashiwano Tsunetada, can be found as problems 15 and 16.

Problem 15

This problem of Tenman shrine in Hirokawa village was proposed by Kashiwano Tsunetada in 1748. Kashiwano wrote a preface on the tablet:

"Mathematics is very important in ordinary life and I like to study mathematics. I have written my three favorite problems on this tablet and have not written the answers for two of them. I am very glad if someone tries to solve the problems."

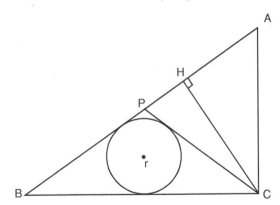

Draw a circle of radius $r = 2.4$ touching the hypotenuse AB and the side BC of right triangle ABC. From vertex C also draw the line CP, which is tangent to the circle. If the length $CP = 13$, find CH.

The answer is on page 281.

15th of September: "I have arrived at Lake Biwako once more. While visiting the Miidera temple in Shiga, I recorded two *sangaku* as follows: . . ."

The first *sangaku* at the Miidera temple was hung by Ogura Yoshisada in 1817. Ogura wrote on it: "Mathematics is the origin of everything in the universe. In particular, when we investigate something in astronomy, mathematics is important. I was admitted to the Seki school when young and

eagerly studied mathematics. Now, I want to hang a *sangaku* on which new problems and their solutions are written. If visitors would look at my *sangaku*, then I would be very happy."

Yamaguchi also viewed the *sangaku* in the Shinomiya shrine located in the area of Miidera temple. Afterward, he visited Okada Jiuemon, who dedicated the Shinomiya *sangaku* in 1821, to discuss math. "Okada said to me that he wanted to enter into my school to further study mathematics. At his home, Okada showed me a copy of *sangaku* of the Kiyomizu temple in Kyoto and the Ishiyamadera temple in Shiga.

"In the evening, a lover of mathematics, Asano Masanao, visited the inn where I am staying. He asked me for permission to advertise 'A lecture on mathematics performed by the famous mathematician Yamaguchi.' I have granted his request. Some days from now, the notices will appear in the town."

Problem 16

Another numerical problem from Kashiwano at the Tenman shrine: I is the center of the circle shown, inscribed in right triangle ABC. If $BI = 4.03888736$ and $AI = 3.87886$, then find a, b, and c.

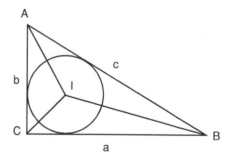

Y23

17th of September: Yamaguchi visited the big Kitanotenman shrine in Kyoto and recorded two *sangaku*. One of these was dedicated by Nakamura Syuhei in 1819. On the tablet, was a postscript: "My teacher Nakamura Fumitora is a very famous mathematician. Many people visit the Nakamura school. He is aged 60 this year. Esteeming his work, we, his son Nakamura Syuhei and his student Hitomi Masahide, have decided to hang a *sangaku* in this shrine. We have selected eight nice problems and have drawn them on the tablet."

One of the problems on this *sangaku* was proposed by samurai Kamiya Norizane in 1819. We give it as exercise 3, page 336, chapter 10.

18th of September: There was a great statue of Buddha in the Hokoji temple of Kyoto. Yamaguchi wanted to see it, but the statue had been destroyed. "I have started in the Hokoji temple at the place of the great statue of Buddha and visited the Kiyomizu temple. There I recorded a *sangaku* hung by Ritouken in 1822. On the tablet, the names of lovers of mathematics were written."

21st of September: "In mathematician Takeda's house, I saw one *sangaku* problem that is to be hung in the near future and another problem which was already written on the tablet of the Tenman shrine. I have written them in my diary."

We give Takeda's problem "to be hung in the near future" as problem 17. The other problem on the Tenman shrine *sangaku* was proposed by Morikawa Jihei and is presented as problem 18.

Problem 17

Here is Takeda's problem "to be hung in the near future": We are given a segment of a circle of radius R. Draw two smaller circles of radius r inside the segment such that they touch each other; both are tangent to the chord AB; one touches the arc AB and one touches the tangent line AP. If $AB = k$ and $AP = m$, find r in terms of k, d, and m.

The answer is on page 281.

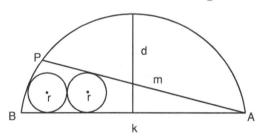

Problem 18

This is Morikawa's problem at the Tenman shrine, proposed at an unknown date. Two circles with radii a and b sit on the line l and touch each other. Between them is an inscribed a square with side x. Find the minimum of x in terms of a and b.

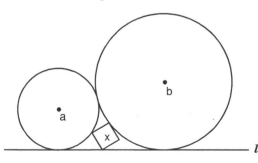

The tablet contained no solution, but Morikawa had written, "I will be very happy if someone can solve this problem." And so, says Yamaguchi, "I went to Morikawa's home with my friend Takeda and asked him what the answer is. He said that he could not solve the problem yet." Neither does Yamaguchi's diary contain a solution and, like Morikawa, we would be very happy if someone solves this problem.

Y24

24th of November: "Four days ago, I stayed at Toraya Kyoemon's home and visited the Atsuta shrine in Nagoya. Crossing the big river Tenryu, I arrived in nearby Hamamatsu city. Here, I visited a shrine Akiha and recorded *sangaku* problems proposed by Harada in 1822."

Y25

29th of November: "I arrived at the famous spa Hakone today. I saw many bamboo souvenirs in the shops here."

Y26

1st of December, 1822: "At last I have arrived at my school in Edo and have finished over two years of travel. I have enjoyed this journey. After some rest, I will plan my next *sangaku* journey. This is the end of my third journey."

Answers and Solutions to Selected Diary Problems

Problem 1: First Problem from the Zenkoji Temple

Yamaguchi did not record his solution in his travel diary because it was too complicated. However, the problem appeared in Fujita Kagen's book *Zoku Shinpeki Sanpō* (chapter 3). The title refers to the fact that it is a "second enlarged edition" of Fujita's 1789 *Shinpeki Sanpō*.

The problem is also found in the notes of certain contemporary mathematicians, among them a manuscript of Yoshida Tameyuki (chapter 3) with the same title as Fujita's book. We present Yoshida's solution to the problem here; although lengthy, it requires no elaborate mathematics. However, before we get to Yoshida's solution proper, some preliminaries are needed.

As in figure 7.1, we circumscribe the polygon with a circle and label the vertices A_k ($k = 1, 2, \ldots, n-1$), such that lengths $A_1 = A_1 A_2 = \cdots = A_{n-2} A_{n-1} = a$.

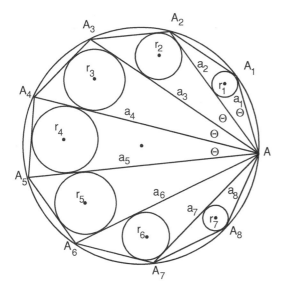

Figure 7.1. An n-sided regular polygon with side length $a_1 = a$.

We are to find r_k $(k = 1, 2, \ldots, n - 2)$, the radius of the inscribed circle of triangles AA_kA_{k+1}, in terms of $AA_1 = a_1 = a$ and $AA_2 = a_2$. [Note: Once we have the answer in terms of a and a_2, it is easy to find a_2 in terms of a.]

The following definitions will prove useful in the proof:

$$e \equiv \frac{a_2}{a}, \quad s \equiv \sqrt{\frac{2 - e}{2 + e}}, \quad l \equiv s(2 - e)a. \tag{1}$$

In terms of these quantities, the answer to the problem is

$$r_1 = \frac{s}{2}a_2,$$

$$r_2 = er_1 - \frac{l}{2},$$

$$r_3 = er_2 - r_1 - \frac{l}{2},$$

$$r_4 = er_3 - r_2 - \frac{l}{2},$$

$$r_{k+2} = er_{k+1} - r_k - \frac{l}{2}.$$

To obtain this result we must first prove two lemmas, which Yamaguchi did not state:

Lemma 1: The relation among the sides a_k is

$$a_3 = ea_2 - a,$$
$$a_4 = ea_3 - a_2,$$
$$a_5 = ea_4 - a_3,$$
$$a_6 = ea_5 - a_4,$$
$$a_{k+2} = ea_{k+1} - a_k.$$

The last expression is termed a recursion relationship. To prove it, notice that, because the polygon is regular, all the chords drawn from vertex A subtend equal angles on the drawn circle. Thus, as indicated in figure 7.1, all the angles $A_k A A_{k+1}$ are the same. Call this angle θ.

For the first triangle AA_1A_2, the law of cosines gives

$$a^2 = a_2^2 + a^2 - 2aa_2\cos\theta,$$

or

$$\cos\theta = \frac{a_2}{2a} = \frac{e}{2},$$

from the definition of e. In general, figure 7.1 shows that

$$\cos\theta = \frac{a_{k+1}^2 + a_k^2 - a^2}{2a_{k+1}a_k} = \frac{e}{2}. \tag{2}$$

For $k = 2$, equation (2) gives

$$a_3^2 - ea_2a_3 + (a_2^2 - a^2) = 0,$$

which is a quadratic equation for a_3 in terms of a_2 and a. Write $x^2 - ea_2x + (a_2^2 - a^2) = 0$. For a quadratic equation $ax^2 + bx + c = 0$, the sum of the roots $x_1 + x_2 = -b/a$. In our case, $x_1 + x_2 = ea_2$. One root, $x_1 = a_1 = a$, can be found by inspection. Figure 7.1 shows that this corresponds to the side $a_{k-1} = a_1$ of the smallest triangle AA_1A_2, which means that the larger root x_2 corresponds to the side we are looking for, $a_{k+1} = a_3$. Hence,

$$a_3 = ea_2 - a.$$

Similarly, for $k = 3$, equation (2) gives

$$a_4^2 - ea_3a_4 + (a_3^2 - a^2) = 0.$$

Here, $x_1 + x_2 = ea_3$. From the $k = 2$ case, we suspect that the smaller root corresponds to the side of the previous triangle, or $x_1 = a_{k-1} = a_2$, which is easily verified by substitution. Therefore, we have at once

$$a_4 = ea_3 - a_2.$$

One can see that, in general,

$$a_{k+2}^2 - ea_{k+1}a_{k+2} + (a_{k+1}^2 - a^2) = 0,$$

and consequently

$$a_{k+2} + a_k = ea_{k+1}. \tag{3}$$

We have proved the desired recursion relation $a_{k+2} = ea_{k+1} - a_k$ and thus Lemma 1. QED.

Lemma 2: If the circle inscribed in triangle ABC touches the side AC at D, then $AD = b = (AB + AC - BC)/2$

By drawing the auxiliary dotted lines in figure 7.2 it is very easy to prove this lemma and we leave it as an exercise for the reader. At this point Yoshida's solution formally begins.

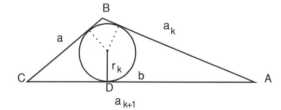

Figure 7.2. Drawing for lemma 2.

Yoshida's solution:

We start by finding r_1. Notice that ΔAA_1A_2 is isosceles, and so its area is $\frac{1}{2}a_2h,$ where h is the altitude. However, one can easily show that $A = \frac{1}{2}r_1(2a + a_2)$. [Hint: Draw a figure similar to figure 7.2 and add up the area of the interior triangles.] From the Pythagorean theorem $h = \sqrt{a^2 - a_2^2/4}$, and so,

$$a_2\sqrt{a^2 - a_2^2/4} = r_1(2a + a_2).$$

Solving for r_1 gives

$$r_1 = \frac{1}{2}\sqrt{\frac{2a - a_2}{2a + a_2}}a_2 = \frac{1}{2}sa_2, \tag{4}$$

where we have used the definition of s in equation (1). This gives r_1 as shown in the answer.

We now find the remaining r_k ($k = 2, 3, \ldots, n-2$). To do this is rather easy, exploiting the lemmas we have already proven. We will also make use of the quantity b_k, which is the length AD in figure 7.2. See also figure 7.3.

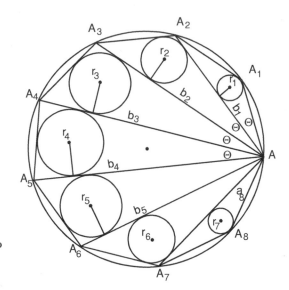

Figure 7.3. The length b_k is the length from A to the point where the kth circle touches a_{k+1}.

Lemma 2 gives directly $b_2 = \frac{1}{2}(a_3 + a_2 - a)$.

By lemma 1, $a_3 + a_2 - a = ea_2 - a_1 + a_2 - a$. Recalling that $a_2 = ea$ and letting $w \equiv 2 - e$, we have $a_3 + a_2 - a = ea_2 - wa_1$ and so

$$b_2 = \frac{1}{2}(ea_2 - wa).$$

By the same method,

$$
\begin{aligned}
b_3 &= \frac{1}{2}(a_4 + a_3 - a) \quad \text{(lemma 2)} \\
&= \frac{1}{2}(ea_3 - a_2 + ea_2 - a - a) \quad \text{(lemma 1 on } a_4 \text{ and } a_3) \\
&= \frac{1}{2}[e(a_3 + a_2) - a_2 - 2a] \\
&= \frac{1}{2}[e(2b_2 + a) - a_2 - 2a] \quad \text{(lemma 2)} \\
&= eb_2 - \frac{1}{2}a_2 - \frac{1}{2}(2 - e)a. \\
&= eb_2 - b_1 - \frac{1}{2}wa.
\end{aligned}
$$

Similarly,

$$b_4 = \frac{1}{2}(a_5 + a_4 - a) \quad \text{(lemma 2)}$$

$$= \frac{1}{2}(ea_4 - a_3 + ea_3 - a_2 - a) \quad \text{(lemma 1)}$$

$$= \frac{1}{2}[e(a_4 + a_3) - (a_3 + a_2) - a]$$

$$= \frac{1}{2}[e(2b_3 + a) - (2b_2 + a) - a] \quad \text{(lemma 2)}$$

$$= eb_3 - b_2 - \frac{1}{2}(2 - e)a_1$$

$$= eb_3 - b_2 - \frac{1}{2}wa.$$

Thus, in general,

$$b_{k+2} = eb_{k+1} - b_k - \frac{1}{2}wa. \tag{5}$$

Now, from figure 7.3, we see that all the right triangles are similar, and so

$$\frac{r_2}{b_2} = \frac{r_3}{b_3} = \cdots = \frac{r_1}{b_1}.$$

But from equation (4) we know that

$$\frac{r_1}{b_1} = \sqrt{\frac{2a - a_2}{2a + a_2}} = s.$$

Thus, the quantity s is in fact the ratio of r_k/b_k. Subsituting equation (5) for b_k gives the final result

$$r_{k+2} = er_{k+1} - r_k - \frac{1}{2}aws \equiv er_{k+1} - r_k - \frac{l}{2},$$

as stated. [Note: The problem in Yamaguchi's diary asks for the solution in terms of a alone. We leave this step as an exercise for the reader.]

Problem 2: Second Problem from the Zenkoji Temple

One example and the answer for the general case were written on the tablet.

The example is as follows: If $2R = 12$ and $AC \times BD = 112$, then $2r = 7$. The answer to the general case:

$$r = \frac{AC \times BD}{2\sqrt{AC \times BD + 4R^2}}.$$

We here offer another proof after Yoshida from the same manuscript. This proof is also long, but perhaps easier than the previous one, requiring nothing more than basic trigonometry and relationships among line segments of triangles circumscribing circles.

The general strategy is to find expressions for AC and BD in terms of R, r, and the other quantities. The first step is to temporarily remove segment BD and consider only AC. We then draw two auxiliary circles, as shown in figure 7.4. Dropping perpendiculars from the centers of these circles to the sides of the quadrilateral, we denote the radius of the larger one by r_1 and the smaller one r_2. Clearly, because circles r and r_1 are inscribed in the same angle, their centers lie along the same chord. The same applies to r and r_2. Then, by similar triangles,

$$\frac{r}{d} = \frac{r_1}{d_1} \quad \text{and} \quad \frac{r}{b} = \frac{r_2}{b_1}. \tag{1}$$

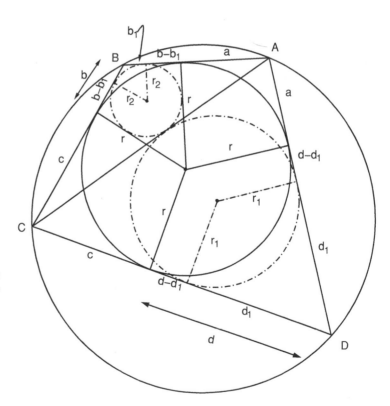

Figure 7.4. The line segment BD is temporarily removed and we draw the two dash-dotted circles of radii r_1 and r_2, inscribed in triangles ADC and ABC, respectively. Both circles are tangent to the chord AC.

Also, the tangent distance from A to circle r_1 is $a + d - d_1$, and from C is $c + d - d_1$, so

$$AC = a + c + 2(d - d_1). \tag{2}$$

Similarly, the tangent distance from A to circle r_2 is $a + b - b_1$ and from C is $c + b - b_1$, so we can also write

$$AC = a + c + 2(b - b_1). \tag{3}$$

Letting $AC \equiv l$ and using equations (1) gives

$$d_1 = \frac{2d + a + c - l}{2},$$
$$r_1 = \frac{r}{2d}(2d + a + c - l), \tag{4}$$

and

$$b_1 = \frac{2b + a + c - l}{2},$$
$$r_2 = \frac{r}{2b}(2b + a + c - l). \tag{5}$$

Next, dividing the quadrilateral $ABCD$ into triangles and adding up their areas (= one-half base × altitude) gives the nice result

$$A_{ABCD} = r(a + b + c + d). \tag{6}$$

Similarly, we find for the area of triangle ACD

$$A_{ACD} = \frac{r_1}{2}[2(a + c + 2(d - d_1)) + 2d_1].$$

Using $l = a + c + 2(d - d_1)$ from equation (2) and the first of equations (4) to eliminate d_1 gives

$$A_{ACD} = \frac{r_1}{2}(2d + a + c + l).$$

For the top triangle ABC we play the same game, with l from equation (3) and the first of equations (5) to eliminate b_1, and get

$$A_{ABC} = \frac{r_2}{2}(2b + a + c + l).$$

Setting $A_{ABCD} = A_{ABC} + A_{ACD}$ yields

$$2r(a + b + c + d) = r_1(2d + a + c + l) + r_2(2b + a + c + l). \tag{7}$$

We can now eliminate r_1 and r_2 through the second of equations (4) and (5). A few lines of algebra gives an expression for $AC^2 = l^2$:

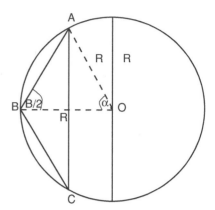

Figure 7.5. The length $AC = 2R\sin\alpha$, but because the triangle OAB is isosceles, α and B are supplementary and $AC = 2R\sin B$.

$$AC^2 = (a + c)^2 + \frac{4(a + c)bd}{(b + d)}. \tag{8}$$

Next we need to make use of a lemma, that $AC(b^2 + r^2) = 4Rrb$ and $AC(d^2 + r^2) = 4Rrd$. Because Yoshida states this result without proof, we give a simple modern proof:

Proof of Lemma:

As shown in figure 7.5, $AC = 2R\sin\alpha$, but α is supplementary to B and so

$$AC = 2R\sin B$$

$$= 4R\sin\frac{B}{2}\cos\frac{B}{2}$$

$$= 4R\frac{r_2}{\sqrt{b_1^2 + r_2^2}}\frac{b_1}{\sqrt{b_1^2 + r_2^2}}.$$

Eliminating b_1 and r_2 with the help of equation (1) gives

$$AC(b^2 + r^2) = 4Rrb. \tag{9}$$

We also have $AC = 2R\sin D$. Following the same procedure yields

$$AC(d^2 + r^2) = 4Rrd, \tag{10}$$

which proves the lemma.

Dividing equation (9) by equation (10) then shows that

$$r^2 = bd, \tag{11}$$

and reinserting this into equation (9) yields the penultimate relationship

$$(b + d) = \frac{4Rr}{AC}. \tag{12}$$

The next stage is to go back to the beginning, remove chord AC from figure 7.4, reinstate chord BD, and repeat the entire analysis to find an expression analogous to equation (12) for BD. By symmetry, however, one can guess the correct answer:

$$(a + c) = \frac{4Rr}{BD}. \qquad (13)$$

The proof is now essentially complete. Inserting the expression just obtained for $(a + c)$ into the right-hand side of equation (8), and eliminating $(b + d)$ with equation (12) gives the desired result

$$(AC \cdot BD)^2 = 4r^2(AC \cdot BD + 4R^2). \qquad (14)$$

The reader can verify that if $2R = 12$ and $AC \times BD = 112$, then $2r = 7$.

Problem 5: Masuda's First Problem

Yamaguchi's answer to Masuda is as follows:

$$t = \frac{7 - \sqrt{49 - 3(2 + \sqrt{108})}}{2 + \sqrt{108}} R = 0.2873R.$$

Yamaguchi seems to have been uncertain about this result and he wrote a second answer above the first in his diary: $t = 3/(7 + \sqrt{43 - \sqrt{972}})R$. Perhaps he meant this as a correction, but the result is numerically identical to the first and cannot be reconciled with the figure.

Fortunately, we have found an original solution to the same problem. The correct answer is

$$t = \frac{R}{12}[\sqrt{59,085 + 3,409\sqrt{3}} - 102\sqrt{3} - 165] = 0.1697R.$$

For the full solution, see chapter 6, problem 13.

Problem 6: Inō's Problem

The solution of Inō's problem requires no more than the Pythagorean theorem. We are given that q equals the length AQ and that segment p bisects the chord AB. Let x equal one-half AB. Then from figure 7.6 $q = x + h$. Note also that $h = x - r$, where r is the radius of the small circle. Therefore

$$h = \frac{q - r}{2}. \qquad (1)$$

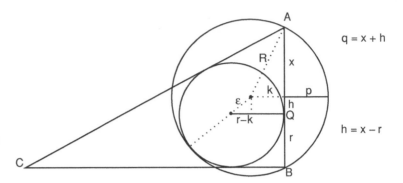

Figure 7.6. A few auxiliary lines
help.

Let R be the radius of the large circle and $k \equiv R - p$. Drawing the auxiliary dotted lines, we see that by Pythagoras

$$x^2 + (R - p)^2 = R^2.$$

Squaring this out with $x = q - h$ yields

$$h^2 = 2Rp + 2qh - q^2 - p^2. \tag{2}$$

Inserting equation (1) into the right-hand side of equation (2) gives

$$h^2 = 2Rp - qr - p^2. \tag{3}$$

The diagram also shows that

$$h^2 + (r - k)^2 = \varepsilon^2. \tag{4}$$

But by inspection $\varepsilon = R - r$. Solving equation (4) for h^2 with $k = R - p$ then gives

$$h^2 = 2Rp - p^2 - 2rp. \tag{5}$$

Substituting equation (5) into equation (3) yields the required result, $q = 2p$.

Problem 7: The Osaka Problem

The general solution is $p = (3a+b)/2$.

We could not find the original proof but the result can be obtained fairly easily as follows:

Draw in the full circle of radius r, as in figure 7.7. Also draw three lines, two radii from the points at which circle a and the equilateral triangle touch circle r, and and a line from the center of r to the

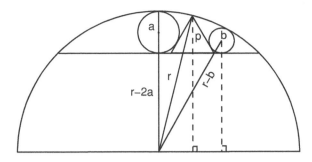

Figure 7.7. The Osaka problem.

center of b. With the Pythagorean theorem it is not difficult to show that

$$r^2 = (p + r - 2a)^2 + \left(\frac{a}{\sqrt{3}} + \frac{p}{\sqrt{3}}\right)^2.$$

Similarly,

$$(r - b)^2 = (b + r - 2a)^2 + \left(\frac{a}{\sqrt{3}} + \frac{2p}{\sqrt{3}} + \frac{b}{\sqrt{3}}\right)^2.$$

Solving each equation for r and eliminating r between them gives

$$(2a - p)b^2 + (6a^2 + 4p^2 - 2ap)b + p(3a - 2p)(5a + 2p) = 0,$$

which factors into

$$[b + (3a - 2p)][(2a - p)b + p(5a + 2p)] = 0.$$

From figure 7.7, the second term must be positive. Therefore $b + 3a - 2p = 0$, or

$$p = \frac{3a + b}{2},$$

as stated. One wonders why Yamaguchi thought about it for four or five years.

Problem 8: Matsumiya's Problem

Matsumiya did not give the answer to his problem but it is very easy and we can obtain the solution as follows:

Find the center of the original circle O of which the given arc is part. As shown in figure 7.8, draw in three radii from O to the end-points of the arc and to the point where one of the perpendiculars, l_k, intersects the arc. Then the Pythagorean theorem gives

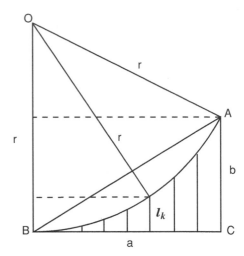

Figure 7.8. For Matsumiya's problem.

$r^2 = a^2 + (r-b)^2$, or $r = (a^2 + b^2)/2b$. If we label the l_k from the left, then the Pythagorean Theorem also gives $r^2 = (ak/8)^2 + (r-l_k)^2$, and hence the desired solution

$$l_k = r - \sqrt{r^2 - \left(\frac{ak}{8}\right)^2} \quad (k = 1, 2, \ldots, 8).$$

Problem 9: Katori Zentarō's Problem

Katori's answer is

$$S_1 = \left(17 - \frac{280}{28 - 3\pi}\right)S_2.$$

To get this result we follow another proof by Yoshida, which requires nothing more than elementary geometry and patience. The plan is to find expressions for t and b (see figure 7.9) in terms of r; this will allow us to compute the required areas.

First, draw the auxiliary triangle shown in the figure. Then, by similar triangles,

$$\frac{t}{p} = \frac{r}{x+p}. \tag{1}$$

But by Pythagoras

$$x^2 + (r-t)^2 = (r+t)^2.$$

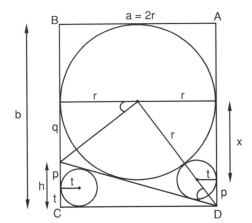

Figure 7.9. For Katori Zentarō's problem.

Squaring this equation and solving for x gives $x = 2\sqrt{rt}$, and therefore from equation (1)

$$\frac{t}{p} = \frac{r}{2\sqrt{rt} + p}.$$

Solving for p yields

$$p = \frac{2t\sqrt{rt}}{r - t}. \tag{2}$$

Convince yourself that the marked angles are the same. [Hint: It may help to drop a perpendicular from the center of the large circle to the hypotenuse of the triangle.] Then once more, by similar triangles,

$$\frac{q}{r} = \frac{t}{p} \quad \text{or} \quad q = \frac{rt}{p}. \tag{3}$$

Since the two sides BC and AD are equal, we have $t + p + q + r = p + 2\sqrt{rt} + r$, or, from the above expression for q,

$$2p\sqrt{rt} = pt + rt.$$

Eliminating p with equation (2) gives after a few steps

$$5rt - r^2 = 2t\sqrt{rt}.$$

Squaring both sides yields the cubic equation

$$r^3 - 10r^2t + 25rt^2 - 4t^3 = 0,$$

which factors into

$$(r - 4t)(r^2 - 6rt + t^2) = 0.$$

Thus, we have three roots for r:

$$r = 4t, \quad r_{\pm} = 3t \pm \sqrt{8}t. \tag{4}$$

Convince yourself from the figure that the $r = 4t$ root is the only one we want, from which equations (2) and (3) give

$$p = \frac{r}{3} \quad \text{and} \quad q = \frac{3r}{4}.$$

We also have $h = t + p = 7r/12$. From the figure, $b = r + h + q$, and so

$$b = \frac{7r}{3} = \frac{7a}{6}. \tag{5}$$

This is the desired result for b.

Now, referring to the original figure on page 256, the area of the black region is $S_2 = \frac{1}{2}h \cdot 2r - \pi t^2$. We use the above expressions to write h and t in terms of r, and solve for r^2 to get

$$r^2 = \left(\frac{48}{28 - 3\pi}\right) S_2. \tag{6}$$

Again referring to the original figure, we are to find the area of the shaded region $S_1 = ab - \frac{1}{2}ah - \pi r^2 - \pi t^2$. By assumption $a = 2r$, and we once more use the above expressions to write h and t in terms of r. Then using equation (6) we get

$$S_1 = \left(\frac{196 - 51\pi}{28 - 3\pi}\right) S_2 = \left(17 - \frac{280}{28 - 3\pi}\right) S_2, \tag{7}$$

which is Katori's answer.

Problem 11: Sawa's Problem from the Syosya Temple

The answer for the specific case $a = 72$, $b = 32$ is $c = 25$.

In general,

$$c = \frac{a(\sqrt{a} + \sqrt{b})^2}{3b + \sqrt{ab}}.$$

Problem 14: Ukawa's Problem from the Takarao Shrine

The number of balls is $n = $ greatest integer part of $h/2r\pi$.

Problem 15: Kashiwano's Problem in the Tenman Shrine

The answer is $CH = 5$.

Problem 17: Takeda's Problem

The answer is

$$2r = \frac{2\{4R - (2S+1)k - 2d\}}{(2S+1)^2},$$

where

$$S = \frac{T}{T + \sqrt{m^2 - T^2} - m}, \quad T = \frac{\sqrt{(1 - m/2R)(4R^2 - k^2)} + k}{(m/2k)^2},$$

$$\text{and} \quad R = \frac{4d^2 + k^2}{8d}.$$

術曰以長徑除短徑自之以減一個餘名春置外徑自

之內減長徑冪餘乘春平方開之名夏內減短徑餘名秋

乘夏以春除之平方開之名冬加外徑以除秋冬差乘

外徑得乙徑甲徑合問

今有如圖球內容曰月球其罅隙環

容逐球　外球徑三十　日球徑一十

月球徑六　甲球徑五寸　問逐球徑幾何

答曰乙球徑一十五寸

丙球徑一十　丁球徑三寸七分五釐

戊球徑二寸五分　己球徑二寸一十一分寸之八

Plate 8.1. The illustration from Uchida Kyō's 1832 collection *Kokon Sankan*, for a problem that was originally proposed in 1822 by Yazawa Hiroatsu on a tablet hung at the Samukawa shrine of Kōzagun, Kanagawa prefecture. The result is known in the West as the Soddy hexlet theorem. (Aichi University of Education Library.)

Eight

East and West

For pairs of lips to kiss maybe
Involves no trigonometry.
'Tis not so when four circles kiss
Each one the other three.
To bring this off the four must be
As three in one or one in three.
—Frederick Soddy, from
"The Kiss Precise"

If there is a single lesson to be drawn from the preceding chapters, it is that creativity respects no geographical or cultural boundaries, in science or art. We are taught in Western schools that mathematics flowed from ancient Greece to Western Europe, and with it so too did the great stream of discovery. One cannot and should not deny that the majority of important "classical" mathematical results have come to us through Greece and Europe but, as far as the subject of this book goes, a few famous theorems attributed to Western authors were in fact posted on *sangaku* prior to their occidental discovery, and a few others, which had been previously found in the West, were independently discovered by traditional Japanese geometers.

We have already employed many of the ancient theorems common to East and West to solve problems throughout *Sacred Mathematics*. Apart from the omnipresent Pythagorean theorem, which reached Japan through China, there was Ptolemy's theorem, "The sum of the products of the opposite sides of a cyclic quadrilateral is equal to the product of the diagonals," which was required to solve problem 1, chapter 6. It is found, for example, in the 1769 *Syuki Sanpō*, or *Mathematics*, by Arima Yoriyuki (chapter 3).

Similarly, the law of cosines, which has figured in many exercises, turns up in an equal number of traditional Japanese manuscripts, for instance, the 1840 *Sanpō Chokujutsu Seikai, Mathematics without Proof*, by Heinouchi Masaomi (?–?). (See also the solution to problem 27, chapter 4.) The law of sines was likewise well known. One finds it written on a surviving tablet dating from 1849 at the Kumano shrine of Senhoku-gun in Akita prefecture, as well as in the earlier book *Sanpō Jojutsu* of 1841. Heron's famous formula for the area of a triangle, which was employed to solve problem 4 in chapter 6, is found in an unpublished nineteenth-century manuscript of Kawakita Tomochika (1840–1919). We pointed out in chapter 3 that the conditions for Pythagorean triples were independently derived by traditional Japanese mathematicians; so too were the less well-known Heron numbers, which are quadruples of integers that, analogously to the Pythagorean triples, can be associated with the sides of a nonright triangle and its area. In the solution to problem 1, chapter 5, we mentioned that Euclid's algorithm was also known in Japan through China.

To mathematicians these theorems are elementary—most are proved in any high school course—and one could argue that it is hardly remarkable that the Japanese came across them. However, traditional Japanese geometers also discovered a number of more advanced and celebrated "modern" theorems independently of their Western counterparts. Let us survey these now.

Descartes Circles, Soddy Hexlets, and Steiner Chains

The Descartes circle theorem concerns the relationship between the radii of four mutually tangent, or kissing, circles and is one of those theorems that has been periodically rediscovered over the centuries. The ancient Greeks often concerned themselves with the properties of tangent circles; Apollonius himself devoted an entire book to the subject in the third century B.C., and it is entirely conceivable the result was known to him; however, his work *On Tangencies* has not survived.

The theorem as we know it receives its name from René Descartes, who mentioned the result in a letter of November 1643 to Princess Elizabeth of Bohemia,[1] with whom he discussed philosophical and mathematical mat-

[1] *Oeuvres de Descartes*, published by Adam et Tannery (Paris, 1901), vol. 4, p. 45.

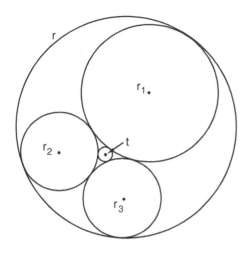

Figure 8.1. The Descartes circle theorem gives the relationships among the radii of four kissing circles. The fourth can Either circumscribe the other three, or vice versa.

ters (presumably there is a lesson here about the change in political leaders between then and now). In modern notation the theorem can be written as it was employed to solve problem 12 in chapter 6:

$$2(k_1^2 + k_2^2 + k_3^2 + \kappa^2) = (k_1 + k_2 + k_3 + \kappa)^2,$$

$$2(k_1^2 + k_2^2 + k_3^2 + \zeta^2) = (k_1 + k_2 + k_3 - \zeta)^2.$$

Here, the k's are the reciprocals of the radii of the circles shown in figure 8.1 $k_1 \equiv 1/r_1$, etc. The reciprocal radius of a circle is termed the curvature, or in some older texts the "bend." For the situation in which the three circles r_1, \ldots, r_3 touch the fourth circle t externally, the curvature of t is taken to be positive, and so $\kappa \equiv 1/t$ comes into the formula with a plus sign. When r_1, \ldots, r_3 touch the fourth circle r internally, the curvature $\zeta \equiv 1/r$ is taken to be negative and comes in with a minus sign.

Descartes himself considered only the first configuration—three circles kissing t—and his sketch was incomplete. In 1826, the great Jakob Steiner (1796–1863), one of the mathematicians who discovered inversion, independently proved the Descartes circle theorem for both configurations shown in figure 8.1. The next Western discoverer seems to have been Philip Beecroft, an English amateur mathematician, who derived the result in 1842. Finally, it was rediscovered again in 1936 by Frederick Soddy (1877–1956). As mentioned in chapter 6, Soddy is known to scientists as the physical chemist who, along with Rutherford, discovered the transmutation of the elements via radioactive decay, and who immediately realized its implications for the future of the world. Soddy won the 1921 Nobel

Plate 8.2. On the right is Descartes' original drawing for his circle theorem as it is found in his letter to Princess Elizabeth of Bohemia of November 1643. On the left is the illustration for the Japanese version of the theorem as it appears in Hasimoto Masataka's 1830 *Sanpō Tenzan Syogakusyo*, or *Geometry and Algebra*. The theorem was well known in Edo Japan and employed to solve numerous *sangaku* problems. (Collection of Fukagawa Hidetoshi.)

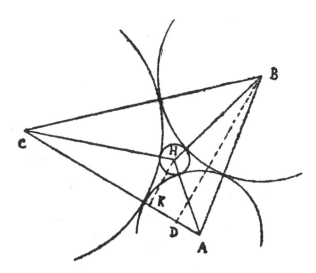

Plate 8.2. (*continued*)

Prize in chemistry for the discovery of isotopes, a term he apparently coined. Being a physical chemist, he was interested in packing problems: How many cylinders (or circles) of differing sizes can be fitted into into a larger circle? In the grand tradition, Soddy published his rediscovery of the Descartes circle theorem as a poem in 1936 in *Nature*.[2] Here it is in its entirety. You will see that that the second verse describes the formula just given:

<div align="center">

The Kiss Precise
by Frederick Soddy

</div>

> For pairs of lips to kiss maybe
> Involves no trigonometry.
> 'Tis not so when four circles kiss
> Each one the other three.
> To bring this off the four must be
> As three in one or one in three.
> If one in three, beyond a doubt
> Each gets three kisses from without.
> If three in one, then is that one
> Thrice kissed internally.

[2] *Nature* **137**, 1021 (1936).

Four circles to the kissing come.
The smaller are the benter.
The bend is just the inverse of
The distance from the center.
Though their intrigue left Euclid dumb
There's now no need for rule of thumb.
Since zero bend's a dead straight line
And concave bends have minus sign,
The sum of the squares of all four bends
Is half the square of their sum.

To spy out spherical affairs
An oscular surveyor
Might find the task laborious,
The sphere is much the gayer,
And now besides the pair of pairs
A fifth sphere in the kissing shares.
Yet, signs and zero as before, For each
to kiss the other four
The square of the sum of all five bends
Is thrice the sum of their squares.

Notice that the final verse describes the Descartes circle theorem for spheres and, indeed, a year later Soddy produced the famous hexlet theorem that bears his name: Given two spheres inscribed within a third sphere, such that they kiss each other as well as the outer sphere, put a necklace of spheres around the two given spheres. If all the spheres in the necklace kiss their nearest neighbors, as well as the outer sphere, then six and only six spheres can be placed in the necklace (see figure 8.2)

Once again Soddy published his result in *Nature*.[3] We recognize this problem, however, as identical to problem 17 of chapter 6, which was originally posted in 1822 by Yazawa Hiroatsu on a *sangaku* hung in the Samukawa shrine of Kōzagun, Kanagawa prefecture. This is apparently the first statement anywhere of the hexlet theorem. Moreover, the final verse in Soddy's poem is a statement of equation (1) in Ōmura Kazuhide's proof, which we gave as the solution to problem 17. Soddy's proof is in fact remarkably similar, almost identical, to Ōmura's. Thus,

[3] *Nature* **139**, 77 (1937).

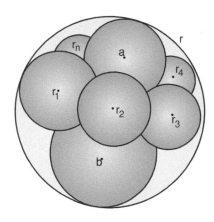

Figure 8.2. Six and only six spheres can be fitted in the "necklace" around spheres *a* and *b*.

we need say little more about it, except to repeat that it is more easily solved by inversion.

\mathcal{A}s for the Descartes circle theorem itself, this seems to have been the common property of traditional Japanese mathematicians. In the Descartes configuration it appeared on a *sangaku* in 1796, which was subsequently lost but recorded in the 1830 book *Saisi Sinzan,* or *Mathematical Tablets,* by Nakamura Tokikazu. For interested readers, we now give a Japanese proof from the 1830 *Sanpō Tenzan Syogakusyo,* or *Geometry and Algebra,* by Hasimoto Masakata. It is about at the level of the problems in chapter 5.

First, we need a preliminary result: Given three kissing circles with radii r_1, r_2, r_3, as in figure 8.3, show that

$$(AB)^2 = \frac{r_1^2 l^2}{(r_1 + r_2)(r_1 + r_3)}, \tag{1}$$

where l is the external tangent common to circles r_2 and r_3. This problem is an easy one and we leave it as an exercise for the reader.

Referring to figure 8.4 and noting that all the circles are mutually kissing, the preliminary result gives at once

$$(AB)^2 = \frac{r_3^2 \left(2\sqrt{r_1 r_2}\right)^2}{(r_1 + r_3)(r_2 + r_3)} = \frac{4 r_3^2 r_1 r_2}{(r_1 + r_3)(r_2 + r_3)},$$

$$(AC)^2 = \frac{4 r_3^2 r_1 t}{(r_1 + r_3)(t + r_3)}, \quad (BC)^2 = \frac{4 r_3^2 r_2 t}{(r_2 + r_3)(t + r_3)}. \tag{2}$$

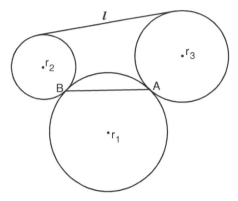

Figure 8.3. Find AB in terms of r_1, r_2, r_3, and l.

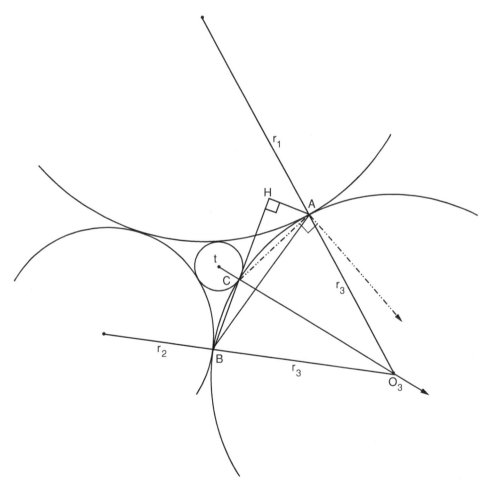

Figure 8.4. Because the indicated angle at A is a right angle, it is inscribed in a semicircle and the two arrows will intersect at the opposite end of the diameter containing CO_3 at a point C' (not shown).

The inscribed angles ABH and $AC'C$ subtend the same arc and so are equal. Thus, from similar right triangles,

$$\frac{AC}{2r_3} = \frac{AH}{AB},$$

which gives with equation (2)

$$(AH)^2 = \frac{(AB)^2(AC)^2}{4r_3^2} = \frac{4r_1^2 r_2 r_3^2 t}{(r_1+r_3)^2(r_2+r_3)(t+r_3)}.$$

From the Pythagorean theorem

$$(CH)^2 = (AC)^2 - (AH)^2 = \frac{4r_1 r_3^2 t}{(r_1+r_3)(t+r_3)}\left\{1 - \frac{r_1 r_2}{(r_1+r_2)(r_2+r_3)}\right\}. \tag{3}$$

Applying the law of cosines to $\triangle ABC$ tells us that $(AB)^2 = (AC)^2 + (BC)^2 + 2(BC)(CH)$. Plugging in the values from equation (2) and (3) yields the ungainly

$$\frac{4r_3^2 r_1 r_2}{(r_1+r_3)(r_2+r_3)} = \frac{4r_3^2 r_1 t}{(r_1+r_3)(t+r_3)} + \frac{4r_3^2 r_2 t}{(r_2+r_3)(t+r_3)}$$
$$+ 2\frac{2r_3\sqrt{r_2 t}}{\sqrt{(r_2+r_3)(t+r_3)}}\frac{2r_3\sqrt{r_1 t}}{\sqrt{(r_1+r_3)(t+r_3)}}\sqrt{1 - \frac{r_1 r_2}{(r_1+r_2)(r_2+r_3)}},$$

which nonetheless readily simplifies to

$$r_1 r_2(t+r_3) = r_1 t(r_2+r_3) + r_2 t(r_1+r_3) + 2t\sqrt{r_1 r_2 r_3(r_1+r_2+r_3)},$$

or, solving for t,

$$t = \frac{r_1 r_2 r_3}{r_1 r_2 + r_1 r_3 + r_2 r_3 + 2\sqrt{r_1 r_2 r_3(r_1+r_2+r_3)}}.$$

We leave it to the reader to show that this is equivalent to result on page 285.

Closely related to the Descartes circle theorem and Soddy hexlet is the "Steiner chain" or "Steiner porism," after Jakob Steiner, who first considered such configurations in the West. Given two circles, one within the other but not concentric, we imagine trying to fit a chain of smaller circles of various sizes between them, each of which kisses both the inner and outer circles, as well as their nearest neighbors. We have already encountered similar configurations in chapter 6; the hexlet is a three-dimensional relative; a precise two-dimensional example is shown in plate 8.3.

Plate 8.3. In about the same year Jakob Steiner was inventing Steiner chains, Ikeda Sadasuke hung this problem at the Ushijima Chōmeiji temple in Tokyo. The drawing is from Shiraishi Nagatada's 1827 book *Shamei Sanpu.* (University of Aichi Education Library.)

One can well imagine that, if the radii of the circles in the loop are not just right, the circles will not fit properly and end up overlapping, or contain a gap at the end of the chain. Employing the method of inversion, which he largely invented, Steiner found the conditions on the radii of the smaller circles in the loop.

However, in 1826, just about the time Steiner was inventing inversion, a *sangaku* was hung by Ikeda Sadakazu at the Ushijima Chōmeiji temple in Tokyo. The tablet was lost, but recorded the following year in Shiraishi Nagatada's book *Shamei Sanpu*, or *Collection of Sangaku*, from which plate 8.3 was taken. The problem asks, given two nonconcentric circles with a loop of fourteen smaller circles inscribed between them, show that

$$\frac{1}{r_1} + \frac{1}{r_8} = \frac{1}{r_4} + \frac{1}{r_{11}}.$$

Ikeda would certainly have solved this with the Descartes circle theorem, as in the solution to problem 12, chapter 6. With the powerful method of inversion, the answer is easy to get. One inverts the inner and outer circles to get two concentric circles. Then all the inverse circles in the chain must have equal radii. The inverse circles r'_1, r'_4, r'_8, and r'_{11}, must therefore lie on a rectangle, and so $1/r_1 + 1/r_8 = 1/r_4 + 1/r_{11}$ by Iwata's theorem, Theorem P, in chapter 10.

The Malfatti Problem

The Malfatti problem has had a long and tortuous history. It was first proposed in the West in 1803 by the Italian mathematician Gian Francesca Malfatti (1731–1807) who asked the following practical question:

> Given a right triangular prism of any sort of material, such as marble, how shall three circular cylinders of the same height as the prism and of the greatest possible volume of material be related to one another in the prism and leave over the least possible amount of material?[4]

One does not need to consider cutting columns from a block of marble, and Malfatti's problem immediately reduces to one of two dimensions: How can you place three circles in a given triangle such that the area of the circles is maximized?

Malfatti intuitively assumed that the maximum was attained by three circles that are mutually tangent, as in figure 8.5. This question, how do you inscribe three circles in a triangle such that they are mutually tangent and each tangent to two sides of the triangle? has, much to everyone's confusion, come to be known as Malfatti's problem, to which Malfatti provided a solution.

To be sure, a number of later geometers, including Steiner himself in 1826, devised other proofs, verifying Malfatti's solution. Strangely, well over a century passed before in 1930 H. Lob and H. W. Richmond pointed out that the Malfatti configuration was not always the solution to the problem as originally posed.[5] For example, in figure 8.6 the configuration of

[4] Gianfrancesco Malfatti, "Memoria sopra un problema sterotomico," *Mem. Mat. Fis. Soc. Ita. Sci.* **10**, No. 1, 235–244 (1803).

[5] H. Lob and H.W. Richmond, "On the solutions to Malfatti's problem for a triangle," *Proc. London Math. Soc.* **2**, No. 30, 287–304 (1930).

Figure 8.5. Malfatti's solution to his own problem
was something like this.

Figure 8.6. The combined area of the circles
on the left is greater than on the right.

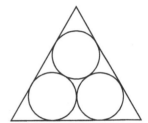

circles on the left—which are not mutually tangent—has a greater area than the kissing circles on the right.

Indeed, in 1967, Michael Goldberg showed that the Malfatti configuration is *never* the solution to the original problem.[6] As to what exactly *is* the best configuration, this question was only laid to rest fairly recently, in 1992, by V. A. Zalgaller and G. A. Los'. Their proof[7] is rather involved, requiring even a computer, but briefly they showed that there were fourteen different configurations of circles-within-triangle to consider, then systematically eliminated twelve of them, to be left with two very different ones, each of which could take on the maximum value depending on the angles of the triangle. The two configurations are shown in figure 8.7. Notice that neither of them are the Malfatti configurations, as Goldberg predicted.

The story now has another chapter. The great Japanese mathematician Ajima Naonobu (chapter 3) gave a solution to the problem: How do you inscribe three mutually tangent circles in a triangle? in a manuscript approximately thirty years before Malfatti proposed it. The manuscript was

[6]Michael Goldberg, "On the original Malfatti problem," *Math. Mag.* **40**, No. 5, 241–247 (1967).

[7]V.A. Zalgaller and G.A. Los', "The solution of the Malfatti problem," *Ukrainskii Geometricheskii Sbornik* **35**, pp. 14–33 (1992); English translation *J. Math. Sci.* **72**, No. 4, 3163–3177 (1994).

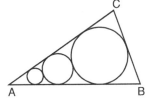

Figure 8.7. The winning configurations. The one on the left wins if $\sin (A/2) \geq \tan (B/4)$.

edited only the year after Ajima's death as *Fukyū Sanpō* or *Masterpieces of Mathematics.*

His solution was somewhat along the lines of problem 4 in chapter 6, but longer and more complicated. Given a triangle *ABC* with an inscribed circle of radius r, then according to Heron's formula for the area of a triangle

$$r = \sqrt{\frac{(s-a)(s-b)(s-c)}{s}},$$

where s is the semiperimeter (see also the solution to problem 1, chapter 6). Let $p \equiv r - (s-a) + \sqrt{r^2 + (s-a)^2}$, $q \equiv r(a-p)$, and $t = \sqrt{q^2 - p^2(s-b)(s-c)}$; then Ajima shows

$$r_1 = \frac{q+t}{2(s-c)},$$

$$r_2 = \frac{q-t}{2(s-b)},$$

$$r_3 = \frac{r_1[b - (t/r + c)]^2}{(2r_1 - p)^2},$$

where the r's are as shown in figure 8.5. Ajima also gave an example: If $a = 507$, $b = 375$, and $c = 252$, then $r_1 = 64$, $r_2 = 56.25$, and $r_3 = 36$. We leave the details as an exercise for intrepid souls.

Other Well-Known Theorems

There are a number of other celebrated Western theorems, discovered as well by the Japanese, that are somewhat more difficult to derive than the above and we end this chapter by giving them a brief mention.

One of the most famous of these is Feuerbach's theorem, after Karl Wilhelm Feuerbach (1800–1834) who published it in 1822. To understand Feuerbach's theorem, one must first know something about the "nine-point circle" (also known as the Euler or Feuerbach circle). Any triangle *ABC* has nine "special" points. These are the midpoints of the sides, the bases (or

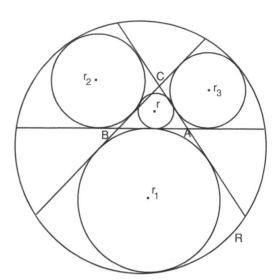

Figure 8.8. Feuerbach's theorem as it appears on a *sangaku*. The sides of triangle *ABC* are extended as shown. Three excircles of radii r_1, r_2 and r_3 are drawn tangent to the extended sides. A smaller circle of radius r is drawn that kisses all three excircles. A large circle of radius R is drawn circumscribing the excircles. Find r and R in terms of r_1, r_2, and r_3. Circle r is the nine-point circle.

feet) of the three altitudes, and the midpoints of the segments from the vertices to the orthocenter (the point at which the three altitudes intersect). It turns out, implausibly, that a *single* circle can be drawn through all the nine special points of the triangle!

What's more, if one extends the sides of *ABC*, one can draw three external circles that are tangent to the original sides. Feuerbach proved that the nine-point circle is tangent to all three of these "excircles" as well as to the incircle (inscribed circle) of *ABC*. The Japanese did not have the concept of the nine-point circle, but the problem to find the radius of a circle tangent to its three excircles was posted on an 1801 *sangaku*, which has disappeared; the solution was recorded in Nakamura Tokikazu's 1830 *Saisi Sinzan*. The circle (see figure 8.8) *is* the nine-point circle. The traditional proof is far too involved to present here[8] but the result on the *sangaku* was

$$r = \frac{(r_1 + r_2)(r_2 + r_3)(r_3 + r_1)}{8(r_1 r_2 + r_2 r_3 + r_3 r_1)},$$

where r is the radius of the nine-point circle and r_1, r_2, and r_3 are the radii of the excircles.

\mathcal{A} somewhat less well-known theorem, but one that is very useful (in fact sometimes used to prove Feuerbach's theorem) was stated by John Casey, apparently in 1857. This one concerns four circles tangent to a fifth circle.

[8] The full proof is given by Fukagawa and Pedoe, *Japanese Temple Geometry Problems*, pp. 111–114 ("For Further Reading: Chapter 6," p. 339).

In slightly less than its most general form, Casey's theorem states that four circles of radii r_1, r_2, r_3, r_4 are tangent to a fifth circle or a line if and only if

$$t_{12}t_{34} \pm t_{13}t_{42} \pm t_{14}t_{23} = 0,$$

where t_{12} is the common tangent between circles 1 and 2, etc.[9]

In 1830 the theorem was stated by Shiraishi Nagatada as follows: For four circles to touch a fifth circle, externally or internally, then

$$t_{12}t_{34} + t_{14}t_{23} = t_{13}t_{24}$$

Casey's theorem is actually not difficult to prove with the tools already at hand. In figure 8.9 let the segment AB from the point of tangency between circles r_1 and r_2 be d_{12}, with similar designations for the other like segments. Then, the preliminary result that we needed to prove the Descartes circle theorem tells us at once that

$$d_{12}^2 = \frac{r_5^2 t_{12}^2}{(r_5 + r_1)(r_5 + r_2)},$$

with similar expressions for the other d_{ij}. Notice that $t_{12}^2 t_{34}^2 = k d_{12}^2 d_{34}^2$, $t_{14}^2 t_{23}^2 = k d_{14}^2 d_{23}^2$, and $t_{13}^2 t_{24}^2 = k d_{13}^2 d_{24}^2$, where

$$k = \frac{(r_5 + r_1)(r_5 + r_2)(r_5 + r_3)(r_5 + r_4)}{r_5^4}.$$

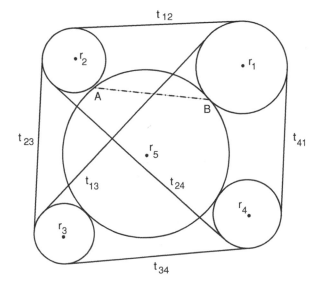

Figure 8.9. Let $AB = d_{12}$, with similar labels for the other segments.

[9] For a proof and more on the significance of the signs, see Paul H. Daus, *College Geometry* (Prentice-Hall, New York, 1941).

Also notice that the segments d_{12}, d_{23}, d_{34}, and d_{41} form a cyclic quadrilateral (an inscribed quadrilateral) in circle r_5. Thus Ptolemy's theorem from above (or see problem 1, chapter 6) applies, and immediately gives

$$d_{12}d_{34} + d_{41}d_{23} = d_{13}d_{24}.$$

Since $(t_{ij}t_{kl})^2 = \text{k}(d_{ij}d_{kl})^2$ for all values of i, j, k, l, Shiraishi writes

$$t_{12}t_{34} + t_{41}t_{23} = t_{13}t_{24},$$

which, however, is not general.

More briefly, as already noted in problem 18, chapter 6, Euler's 1778 formula for a spherical triangle was posted on a *sangaku* about a quarter of a century later, in 1804. Euler showed that the area of a spherical triangle ABC on the surface of a sphere of radius r could be written as $S = Er^2$, where

$$\cos\frac{E}{2} = \frac{1 + \cos A + \cos B + \cos C}{4\cos(A/2)\cos(B/2)\cos(C/2)}.$$

In this formula, A, B, and C represent angles such that $\sin(A/2) = a/(2r)$, $\sin(B/2) = b/(2r)$, $\sin(C/2) = c/(2r)$, with a being the straight-line segment opposite $\angle A$, etc. Employing the identities $\cos A = 1 - 2\sin^2(A/2)$, $\cos B = 1 - 2\sin^2(B/2)$, and $\cos C = 1 - 2\sin^2(C/2)$, Euler's formula becomes $S = Er^2$, where

$$\cos E = \frac{1 - (1/2)\left[(a/2r)^2 + (b/2r)^2 + (c/2r)^2\right]}{\sqrt{1 - (a/2r)^2}\,\sqrt{1 - (b/2r)^2}\,\sqrt{1 - (c/2r)^2}},$$

identical to the the result of problem 18 (chapter 6).

Readers who have worked through problem 24 in chapter 5 will also know that the problem of finding the volume cut out of a sphere by two parallel cylinders—known in the West as the solid of Viviani, after Galileo's student Vincenzio Viviani (1622–1703)—was written down in 1844 by Uchida Kyūmei (chapter 9) in his 1844 *Theory of Integrations*. There is little to add to except to say that Uchida's complicated method bore little resemblance to anything we would try today.

Finally, in 1896, Joseph Jean Baptiste Neuberg published a problem in the French mathematics journal *Mathesis*.[10] Here is a translation. Neuberg did not accompany his problem with a diagram; we will be merciful(?): Given a triangle ABC, let R, r, r_a, r_b, r_c be the radii of the circumcircle O, the incircle I, and the three excircles I_a, I_b, I_c, respectively.

[10]J. Neuberg, *Mathesis*, p. 193, problem 1078 (1896).

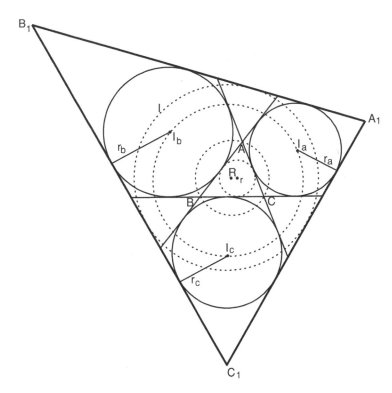

Figure 8.10. Neuberg's problem. The excircles, I_a, I_b, I_c are drawn in solid lines. $\Delta I_a I_b I_c$ is not drawn but its circumcircle is the dotted line through I_a, I_b, I_c. The radii of ΔABC's incircle and circumcircle are r and R; the circles are drawn in dotted lines. The radii of the excericles are r_a, r_b, and r_c. The incircle of $\Delta A_1 B_1 C_1$, also dotted, is marked I.

The fourth tangents common to pairs of the excircles I_a, I_b, I_c form a triangle $A_1 B_1 C_1$. Show that the center of the incircle of triangle $A_1 B_1 C_1$ is the same as the center of the circumcircle of triangle $I_a I_b I_c$ and that the following relation holds:

$$r_1 = 2R + r = \frac{r + r_a + r_b + r_c}{2}.$$

The result $2r_1 = r + r_a + r_b + r_c$ was presented in 1803 by Yamamoto Norihisa (?–?) on a *sangaku* at the Echigo Hakusan shrine, Niigata prefecture. The tablet, subsequently lost, was recorded in Nakamura's 1830 manuscript "Saishi Shinzan."

Although Neuberg's problem is itself of little consequence, along with the other theorems discussed in this chapter, it probably does serve to support the true mathematician's conviction that mathematics in a parallel universe would be the mathematics we know.

Plate 9.1. The area of a circle of diameter d is $S = (\pi/4)\mathrm{d}^2 = (\pi d/2) \times d/2$. Here, in an illustration from the *Jinkō-ki* of 1778, a circle is sliced into a collection of sectors and thus changed into a rectangle with sides $d/2$ and $\pi d/2$. Consequently, the area of the original circle is $S = \pi d/2 \times d/2 = (\pi/4)\,d^2$. Approximating the value of π and calculating the area of circles was central to the *Enri* concept. (Collection of Fukagawa Hidetoshi.)

The Mysterious Enri

The circle principle is a perfect
method, never before known in ancient
or in modern times. It is a method
that is eternal and unchange-
able . . . It is the true method . . .
 —Hachiya Sadaaki,[1] as quoted by
 Smith and Mikami

We devote the final two chapters of *Sacred Mathematics* to matters of tech-
nique. Chapter 9 is dedicated to providing an answer, insofar as there is
one, to a question that has certainly occurred to readers who have at-
tempted certain of the more difficult problems: Given that *wasan* did not
include a fully developed theory of calculus, how did traditional Japanese
geometers solve the maxima-minima problems, which require differentia-
tion, or solve problems requiring integration? In the solutions to chapters
5 and 6 we have given an idea of how the Japanese approached integration,
although we have said nothing about differentiation. Here we tackle both
matters explicitly.

Differentiation

The question of differentiation in some sense is more difficult than that of
integration because, although traditional Japanese mathematicians wrote
volumes on integration techniques, they were virtually silent about how
they took derivatives. One thing is certain: the Japanese did not have the

[1] Sometimes Hachiya Teisho.

concept of differentiation as we know it. In no traditional manuscript do we find the fundamental formula for the derivative:

$$f'(x) = \lim_{\varepsilon \to 0} \frac{f(x+\varepsilon) - f(x)}{\varepsilon}.$$

Without this concept it is difficult or impossible to develop a formal theory of differentiation. Perhaps for this reason in the *wasan* differentiation was confined to finding the maximum or minimum of functions.

How did the traditional geometers do this? For quadratic functions, parabolas, one knows without calculus that the maximum or minimum is at the vertex of the parabola, and so for functions of the form $y = ax^2 + bx + c$, one can write down the answer: $x_{\min/\max} = -b/2a$ and $y_{\min/\max} = y(x_{\min/\max})$. By induction, one can do this for a few polynomials, $y = f(x) = a_0 + a_1 x + a_2 x^2 + a_3 x^3 + \cdots$ and postulate that the extremum of the function will be at $0 = a_1 + 2a_2 x + 3a_3 x^2 + \cdots$. It is certainly the case that the traditional Japanese geometers did not differentiate nonpolynomial functions.

For example, in problem 44, chapter 4, we obtained an expression for the area that we wanted to maximize, $S(t) = 2t\sqrt{a^2 - t^2} - 2t^2$. From that point on we gave a modern solution:

$$S'(t) = 2\sqrt{a^2 - t^2} - \frac{2t^2}{\sqrt{a^2 - t^2}} - 4t,$$

and $S' = 0$ implies $a^2 - 2t^2 = 2t\sqrt{a^2 - t^2}$.

The Japanese geometers, however, could not differentiate $S = 2t\sqrt{a^2 - t^2} - 2t^2$ directly. Instead they probably did something like this:

$$S = 2t\sqrt{a^2 - t^2} - 2t^2, \qquad (1)$$
$$(S + 2t^2)^2 = 4t^2(a^2 - t^2),$$
$$S^2 + 4St^2 + 4t^4 = 4a^2 t^2 - 4t^4,$$
$$2SS' + 4(S't^2 + 2St) + 16t^3 = 8a^2 t - 16t^3.$$

If at the maximum $S' = 0$, then

$$S = a^2 - 4t^2,$$
$$2t\sqrt{a^2 - t^2} - 2t^2 = a^2 - 4t^2,$$
$$a^2 - 2t^2 = 2t\sqrt{a^2 - t^2}, \qquad (2)$$

as before.

Unfortunately, the traditional mathematicians wrote down only steps (1) and (2), and we have no evidence how they got from one to the other. For polynomials, the product rule $(St^2)' = S't + 2tS$ can be established with-

out too much difficulty, but how they extended it to other functions, whether they just assumed it was true, is nowhere made explicit. The above sketch, then, is our best guess and it will have to suffice.

Toward Integration

At the outset of the book we spoke of how the traditional Japanese concept of integration is bound up with the *Enri*, usually translated as the ineffable "circle principle." During the early days of *wasan*—we gave abundant evidence in chapter 3—Japanese mathematicians were deeply concerned with approximating π, which is virtually inseparable from the essential concept of "circle." Such calculations were facilitated and spurred on by the *soroban*, and

Plate 9.2 Early *Enri* calculations were largely concerned with finding the value of π. Here is an illustration from Takebe Katahiro's 1710 book *Taisei Sankei*, in which he used a 1,024-sided regular polygon to approximate π as $\pi = 3.14159265358981538324194$ (see chapter 3). (Collection of Fukagawa Hidetoshi.)

the term *Enri* initially referred to such computations. A samurai computing π, when asked what he did while not at his government job, might have replied that he was engaged in *Enri* calculations. It was only later that the *Enri* took on the connotation of finding areas and volumes by definite integration.

The transition from calculating π to finding areas and volumes took place over centuries. For simple geometrical figures, of course, it is quite easy to find the area, and no calculus is required. A curious example of how to compute the area of a circle is shown in plate 9.1 from the 1778 edition of the *Jinkō-ki*. While it tacitly assumes that you already know the formula for the area of a circle, it does contain the notion of slicing up a figure, which is crucial in the calculus approach to computing areas.

An important step in the direction of calculus was taken by Takebe Katahiro (chapter 3). One of the most important problems in traditional Chinese and Japanese mathematics was to find an arclength l of a circle in terms of its radius and k, the length of the sagitta (figure 9.1). ("Sagitta," from the Latin "arrow" is a trigonometric function unfortunately not much in use nowadays. Figure 9.1 gives an idea of where the word comes from. It is also known as the versine, versin $\theta \equiv 1 - \cos\theta$.) Takebe was the first Japanese mathematician to devise a successful method, which he did by introducing the notion that functions could be expanded in infinite series.[2] This was an original contribution and one not imported from China.

Takebe does not fully explain his methods, but for a circle with $2r = 10$ and sagitta $k = 10^{-5}$ he found, by enormous computational ability and the *soroban*, $(l/2)^2 = 0.000010000003333351111225396906$. From this calculation, he deduced—apparently by trial and error—the expansion $(l/2)^2 = k + (1/3)k^2$, and after further calculation decided on the infinite series $(l/2)^2 = k + (1/3)k^2 + (8/45)k^3 + \cdots$.

Today we would probably do Takebe's calculation by taking $k = r(1 - \cos\theta) = 2r\sin^2(\theta/2)$, which implies that $l/2 = r\theta = 2r\sin^{-1}\sqrt{(k/2r)}$, and then expanding the inverse sine function in a Taylor series as in Eq. (5), below.

If, like Takebe, one takes the length of the sagitta to be the radius of the circle, then one immediately has a formula for π^2, which makes it clear why such computations fell under the circle principle.

[2] Readers unfamiliar with series expansions should know that most functions $f(x)$ can be approximated as the sum of powers of x. For instance $e^x = 1 + x + x^2/2! + x^3/3! + \cdots$ and $\sin\theta = \theta - \theta^3/3! + \theta^5/5! - \theta^7/7! \cdots$. Generally, the more powers of x—or in the latter case θ—included, the more accurate the approximation. Such series are usually referred to as Taylor series or Maclaurin series. To take the derivative of a function, one can differentiate the series term by term or, conversely, one can integrate a function by integrating its series representation term by term.

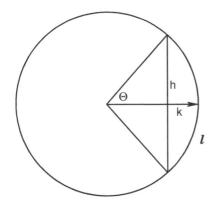

Figure 9.1. In this figure, l is the full arclength subtended by the chord. The segment h is the full chord. For a unit circle, $k \equiv 1 - \cos\theta$ is termed the sagitta.

Matsunaga Yoshisuke, who calculated more digits of π than any other traditional Japanese mathematician (chapter 3) employed Takebe's methods. In his book *Hōen Sankei* of 1739, Matsunaga presented many numerical methods for use with the *soroban*, in other words computer programs. These recipes took the form of Takebe's series expansions. The following problems are typical of what traditional Japanese mathematicians called *Enri* calculations.

Problem 1

We are given a circle of diameter 1 and a segment with arc l, chord h, and sagitta $k = 1/2 - \sqrt{1/4 - h^2/4}$. Confirm that the following series representations are correct:

(1) k in terms of l:

$$2k = \frac{l^2}{2!} - \frac{l^4}{4!} + \frac{l^6}{6!} - \frac{l^8}{8!} \cdots$$

where $n! = 1 \cdot 2 \cdot 3 \cdot \cdots \cdot n$.

Originally, Matsunaga wrote this in a somewhat more complicated way:

$$k = A_0 - A_1 + A_2 - A_3 + A_4 - A_5 \cdots$$

where $A_0 = l^2/4$; $A_1 = (l^2/12)A_0$; $A_2 = (l^2/30)A_1$; $A_3 = (l^2/56)A_2$; \cdots.

(2) h in terms of l:

$$h = l - \frac{l^3}{3!} + \frac{l^5}{5!} - \frac{l^7}{7!} \cdots.$$

Matsunage wrote this series in a way analogous to the previous, but we omit it.

Modern solutions can be found on page 311.

As already remarked, Takebe evidently discovered his series by trial and error, not to mention hard *soroban* handling. The formal concept of the Taylor series had yet to be invented. A more theoretical approach was introduced by Wada Yasushi,[3] who was born samurai in 1787 into the Ban-syu clan of Hyogo province. Later he moved to Edo to become a Master of Mathematics in an astronomy institute. As we shall see momentarily, Wada's main work was on definite integrals. He wrote sixty-six manuscripts but they were all destroyed by fire. Anxious to help his friend, and angered that other mathematicians were plagiarizing Wada's results, Koide Kanemasa (1797–1865) published the *Enri Sankei* (1842), or *Mathematics of the Enri*, making clear that it was Wada's work. Wada's sole passion was mathematics and he disdained honors, with the consequence that he spent his entire life in poverty, dying in 1840.

In the *Enri Sankei*, or the *Mathematics of Enri*, Wada deduces the expansion of $\sqrt{1-x}$ by assuming that $\sqrt{1-x} = a_0 + a_1 x + a_2 x^2 + a_3 x^3 + \cdots$. Squaring both he gets $1-x = a_0^2 + 2a_0 a_1 x + (a_1^2 + 2a_0 a_2)x^2 + \cdots$, which implies $a_0 = 1$, $a_1 = -1/2$, $a_2 = -1/8$, $a_3 = -3/48, \ldots$, or

$$\sqrt{1-x} = 1 - \frac{1}{2}x - \frac{1}{8}x^2 - \frac{3}{48}x^3 - \frac{15}{384}x^4 - \frac{105}{3840}x^5 - \cdots \tag{3}$$

in agreement with the binomial expansion. Similarly,

$$\frac{1}{\sqrt{1-x}} = 1 + \frac{1}{2}x + \frac{3}{8}x^2 + \frac{15}{48}x^3 + \frac{105}{384}x^4 + \frac{945}{3840}x^5 + \cdots. \tag{4}$$

Definite Integration

With such expansions, Wada and other Japanese mathematicians were in a position of being able to calculate various definite integrals. Their basic procedure was essentially what every calculus student learns when first calculating the areas under curves $y = f(x)$: Divide the domain of integration from 0 to x_f into small subintervals $\Delta x = (x_f)/N$; approximate the area under the curve as $A = \Sigma_{n=1}^{N} f(x_n)\Delta x$, and let $N \to \infty$. The difficult part of this procedure is evaluating $\Sigma f(x_n)$. Taking the function $f(x) = x^2$ as a standard example, we let $x_n = (x_f) \cdot n/N$. Then

$$A = \sum_{n=1}^{N} x_n^2 \Delta x = \sum_{n=1}^{N} x_f^3 \cdot \frac{n^2}{N^3} = \frac{x_f^2}{N^3} \sum_{n=1}^{N} n^2.$$

[3] Sometimes Wada Nei.

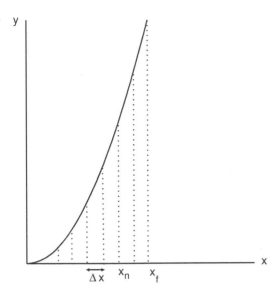

Figure 9.2. In this standard calculus example, the function is $y = x^2$. The interval along the x-axis between 0 and x_f, the final value of x, is divided into subintervals each with width $\Delta x = x_f/N$, where N is some large integer. An intermediate point x_n is given the value $x_n = n\Delta x = nx_f/N$, where $n < N$ is another integer. As explained in the text, taking the limit $N \rightarrow \infty$ leads to the definite integral of x^2.

But from chapter 2, problem 4-7, we know how this series sums, and so

$$A = \frac{x_f^3}{N^3}\left(\frac{N^3}{3} + \frac{N^2}{3} + \frac{N}{6}\right).$$

Taking the limit $N \rightarrow \infty$, yields the well-known result $A = x_f^3/3$.

Calculus students, though, quickly learn more efficient methods of evaluating integrals. Employing the universal method of substitution, we usually bring complicated functions into polynomial form, which is then easy to integrate. The traditional Japanese geometers did not go that far. Regardless of the function, they expanded it in a series and calculated the definite integral as we have just done. Wada's *Enri Sankei*, for example, includes many tables, the *Enri Hyō*[4] of definite integrals of irrational functions. Wada's near contemporary, Uchida Kyūmei (?–1868), made a detailed study of such integrals. It is worth saying a few words about Uchida. Like most of the other mathematicians we met earlier, Uchida was a samurai, from the Hikone clan in Shiga province, and he eventually become mathematics teacher to the lord of the clan himself, Ii Naosuke. Uchida's main work is the *Sanpō Kyūseki Tsu-ko* of 1844, the five–volume *Theory of Integrals*, from which we have already taken solutions to problems 22 and 23 in chapter 5 and problem 19 chapter 6. Here are further examples of definite integration from the *Enri Sankei* and the *Sanpō Kyūseki Tsu-ko* that employ the expansion of $\sqrt{1-x^2}$ and $1/\sqrt{1-x}$.

[4] Literally "folding tables," from the Japanese term for integration.

Plate 9.3. These *Enri* tables by Wada Yasushi are from his *Enri Sankei* 1842 manuscript. The columns on the right-hand page are series for the circumference of a circle, and series for the area. (Japan Academy.)

Problem 2

From figure 9.1, find the length *l* in terms of *r* and the chord length *h*.

Uchida's Original Solution: The method of solution is similar to several other problems we have encountered, especially problems 22–24 in chapter 5. Here, let *h* be the half-length of the chord. The infinitesimal arclength along the circle is $\sqrt{dx^2 + dy^2}$. We integrate along *y*. Then

$$l = 2 \int_0^h \sqrt{1 + (dx/dy)^2} \, dy$$

From similar triangles, as in figure 5.39 or 5.41 of chapter 5, we find $dx/dy = -y/x$. Along the circle $x^2 = r^2 - y^2$. Eliminating *x*, making the substitution $y = ht$ and expanding the denominator by Eq. (4) gives

$$l = 2h \int_0^1 \frac{1}{\sqrt{1 - (ht/r)^2}} \, dt$$

$$= 2h \int_0^1 [1 + (1/2)\,(ht/r)^2 + (1 \cdot 3/2 \cdot 4)\,(ht/r)^4 + (1 \cdot 3 \cdot 5/2 \cdot 4 \cdot 6)\,(ht/r)^6 + \cdots,] dt$$

$$= 2h[1 + (1/2 \cdot 3)\,(h/r)^2 + (1 \cdot 3/2 \cdot 4 \cdot 5)\,(h/r)^4 + (1 \cdot 3 \cdot 5/2 \cdot 4 \cdot 6 \cdot 7)\,(h/r)^6 + \cdots].$$

In modern notation we would write this as

$$l = 2r \arcsin(h/r) = 2h\left[1 + \frac{1}{2\cdot 3}(h/r)^2 + \frac{1\cdot 3}{2\cdot 4\cdot 5}(h/r)^4 + \frac{1\cdot 3\cdot 5}{2\cdot 4\cdot 6\cdot 7}(h/r)^6 + \cdots\right],$$

or, with $x = h/r$,

$$l = \arcsin x = x + \frac{1}{2\cdot 3}x^3 + \frac{1\cdot 3}{2\cdot 4\cdot 5}x^5 + \frac{1\cdot 3\cdot 5}{2\cdot 4\cdot 6\cdot 7}x^7 + \cdots.$$

Two decades earlier, in 1822, Sakabe Kōhan (1759–1824) had employed the same procedure to to find the length of an ellipse, a result he wrote down in his manuscript *Sokuen Syukai*, or "Circumference of Ellipse." Sakabe was the first Japanese mathematician who succeeded in doing this.

Problem 3

Here are three of Wada's expansions from plate 9.3. Two are for the area of a circle and one for the circumference. Confirm their correctness.

$$(1)\ A = d^2\left(1 - \frac{1}{3} + \frac{1}{5} - \frac{1}{7} + \frac{1}{9} - \cdots\right),$$

$$(2)\ A = d^2\left(1 - \frac{1}{2\cdot 3} - \frac{1}{5\cdot 8} - \frac{3}{7\cdot 48} - \frac{15}{9\cdot 384} - \frac{105}{11\cdot 3840}\cdots\right),$$

$$(3)\ C = 2d\left(1 + \frac{1}{2\cdot 3} + \frac{3}{5\cdot 8} + \frac{15}{7\cdot 48} + \frac{105}{9\cdot 384} + \frac{945}{11\cdot 3840}\cdots\right).$$

Solutions are on page 311.

As a final example of the *Enri*, also from Uchida's *Sanpō Kyūseki Tsu-ko*, we return to problem 19 from chapter 6, one of the most difficult problems in the *wasan*. We were to find the surface area cut out of an elliptic cylinder by the sectors of two right circular cylinders. The problem resulted in the integral

$$S = 4d\sqrt{Dd}\int_0^1 t^{1/2}\sqrt{1 - (d/D)t}\,\sqrt{\frac{1 - (1 - b^2/a^2)(d^2/a^2)t^2}{1 - (d^2/a^2)t^2}}\,dt,$$

which we evaluated numerically. Although the author of the problem, Matsuoka Makota, did not write down his detailed calculations on the *sangaku*, he evidently did much the same but in a fashion more suitable for *soroban* calculations. The integrand contains three square roots, two of which are of the same form. We use the binomial expansions above for $\sqrt{1-x}$ and $1/\sqrt{1-x}$, applying the first expansion to the two square roots in the

numerator and the second expansion to the square root in the denominator. Thus, we are multiplying together three infinite series. This results in calculations too lengthy to reproduce here, but Makota did summarize them on the tablet. First, he writes the three infinite series in terms of the following recursion formulas:

(1) With $s \equiv 1 - b^2/a^2$, a and b as above, let

$$c_1 \equiv \frac{1}{2}(1 - s),$$

$$c_2 \equiv \frac{1}{4}(3 + s)c_1$$

$$c_3 \equiv \frac{1}{6}(5 + 3s)c_2 - \left(\frac{1}{3}\right)sc_1,$$

$$c_4 \equiv \frac{1}{8}(7 + 5s)c_3 - \left(\frac{2}{4}\right)sc_2,$$

$$c_5 \equiv \frac{1}{10}(9 + 7s)c_4 - \left(\frac{3}{5}\right)sc_3,$$

$$\cdots \equiv \cdots .$$

(2) With $w \equiv d^2/a^2$ and $c \equiv \sqrt{D^2 - (D - 2d)^2}$, let

$$B_1 \equiv \frac{c^3}{D},$$
$$B_2 \equiv wB_1,$$
$$B_3 \equiv wB_2,$$
$$B_4 \equiv wB_3,$$
$$\cdots \equiv \cdots .$$

(3) With $t \equiv d \cdot D/a^2$ and $k \equiv D/d$, let

$$A_0 \equiv 2S_1, \quad D_1 \equiv \left(\frac{1}{8}\right)t\left(3A_0 - \frac{5}{6}kB_1 - B_1\right),$$

$$A_1 \equiv c_1D_1, \quad D_2 \equiv \left(\frac{1}{12}\right)t\left(7D_1 - \frac{9}{10}kB_2 - B_2\right),$$

$$A_2 \equiv c_2D_2, \quad D_3 \equiv \left(\frac{1}{16}\right)t\left(11D_2 - \frac{13}{14}kB_3 - B_3\right),$$

$$A_3 \equiv c_3D_3, \quad D_4 \equiv \left(\frac{1}{20}\right)t\left(15D_3 - \frac{17}{18}kB_4 - B_4\right),$$

$$A_4 \equiv c_4D_4, \quad D_5 \equiv \left(\frac{1}{24}\right)t\left(19D_4 - \frac{21}{22}kB_5 - B_5\right),$$

$$\cdots \equiv \cdots .$$

Then the final result, written on the tablet, is given as

$$S = A_0 + A_1 + A_2 + A_3 + A_4 + \cdots.$$

We leave it an an exercise for the reader to fill in the details, but the result is correct.

Solutions to Selected Chapter 9 Problems

Problem 1

(1) In this case we do not have a unit circle, but rather $r = 1/2$. Thus, from figure 9.1, $\mathrm{versin}\,\theta = k = r - x = r(1 - \cos\theta)$, and $l = 2r\theta = \theta$. Expanding $\cos\theta$ in a Taylor series immediately gives

$$2k = 2r(1 - \cos\theta)$$

$$= 2r\left[1 - \left(1 - \frac{\theta^2}{2!} + \frac{\theta^4}{4!} - \frac{\theta^6}{6!} + \frac{\theta^8}{8!}\cdots\right)\right]$$

$$= \frac{l^2}{2!} - \frac{l^4}{4!} - \frac{l^6}{6!} + \frac{l^8}{8!}\cdots.$$

(2) Since h is the full chord, $h/r = 2\sin\theta$. As in part 1, we expand $\sin\theta$ in a Taylor series or, equivalently, differentiate the series for $\cos\theta$. Since $l = \theta$, we have at once

$$h = \sin l = l - \frac{l^3}{3!} + \frac{l^5}{5!} - \frac{l^7}{7!}\cdots.$$

Problem 3

(1) The area should be $A = \pi d^2/4$. We recognize the quantity in parentheses as $\tan^{-1}x = x - x^3/3 + x^5/5 - x^7/7 + \cdots$, for $x = 1$. $\mathrm{Arctan}(1) = \pi/4$. Therefore we regain $A = \pi d^2/4$.

(2) The area of a unit circle is

$$A = 4\int_0^1 dx \int_0^{\sqrt{1^2 - x^2}} dy = 4\int_0^1 \sqrt{1 - x^2}\,dx.$$

Use the binomial expansion given in equation (3) to get

$$\sqrt{1 - x^2} = 1 - (1/2)x^2 - (1/8)x^4 - (3/48)x^6 - \cdots$$

and integrate both sides. Multiply by $d^2/4$ to get Wada's result.

(3) This result follows from problem 2 in the text. There we found l by expanding $1/\sqrt{1 - x^2}$ to get $l = 2r\arcsin(h/r)$. Notice that the series in Uchida's solution is the one we are asked to confirm. Merely substitute $(h/r) = 1$ and multiply by 2 to get $C = \pi d$.

Plate 10.1. Traditional Japanese geometry problems typically involve multitudes of circles within circles, such as those shown here or in chapter 6. Traditional Japanese mathematicians would have solved them using the methods of chapter 6, but they are more easily solved by the technique of inversion, the subject of this chapter. The original illustrations here are from Fujita Kagen's *Shinpeki Sanpō* of 1789. The problem, which asks you to show that $r_7 = r/7$, is from a lost tablet hung by Kanei Teisuke in 1828 in the Menuma temple of Kumagaya city, Saitama pefecture. We know of it from the 1830 manuscript *Saishi Shinzan* or *Collection of Sangaku* by Nakamura Tokikazu (?–1880). (Japan Academy.)

Ten

Introduction to Inversion

The world needs to be turned upside down in order to make it right side up
—Billy Sunday, possibly

In chapter 6 we encountered several problems with multiple circles in contact with one another. A striking example was problem 12, proposed by Hotta Jinsuke and hung in 1788 at the Yanagijima Myōkendō temple of Tokyo. Yoshida's original solution of Hotta's problem deployed the Japanese equivalent of the Descartes circle theorem, but this problem and many similar ones can be solved more easily by an extraordinarily powerful and simple technique known as *inversion*, which was discovered in the West independently by several mathematicians between 1824 and 1845, and which was unknown to the practitioners of traditional Japanese mathematics. Roughly speaking, inversion is a way of turning figures inside out; points that were inside the figure become points outside the figure, and vice versa. Certain problems involving circles that at first glance seem impossible are quickly vanquished in this inside-out space, after which one "reinverts" back to the original space to get the final result.

Inversion can only be called "way cool," and although it is simple enough to be mastered by high school seniors, it is evidently no longer taught in the United States except in some advanced undergraduate mathematics courses. Therefore in this chapter we give an introduction to the technique, including enough theorems to solve the problems in the book. The proofs are fairly standard; and interested readers can find variations on them in any of the references in the "Further Reading" section. Once the theorems are in hand, we employ them to solve Hotta's problem.

Figure 10.1. Inversion is defined with respect to the circle Σ. The points P and P' are termed inverses. The point T is termed the center of inversion.

\mathcal{I}nversion is an operation generally defined with respect to a circle. Suppose we are given a circle Σ with radius k and center T (see figure 10.1).

P and P' are two points in the plane containing Σ. Notice that *by construction P and P' lie on the same line.* If the lengths TP and TP' in the figure are such that

$$TP \cdot TP' = k^2, \tag{1}$$

we say that P and P' are *inverses*. In other words, when the radius k is the geometric mean of TP and TP', P and P' are inverses. Equivalently, we can say that the point P has been *inverted* with respect to the circle Σ. Geometrically, the meaning of inversion can easily be seen from the figure. By construction, triangles TAP and TAP' are similar, so

$$\frac{TP}{k} = \frac{k}{TP'},$$

or $TP \cdot TP' = k^2$, as already stated.[1] As we will show later, when solving problems we usually set $k = 1$. Then we have simply $TP' = 1/TP$ and it becomes clear why P and P' are termed inverses. Points that are inside Σ are thrown outside and vice versa.

Not only individual points but entire figures can be inverted. That is, suppose we have some figure F that we wish to invert with respect to Σ. Each point P on F inverts to a point P', with the result that the entire world inside Σ is tossed outside and the reverse. The question is, What sort of figure is F'? Except in diabolical situations, the figure F to be inverted is a straight line or a circle itself, so the question becomes, what is the locus of points described by the inverse F' of a line or a circle F? In order to answer this question, and solve Hotta's problem, we need several theorems about inversion. For convenient reference, we list them first and prove most afterward.

[1] Readers who have studied complex variables will recognize inversion as a type of conformal transformation.

Basic Theorems about Inversion

Suppose we have a circle Σ, as shown in figure 10.1, whose center T is called *the center of inversion*. Assume we also have a straight line l that we wish to invert with respect to Σ. Then:

Theorem A

A straight line passing through the center of inversion inverts into itself. A straight line *not* passing through the center of inversion inverts into a circle that passes *through* the center of inversion.

The former situation is shown in figure 10.1; the latter situation is illustrated in figure 10.2

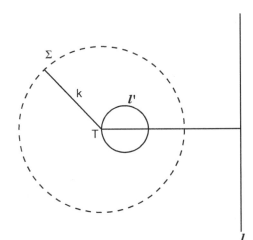

Figure 10.2. Theorem A. The line l does *not* pass through the center of inversion T. Its inverse with respect to circle Σ is the small circle l', which *does* pass through T.

Now assume we have a circle C and that we wish to invert C with respect to Σ. Then:

Theorem B

If circle C *does not* pass through the center of inversion T, then C inverts into another circle C'.

An example of such a situation is shown in figure 10.3.

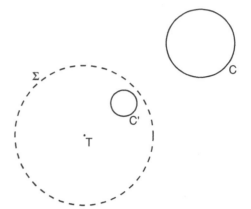

Figure 10.3. The circle *C* does *not* pass through the center of inversion *T* and so its inverse *C'* is also another circle, which does not pass through *T*.

Theorem C

If circle C does pass through the center of inversion T, then C inverts into a straight line that does not pass through the center of inversion. (This is the converse of theorem A.)

Furthermore, if for simplicity we take *T* to lie at the origin (0, 0) of a coordinate system, then the equation of the line is

$$y' = \frac{-gx'}{f} + \frac{k^2}{2f}.$$

Here, (*g*, *f*) are the coordinates of the center of *C* with respect to *T. Primes denote coordinates in the inverted system.* An example of such a situation is shown in figure 10.4. Note that the equation is of the usual slope-intercept form $y' = mx' + b$, with $m = -g/f$ and $b = k^2/2f$.

Figure 10.4. The circle *C* passes through the center of inversion *T*, which is located at (0, 0). The center of *C* is located at (0, 1), so by Theorem C the inverse *C'* is a horizontal line with equation $y' = k^2/2$. If the radius of Σ (not shown) is taken to be 1, which is generally allowed, the equation becomes simply $y' = 1/2$, as shown on the right.

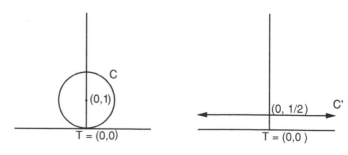

Theorem D

If r is the radius of C and r' is the radius of C', then r and r' are related by

$$r' = \frac{k^2}{|(d^2 - r^2)|}\, r,$$

where d is the distance between T and the center of C.

Theorem E

If L is the length of the tangent from T to the inverse circle C', then

$$rL^2 = k^2 r'.$$

The geometry is somewhat clarified by Figures 10.6 and 10.10 below.

Theorems A–E figure in virtually all inversion problems and, what's more, theorems B–E are all that is needed to solve Hotta's problem. The reader may first want to go through the proofs of those theorems, and then peruse the additional theorems listed below as they come up for an occasional advanced problem:

Theorem F

Points on the circle of inversion are invariant.

Theorem G

Concentric circles whose center is the center of inversion invert into concentric circles.

Theorem H

The center of the inverse circle is *not* the inverse of the center of the original circle.

Theorem K

If two circles are tangent to each other at T, they invert into parallel lines. If two circles are tangent to each other at a point P that is not the center of inversion, then the inverse circles must be tangent to each other at some point P'. *Points of tangency are preserved.*

Theorem L

Inversion preserves angles (That is, if two curves intersect at a given angle, their inverses intersect at the same angle.)

Theorem M

A circle, its inverse, and the center of inversion are colinear.

Theorem N

By the proper choice of the center of inversion T, two circles that are not in contact can be inverted into two concentric circles.

Theorem P (Iwata's theorem).

If four circles can be inverted into four circles of equal radii, r', whose centers form the vertices of a rectangle, then

$$\frac{1}{r_1} + \frac{1}{r_3} = \frac{1}{r_2} + \frac{1}{r_4},$$

where r_1, r_2, r_3, r_4 are the radii of the original circles (see figure 10.15).

Proofs of Theorems A–E

To prove the basic theorems is not difficult. The first part of theorem A follows directly from the definition of inversion: We may take a line passing through the center of inversion to be the horizontal line drawn in figure 10.1. Under inversion, points P and P' are merely swapped, as are all the other points and their inverses on the line, but by construction all of them remain on the same line. Thus the line inverts into itself. The second part of theorem A is proved by figure 10.5. Therefore, we have again

Theorem A

A straight line passing through the center of inversion inverts into itself. A straight line not passing through the center of inversion inverts into a circle that passes *through* the center of inversion.

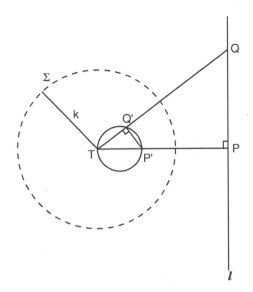

Figure 10.5. Proof of theorem A. Take points *P* and *Q* on line *l*. Their inverses *P'* and *Q'* lie on straight lines through the center of inversion *T*. By definition of inversion, we must have $TP \cdot TP' = k^2$ and $TQ \cdot TQ' = k^2$, which implies $TQ/TP' = TP/TQ'$. Together with the fact that angle *T* is common to both $\triangle TPQ$ and $\triangle TP'Q'$, this means the two triangles are similar, and so $\angle TQ'P'$ is a right angle. Point *Q* on *l* was chosen arbitrarily, and so, for any *Q*, *Q'* must be such that $\angle TQ'P'$ remains a right angle. A basic theorem in geometry says that any angle inscribed in a semicircle is a right angle, so the locus of points traced out by *Q'* must be a circle.

Thus the inverse of a straight line *not* passing through the center of inversion is a circle that passes *through* the center of inversion. The converse clearly holds (see figure 10.7), so the inverse of a circle passing *through* the center of inversion is a straight line that does *not* pass through the center of inversion.

Theorem B states that the inverse of a circle *not* passing through the center of inversion inverts into another circle, while Theorem C states that a circle passing *through* the center of inversion inverts into a straight line (the converse of Theorem A). The basic proofs can be carried out by construction as in figures 10.6 and 10.7. However, it is often useful to have the actual equations for the original circle and its inverse. For simplicity, we take the center of inversion *T* to lie at (0, 0), the origin of the coordinate system. This, then, is also the center of Σ.

Now, the equation of a circle *C* with center (g, f) can be written

$$x^2 + y^2 - 2gx - 2fy + c = 0, \tag{2}$$

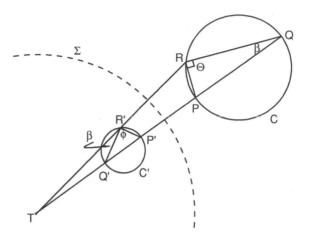

Figure 10.6. Proof of theorem B. This is similar to the proof of theorem A. Take points *P*, *Q*, and *R* on circle *C*. *P′*, the inverse of *P*, lies on the line *TP*, while *R* and *R′* lie on *TR*. By definition of inversion, $TR \cdot TR' = k^2$ and $TP \cdot TP' = k^2$, which implies $TR/TP = TP/TR'$. Hence, as in the proof of theorem A, ΔTPR and $\Delta TP'R'$ are similar, with $\angle TPR = \angle TR'P'$. By the same argument, ΔTQR and $\Delta TQ'R'$ are similar with $\angle TQR = \angle TR'Q'$ (marked β).

However, $\angle TPR$ is an exterior angle of ΔPQR and so $TPR = \theta + \beta = TR'P'$. Moreover, we see from the diagram that $\angle TR'P' = \beta + \phi$. Therefore $\phi = \theta$. But θ is a right angle, and once again the locus of points traced out, this time by *R′*, must be a circle. The proof assumes that *TP* is nonzero, or that circle *C* does not pass through *T*. Notice that in this proof and the previous, the radius of inversion *k* was not important. For this reason one can often set $k = 1$.

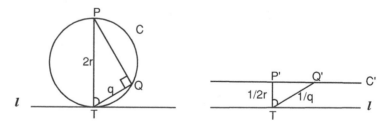

Figure 10.7. Proof of theorem C. This is the converse of Theorem A. We know that $\angle TQP$ in the circle *C* on the left must be a right angle. The circle of inversion Σ is not drawn. If we take $k = 1$ for simplicity, then by definition of inversion $TP \cdot TP' = 1$ and since *TP* is the diameter of $C = 2r$, then $TP' = 1/2r$. If the distance $TQ = q$, then $TQ' = 1/q$. *Q′* lies along the same line from *T* as *Q* and so the marked angle does not change. Also notice $TP'/TQ' = q/2r = TQ/TP$. Thus triangle *TPQ* on the left is similar to triangle *TQ′P′* on the right, and $\angle TP'Q'$ must be a right angle. Thus circle *C* inverts into a straight line parallel to *l* at a distance of $1/2r$.

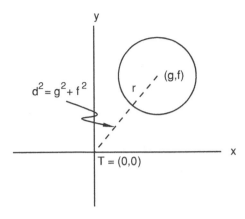

Figure 10.8. A circle with center (g, f). The distance from the origin to (g, f) is d.

or equivalently, upon completing the square,

$$(x - g)^2 + (y - f)^2 = g^2 + f^2 - c. \tag{3}$$

This is the more usual form, where $g^2 + f^2 - c = r^2$ is the radius squared of C. By the Pythagorean theorem $g^2 + f^2 \equiv d^2$ is the squared distance from the origin T to the center of C, as shown in figure 10.8.

From either of the above expressions we see that, if $x = y = 0$, then $c = 0$. Thus $c = 0$ implies that the circle *passes through the origin T*; $c \neq 0$ implies that the circle *does not* pass through T.

We now find an equation for the inverse figure of C and show that this is a circle C'. The easiest way to do this is to write the coordinates of a point P on C as

$$x = s \cos \theta, \quad y = s \sin \theta, \tag{4}$$

where θ is the angle shown in figure 10.9.

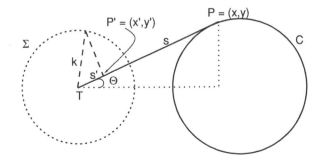

Figure 10.9. The point P on circle C has coordinates $(x, y) = (s \cos \theta, s \sin \theta)$. Because P and its inverse P' lie on the same line, P' has coordinates $(x, y) = (s' \cos \theta, s' \sin \theta)$.

As seen in the diagram, P', the inverse of P, lies along the same radius of Σ as P and so it shares the same angle θ. Hence the coordinates of P' must be

$$x' = s' \cos \theta, \quad y' = s' \sin \theta, \tag{5}$$

where s' is the distance from T to P'.

Now, divide equation (4) by equation (5) to get

$$x = \frac{s}{s'} x', \quad y = \frac{s}{s'} y'. \tag{6}$$

But by the definition of inversion $ss' = k^2$, so $s = k^2/s'$. Inserting this relationship into equation (6) yields

$$x = \frac{k^2}{x'^2 + y'^2} x', \quad y = \frac{k^2}{x'^2 + y'^2} y',$$

where $x'^2 + y'^2 = s'^2$ by the Pythagorean theorem.

Plugging these expressions into Eq. (2) and multiplying through by $(x'^2 + y'^2)$ gives

$$c(x'^2 + y'^2) - 2k^2 g x' - 2k^2 f y' + k^4 = 0. \tag{7}$$

When $c \neq 0$, the condition that circle C does not pass through T, we can divide through by c to get

$$x'^2 + y'^2 - \frac{2k^2 g}{c} x' - \frac{2k^2 f}{c} y' + \frac{k^4}{c} = 0. \tag{8}$$

Notice now that equation (8) is of exactly the same form as equation (2). Thus we have, once again,

Theorem B

If the circle C *does not* pass through T, then inversion maps C into another circle C'. Moreover, the center of this circle is at $(k^2 g/c, k^2 f/c)$.

If c does equal zero, then the circle C passes through T and equation (7) immediately gives

Theorem C

If the circle C *does* pass through T, then inversion maps C onto the straight line

$$y' = \frac{-g x'}{f} + \frac{k^2}{2f}.$$

Theorem D is easily derived by referring to figure 10.6. The radius r' of the inverse circle is $(TP' - TQ')/2$. From the definition of inversion we can write this as

$$r' = \frac{k^2}{2}\left(\frac{1}{TP} - \frac{1}{TQ}\right) = \frac{k^2}{2}\left(\frac{TQ - TP}{TP \cdot TQ}\right). \tag{9}$$

However, we also have $r = (TQ - TP)/2$, and so if we call d the distance from T to the center of circle C, equation (9) can be written as

$$r' = \frac{k^2}{(d-r)(d+r)}\,r.$$

Recognizing that d may be greater or less than r, but that r' must always be positive, we recast this as

Theorem D

$$r' = \frac{k^2}{|d^2 - r^2|}\,r.$$

This result may also be obtained analytically by completing the square in equation (8) and writing the equation of the inverse circle analogously to equation (3):

$$\left(x' - \frac{k^2 g}{c}\right)^2 + \left(y' - \frac{k^2 f}{c}\right)^2 = \left(\frac{k^2 g}{c}\right)^2 + \left(\frac{k^2 f}{c}\right)^2 - \frac{k^4}{c}.$$

We leave it as an exercise to show that this expression also leads directly to theorem D. However, here is a clear case where geometric reasoning saves work over algebra, as in the previous proofs.

Theorem E is proved in a manner similar to theorem D. Figure 10.10 depicts the inverse circle shown in figure 10.6 with the tangent L drawn in. As in equation (9) we can write

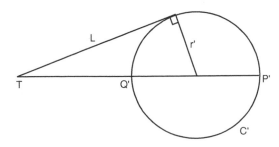

Figure 10.10. The inverse circle C' from figure 10.6 with radius r'. An elementary theorem says that $L^2 = TP' \cdot TQ'$.

$$2r = \frac{(TP' - TQ')}{TP' \cdot TQ'} k^2. \tag{10}$$

However, $TP' - TQ' = 2r'$, and a basic result ("the secant-tangent segments theorem") from first-year geometry states that $TP' \cdot TQ' = L^2$. Thus equation (10) immediately gives

Theorem E

$$\frac{r}{r'} = \frac{k^2}{L^2}.$$

Proofs of Selected Theorems F–P

As already mentioned, theorems B–E are all that are needed for basic inversion problems, and readers interested in the solution to Hotta's problem can skip this section. However, a number of other facts and theorems arise in solving some of the remaining problems in chapter 6—and advanced inversion problems in general. Theorem F, that points on the circle of inversion are invariant, follows trivially from the definition of inversion, but it is useful to bear in mind when constructing diagrams. Theorem G, that concentric circles whose centers are the center of inversion invert into concentric circles, is likewise trivial. Many students mistakenly assume that the center of the inverse circle is the inverse of the center of the original circle. This is not true, as theorem H states, but we do not prove it here.

The first part of theorem K, that two circles tangent to each other at the center of inversion invert into parallel lines, follows directly from theorem C and figure 10.7; we leave the few details as an exercise for the reader. The second part, that if two circles are tangent at a point P not the center of inversion, they must be tangent at some other point P' is also reasonable; after all, the point of tangency is *a single* point and it can only be inverted to *a single* destination P'.

For one or two of the problems in chapter 6, it is also important to keep in mind theorem M, that the centers of the original circle, the inverse and the circle of inversion are colinear, but this is also fairly obvious and we do not prove it. We, however, do prove theorem L, that inversion preserves angles. For the proof see figure 10.11

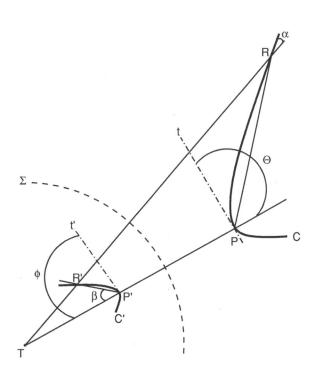

Figure 10.11. Proof of theorem L. This diagram is meant to go with the proof of theorem B, figure 10.6. Suppose a curve C cuts the radial lines TP and TR at points P and R. Curve C is inverted into curve C', which cuts TP and TR at P' and R'. The angle C makes with TP at P is θ, the angle between TP and C's tangent t (dash-dotted line) at P. Similarly, the angle C' makes with TP is given by ϕ. We already proved for theorem B that under inversion triangles TPR and $TP'R'$ are similar; hence $\alpha = \beta$. As R moves toward P, the side of the triangle PR becomes coincident with tangent t, and so in this limit $\alpha = \theta$. Similarly, $\beta = \phi$. Hence in the limit, $\phi = \theta$, and the angles C and C' make with TP are the same. If there is a second curve, call it S, that intersects TP at P at an angle ζ, then one merely repeats the analysis for S, finding that ζ is preserved under inversion. The angle between the two curves $\zeta - \theta$, will thus also be preserved.

Theorem N was also required for one of the problems in chapter 6. A totally rigorous proof requires a considerable number of preliminaries. However, with one or two shortcuts we can be quasi-rigorous.[2]

Figure 10.12 shows several members of a nonintersecting family of circles.[3] The important thing here is that we have chosen the coordinate system so the centers of all the circles α in the family lie on the x axis. Now, for any circle α with its center at point $(g, 0)$, equation (2) above becomes

$$x^2 + y^2 - 2gx + c = 0, \tag{11}$$

or equivalently, as before,

$$(x - g)^2 + y^2 = g^2 - c = r^2 \tag{12}$$

For such a system, c is taken as fixed, while varying g generates an infinite number of different α-circles (see footnote 4). Notice that, if $c = 0$, the ra-

[2] For fuller discussions, see Pedoe, *Geometry*, or Durell, *Course of Plane Geometry* ("For Further Reading, Chapter 10," p. 339).

[3] Advanced students will recognize this as a so-called coaxal or coaxial system of circles.

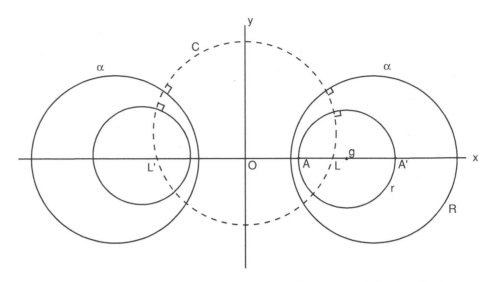

Figure 10.12. The coordinate axes are chosen so the centers of the family of circles α lie on the x-axis. The dashed circle C passes through points L and L'.

dius of any circle is just g and the circle touches the y axis. For $c > 0$ a circle does not reach the y axis, and, for $c < 0$, a circle crosses the y axis. However, as drawn, $c > 0$, which also means that none of the circles intersect.[4] Since $c > 0$, we can write $c = p^2$, and the radius of a given circle is $r = \sqrt{g^2 - p^2}$. For r to be real, we see that $g^2 \geq p^2$, which means that no circle in the system can have a center between $(-p, 0)$ and $(+p, 0)$ and that the circles centered there have zero radius. For that reason $(-p, 0)$ and $(+p, 0)$ are usually termed *limiting points* and are denoted as L and L' on figure 10.12.

Considering the point $x = A$ where the indicated circle intersects the x axis, we have from above $A^2 - 2Ag + p^2 = 0$, or $p^2 = 2Ag - A^2$. With $A = OA$ and $g = (OA + OA')/2$, the figure shows that

$$p^2 = OA \cdot OA' = OL^2 = (OL')^2. \tag{13}$$

This should begin to look familiar.[5] Redesignate the center g of circle r as O' (to get all capital letters), as in figure 10.13. It is then easy to show

[4]From equation (11), it is a simple exercise to show that the points of intersection of two circles with g_1, g_2 and c_1, c_2 lie on the straight line $2(g_2 - g_1)x + c_1 - c_2 = 0$. This line is termed the "radical axis" and it is always perpendicular to the line connecting the centers of the two circles. However, since we have required $c_1 = c_2$ above, we see that this equation becomes $x = 0$, or the y axis. Since none of the circles cross this axis, they do not intersect.

[5]By way of terminology, A, A' and L, L' are referred to as *harmonic conjugates* and are said to divide the segment $L'A'$ harmonically.

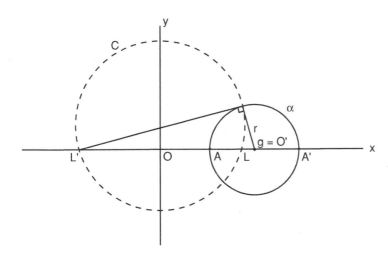

Figure 10.13. Redesignate the center g of the α-circle r as O'. One sees that L and L' are inverses with respect to O'. Thus, circle C must intersect circle r orthogonally.

from equation (13) that, for $r = (OA' - OA)/2$, the radius of the indicated circle,

$$r^2 = (O'L)(O'L'),$$

and hence by definition *the limiting points are inverses with respect to O'*!

Next, a basic theorem in geometry (which we used to prove theorem E) says that a tangent drawn from an external point (O') to a circle (C) is the geometric mean between the external segment ($O'L$) and the entire secant ($O'L'$); consequently, the radius r must be tangent to circle C. In that case we have the very important result: *Because L and L' are inverses, circles C and r intersect orthogonally.*[6] Notice we could draw an infinite number of circles C with different diameters through L and L' but we have not specified any diameter. Thus, *any circle C and any circle α intersect orthogonally.*

Now to theorem N. Let us invert the entire figure 10.12 with respect to one of the limiting points, say L. By theorem B, because none of the α-circles on the left pass through the center of inversion, they will all invert into other circles α' whose centers lie somewhere on the x axis, as shown in figure 10.14. On the other hand, since every C-circle passes through the center of inversion, L, they must invert into a straight line, C'. Further, because any C-circle is orthogonal to all the α-circles, any C' must be orthogonal to the inverse circles α'. (If this is not obvious, quote theorem L above.) Consequently, C' must be a diameter of α'. In fact, all the C' must intersect

[6] "Orthogonal" here has its usual meaning: at right angles.

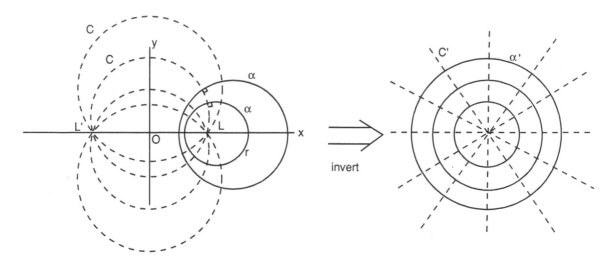

Figure 10.14. Invert figure 10.13 (left) with respect to the limiting point L. The α-circles invert into a concentric family of circles α' (right) with center L'' and the C-circles invert into straight lines orthogonal to the α'.

at the inverse of L' (call it L''), and so L'' is the center of a family of concentric circles α'. Thus we have

Theorem N

By the proper choice of the center of inversion T, two circles that are not in contact can be inverted into two concentric circles. (The proper choice of T is one of the limiting points.)

To prove theorem P, consider figure 10.15. Drop a perpendicular TM onto $O'_3 O'_4$, as shown, where the O' designate the centers of the inverse circles. Then by the Pythagorean theorem

$$(O'_1 T)^2 + (O'_3 T)^2 = (O'_1 M)^2 + (TM)^2 + (O'_3 N)^2 + (NT)^2$$
$$= (O'_4 N)^2 + (NT)^2 + (O'_2 M)^2 + (TM)^2$$
$$= (O'_4 T)^2 + (O'_2 T)^2.$$

But the length of the tangent L from any external point T to a circle of radius r' is also given by Pythagoras as $L^2 = (O'T)^2 - r'^2$, where O' is the circle's center. Thus in our case

$$L_1^2 + L_3^2 = (O'_1 T)^2 + (O'_3 T)^2 - 2r'^2,$$

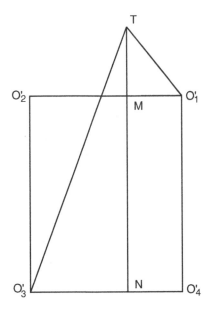

Figure 10.15. The centers of the four inverse circles O_1', O_2' O_3', O_4' are assumed to form the vertices of a rectangle.

or from above,

$$L_1^2 + L_3^2 = (O_4'T)^2 + (O_2'T)^2 - 2r'^2$$
$$= L_2^2 + L_4^2.$$

Theorem E then immediately gives the desired result:

Theorem P

If four circles r_1, r_2, r_3, r_4 can be inverted into four circles of equal radii r' whose centers lie on a rectangle, then

$$\frac{1}{r_1} + \frac{1}{r_3} = \frac{1}{r_2} + \frac{1}{r_4}.$$

Solution to Hotta's Problem

With theorems A–E in hand, many problems like those in chapter 6 are surprisingly easy to solve and require no more than high school geometry. We demonstrate this by solving Hotta's problem.

Begin by referring to figure 10.16. We are given that the radius of the outer circle α is r and the radii of the two largest inscribed circles β and γ

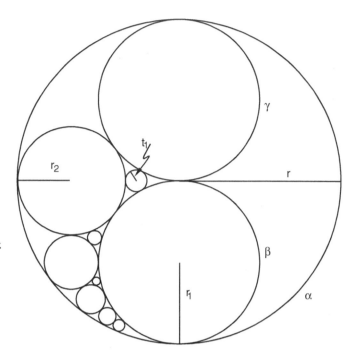

Figure 10.16. Hotta's problem. The radius of the circle α is r. The radius of the inscribed circles β and γ is $r_1 = 1/2r$. The nth circle in the outer chain will have radius r_n, and the nth circle in the inner chain will have radius t_n. The largest circle in the inner chain t_1 is indicated.

are each $r/2$. The problem asks us to find the radius of the nth circle in the outer or inner contact chains in terms of r. Denote by r_1 the radius of circles β and γ. As just stated, $r_1 = r/2$. Let $r_2 =$ radius of the third largest circle and $t_1 =$ radius of the largest circle in the inner chain. We will use r_n and t_n to designate the radii of the nth circle in the outer and inner chains. As we have throughout the book, we will also use r_n and t_n to designate the circles themselves.

Before employing inversion we will need the radii r_2 and t_1. From Figure 10.17, we see that $r - 2r_2 = h$. Also, the Pythagorean theorem gives

$$(r_1 + r_2)^2 = r_1^2 + (r_2 + h)^2.$$

From these two relationships, and remembering that $r = 2r_1$, we quickly find that

$$r_2 = \frac{1}{3}r. \tag{14}$$

Similarly, using the Pythagorean theorem on the small circle t_1 (figure 10.18) leads to

$$t_1 = \frac{r}{15}. \tag{15}$$

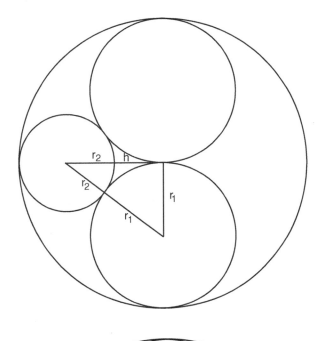

Figure 10.17. The relationships needed to show that $r_2 = r/3$ (equation (14)). Note that $h = r - 2r_2 = 2r_1 - 2r_2$, where the last equality follows because $r = 2r_1$.

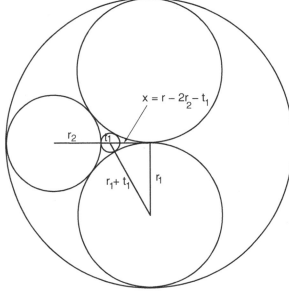

Figure 10.18. The relationships needed to show that $t_1 = r/15$ [equation (15)].

We now begin to invert the figure with respect to the point T, chosen as shown in figure 10.19. For simplicity we can take the radius of the inversion circle Σ to be $k = 1$ (which only means that everything is scaled to 1). Then, by the definition of inversion, we must have for point O

$$TO \cdot TO' = 1.$$

Figure 10.19. Because they pass through the center of inversion *T*, the circles α and β must invert into straight lines, as shown. The distances of α' and β' from *T* are given by equations 16 and 17.

But $TO = r$. Thus

$$TO' = \frac{1}{r}. \tag{16}$$

Similarly for point *B*,

$$TB \cdot TB' = 1, \quad TB = 2r,$$

or

$$TB' = \frac{1}{2r}. \tag{17}$$

Now, note that circle α *passes through the center of inversion, T*. Thus, by theorem C, α must invert into a straight line, in particular into a horizontal line because we have chosen *T* to lie directly below *O* (*x* coordinate of $O = g = 0$). Similarly, circle β also passes through *T*, so β must invert into a horizontal line. Equations (16) and (17) give the distances from *T* to these lines. Figure 10.19 shows these relationships.

Next, consider the upper circle, with $r = r_1$. This circle *does not* pass through *T*, so by theorem B it must invert into another circle. But circle r_1 is tangent to circle β at point *O* and tangent to circle α at point B. Therefore it must invert into the circle r_1' that lies between β' and α', as shown in figure 10.20. Similarly, circle r_2 is tangent to α, β and r_2 as shown. Therefore it must invert into the circle r_2' shown in figure 10.20. The same is true for all the circles in the outer chain.

Thus we have the remarkable result that all the inverse circles in the outer chain have the same radius!

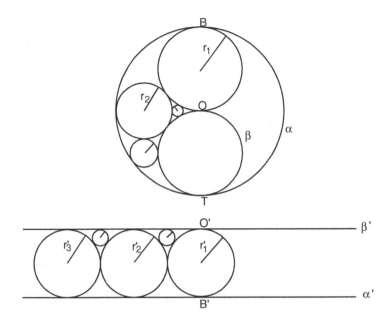

Figure 10.20. Because r_1 is tangent to both α and β at the points O and B, it must invert into a circle that lies between α' and β' and tangent to them at O' and B'. In the same way, the circle r_2 is tangent to r_1, α, and β. Thus, the outer chain of circles maps to a contact chain of inverse circles that all must lie between α' and β'. In other words, all the inverse circles have the same radius!

$$r_1' = r_2' = r_3' = \cdots = r_n' \equiv r'.$$

In the same way, all the circles of the inner chain map into circles of equal radius:

$$t_1' = t_2' = t_3' = \cdots = t_n' \equiv t'.$$

We now relate r' and t' to r. Consider r_1. The distance from T to the center of circle $\gamma\,(r_1)$ is by definition d in theorem D. In this case, from figure 10.16, $d = 3r_1$. Theorem D states that $r_1'^2(d^2 - r_1^2)^2 = r_1^2$, which yields

$$r' = r_1' = \frac{1}{8r_1}.$$

But $r_1 = r/2$, so

$$r' = \frac{1}{4r}$$

Similarly,

$$t' = \frac{1}{16r} \qquad\qquad (19)$$

Now that we have r' and t' in terms of r, we can get back to the r_n's and t_n's. We draw the tangent L_n from T to r_n', as in figure 10.21. Notice first from the figure that the distance to the center of r_n' is given by

$$x_n = 2(n-1)r'. \qquad\qquad (20)$$

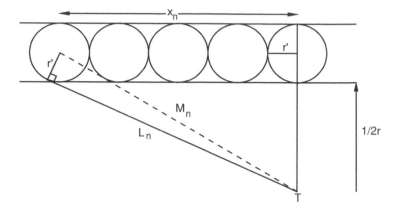

Figure 10.21. The distance L_n from T to r'_n is given by the Pythagorean theorem.

Also, by the Pythagorean theorem,

$$L_n^2 + r'^2 = M_n^2,$$

$$M_n^2 = \left(r' + \frac{1}{2r} \right)^2 + x_n^2. \tag{21}$$

We now employ theorem E, which tells us that

$$L_n^2 = \frac{r'}{r_n}. \tag{22}$$

Substituting equations (18), (20), and (22) into equation (21) and solving for r_n yields

$$r_n = \frac{r}{2 + (n-1)^2}. \tag{23}$$

This gives the radius of the nth circle in the outer chain in terms of r, as required.

For the inner chain, we follow the same procedure (figure 10.22). In this case we have

$$L_n^2 = M_n^2 - t'^2,$$

$$M_n^2 = \left(\frac{1}{r} - t' \right)^2 + x_n^2. \tag{24}$$

From equation (19) we have $t' = (1/16)r$ and from figure 10.11, $x_n = (2n-1)r'$. This time theorem E gives $L_n^2 = t'/t_n$. Substituting these expressions into equation (24) yields

$$t_n = \frac{r}{(2n-1)^2 + 14}, \tag{25}$$

the desired result. As an example, for $n = 5$, $t_n = r/95$. QED.

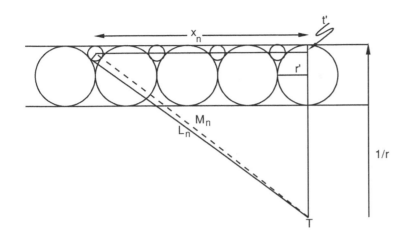

Figure 10.22. The distance L_n from T to t'_n is given by the Pythagorean theorem.

Further Practice with Inversion

For further practice with the inversion technique, we here give three more (nontrivial) exercises from *sangaku*, without solution.

Exercise 1

This problem is from a lost tablet hung by Adachi Mitsuaki in 1821 in the Asakusa Kanzeondō temple, Tokyo prefecture. We know of it from the 1830 manuscript *Saishi Shinzan* or *Collection of Sangaku* by Nakamura Tokikazu (?–1880).

Inside the semicircle of radius r shown in figure 10.23 are contained nine circles with the tangent properties indicated. Show that

$$r_1 = \frac{r}{2}; \quad r_2 = \frac{r}{4}; \quad r_3 = \frac{r}{15}; \quad r_4 = \frac{r}{12}; \quad r_5 = \frac{r}{10}.$$

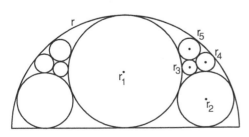

Figure 10.23. Show that $r_1 = r/2$; $r_2 = r/4$; $r_3 = r/15$; $r_4 = r/12$; $r_5 = r/10$.

Exercise 2

Like the previous exercise, this one also comes from Nakamura Tokikazu's *Collection of Sangaku*.

In figure 10.24, show that

$$\frac{1}{\sqrt{r_1}} + \frac{1}{\sqrt{r_3}} = \frac{2(2\sqrt{2} - 1)}{\sqrt{r_2}}.$$

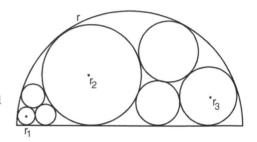

Figure 10.24. Find the relationship among r_1, r_2, and r_3, which are inscribed in a semicircle of radius r.

Exercise 3

This problem dates from 1819 and comes from Yamaguchi's diary.

In figure 10.25 four chains of circles of radii r_k ($k = 0, 1, 2, 3, \ldots, n$) kiss the large circle of radius r internally as well as kiss two circles of radii $r/2$ externally. Find r_k in terms of r.

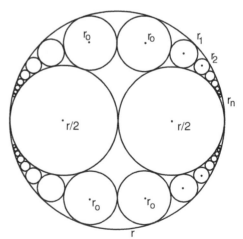

Figure 10.25. Find r_k, $k = 0, 1, 2, 3, \ldots, n$ in terms of r.

For Further Reading

What Do I Need to Know to Read This Book?

Three popular high school geometry texts are listed below. Each has its supporters and detractors. Of the first two, the first is definitely more attractive, but apparently lacks some necessary results contained in the second. We are not very familiar with the third. None will provide enough technique to conquer all the problems in this book, and they will need to be supplemented by other sources on trigonometry and calculus.

Harold R. Jacobs, *Geometry: Seeing, Doing, Understanding,* third edition (W. H. Freeman, New York, 2003).

Ray C. Jugensen, Richard G. Brown, John W. Jurgensen, *Geometry* (Mcdougal Littell/ Houghton Mifflin, New York, 2000).

Larson, Boswell, Stiff, *Geometry,* tenth edition (Mcdougal Littell/Houghton Mifflin, New York, 2001).

Below are several advanced texts, more closely matched to the harder problems in this book. Ogilvy is very readable, but presents only selected topics. Coxeter and Grietzer is a no-nonsense college-level text. Pedoe's approach to geometry is more algebraic than the others. Durell's book is a century old but somewhat clearer than Pedoe's and presents many theorems not discussed elsewhere.

Stanley Ogilvy, *Excursions in Geometry* (Dover, New York, 1990).

H. Coxeter and S. Greitzer, *Geometry Revisited* (New Mathematical Library, New York 1967).

Dan Pedoe, *Geometry, A Comprehensive Course* (Dover, New York, 1988).

Clement Durell, *A Course of Plane Geometry for Advanced Students* (Macmillan, London, 1909), part 1.

Chapter One. Japan and Temple Geometry

In English

Two large-scale surveys of Japanese history that have been very helpful for chapter 1 are

Marius B. Jansen, *The Making of Modern Japan* (Harvard University Press, Cambridge, 2000).

Conrad Totman, *Early Modern Japan* (University of California Press, Berkeley, 1993).

Only two histories devoted to Japanese mathematics are readily available in the United States, and they are now nearly 100 years old:

Yoshio Mikami, *The Development of Mathematics in China and Japan* (Chelsea, New York, 1974; reprint of 1913 edition).

David Smith and Yoshio Mikami *A History of Japanese Mathematics* (Open Court, Chicago, 1914).

Despite any shortcomings and mistakes they are the major references in English on the history of Japanese mathematics.

On the Web

A fairly comprehensive and reliable website on the history of mathematics is the *MacTutor History of Mathematics Archive*, which has been established at

http://www-history.mcs.st-andrews.ac.uk/history/index.html

The archive does not contain a special section on Japanese mathematics, but it does contain biographies of several of the mathematicians mentioned throughout this book.

In Japanese

A website on Traditional Japanese Mathematics by Fukagawa and Horibe:
http://horibe.jp/Japanese_Math.htm
The Japanese translation of the *Scientific American* article can be obtained via
http://www.nikkei-science.com/

Chapter 2. The Chinese Foundation of Japanese Mathematics

In English

Yoshio Mikami, *The Development of Mathematics In China and Japan* (Chelsea New York, 1974; reprint of 1913 edition).

David Smith and Yoshio Mikami, *A History of Japanese Mathematics* (Open Court, Chicago, 1914).

Colin A. Ronan, *The Shorter Science and Civilization in Ancient China: An Abridgement of Joseph Needham's Original Text* (Cambridge University Press, Cambridge, 1995), Vol. 2.

Jean-Claude Martzloff, *A History of Chinese Mathematics* (Springer, Berlin, 1995).

Christopher Cullen, *Astronomy and Mathematics in Ancient China: The Zhou Bi Suan Jing* (Cambridge University Press, Cambridge, 1996).

Roger Cooke, *The History of Mathematics: A Brief Course* (Wily-Interscience, New York, 2005).

On the Web

 The *MacTutor History of Mathematics Archive* at
 http://www-history.mcs.st-andrews.ac.uk/history/index.html

 A good starting point for this chapter is
 http://turnbull.mcs.st-and.ac.uk/history/Indexes/Chinese.html

In Japanese

 Li Di, *History of Chinese Mathematics*, Japanese translation by Otake Shigeo and Lu
 Renrui (Morikita Syuppan, Tokyo, 2002).

Chapter 6. Still Harder Temple Geometry Problems

Additional temple geometry problems, most fairly difficult, can be found in
 Fukagawa Hidetoshi and Dan Pedoe, *Japanese Temple Geometry Problems*, available
 from Charles Babbage Research Centre, P.O. Box 272, St. Norbert Postal Station,
 Winnepeg Canada, R3V 1L6.
 Fukagawa Hidetoshi and John Rigby, *Traditional Japanese Mathematics Problems of the
 18th and 19th Centuries* (SCT, Singapore, 2002).

Chapter 10. Introduction to Inversion

 The advanced texts listed in the section "What Do I Need to Know to Read This
Book?" all discuss inversion in less or more detail. They are:
 Stanley Ogilvy, *Excursions in Geometry* (Dover, New York, 1990).

At a higher level but more complete are
 H. Coxeter and S. Greitzer, *Geometry Revisited* (New Mathematical Library, New York,
 1967).
 Dan Pedoe *Geometry, A Comprehensive Course* (Dover, New York, 1988).
Probably the clearest, and containing literally hundreds of results on inversion is
 Clement Durell, *A Course of Plane Geometry for Advanced Students* (Macmillan, Lon-
 don, 1909), Part 1.

 Many websites devoted to inversion can be found on the Internet. The degree of
comprehensibility varies widely. A few sites that may be helpful with definitions and
constructions are:
 http://whistleralley.com/inversion/inversion.htm
 http://aleph0.clarku.edu/~djoyce/java/compass/compass3.html

Index